19TH-CENTURY AMERICA

PAINTINGS AND SCULPTURE

Introduction by

JOHN K. HOWAT
Associate Curator in Charge of American Paintings and Sculpture

and JOHN WILMERDING
Chairman, Department of the Fine Arts, Dartmouth College

Texts by

JOHN K. HOWAT

NATALIE SPASSKY

and others

19TH-CENTURY AMERICA

PAINTINGS AND SCULPTURE

AN EXHIBITION IN CELEBRATION OF

THE HUNDREDTH ANNIVERSARY OF

THE METROPOLITAN MUSEUM OF ART

APRIL 16 THROUGH SEPTEMBER 7, 1970

THE METROPOLITAN MUSEUM OF ART

Distributed by NEW YORK GRAPHIC SOCIETY LTD.

All photographs supplied by the lenders except: E. Irving Blomstrann, 8, 128; Donald Brennwasser, 2, 22, 184, 187; George M. Cushing, 98; Frick Art Reference Library, 142, 148; Robert S. Halvey, 16; Helga Photo Studio, Inc., 1; Kennedy Galleries, 70; Joseph Klima, Jr., 179; Lyman Allyn Museum, 143; Taylor and Dull, 12, 24, 30, 41, 80, 108, 121, 124, 136, 137, 144, 160, 164, 195, 196; Herbert P. Vose, 153

ON THE COVER:

Cider Making, by William Sidney Mount, NO. 53

Designed by Peter Oldenburg
with the assistance of Polly Cone
Composition by Harlowe Typography, Inc.
and Haber Typographers, Inc.
Printed in Great Britain by The Curwen Press Ltd.
Library of Congress catalog card number 70-109966
Cloth binding: Standard Book Number 87099-006-3
Paperbound: Standard Book Number 87099-007-1

PREFACE

IN HIS SPEECH IN 1869 advocating the founding of The Metropolitan Museum of Art, William Cullen Bryant, newspaperman, author, poet, collector, and prime mover, said: "... we require an extensive public gallery to contain the greater works of our painters and sculptors. The American soil is prolific of artists. The fine arts blossom not only in the populous regions of our country, but even in its solitary places."

Bryant's idea of the function of this "gallery" was not that of a shrine, where art was to be contained and from time to time beheld, remote from other pursuits of life or from the art of the day. Rather, the Museum was to be an active, living place where artists, by contact with the best works of the past and of the present, could receive inspiration for future work. Bryant went on to point out: "Go where you will, into whatever museum of art in the old world, you will find there artists from the new, contemplating or copying the masterpieces of art which they contain. . . . But there are beginners among us who have not the means of resorting to distant countries for that instruction in art which is derived from carefully studying the works of acknowledged excellence. For these a gallery is needed at home, which shall vie with those abroad, if not in multitude, yet in the merit, of the work it contains."

Bryant was the intimate or acquaintance of almost every important American painter, sculptor, and architect active in the middle years of the century, six of whom joined him as founding Trustees of the Metropolitan. His words thus expressed the hopes and needs of the artists, as well as the genial wishes of the patrons and the general public. One hundred years later, as we celebrate the accomplishments of the Metropolitan during its first century, we are proudly re-emphasizing the founders' ideas, as vital today as they were then, that the Museum's function is educational, and that it has an essential role as a living force in the community.

Because the Metropolitan Museum is in great measure the creation of the American painters, sculptors, and architects prominent at the time of its founding, it is wholly appropriate that in celebration of the Centennial we announce our firm intent to develop a new and vastly enlarged American Wing, which will enable us to show the best paintings and sculpture as well as the finest of the decorative arts produced by America's artists from the seventeenth century to the present. The exhibition *Nineteenth-Century America*, a superb suite of formal galleries of paintings and sculpture, period rooms, and vignettes, is thus a sort of preview—and a most enticing one—of a new section of the Wing. The extensive work of selection and planning of the exhibition has been the joint effort of John K. Howat, Associate Curator in Charge of American Paintings and Sculpture, with John Wilmerding, Chairman of the Department of the Fine Arts, Dartmouth College, and Berry B. Tracy, Curator of the American Wing; the decorative arts are catalogued in a companion volume.

Looking at this exhibition, one can assess the folly of the genteel neglect and snobbish disdain that has until recently been the lot of much of this work. There is extraordinary vitality, variety, and delight to be found in these marbles and bronzes and in these paintings—portraits, still lifes, landscapes, and genre scenes. The century, in its turbulence and variety, is here before our eyes: a battle from the War of 1812 and the bombardment of Fort Sumter; the scientific spirit, in Peale's Exhuming the Mastodon, Audubon's study of a hawk preying on quail, and Eakins's Gross Clinic; our native literature illustrated by Quidor; our coasts

v

and rivers, the Great Plains, the West, and the Indians; our politics, in busts of Andrew Jackson and Daniel Webster and in Bingham's County Election and Johnson's The Funding Bill; our romantic visions in Cole.

More important than its reflection of history is the quality of this work: Sully's portraits are exquisite, and Mount's evocations of country life capture perfectly the atmosphere of the 1850s; Bierstadt's vast western panoramas are rendered with crystalline clarity; Eakins's and Homer's perception and insight place them in the ranks of our greatest artists.

Throughout, there is still evidence of dependence on older cultures, on classical allusion for subject matter, on the European schools for style. The country and its artistic tradition were still young, and many artists felt the need to look at the older tradition for both encouragement and approval. But the American characteristics of optimism, pragmatism, and inventiveness keep recurring, and even in the work of the American artists who toward the end of the century made themselves almost European, there was an American flavor.

This exhibition, *Nineteenth-Century America*, might well have been called America the Beautiful! or even better, America the Creative! Now for the first time, we can fully recognize and delight in the beauty and creativity of the arts of nineteenth-century America. This recognition and delight have been long coming to America, but I am confident that through this exhibition a wave of enthusiasm for our artistic past will rise and soon will reach "from sea to shining sea."

The Trustees and I want to thank all of those who through gifts of works of art or funds for purchase have made the Museum's collection of American art among the foremost in the world. We are also grateful to those individuals and institutions who have lent us works specially for this exhibition. Finally, for their work in selecting and cataloguing the paintings and sculpture in the exhibition, we thank John K. Howat, John Wilmerding, Natalie Spassky, and their colleagues, whose efforts and expertise have made the exhibition the splendid accomplishment that it is.

THOMAS P. F. HOVING
Director

ACKNOWLEDGMENTS

The planning and arranging of the paintings and sculpture for *Nineteenth-Century America* and the publication of this portion of its catalogue have been the central concern of the Department of American Paintings and Sculpture during the past eighteen months. During that time we have received extraordinary encouragement and support from lending institutions and private collectors, other museums and libraries, people knowledgeable in the field, and this Museum's own staff. Mounting major exhibitions such as this one, which attempts to show a large number of important objects, is difficult primarily because of the understandable reluctance of prospective lenders to part with their treasures. The participating institutions and individuals have shown not only great generosity in sending their paintings and sculptures, but have spent valuable time and energy supplying us with photos and information about them.

Equally generous with their time and assistance have been: John I. H. Baur, Arthur Breton, Butler Coleman, Wayne Craven, Carl C. Dauterman, Edward H. Dwight, Stuart P. Feld, Lawrence Fleischman, James T. Flexner, William H. Gerdts, Lloyd Goodrich, Donald J. Gormley, James J. Heslin, Marilynn Johnson, Richard J. Koke, Martin Leifer, Russell Lynes, John A. Mahey, Captain Dale Mayberry, U.S.N. (Ret.), Edgar deN. Mayhew, Denis Peploe, James Pilgrim, Olga Raggio, Oliver W. Robbins, Mrs. John L. Schaffer, Marvin D. Schwartz, Richard Taylor, James G. Tobin, Berry B. Tracy, William H. Truettner, Evan H. Turner, Nicholas B. Wainwright, and staff members of The Archives of American Art, Frick Art Reference Library, Lincoln Center of Performing Arts Library, The Metropolitan Museum of Art Library, The New-York Historical Society, The New York Public Library and The New York Society Library.

From the first George Trescher, Secretary of the 100th Anniversary Committee, and his staff, especially Inge Heckel and Linda R. Hyman, have provided help of the most useful kind, as have William D. Wilkinson, the Museum Registrar, Richard R. Morsches, the Operating Administrator, Peter Zellner of Exhibition Design, Hubert F. von Sonnenburg of Paintings Conservation, Edward Bloodgood, Sandy Canzoneri, and Roland Brand, Senior Departmental Assistants. The exhibition and its catalogue are the result of long and hard work by a hardy and ingenious group of people who have handled mountains of paperwork, researched, written, rewritten, and typed copy beyond the normal bounds of dedication and patience. Little could have been accomplished without the efforts of Katharine L. Beach, Meredith J. Blatt, Robin Bolton-Smith, Mrs. William C. Flannery, Carol Gordon, Sally Muir, Shelby Roberts, Mary Sittig, and Catherine Struse-Springer. Anne S. Davidson has worked prodigiously on the bibliography, and Joan Foley has been a creative and incisive editor who has prevented much nonsense from appearing in print. Natalie Spassky, particularly, deserves credit not only for her invaluable contribution of researching, writing, and editing of numerous entries, but for her ability to master the seemingly endless organizational details connected with such an exhibition. Finally, the basic conception and selection of paintings and sculpture, as well as the writing of the introductory essay, was evolved with the active participation of John Wilmerding, who has been a great source of ideas and encouragement throughout. The study of nineteenth-century American art has been served well by these people who merit so much thanks.

JOHN K. HOWAT
Associate Curator in Charge
American Paintings and Sculpture

LENDERS TO THE EXHIBITION

The Academy of Natural Sciences of Philadelphia

Addison Gallery of American Art, Phillips Academy, Andover

Albright-Knox Art Gallery, Buffalo

Art Commission of the City of New York

The Art Institute of Chicago

John Astor, New York

The Brooklyn Museum

Mrs. John Crosby Brown II, Old Lyme, Connecticut

Mrs. Charles Burlingham, New York

Dr. and Mrs. Irving F. Burton, Huntington Woods, Michigan

The Century Association, New York

City Art Museum of Saint Louis

Sterling and Francine Clark Art Institute, Williamstown, Massachusetts

The Columbus Gallery of Fine Arts, Columbus, Ohio

The Commissioners of Fairmount Park, Philadelphia

The Corcoran Gallery of Art, Washington

The Detroit Institute of Arts

M. H. de Young Memorial Museum, San Francisco

Mrs. Madeleine Thompson Edmonds, Northampton, Massachusetts

Essex Bar Association, Commonwealth of Massachusetts, Salem

Mr. and Mrs. Irving Mitchell Felt, New York

Fort Worth Art Center Museum

Glasgow Art Gallery and Museum

Mr. and Mrs. H. John Heinz III, Pittsburgh

The Historical Society of Pennsylvania, Philadelphia

Mr. and Mrs. Raymond J. Horowitz, New York

The Jefferson Medical College of Philadelphia

Joslyn Art Museum, Omaha

Mr. and Mrs. J. William Middendorf II, New York

The Minneapolis Institute of Arts

Munson-Williams-Proctor Institute, Utica

Museum of Art, Carnegie Institute, Pittsburgh

Museum of Fine Arts, Boston

National Academy of Design, New York

National Collection of Fine Arts, Smithsonian Institution, Washington

National Gallery of Art, Washington

William Rockhill Nelson Gallery of Art-Atkins Museum of Fine Arts, Kansas City

The Newark Museum

The New Britain Museum of American Art

The New-York Historical Society

The New York Public Library; Astor, Lenox and Tilden Foundations

New York State Historical Association, Cooperstown

North Carolina Museum of Art, Raleigh

The Peale Museum, Baltimore

The Pennsylvania Academy of the Fine Arts, Philadelphia

Pennsylvania Hospital, Philadelphia

Philadelphia Museum of Art

The Phillips Collection, Washington

The Putnam County Historical Society, Cold Spring, New York

James Ricau, Piermont, New York

Mr. and Mrs. Ernest Rosenfeld, New York

Mrs. John Barry Ryan, New York

J. B. Speed Art Museum, Louisville

The State Historical Society of Missouri, Columbia

The Suffolk Museum and Carriage House, Stony Brook, Long Island

Syracuse University

The Toledo Museum of Art

The Union League of Philadelphia

U.S. Department of the Interior

U.S. Naval Academy Museum, Annapolis

The University of Liverpool

Wadsworth Atheneum, Hartford

The Walters Art Gallery, Baltimore

Wichita Art Museum

Mrs. Norman B. Woolworth, New York

Worcester Art Museum

Yale University Art Gallery, New Haven

Anonymous (2)

INTRODUCTION

AMERICAN PAINTING AND SCULPTURE came of age in the nineteenth century. As the United States matured, and grew geographically, commercially, politically, and intellectually, the nation's artists expanded their horizons, discovering new subject matter and acquainting themselves with the broader artistic traditions of Europe. In part these developments were made possible by the increased patronage provided by greater and more widely distributed wealth. The main concern of artists, critics, and patrons was to blend the sophistication of European art with native sensibility to establish an authentic and recognizably American school proclaiming the spiritual independence of the young nation.

Eighteenth-century American painting comprised primarily portraiture, simple topographical art, and history scenes of the Colonial wars and the Revolution. As numerous American painters and sculptors traveled abroad to study the old masters, and academies and museums were created for the instruction of artists and public, the demand for new subjects grew. During the nineteenth century, topics essentially new to America—still life, genre, figure compositions, technology, natural history, and particularly romantic landscape—became extremely popular. In sculpture, as knowledge of the Italian, English, and French models spread, the utilitarian forms were joined by more elaborate portraits and fancy pieces. Academic styles and subjects became the norm among the more up-to-date artists and artisans; from Europe, neoclassicism, romanticism, realism, and impressionism swept America, and were adapted to produce a distinctive native art.

Americans are a pragmatic, optimistic, curious, and inventive people, whose attitudes are expressed in their art. As pragmatists they prefer fact over abstraction, physical presence over idea. John Singleton Copley's lucid materiality in his portraits is the high point of eighteenth-century American painting. Similarly, throughout the next hundred years, exactitude and directness, tempered by European influences, remained the key for our artists. A tone of optimism runs through their works: in the simple pleasure of discovery in Charles Willson Peale's Exhuming the Mastodon; in the grandiloquent landscapes of the Hudson River school; in the glow of well-being pervading the works of William Sidney Mount and George Caleb Bingham; and even in the forthrightness with which Thomas Eakins and Winslow Homer painted their milieu no matter how "unartistic" the subject.

As Americans explored their continent, they recorded their finds in zoological, botanical, and ethnological studies. Numerous explorer-painters, among them John J. Audubon and Albert Bierstadt, sought out the remote places where uncultivated landscape, the Indians, and native flora and fauna could be freshly seen and set down. Occasionally the raw vitality of this youthful country gave rise to images of violence, such as John Vanderlyn's Death of Jane McCrea or John Mix Stanley's Osage Scalp Dance, but most artists, governed by nineteenth-century ideas of suitability and decorum, chose not to emphasize this aspect of American life. Rather violence appears in the form of the destructive power of nature, as implied in the landscapes of Thomas Cole, Frederic Church, Albert Bierstadt, Thomas Moran, and Homer.

The most formative period for American art was the opening decades of the nineteenth century, during which the aesthetic absolutes inherited from the pre-

ceding era and another country were reaffirmed and then subsequently discarded. The grandiose concepts of Edmund Burke's Beautiful and Sublime, William Gilpin's Picturesque, and the belief of Joshua Reynolds that art should reveal the ideal truths expressed in antique and Renaissance works strongly affected Benjamin West. But West held that while there were established criteria for certain kinds of art, the artist's job was to select and synthesize from his observations of nature to create a work morally uplifting and instructive. The American painters who studied with West in London, notably John Trumbull, Gilbert Stuart, Charles Willson Peale, John Vanderlyn, Washington Allston, and Samuel F. B. Morse, determined the basic directions of nineteenth-century American art.

Probably the most remarkable artists of the fledgling American school were the members of the Peale family, headed by its virtuoso patriarch, Charles Willson Peale. Together Charles, James, Raphaelle, and Rembrandt painted all the old and new subjects that flourished during the century with a crisp and unfettered Yankee perception that set the highest standards.

While the Peales presented a cross section of the new interests, Gilbert Stuart continued the old ones and became the painter par excellence of Federal men of affairs and socialites; at his best he could combine the soft elegance of the English manner with his own direct, often acid, understanding of personality.

John Vanderlyn and Washington Allston epitomized in their work the imported stylistic forms and varying attitudes that took hold early in the century. Vanderlyn, probably the first American to study in Paris rather than London, was the leading proponent in this country of the strict neoclassicism practiced in France by Jacques-Louis David and his followers. Vanderlyn's best paintings, done during the first decade of the century, depict mythological and historical events in a careful linear style. Their warm expressive coloring and mysterious landscapes, however, show an underlying romanticism prophetic of later developments such as the luminous works of the Hudson River school. By contrast, Allston's brooding dramatic figure, history, and landscape paintings are completely romantic. An accomplished pupil of West and a companion of Coleridge and Wordsworth, Allston was the leading representative in America of full-blown English romanticism.

Samuel F. B. Morse, a youthful intimate and pupil of Allston who studied in Paris and Rome after four years with West, blended neoclassicism and romanticism in his portraits, landscapes, and detailed interior views. Like Allston, and so many later artists, Morse was dedicated to the formation of a truly American school of painting, but he thought it should be based on the best old master models. His interest in both art and science is in the tradition of Charles Willson Peale and Audubon, a tradition continued by William Rimmer and Thomas Eakins during the second half of the century.

Many lesser artists of the early nineteenth century, such as Henry Sargent or the craftsmen of the Skillin workshop, worked in a sedate neoclassical manner, particularly attractive for its clarity and simplicity. However, works more important to the future of American painting were being turned out by the landscapists Thomas Birch, Francis Guy, and Robert Salmon: these men placed a new emphasis on light and atmosphere in their realistic, sympathetic views that laid the foundations for the shimmering landscapes of the Hudson River school.

The neoclassical style in its characteristic revivalism and romanticising of the past was part of the larger romantic movement, which, as the century progressed, expanded its eclectic purview to include a wide range of styles. Artists sought

greater naturalism. In fact, nature increasingly became the principal inspiration; one needed only a trained hand, sensitivity, and imagination to be an artist. Beauty was in nature, the work of art, and the beholder; it was no longer laid down in an abstract set of rules or based on the opinion of some arbiter-critic. The call for identification with nature found its fullest expression in landscape painting, and to a lesser extent, in genre, in which Americans were shown as happily and confidently responding to their surroundings.

Thomas Cole was the unquestioned leader of the landscape painters and founder with Thomas Doughty of the Hudson River school, which flourished during the second and third quarters of the century. Much of Cole's work was religious or literary in content, establishing man's insignificance before God, time, and nature; but the balance of it reverently depicted native scenery. Louis Legrand Noble, Cole's friend and biographer, described one aspect of Cole's search for God in nature: ". . . in the study . . . of forms, he always himself first sought to penetrate their vital principle or spirit; laying it down as a law, that knowledge of the subtle truth of form, even in its most palpable outline, was impossible without a knowledge of its informing power." (*The Life and Works of Thomas Cole,* Cambridge, Massachusetts, 1964, p. 52.)

In Cole's landscapes the profound opposition of nature and civilization is made clear. In the purest romantic position, Cole saw in the former virtue, serenity, dignity, and purity, and in the latter little but historical piquancy, as is evidenced by his many views of the once-proud, lofty ruins of antiquity and the middle ages.

In 1847 a New York critic, discussing the landscapes of one of Cole's principal followers, Jasper F. Cropsey, saw the duty of the artist as almost a consecrated mission: "The axe of civilization is busy with our old forests, and artisan ingenuity is fast sweeping away the relics of our national infancy. What were once the wild and picturesque haunts of the Red Man, and where the wild deer roamed in freedom, are becoming the abodes of commerce and the seats of manufactures. Our inland lakes, once sheltered and secluded in the midst of noble forests, are now laid bare and covered with busy craft; and even the primordial hills, once bristling with shaggy pine and hemlock, like old Titans as they were, are being shorn of their locks, and left to blister in cold nakedness in the sun. 'The aged hemlocks, through whose branches have whistled the winds of a hundred winters,' are losing their identity, and made to figure in the shape of ideal boards and rafters for unsightly structures on the bare commons, ornamented with a few peaked poplars, pointing like fingerposts to the sky. Yankee enterprise has little sympathy with the picturesque, and it behooves our artists to rescue from its grasp the little that is left, before it is ever too late." (*The Literary World,* no. 15, May 15, 1847, pp. 347-348.)

Cole, his colleagues Thomas Doughty and Asher B. Durand, and their followers carefully observed and recorded every aspect of nature, from the blazing sunset to the humblest mullen plant, and they were also instrumental in creating a new lyrical spaciousness in landscape painting. Subsequently, Frederic Church, Fitz Hugh Lane, John F. Kensett, Martin Johnson Heade, Sanford R. Gifford, and other members of the second generation of the Hudson River school, often referred to as the luminists, developed and refined this spaciousness, adding the glowing atmosphere, flickering light, and masterful textural differentiations that so poetically described the American landscape.

In the pioneering pictures of John Quidor, genre painting reflected national pride and optimism in the illustration of scenes from the stories of Washington

Irving and James Fenimore Cooper, who were themselves dedicated to establishing an awareness of American history and culture. During the middle decades genre painting thrived in the refined and somewhat sentimental works of Richard Caton Woodville, James G. Clonney, and J. G. Brown and the more satirical ones of David Gilmour Blythe and Albertus D. O. Browere. However, genre, like landscape, grew increasingly spacious and light-conscious, less concerned with the intricacies of story-telling and more cognizant of the broader qualities of the American spirit and environment. This greater pictorial interest is clear in the works of Jerome Thompson, William Sidney Mount, and George Caleb Bingham.

Both landscape and genre painters responded to exoticism as the East became densely populated, its scenery extensively cultivated, and most of the available subject matter all too familiar. With the expansion of the nation into the West and of her merchants into foreign commerce, artists sought new experiences not only in our own untamed wilderness, vast plains, and towering mountains but in foreign places as well. George Catlin, among the first of the purposeful ethnological painters, during the 1830s portrayed the Indians in their waning glory; he was followed by Seth Eastman and William Ranney. Frederic Church's vast images of North and South America and Bierstadt's of the West, nearly panoramic in scale, seem in some way a physical response to the magnitude and grandeur of these new locations. Their works became almost a metaphor for the American wilderness and the whole of nature itself and were influential in the formation of our national parks system. Following a less dramatic lead, William Page tried to introduce sixteenth-century Venetian techniques and old master subjects into American art.

Landscape and genre painting were by no means the most numerous products of mid-century artists. Portraiture poured from the busy studios of skilled practitioners like Samuel Lovett Waldo, Chester Harding, Cephas G. Thompson, George P. A. Healy, Charles Cromwell Ingham, Thomas Hicks, Charles Loring Elliott, and William Morris Hunt. Portraits by these men were generally distinguished by their unelaborated mood, pose, and technique, reflecting the growing competition of the camera as well as the uncomplicated tastes of the patrons. Pleasant still lifes were popular, presenting pridefully—as does John F. Francis's Wine Bottles and Fruit—the abundance of food and table wares.

Mid-century was a period deeply concerned with developing nationalism, and it is not surprising that paintings celebrating the birth of the nation and the growth of democracy became more common. Great size has always impressed Americans, and large-scale patriotic scenes such as Emanuel Leutze's Washington Crossing the Delaware almost immediately became favorites.

Sculptors devoted themselves to neoclassical marble busts of leading citizens, sentimentalized renditions of literary and historical figures, and large public monuments. As the century progressed, the neoclassical style lost much of its appeal and was replaced by Beaux-Arts realism. Bronze became the favored material for statuary, because it allows a more intricately worked surface, has more warmth of color, and offers a less limited production of replicas. American sculptors were not the innovators that the painters were, but throughout the century they achieved a solid realism in portraiture that has greater value than mere stylishness.

During the last third of the century a new gentility and cosmopolitanism appeared that threatened the vigor of American art. The cheerfulness and faith in the country so prevalent in art before the Civil War began to fade in the interest of greater artistic sophistication. Almost as though trying to escape the American

ambience, painters and sculptors after the 1860s went in droves to study in Paris, in Munich, and later with the avant-garde impressionists working in and around Paris. The majority of important artists felt the need to draw upon the pure European Beaux-Arts influences, as both new stylistic departures and revivalism fought for control over the world of taste. Lesser figures submitted themselves almost wholly to the French and German styles of photographic, and often saccharine, realism, but the men who dominated the last decades—Winslow Homer, Eastman Johnson, and Thomas Eakins—absorbed the impact of photography, academic training, and impressionistic techniques to produce a powerful expression rarely admitting of sentimentality and maintaining the essentially tart American vision.

Homer, an artist-correspondent during the Civil War, was fascinated by the out-of-doors, and during the late 1860s and the 70s he devoted himself to depicting the pleasures of the farm and seashore. After a trip to Tynemouth, England, in 1881/82, where he saw fishermen heroically fighting the sea for their existence, a deeper mood was apparent in his landscapes. His late marine paintings are stirring and dramatic, expressing the overwhelming force of the tumultuous waves and roaring tides.

Often compared to Homer for his early genre pictures, Eastman Johnson was far less bold and more sentimental. Responding to the qualities of light and atmosphere, Johnson worked with swift, vivid touches of paint, especially in his Nantucket sketches and later portraits, achieving effects of chiaroscuro reminiscent of the seventeenth-century Dutch works he so carefully studied.

Homer's concern for humanity and Johnson's for light come together in the work of Thomas Eakins, America's greatest artist. Trained in American and Parisian art academies and at Jefferson Medical College as an anatomist, Eakins portrayed, with the deepest feeling and dedication to his craft, people and activities of his native Philadelphia. His sitters included fellow painters, architects, musicians, doctors, and priests—sympathetic personalities with similar creative drives. Eakins's portraits are never light-hearted. His sporting and genre pictures have none of the gaiety of Mount's or Bingham's but are characterized by an intensity and solemnity, and these qualities actually worked against their commercial success.

Eakins and Homer were the finest American painters of their period, combining the perceptions of the inner and outer eye; but there was another group of painters whose visions, in a marked departure from earlier American painting, were mystical and detached from objective reality. The foremost of these, Albert Pinkham Ryder, painted literary scenes and moonlight marines remarkable for their poignant expression of man's loneliness. Ralph Blakelock, usually associated with Ryder, produced haunting nocturnal landscapes, often of Indian camps, which are filled with a melancholy solitude similar to that of Ryder's works. Others sharing this sense of dissociation and surreality were John La Farge and Elihu Vedder, who often looked to Oriental art for new and exotic subjects. George Inness began as a leader of the Hudson River school and developed in his landscapes an intense personal brand of impressionism, partly the result of his involvement in Swedenborgianism. His richly atmospheric pictures are often as haunting as Ryder's, although they are rarely as unrealistic.

While Inness never embraced the tenets of French impressionism, many other Americans did. William Morris Hunt's Gloucester Harbor, of 1877, with its lively surface and dazzling light is an early fully developed example of American im-

pressionism. By the close of the century a small but growing group of Americans were actually labeling themselves "impressionists" and in 1898 formed an association called Ten American Painters, or The Ten, after the number of its founding members. Among these were Childe Hassam, Edmund C. Tarbell, John Twachtman, and J. Alden Weir; more loosely associated with the style were Homer D. Martin, Alexander Wyant, and Robert W. Vonnoh. The movement was aggressively opposed by the old-guard painters; but for all their supposed formlessness and revolutionary subject matter, American impressionist works retained a definition of fact almost completely lost in the painterly French models.

Three Americans who were closely associated with impressionism and succumbed to Europe almost entirely were the expatriates Whistler, Sargent, and Mary Cassatt. Whistler, who spent most of his time in London, combined delicate drawing and decorative patterns of color in works that he considered "art for art's sake." He saw his pictures as harmonious formal abstractions. Sargent, for much of his career, moved in the fashionable circles of America and Europe as a portrait painter, doing large numbers of freely impressionistic landscape and genre pictures on the side. He maintained a New Englander's keen perspicacity that gave substance to his overconfident and technically brilliant paintings. Mary Cassatt, a proper Philadelphian, spent her mature career in the company of French impressionists, and although never as original as they, she was accepted by them as an equal. Her limiting preference for mothers with their young children as her subjects fits neatly into the prevalent end-of-the-century taste in America for pictures of domestic tranquility, a curious reaction against the sometimes stark realism of Eakins or Homer, or the material presence and abstract orderliness of the "plebeian" still lifes of William Harnett, John Peto, and John Haberle.

Still another style during the last quarter of the century was the somber realism of the Munich school as practiced by Frank Duveneck and William Merritt Chase, who met in Munich during the 1870s. Drawn primarily from seventeenth-century Spanish and Dutch painting, the Munich style consisted of strong lighting effects, dark tonalities, and broad, vigorous brushwork. At its best the style could be a powerful expression, as in Duveneck's The Turkish Page; at its worst flashy and superficial.

During the nineties Chase moved toward impressionism, lightening his palette. More important, he turned to teaching, first on Long Island and in New York City in the mid-nineties, and then in 1897 at the Pennsylvania Academy of the Fine Arts. Several of the most prominent artists of the early twentieth century studied under Chase at this time, among them Robert Henri, George Bellows, and John Sloan. These three became members of the Ashcan school, so called because of its insistence upon subjects taken from everyday urban life. The reliance of these painters on spontaneity of execution, sensuous brushwork, and sober tonalities carried the manner of Chase and Duveneck into a new age.

While nineteenth-century artists were concerned primarily with landscape and new frontiers, the artists of the beginning of this century chose, decisively and appropriately, the city for their subject matter. For in the nineteenth century America's driving interest was the relation of man and nature; in the twentieth she turned her attention to man and society.

19TH-CENTURY AMERICA
PAINTINGS AND SCULPTURE

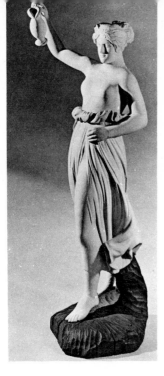

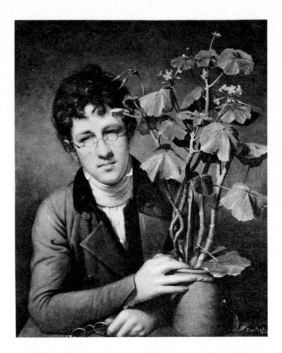

1 Hebe

Workshop of Simeon Skillin

Wood carving was a flourishing art in Colonial America long before stone and metal replaced wood as the favored sculptural material during the 1820s. Artisans such as Simeon Skillin and his sons John and Simeon, Jr., produced ship's carvings, furniture decorations, shop signs, portrait and figure sculptures in large numbers before the turn of the century. The Skillins, along with Samuel McIntire, leading architect and master carver of Salem, were patronized by the wealthy Salem merchant and shipowner Elias Hasket Derby during the construction and decoration of his elegant Federal mansion, completed about 1798. This lithe neoclassical figure of Hebe, probably made in the Skillin shop and said to have been owned by the Derby family, may have been intended as sculpture for the garden of the house. Carved from pine and originally painted gray and red in imitation of marble, the figure is an obvious derivation from Antonio Canova's marble Hebe of 1801, which was well known through engravings. Made for Josephine Bonaparte and exhibited at the Louvre, it is now in the Hermitage, Leningrad.

Painted pine, H. 58 inches

The Metropolitan Museum of Art, Rogers Fund, 67. 248

2 Rubens Peale with a Geranium

Rembrandt Peale (1778–1860)

Rembrandt Peale, born in Bucks County, Pennsylvania, was the second son of Charles Willson Peale (see no. 11). Following the family tradition, he took up painting in 1791, receiving his earliest instruction from his father and later studying with Benjamin West in London. Rubens Peale with a Geranium, painted in 1801, is Rembrandt's study of his younger brother at the age of seventeen. Rubens, shown both holding and wearing spectacles, suffered all his life from poor eyesight, and this condition prevented him from becoming a professional artist, although for a time he attempted still-life and animal painting. Rubens became chief helper in his father's Philadelphia museum, taking charge in 1810 and later managing Peale museums in Baltimore and New York. Here he is depicted with what was supposed to be the first geranium brought to this country, undoubtedly for display in the museum. Rubens Peale with a Geranium was done when Rembrandt was twenty-three, and does not suffer from the rather dry, mechanical rendering that affected his later portraits. Considered the masterpiece of Rembrandt's youth, this picture, rich in color and texture, is warmly expressive of the sitter's sensitive nature and shows the artist to have been a gifted portraitist.

Oil on canvas, 28 x 24 inches

Signed and dated (lower right): Rem Peale/1801

Mrs. Norman B. Woolworth, New York

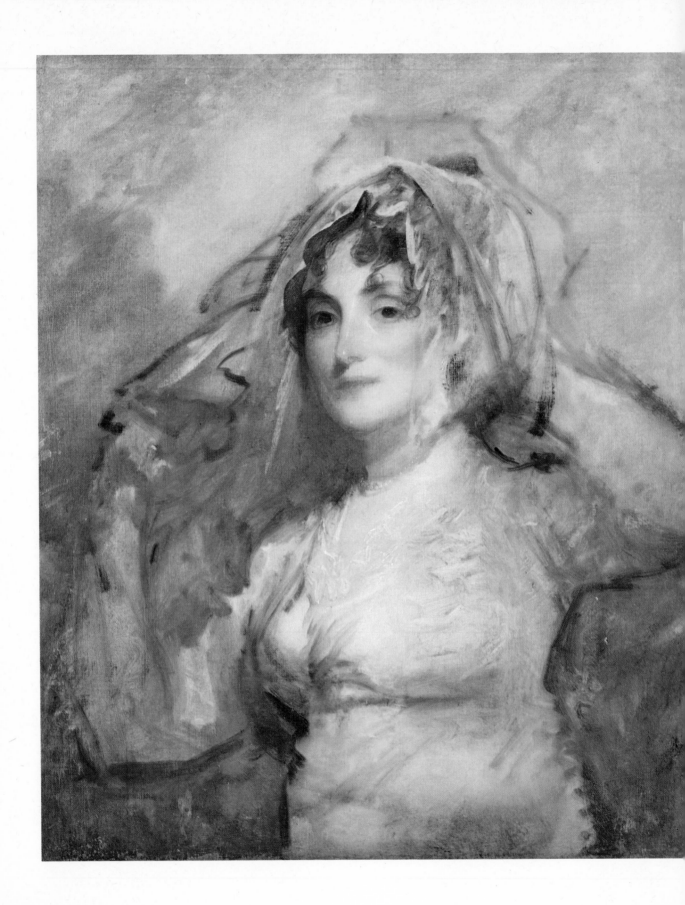

3 Mrs. Perez Morton
Gilbert Stuart (1755–1828)

Born near Newport, Rhode Island, Stuart went to Edinburgh in 1772 with his teacher, Cosmo Alexander, a Scottish portraitist working in Newport. After Alexander's death he returned to America. In 1775, when political and economic disturbances preceding the Revolution resulted in a decline in portrait commissions, Stuart went to London, where he lived and worked with Benjamin West from 1777 to 1782 before opening his own studio. Although he was successful, a combination of financial ineptitude and high living drove him into debt, and the demands of his creditors forced him to move to Dublin. Eventually he returned to America, where his reputation was established with the portrait of George Washington, now in the National Gallery, that he painted for Samuel Vaughan of Philadelphia.

Sarah Wentworth Apthorp Morton, a poetess whose tragic verse won her the title of "the American Sappho," was the wife of the Boston lawyer and statesman Perez Morton. Stuart painted three portraits of Mrs. Morton, including this unfinished version about 1802. After seeing one of these portraits, Sarah Morton wrote a poetic tribute to the painter, who responded in kind:

> Who would not glory in the wreath of praise
> Which M . . . n offers in her polished lays?
> I feel their cheering influence at my heart,
> And more complacent I review my art;
> Yet, ah, with Poesy, that gift divine,
> Compar'd, how poor, how impotent is mine! . . .
> Nor wonder, if in tracing charms like thine,
> Thought and expression blend a rich design:
> 'Twas heaven itself that blended in thy face,
> The lines of Reason with the lines of Grace;
> 'Twas heaven that bade the swift idea rise,
> Paint thy soft cheek, and sparkle in thine eyes:
> Invention there could justly claim no part,
> I only boast the copyist's humble art.

Mrs. Perez Morton displays Stuart's technique at its freest, and reveals his method of working from an amorphous to a distinct image, building his portraits around the face, capturing the exact flesh tint, then selecting colors to harmonize with it. This portrait is a brilliant example of the vivid coloring that Stuart sought in his flesh tones. According to William Dunlap, the first historian of American art, Stuart said: "Good flesh coloring partook of all colors, not mixed, so as to be combined in one tint, but shining through each other, like the blood through the natural skin."

Oil on canvas, 29 1/16 x 24¹/8 inches
Worcester Art Museum, Gift of the Grandchildren of Joseph Tuckerman

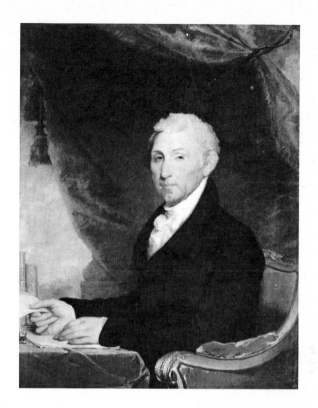

4 James Monroe
Gilbert Stuart

About 1818 to 1820 Stuart produced for John Doggett, a Boston art dealer, a set of half-length portraits of the first five presidents (Washington, Adams, Jefferson, Madison, and Monroe). The only known surviving painting of the commission is that of James Monroe, which is based on a smaller bust portrait, now at the Pennsylvania Academy of the Fine Arts, Philadelphia, that Stuart painted for Monroe in 1817. For this half-length Stuart introduced the carefully studied hands, added a more formal decorative setting of books, furniture, and drapery, and followed his own dictum that the figure should "turn well on its own centre." Monroe was a strong, popular president, and a man of notably determined but unassuming character. Stuart, showing Monroe's poised and cool glance, has captured in a forceful and sophisticated composition the essence of the man's personality. The painting, far more spirited and lively than most of Stuart's late work, is probably evidence of the high quality of the series.

Oil on canvas, 40¹/4 x 32 inches
The Metropolitan Museum of Art, Bequest of Seth Low, 29.89

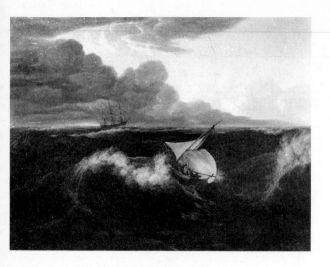

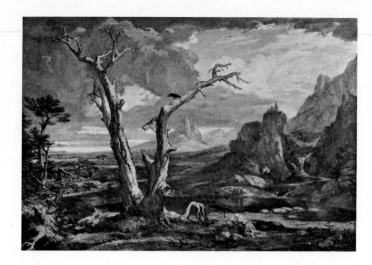

5 The Rising of a Thunderstorm at Sea
Washington Allston (1779–1843)

Allston left Georgetown, South Carolina, to study at Harvard. In 1801 he went to London and attended the Royal Academy as a pupil of Benjamin West. For the next seventeen years, except for three spent in Boston, he worked and studied in England and on the Continent. The Rising of a Thunderstorm at Sea is an early work, painted in Paris in 1804. During a visit to the Louvre, Allston had been impressed by the highly dramatic storm and shipwreck pictures of the eighteenth-century French painter Joseph Vernet, and he decided to try his hand at a seascape. In contrast to the then current practice of English and American topographical art, Allston subordinated interest in detail to grand design. In his concept of boats battling the sea against an approaching storm, there is a feeling for the power of nature and helplessness of man that marks the work as an early example of the romantic movement in American landscape art.

Oil on canvas, 38¹/₂ x 51 inches
Museum of Fine Arts, Boston, Everett Fund

6 Elijah in the Desert
Washington Allston

Elijah in the Desert, showing the prophet being fed by ravens, is one of the last works Allston painted before he left the Continent for America in 1818. Its quiet, contemplative mood contrasts sharply with the dramatic subject matter of his early works such as The Rising of a Thunderstorm at Sea (no. 5). For Elijah in the Desert Allston used an experimental technique somewhat resembling fresco, described in Jared B. Flagg's *The Life and Letters of Washington Allston* (1893): "My colors were prepared in dry powders, and my vehicle was *skim-milk;* with this I moistened my powdered colors and mixed them of the same consistency as oil colors. My canvas had an absorbent ground, and my colors dried nearly as fast as I could paint. . . . And it was the most brilliant for tone and color I ever painted." One of Allston's contemporaries, who saw the painting immediately after its completion, wrote: "The picture was therefore a landscape of a most sublime, impressive character, and not a mere representation of a passage of Scripture history. . . . For melancholy, dark, and terrific, almost, as are all the features of the scene, a strange calm broods over it all."

Oil on canvas, 48³/₄ x 72¹/₂ inches
Signed and dated (on back): W. Allston 1818/ W. Allston A.R.A.
Museum of Fine Arts, Boston, Gift of Mrs. Samuel and Miss Alice Hooper

7 Moonlit Landscape
Washington Allston

Moonlit Landscape, painted by Allston in 1819, shows the impact of his four-year stay in Italy. The setting is an Italian hill town, and the wonderful luminosity is partly the result of Allston's continued experiments with color, prompted by his admiration for Venetian artists of the sixteenth century. Instead of mixing colors with a palette knife in the traditional manner, which would have given a uniform hue, he mixed paints on the brush, thereby obtaining a varied effect, a glow of colors. But more important, he created a mood. The shadowy silhouettes of man, woman, and child stopping a horseman by the water's edge lend an air of mystery to the dreamlike, nocturnal scene. The painting is filled with suggestion rather than statement.

Oil on canvas, 24 x 35 inches
Museum of Fine Arts, Boston, Gift of William Sturgis Bigelow

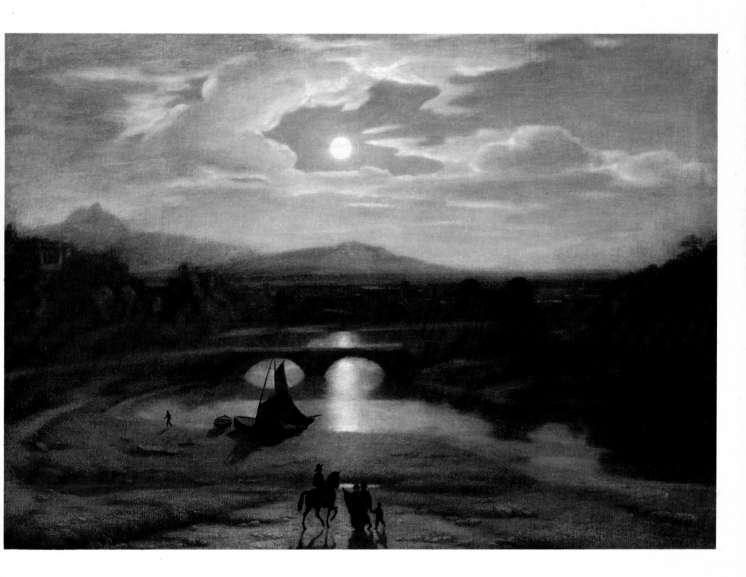

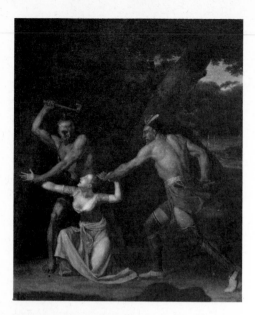

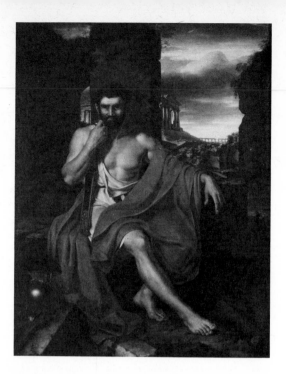

8 The Death of Jane McCrea
John Vanderlyn (1775–1852)

As a young man in Kingston, New York, Vander-
lyn came to the attention of Aaron Burr, who paid
for his lessons with Gilbert Stuart and in 1796
sent him to study in Paris. Except for brief visits
home, Vanderlyn remained in Europe until 1815.
The Death of Jane McCrea, painted in Paris in
1804, was his first attempt at history painting.
The killing and scalping of Jane as she awaited
her fiancé, a British soldier, was a well-known
incident of the Revolutionary War and popular
with writers and painters in the early nineteenth
century. The picture was commissioned by Joel
Barlow to serve as the basis for an engraved
illustration in the *Columbiad* (1807), his epic on
the founding of America, wherein the tragedy
is thus described:

> With calculating pause and demon grin,
> They seize her hands and thro her face divine
> Drive the descending axe; the shriek she sent
> Attain'd her lover's ear; . . .

The figures show the influence of Vanderlyn's
studies of antique statuary in the Louvre: they
are arranged as in a classical relief before a dark
mass of trees. However, it is the grim, realistic
details, particularly the facial expressions and
powerful hands, that give the painting its dra-
matic effect.

Oil on canvas, 32 x 26¹/₂ inches
Wadsworth Atheneum, Hartford

9 Marius amidst the Ruins of Carthage
John Vanderlyn

Marius amidst the Ruins of Carthage was com-
pleted in 1807, the second year of Vanderlyn's
residence in Rome. "Rome was well adapted
for the painting of such a subject," he wrote,
"abounding in classical ruins, of which I endeav-
ored to avail myself, and it is much more free
from the fashion and frivolities of life than most
all other places." According to Plutarch's *Lives*,
Marius, a Roman general, having been defeated
in battle, fled to Africa, where he was met by an
officer of the Roman governor who forbade him
to set foot there. Marius sent the officer back to
the governor saying: "Go and tell him that thou
hast seen Marius sitting on the ruins of Carthage."
Vanderlyn adapted the figure of Marius from an-
cient sculptures and the ruins of Carthage from
the Parthenon, the Villa of Hadrian, and the
Claudian Aqueduct. The picture, although an
academic work somber and severe in coloring,
earned Vanderlyn almost immediate fame. It was
one of 1200 paintings in the Louvre exhibition of
1808, where it was selected by Napoleon himself
for the gold medal given to the best original
work. After the exhibition, Napoleon attempted
to buy the painting for permanent display in the
Louvre, but Vanderlyn declined and in 1815
brought the picture home to America.

Oil on canvas, 87 x 68¹/₂ inches
*Signed and dated (lower center): J. Vanderlyn
fec. Roma. 1807*
*M. H. de Young Memorial Museum, San Fran-
cisco, Gift of M. H. de Young*

10 Ariadne Asleep on the Island of Naxos
John Vanderlyn

In 1809 Vanderlyn wrote to Washington Allston that he wished to paint "something in the female to make it more engaging to the American spirit" and began this picture while he was living in Paris. In December 1811 he commented on the "nearly finished" painting: "Ariadne asleep, naked and abandoned by Theseus . . . I think myself it exhibits as much female beauty as I have seen represented in any picture, but, as I am the parent thereof, my opinion may be biased in favor of the offspring." Presumably he completed it the following year, although he did not sign and date it until 1814.

Combining classical references and a female nude conformed to the tastes of Napoleonic France, but there was a further motivation—a financial one—for Vanderlyn's choice of subject. In Philadelphia the exhibition of a female nude by Adolph Ulrich Wertmüller brought him notoriety and a sizeable income. Although nudity in art was publicly protested by Americans, Vanderlyn observed that they would pay to see pictures of which they disapproved. He set about making copies of two famous nudes by Correggio and Titian for exhibition here, after which he began the Ariadne. In this painting Ariadne's

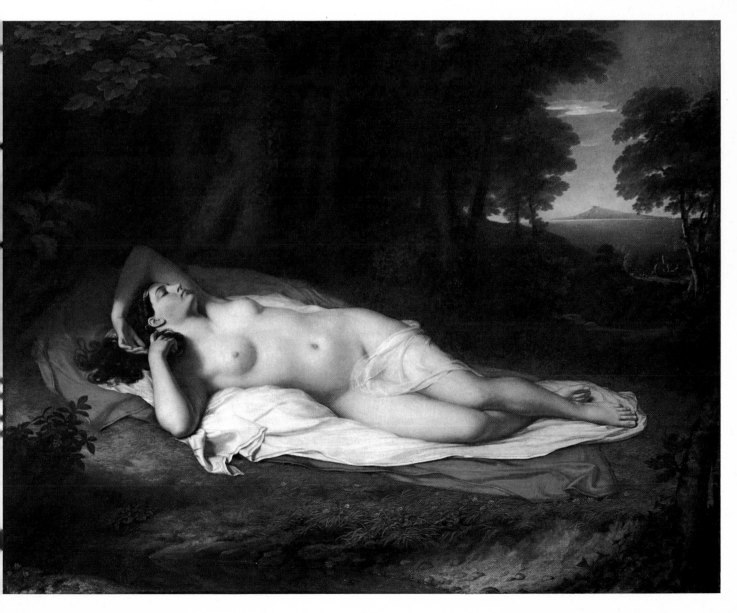

pristine and delicately drawn body is firmly outlined against a background of drapery and grass. It is a dignified work of monumental size, clearly derived from the models of Titian and Giorgione but completely impressive as the most appealing, and probably the first, neoclassical nude by an American artist.

When Vanderlyn returned to America in 1815, he showed Ariadne with his paintings The Death of Jane McCrea and Marius amidst the Ruins of Carthage (nos. 8, 9) in the New York Rotunda, built to house his panorama of Versailles, now at the Metropolitan Museum. He later sold Ariadne to Asher B. Durand, who owned it for twenty years and made a small copy, also in the collection of the Metropolitan, and an engraving of the picture before selling it.

Oil on canvas, 68 x 87 inches
Signed and dated (lower left): J Vanderlyn fect/ Parisiis 1814
The Pennsylvania Academy of the Fine Arts, Philadelphia

11 Exhuming the Mastodon
Charles Willson Peale (1741–1827)

Charles Willson Peale, artist, inventor, saddler, scientist, soldier, writer, naturalist, and museum proprietor, was born in Queen Annes County, Maryland. After receiving some painting instruction from John Hesselius and John Copley, he went to London in 1767 to study with Benjamin West. Peale settled in Philadelphia in 1776. He married three times and fathered seventeen children, some of whom he named after painters, some after naturalists. Peale painted throughout his life, but as he grew older he gradually devoted himself to other projects, especially his museum of natural history, the first of its kind in the United States.

In 1801 Peale purchased the bones of a mastodon for $200 from the farmer who had discovered them, and obtained, for an additional $100, the right to make further excavations. On orders of President Jefferson, he was aided by equipment supplied by the army and navy. In July Jefferson wrote Peale: "I have to . . . congratulate you on the prospect . . . of obtaining a complete skeleton of the great incognitum, and the world on there being a person at the critical moment of the discovery who has zeal enough to devote himself to the recovery of these great animal monuments." The unearthing of one of the skeletons is depicted in Exhuming the Mastodon, painted between 1806 and 1808 to hang in the "mammoth room" of Peale's Philadelphia museum, where the bones were then on display. His first attempt at a narrative picture, the work honors both natural history and the artist's family, for besides a number of notable scientists of the day at least twenty of his relatives are shown. Although only his son Rembrandt was present at the excavation, the painting includes in the group at right: the artist, clutching his scale drawing of the leg bone; his wife, Hannah, in her Quaker cap; the Rembrandt Peales; Rubens Peale, with his spectacles; and the Raphaelle Peales. The owner of the site, John Masten, is shown climbing a ladder in the foreground. Peale's rendition of the scene is a subtle combination of history, figure, genre, and landscape painting, treated with an informality and directness typical of American painting.

Oil on canvas, 50 x 62^1/$_2$ inches
Signed and dated (lower right): C W Peale/ 1806
The Peale Museum, Baltimore, Gift of Mrs. Harry White, in memory of her husband

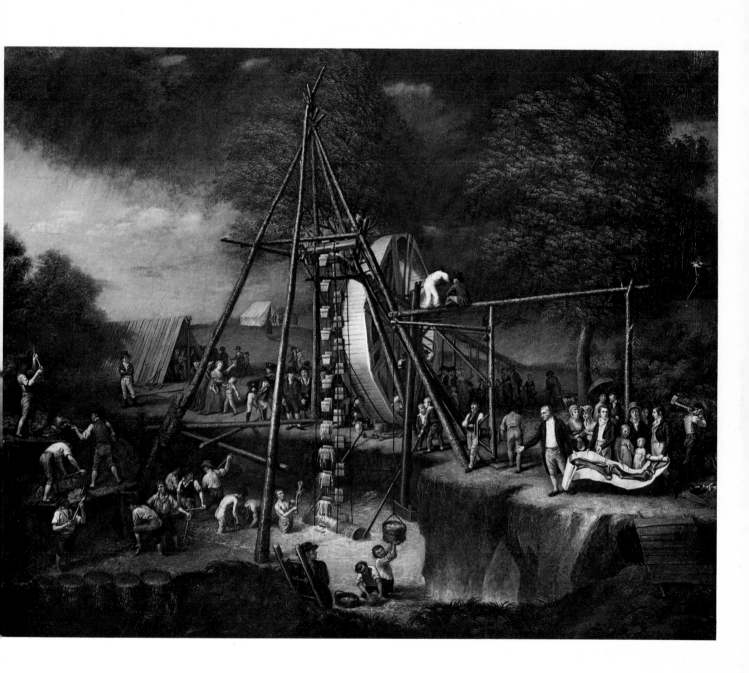

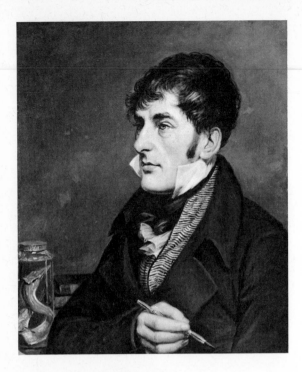

12 **Charles Alexandre Lesueur**
Charles Willson Peale

This portrait of Charles Alexandre Lesueur was
painted by Peale in 1818 and recorded in his
Philadelphia museum's accession book, now at
the Historical Society of Pennsylvania, Philadel-
phia, on January 27. Lesueur, a French-born na-
turalist and artist, arrived in America in 1816 on
an expedition with the Scottish geologist William
Maclure. He lived in the Philadelphia area from
1816 to 1825 and became a member of the
Academy of Natural Sciences in that city; he was
among the first to study American marine life.
He and Peale shared many scientist friends,
among them Maclure, whom Peale portrayed
the same year. Dressed in the French fashion,
Lesueur appears with the attributes of his pro-
fession, a bottled specimen, books, and a pen.
A strong and perceptive work with emphasis on
line and brushstroke, the painting represents the
vivid realism of Peale's late style.

Oil on canvas, 23 x 19 inches
The Academy of Natural Sciences of
Philadelphia

13 **Madame Dubocq and Her Children**
James Peale (1749–1831)

James Peale, born in Chestertown, Maryland,
was the youngest brother of Charles Willson
Peale. He spent his early years in Annapolis,
learning saddlery from his brother and working
as carpenter and cabinetmaker. In 1770 he de-
cided to become a painter and received lessons
in water-color and oil painting from Charles
Willson. After the Revolutionary War, James
established himself in Philadelphia, becoming
skilled as a miniaturist and still-life painter. His
early portrait style was based on the rather aus-
tere style of his brother, whom he assisted in
turning out a number of full-length studies of
George Washington. After 1800 James's portraits
present increasingly more serene personalities
and greater simplification of technique. He was
particularly adept at portraying women as pen-
sive, delicate, and gentle beings. Madame Du-
bocq and Her Children, done in 1807, is an ex-
cellent example, which achieves its effect in the
touching rapport established between the ele-
gant lady and her equally elegant charges. The
strongly neoclassical flavor, seen in the high-
waisted dresses and repetition of sinuous, deco-
rative line, testifies to the impact of Napoleonic
taste during the Jefferson administration.

Oil on canvas, 51 x 41 inches
Signed and dated (lower center): I.P. 1807
J. B. Speed Art Museum, Louisville

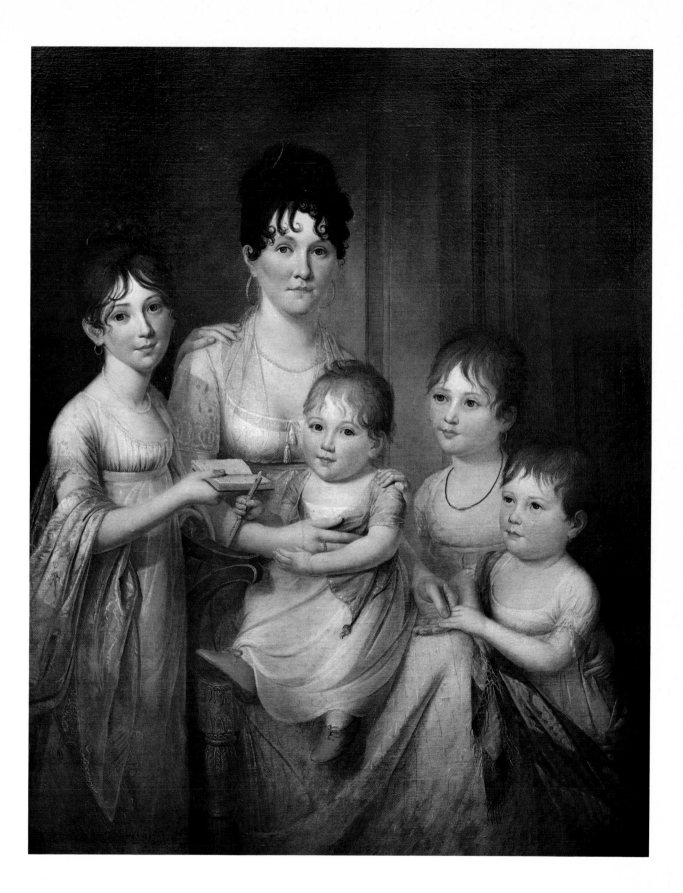

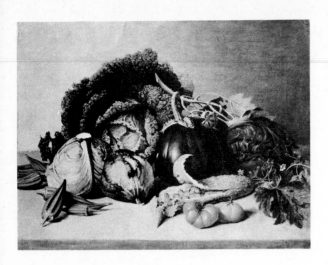

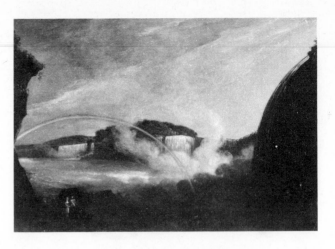

14 **Balsam Apple and Vegetables**
James Peale

James and his nephew Raphaelle Peale pioneered in American still-life painting, and their work profoundly influenced its development. James's pictures were far more popular in their day than those of Raphaelle (see no. 22), perhaps because his arrangements were more opulent. Balsam Apple and Vegetables, thought to date from the 1820s, is characteristic of James's work in its exuberant display and variety of forms, but its freely painted, rather casual arrangement is a departure from his usual carefully painted, formal compositions. The thick pigment is well suited to the richly textured vegetables, and the blond palette adds a lightness and vigor that sets this work apart from the somber coloring more commonly found in James's still lifes.

Oil on canvas, 20¹/₄ x 26¹/₂ inches
The Metropolitan Museum of Art, Maria De Witt Jesup Fund, 39.52

15 **View of Niagara from below the Great Cascade, British Side**
John Trumbull (1756–1843)

Trumbull, son of the Revolutionary governor of Connecticut, graduated from Harvard and rose to the rank of colonel in the Continental Army before resigning his commission. He studied history painting with Benjamin West in London and became acquainted with Jacques-Louis David in Paris before producing his well-known series of portraits and Revolutionary War scenes now at the Yale University Art Gallery, New Haven. Working intermittently as diplomatic secretary to John Jay, Trumbull continued to paint portraits and history and religious scenes. He also made many landscape sketches in Europe and America. An early tourist to upstate New York, he depicted a number of natural wonders in the years between 1806 and 1808, including Niagara Falls. View of Niagara from below the Great Cascade, British Side, painted about 1807, is a somewhat crude but dramatic interpretation of the subject, related to a large panorama now at the New-York Historical Society, which was completed in London in 1808. According to William Dunlap's *A History of the Rise and Progress of the Arts of Design in the United States* (1834), when Trumbull returned to that city in 1808, he took along several Niagara paintings "with a view to have a panorama of that great scene painted . . . that species of exhibition being at the time fashionable and profitable in London."

Oil on canvas, 23¹/₄ x 35⁵/₈ inches
Wadsworth Atheneum, Hartford

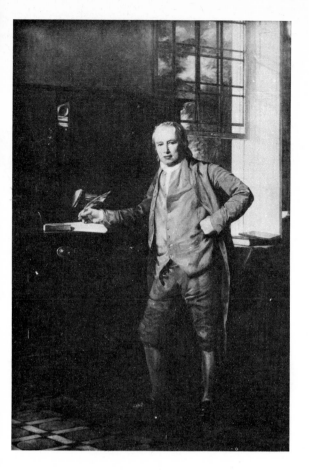

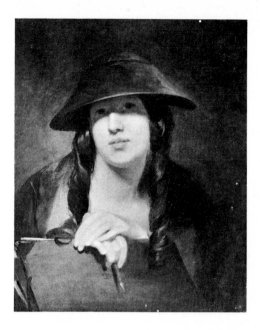

16 **Samuel Coates**
Thomas Sully (1783–1872)

Sully, born to an English theatrical family that
settled in America when he was nine years old,
began his career assisting his brother Lawrence
as a miniature and device painter. He worked
along the Atlantic seaboard as a portraitist until
1809, when he went to London and studied the
works of fashionable portrait painters, especially
those of Sir Thomas Lawrence. Sully painted this
portrait of Samuel Coates in 1812, two years after
returning from England. According to his Regis-
ter, in which he wrote the dates, dimensions, and
prices of his pictures, it was completed in five
days. The fluency of technique and freshness of
complexion are characteristic of Sully's work, but
the realistic interior, with its skillful handling of
space and light, is rare. Coates was a successful
Philadelphia Quaker merchant, who from 1785
to 1825 was manager of the Pennsylvania Hos-
pital and for fourteen years its president. Sully
depicted him in an office of the hospital, to
which he later presented the picture.

Oil on canvas, 94 x 64 inches
Pennsylvania Hospital, Philadelphia

17 **The Student**
Thomas Sully

Two years after Lawrence Sully's death, Thomas
Sully married his brother's widow, and aside
from Lawrence's three children, they ultimately
had nine of their own. This picture, which Sully
entitled "The Student," is a portrait of his daugh-
ter Rosalie, herself an amateur painter. It was
painted in 1839, when Sully was at the height of
his fame. The unusually high valuation of $200
he placed on it in his Register and the fact he
made several replicas suggest it was one of his
favorite works. The strange hat casting a shadow
across Rosalie's face is traditionally supposed to
be a lampshade from Sully's studio, an example
of the way in which he deliberately composed
his subjects for pictorial effect. The graceful treat-
ment of the crossed hands, elegant curve of the
neck, and dramatic shadow create a portrait of
studied but arresting charm.

Oil on canvas, 23¹/₂ x 19¹/₂ inches
Signed, dated, and inscribed: (lower center)
TS (monogram) 1839; (on back) The Student/
TS (monogram 1839
The Metropolitan Museum of Art, Bequest of
Francis T. S. Darley, 14.126.4

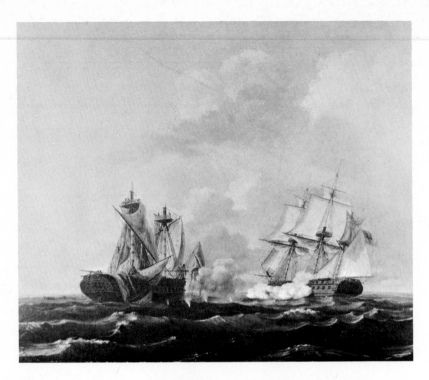

18 **Naval Engagement between the Frigates "United States" and "Macedonian"**
Thomas Birch (1779–1851)

Birch, son of an immigrant English engraver, miniaturist, and landscape painter, was trained as an artist by his father in the late 1790s. Young Birch worked in Philadelphia as an engraver, profile portraitist, decorator, coin designer, and curator of the Pennsylvania Academy of the Fine Arts, before specializing in marine view painting in the Dutch style. During and after the War of 1812, Birch supplied a lively market for patriotic battle scenes with pictures like the Naval Engagement between the Frigates *United States* and *Macedonian,* depicting American arms triumphant over the English. He often based such compositions on interviews with the victorious captains, but in this instance he could have read Commodore Stephen Decatur's widely published official report of the action, which described how "The *Macedonian* lost her mizen mast, fore and main topmasts and main yard, and was much cut up in her hull." Birch accurately caught the appearance of the damaged vessel and the wind-whipped, heavy seas in which the two warships fought. He repeated this subject at least six times.

Oil on canvas, 28 x 34¹/₂ inches
Signed and dated (lower left): T. Birch: 1813
The Historical Society of Pennsylvania, Philadelphia

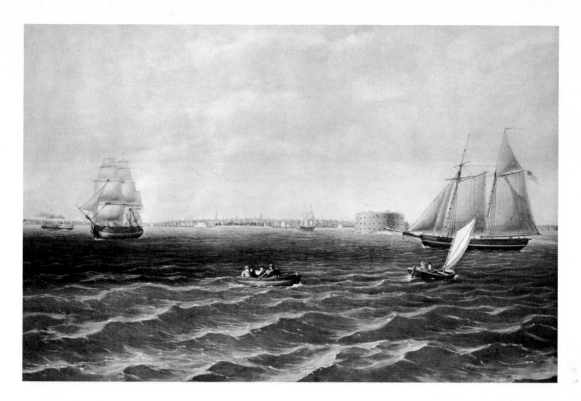

19 **New York Harbor**
Thomas Birch

As the United States resumed normal life after the War of 1812, and its people returned to the business of building the new nation, Birch turned increasingly to painting scenes taken from daily life, commerce, or the beckoning countryside and seas, which he thought would appeal to the change in public taste as enthusiasm for martial subjects died down. During the 1820s and 30s he recorded numerous mid-Atlantic and New England coastal views, among them the harbors of Philadelphia and New York. New York Harbor, painted between 1827 and 1835, shows the southern tip of Manhattan in the distance, Governor's Island, with Castle Williams at the right, and a variety of commercial shipping. Birch's intimate knowledge of wind, water, and sailing appears in the correctness with which each boat is depicted navigating a flood tide in a northwest breeze. The cheerful brightness of the scene is characteristic of Birch's topographical pictures and is antecedent to the atmospheric studies of the Hudson River school landscapists.

Oil on canvas, 20¹/₄ x 30¹/₄ inches
Signed (on back): New York/T. Birch/Phila.
Museum of Fine Arts, Boston, M. and M. Karolik Collection

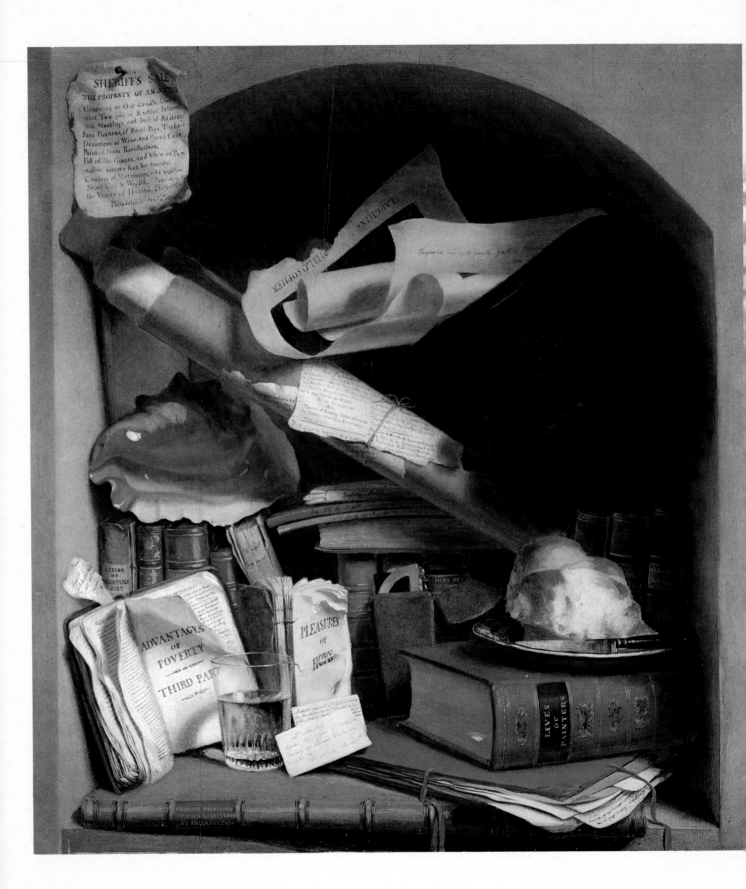

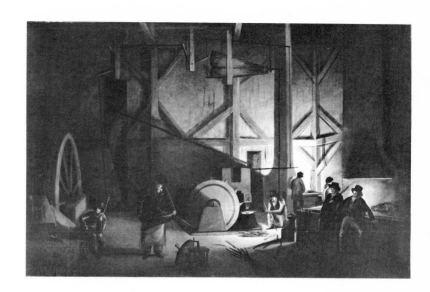

20 The Poor Artist's Cupboard

Charles Bird King (1785–1862)

King, born in Newport, Rhode Island, was a pupil of the engraver Edward Savage in New York and, from 1805 to 1812, studied with Benjamin West in London. After he returned to America, King spent several years in Philadelphia and Baltimore before settling permanently in Washington, D.C. He was primarily a portrait painter and recorded many of the political and social celebrities of his day, but he was especially well known for his portraits of Indian visitors to the capital. The Poor Artist's Cupboard, thought to have been painted in Philadelphia about 1815, is one of King's two known still lifes. A rueful comment on the artist's lot, it is one of his most interesting works. The picture is a complex arrangement of objects of different shapes, sizes, textures, and colors depicted with moral and humorous overtones. Among the everyday items one would expect to find in a struggling painter's studio are a loaf of bread, glass of water, and unpaid bills. Additionally there are a number of worn volumes, including *Advantages of Poverty* and *Pleasures of Hope*, and a sheriff's sale list affixed to the cupboard. The trompe-l'oeil technique gives intense realism to King's satire; the picture is an impressive forerunner of the American school of trompe-l'oeil painting that flourished during the 1880s and 90s.

Oil on wood, 29³/₄ x 27³/₄ inches
The Corcoran Gallery of Art, Washington

21 Interior of a Smithy

Bass Otis (1784–1861)

Born in Bridgewater, Massachusetts, Otis spent his early years as an apprentice to a scythemaker before starting a painting career, for which he was largely self-taught. He established himself as a portrait painter in New York and then moved, in 1812, to Philadelphia, where he spent most of his later life. In 1818 Otis produced the first lithograph in the United States, but soon abandoned lithography to return to portrait painting. The only known large composition by Otis, the Interior of a Smithy was exhibited at the Pennsylvania Academy of the Fine Arts in 1819 and was well received by the public. The painting shows the scythemaker's shop where Otis served his apprenticeship, with its flaming forges creating deep, mysterious shadows. Like Charles Willson Peale (see no. 11), Otis was interested in depicting the dramatic aspects of technology.

Oil on canvas, 50¹/₂ x 80¹/₂ inches
The Pennsylvania Academy of the Fine Arts, Philadelphia

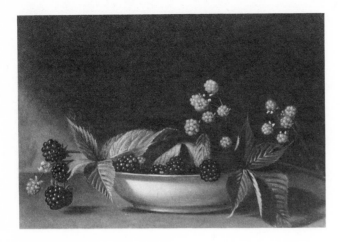

22 Dish of Blackberries
Raphaelle Peale (1774–1825)

The eldest son of Charles Willson Peale, Raphaelle was born in Annapolis, Maryland, two years before his father moved to Philadelphia. He began his career collaborating with his father on portraits and painting miniatures. He turned to still lifes about 1812, when severe gout in his hands prevented him from continuing the exacting work of the miniaturist. Dish of Blackberries, done about 1815 to 1817, is characteristic of Raphaelle's still-life style in its use of natural colors against a neutral ground and simple subject enriched by luminous effects and contrasting textures.

Oil on wood, 7 x 10 inches
Lent anonymously

23 After the Bath
Raphaelle Peale

By 1823 Raphaelle Peale had become an alcoholic and was painting solely to pay his bills—reducing his prices, even raffling off many of his still lifes. After the Bath, which shows the lighter, fun-loving side of his nature, was done at the end of his sad and difficult life. It was painted by Raphaelle apparently to shock and fool his hot-tempered wife, Patty, who nagged him day and night. The illusion of a naked woman behind a sheet was supposedly so successful that Patty tried to pull the sheet away and instead—much to her husband's amusement—found herself scratching the canvas. Although the work is best known for its witty subject, the superb treatment of light on the creased white linen sheet marks it as a masterpiece among American still-life compositions.

Oil on canvas, 29 x 24 inches
Signed and dated (lower right): Raphaelle Peale 1823/Pinxt
William Rockhill Nelson Gallery of Art-Atkins Museum of Fine Arts, Kansas City, Nelson Fund

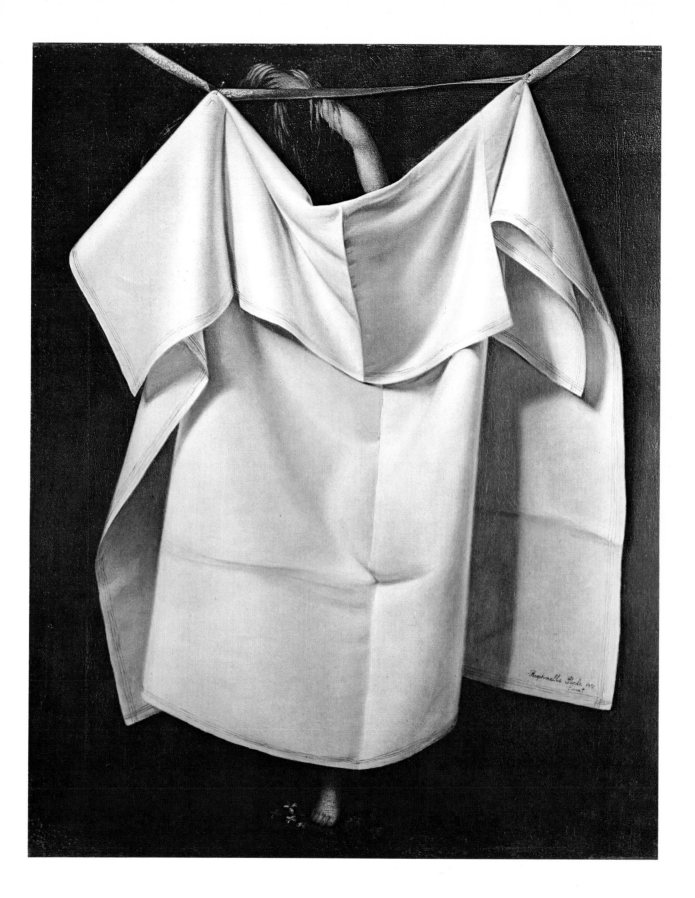

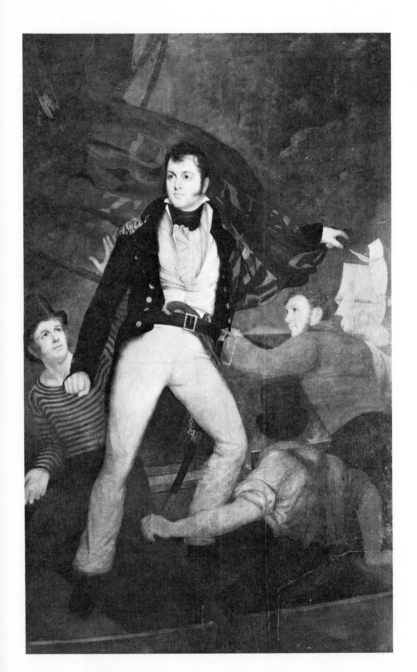

24 Commodore Oliver H. Perry
John Wesley Jarvis (1780–1840)

Born in England, Jarvis was brought to Philadelphia as an infant and was working as an engraver and miniaturist in New York by 1802. Though his paintings were uneven in quality, Jarvis was thought by many to be the foremost portrait painter in New York during the first quarter of the nineteenth century. In 1813 the City Council commissioned a series of full-length portraits of the heroes of the War of 1812. Jarvis painted six of the seventeen pictures that eventually decorated City Hall. His Commodore Oliver H. Perry was done in 1816. The commodore and three sailors are shown, having abandoned their disabled brig, accomplishing a daring passage to the ship *Niagara* in the full heat of the fight. Perry, about to turn apparent defeat into victory, dominates the composition. Billowing about him is a flag bearing the words "DON'T GIVE UP THE SHIP." The sailor wearing the striped jersey and urging Perry not to expose himself to enemy fire is reputedly a likeness of Jarvis. The picture testifies to Jarvis's true artistic ability and to his reliance on eighteenth-century English heroic portraiture, giving a forceful representation of the commodore both as a hero and a man.

Oil on canvas, 96 x 60 inches
Art Commission of the City of New York

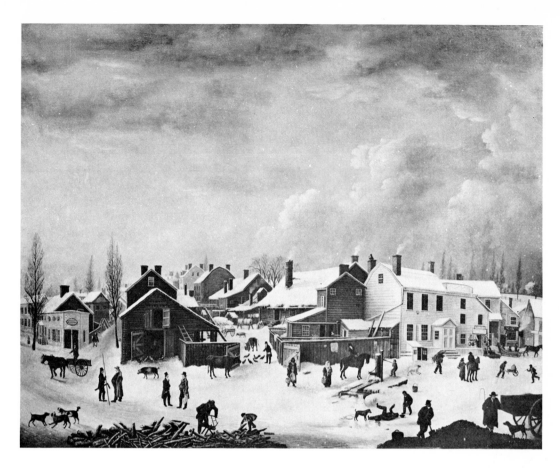

25 Winter Scene in Brooklyn
Francis Guy (about 1760–1820)

Guy, an eccentric English cloth dyer, established himself in Baltimore about 1800 as a landscape painter. He was self-taught, and although he could imitate with some facility the styles of the Dutch and French schools, his finest work has a naïve originality. In 1817 he moved to Brooklyn, where during the last three years of his life he painted his best-known work, Winter Scene in Brooklyn. Providing a view from Guy's house at 11 Front Street, between James and Fulton, the picture recalls the Dutch tradition in its hard, crisp lines, tonal harmonies, lively figures, and multiple incidents. In *A History of the City of Brooklyn* (1869), Henry R. Stiles gives a key to the streets, houses, and figures shown and recounts that "Guy, as he painted, would sometimes call out of the window, to his subjects, as he caught sight of them on their customary ground, to stand still, while he put in the characteristic strokes." The finished painting delighted Guy's neighbors, and at least one critic admired its genial familiarity of subject and rich pictorial treatment, calling it "one of the most natural, lively and fascinating Pictures ever produced by the Pencil." Guy painted two versions of this subject, as well as the same view in summer and a study of the buildings without figures.

Oil on canvas, 58³/₄ x 75 inches
Inscribed (on fence at center): TO BE SEEN/ A VIEW / WINTER SCENE / BY GUY / OF BROOKLYN
The Brooklyn Museum, Gift of the Brooklyn Institute

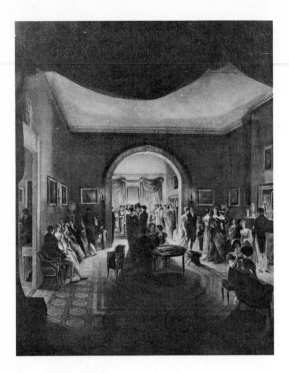

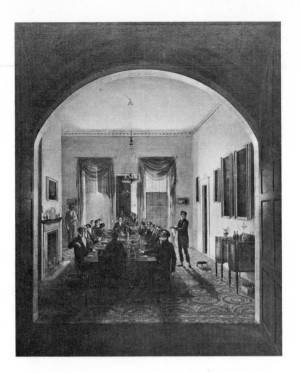

26 **The Tea Party**

Henry Sargent (1770–1845)

Born in Gloucester, Massachusetts, Sargent studied in London with Benjamin West and John Copley during the mid-1790s, and afterward in Boston he continued to paint while pursuing a public career. He became a captain in the Boston Light Infantry, served as an advisor to Governors Gore and Strong, and was twice a member of the Massachusetts State Legislature. Sargent's oeuvre includes portraits, historical and religious compositions, and genre scenes. The Tea Party, depicting a reception at the artist's home, was painted about 1821 to 1825, but it is said to commemorate an occasion of about 1798. Although probably working from memory, Sargent recorded in detail the restrained manners, Napoleonic costumes, and delicate neoclassical decor of the turn of the century. The extraordinary effect stems from the combination of realism, somewhat primitive drawing, and ambitious scheme of composition and lighting derived—like that of its companion piece, The Dinner Party (no. 27)—from Granet's The Capuchin Chapel. The Tea Party and The Dinner Party were well known and quite popular in Sargent's time.

Oil on canvas, 64^1/$_4$ x 52^1/$_4$ inches

Museum of Fine Arts, Boston, Gift of Mrs. Horatio A. Lamb, in memory of Mr. and Mrs. Winthrop Sargent

27 **The Dinner Party**

Henry Sargent

In his novel *Randolph* (1823) John Neal remarked that Henry Sargent "has just painted a piece called the DINNER PARTY, after the manner of the 'Capuchin Chapel.'" Known in several versions (one of which is now in the Metropolitan Museum), The Capuchin Chapel, by the French neoclassicist François Granet, depicts the interior of the Capuchin Church at Rome with the friars at their devotions, and is notable as a tour de force of interior perspective and lighting. In The Dinner Party, and The Tea Party, Sargent took Granet's composition and reproduced it as closely as possible in a domestic scene. The result, according to the contemporary historian and critic William Dunlap, was "a specimen of the extraordinary power of light and shade," and perhaps also a humorous take-off on its well-known prototype. But the picture's real importance lies in its careful rendering of the furniture and other accoutrements of a well-appointed dining room of the period—even to the wine bottles resting in their straw-packed case under the sideboard—making it a remarkable genre piece in its own right.

Oil on canvas, 59^1/$_2$ x 48 inches

Museum of Fine Arts, Boston, Gift of Mrs. Horatio A. Lamb, in memory of Mr. and Mrs. Winthrop Sargent

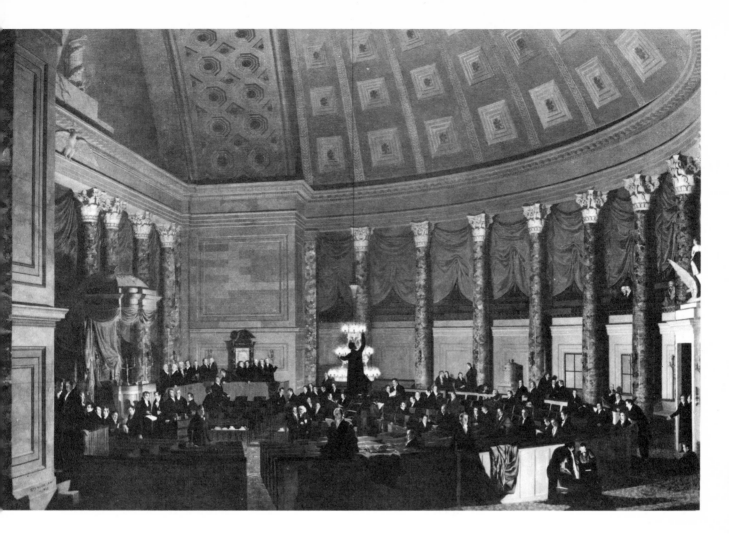

28 The Old House of Representatives
Samuel Finley Breese Morse (1791–1872)

Morse, son of a renowned Boston minister, went to London in 1811, upon the advice of Gilbert Stuart and Washington Allston, to study under Benjamin West. West and Allston strengthened Morse's interest in history painting, and Morse hoped to match his masters with a large historical composition, but the cost of such a picture caused him to put it aside. Returning to America in 1815, Morse earned a living painting portraits in New England and South Carolina until 1821, when he again took up the idea of a great canvas. The subject was to be the House of Representatives, with its members portrayed in the newly opened assembly chamber designed by Benjamin Latrobe. Backed by President Monroe,

Morse was given a room adjacent to the chamber, where he took portraits of the eighty congressmen. The complicated perspective of the chamber had to be redrawn three times, and the lighting of the chandelier was repeatedly studied by Morse, who worked on the picture fourteen hours a day for almost a year. This portrait of democracy in action was a financial failure, for the public would not pay to see it, and Morse finally sold it. Twenty-five years later the picture was found in poor condition in a New York shop.

Oil on canvas, 86¹/₂ x 130³/₄ inches
Signed and dated (lower left): S.F.B. MORSE pinxt/1822
The Corcoran Gallery of Art, Washington

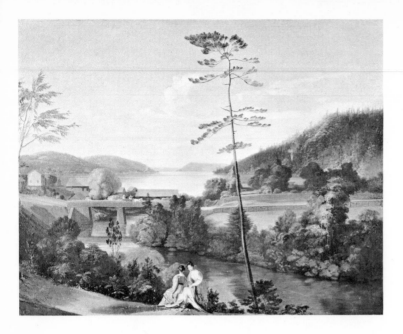

29 **View from Apple Hill**
Samuel Finley Breese Morse

From 1827 to 1829 Morse spent his summers in upstate New York, where he had friends and relatives in several towns. At Cooperstown he visited Apple Hill, the estate of John Adams Dix (later governor of New York), on the southern edge of Otsego Lake. View from Apple Hill shows the lake in the distance, with the figures of Mrs. Dix and her cousin Margaret Willet on the bank of the Susquehanna River in the foreground. Morse painted few landscapes, and this one, done about 1828, is his finest, notable for its crisp brushwork, fresh color, and silvery sky.

Oil on canvas, 22 x 29 inches
New York State Historical Association, Cooperstown

30 **The Gallery of the Louvre**
Samuel Finley Breese Morse

"Lay it on here, Samuel—more yellow—the nose is too short—the eye is too small—damn it if I had been a painter what a picture I should have painted. . . . Crowds get round the picture, for Samuel has quite made a hit in the Louvre." Thus James Fenimore Cooper jocosely described his encouragement of Morse, "stuck up on a high working stand" in the French museum, painting this picture, The Gallery of the Louvre. Showing the Salon Carré and the gallery beyond, the picture, according to Morse, was "designed to give, not only a perspective view of the long gallery, which is seen in its whole length of fourteen hundred feet through the open doors of the great saloon, but accurate copies, also, of some of the choicest pictures of the collection, displayed upon the walls, amounting to thirty-seven in number." Basing his composition upon detailed views of Italian galleries by the eighteenth-century Venetian painter Giovanni-Paolo Pannini, Morse included such familiar masterpieces as Titian's The Entombment, Raphael's La Belle Jardinière, and Leonardo da Vinci's Mona Lisa. Morse regarded the painting, which he hoped would gain him a fair reward of money and fame, as an educational instrument, meant to benefit Americans who could not travel abroad to see the Louvre for themselves. The picture was unfinished when Morse left France late in 1832 on his historic passage to New York aboard the *Sully,* during which he conceived the idea for the electric telegraph.

Oil on canvas, 76 x 106¹/₂ inches
Syracuse University

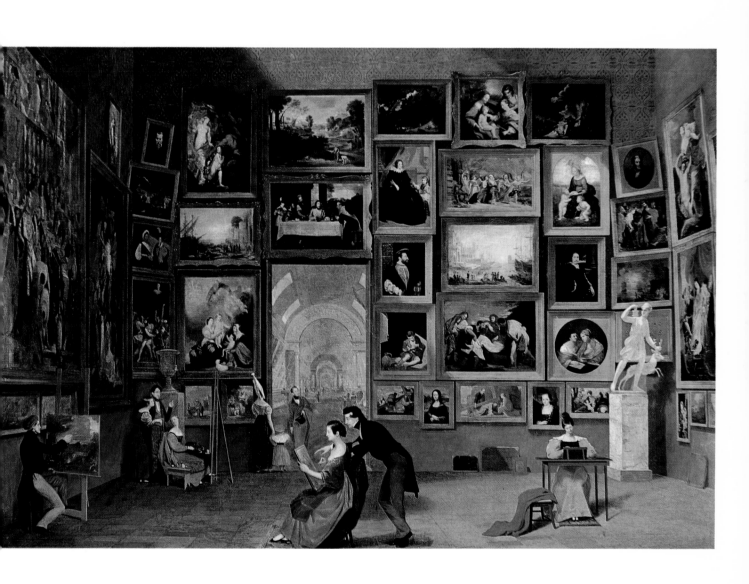

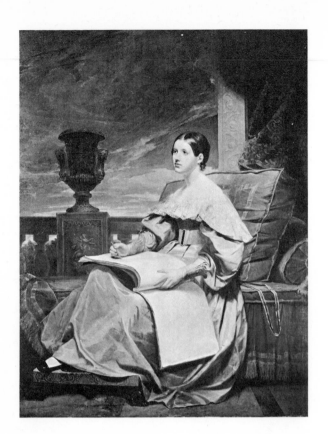

31 The Muse—Susan Walker Morse
Samuel Finley Breese Morse

Between 1835 and 1837, when he was professor of art at New York University, Morse painted The Muse, a moving portrait of his eldest daughter, Susan. The picture, an extraordinary combination of glowing tones, beautifully rendered surfaces, and sympathetic characterization in a dramatic Greek revival setting, was among Morse's last works, produced at the most difficult period of his life when he was torn between art and scientific research. In 1837 Morse had been publicly and embarrassingly denied the important commission to provide a large historical canvas for the Capitol rotunda. Despite the efforts of influential friends to change the decision by hanging this portrait in the Capitol, the embittered Morse stopped painting to devote himself to the electric telegraph. The picture is among Morse's most skillful and illustrates the magnitude of the loss sustained by American painting with his change of profession.

Oil on canvas, 73³/₄ x 57⁵/₈ inches
The Metropolitan Museum of Art, Bequest of Herbert L. Pratt, 45.62.1

32 Mrs. Waldo
Samuel Lovett Waldo (1783–1861)

Waldo spent his youth on a farm in Windham, Connecticut. After studying with Hartford artist Joseph Steward, he began painting portraits in Hartford, later working in Litchfield, Connecticut, and Charleston, South Carolina. In 1806 he went to London, where he met John Copley and Benjamin West and studied at the Royal Academy. After his return to America in 1809, Waldo opened a studio in New York, taking on William Jewett as pupil and assistant. About 1818 Waldo and Jewett formed a partnership to produce portraits, with Waldo painting faces and hands and Jewett working on backgrounds. This unfinished portrait of Waldo's second wife, Deliverance Mapes, was probably done at the time of their marriage in 1826. Executed with refreshing facility in light and subtle colors, it illustrates a work in progress before Jewett's contribution, which presumably would have been the usual dark, staid costume study and drapery background.

Oil on wood, 30¹/₄ x 25⁵/₈ inches
The Metropolitan Museum of Art, Amelia B. Lazarus Fund, 22.217.2

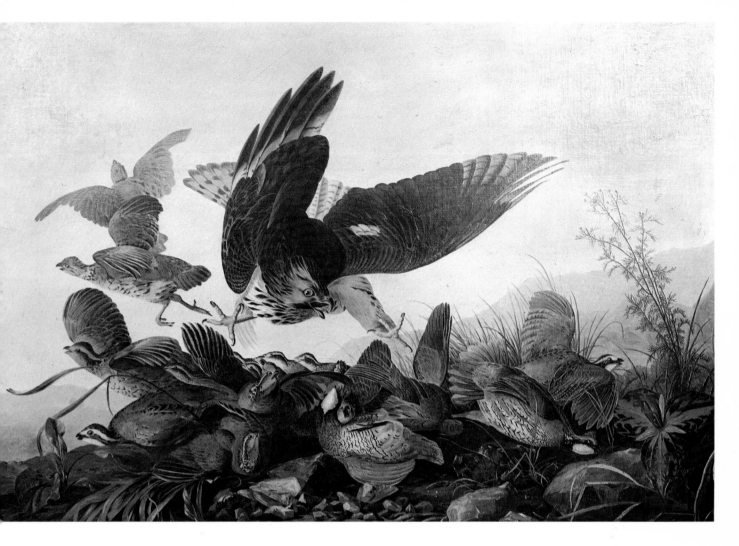

33 **Hawk Pouncing on Quail**
John James Audubon (1785—1851)

Born in Haiti of a French father and Creole mother, Audubon was raised in France. In 1803 he was sent to America to manage his father's Pennsylvania estate, where he spent most of his time hunting, drawing animals and birds, and collecting ornithological specimens. Following his marriage in 1808, Audubon engaged in several disastrous business ventures in the upper Ohio Valley, while continuing to add to his drawings. In 1820 he wrote to Governor Miller of the Arkansas Territory that it was his "ardent Wish to Compleat a collection of drawings of the *Birds* of our Country, from *Nature*, all of Natural *Size* . . . and to Acquire either by *occular,* or reliable observations of others the Knowledge of their Habits & residence; . . ."

Failing in his attempt to find an American publisher for his proposed bird folio, Audubon sailed

to England in 1826. There he began painting oil copies of his drawings and water colors of birds, usually as gifts. Although Audubon preferred to work in a mixed medium of water color, pencil, pen, and pastel, which allowed greater accuracy in depicting anatomy, varying textures, and color, he considered the canvases more impressive for presentation purposes. After completing these first oils, Audubon painted others for sale to help meet the expense of having his bird drawings engraved. In 1827 he exhibited seven paintings at the Liverpool Academy, one of which was Hawk Pouncing on Quail, then called A Pounce on Partridges. It was engraved and published in 1830 as plate 76 of The Birds of America—"Red-Shouldered Hawk and Virginian Partridges." Audubon described the subject in his Ornithological Biography (1831): "I have represented a group of Partridges attacked by a Hawk. The different attitudes exhibited by the former cannot fail to give you a lively idea of the terror and confusion which prevail on such occasions." Hawk Pouncing on Quail is a fine example of his competence in oils and of the vitality and control with which he used line and color to recreate the birds in action in their natural habitats.

Oil on canvas, 26 x 40 inches
Signed and dated (lower center): J. J. Audubon/ 1827
The University of Liverpool

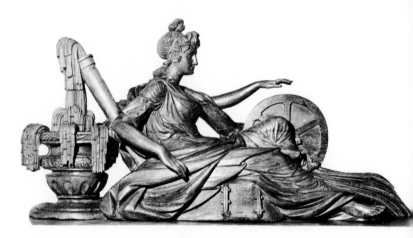

34 The Schuylkill Freed
William Rush (1756–1833)

Rush was trained in Philadelphia as a ship's carver. Rush's figureheads were masterpieces of the genre, but it is his large allegorical figures that gained him popular renown as the first American sculptor. The finest of these, The Schuylkill Freed, was carved about 1828 as part of the decoration of the recently completed Fairmount Water Works, for which Rush was a member of the committee supervising the location and building. A contemporary account described the piece: "The female figure is . . . seated near the pump which pours water into the reservoir. On the left side is . . . a water-wheel; her left arm gently waved over it is indicative of water-power; her right arm or elbow, rests on the edge of a large vase, representing the reservoir at Fairmount. On the side of the vase a pipe represents the ascending main. Water gushes out of the top, falling into the vase, and, to make it more picturesque, but not appropriate, overflowing the vase and falling down its sides." Rush based this sculpture on designs taken from Charles Taylor's The Artist's Repository, published in 1808 in London. The sharp silhouetting, crisp carving, and naive conception of the subject are characteristic of the work of a pioneering artist.

Pine, originally painted, H. 42 inches
The Commissioners of Fairmount Park, on loan to the Philadelphia Museum of Art

35 Boston Harbor from Constitution Wharf

Robert Salmon (about 1775—about 1843)

Shortly after his arrival in Boston from England in 1828, Salmon painted several large views of the harbor, of which this, Boston Harbor from Constitution Wharf, is one of the most serene and interesting. Its balanced composition and the concern with light reflect his earlier observation of Turner's work. There is also a suggestion of Claude Lorrain and Canaletto, whose paintings were well known to Salmon's generation in England and Scotland. This view of Boston's harbor in its heyday of maritime activity possesses obvious historical importance, but the preoccupation with the poetry of light also looks forward to the luminist painters of the next generation, particularly to Fitz Hugh Lane (see nos. 98, 99), who often painted here in the 1850s.

Oil on canvas, 26³/₄ x 40³/₄ inches

U. S. Naval Academy Museum, Annapolis

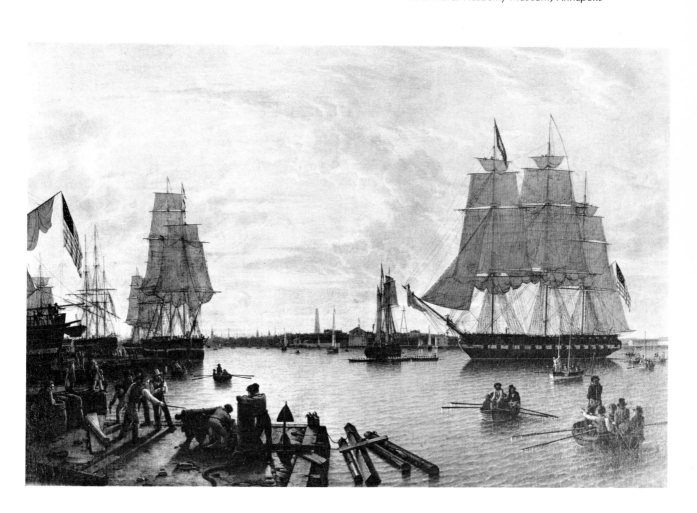

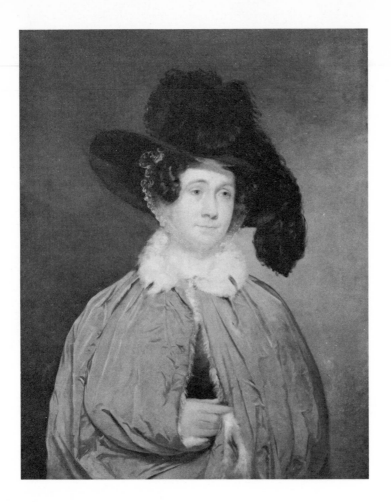

36 **Mrs. Thomas Brewster Coolidge**
Chester Harding (1792–1866)

Fashionable American portraiture during the first half of the nineteenth century was essentially the product of English and, to a lesser extent, French influences. Harding, who was born a New Hampshire farm boy, learned the rudiments of his craft first as a house and sign painter, then as an itinerant portraitist in western Pennsylvania, Kentucky, Ohio, Missouri, and New England. Financial success enabled Harding to go to London, where, from 1823 to 1826, he added polish to his style and became a leading portraitist in that city. His Mrs. Thomas Brewster Coolidge was painted about 1828 to 1830 in Boston, where he settled upon returning to this country. The picture of this benign lady smothered in fur-lined silk, feathers, and lace is more of an effort at still-life painting than portraiture, but Harding's skill as an artist is established beyond a doubt.

Oil on canvas, 36¹/₄ x 28 inches
The Metropolitan Museum of Art, Rogers Fund, 20.75

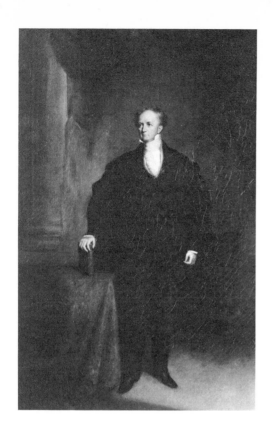

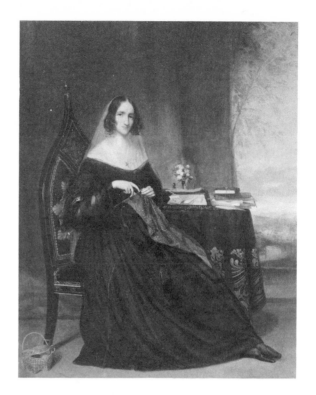

37 38 Mr. Abbott Lawrence
Mrs. Abbott Lawrence
Chester Harding

Between 1840 and 1850 Harding painted these
small, or cabinet, portraits of Mr. and Mrs. Abbott
Lawrence. Lawrence, a highly successful Boston
merchant and an early developer of New England
textile and railroad industries, is portrayed in a
slightly dry manner in a pose and setting more
characteristic of much larger formal portraits. The
main focus is on the face and hands of the sitter;
there are few distracting elements of costume or
in the casually painted background to draw atten-
tion elsewhere. Harding's Mrs. Lawrence is a
more elaborate picture, a record of a thoughtful
woman seated in her mid-Victorian parlor, which
is furnished with a Gothic revival chair and a
round table under a richly brocaded cover. He
did not idealize Mrs. Lawrence; he depicted her
as rather plain, with unnaturally long legs. The
subtleties of anatomy and composition eluded
Harding, but in his portraits there is a simplicity
and directness that clearly expresses the charac-
ter of the sitter.

Oil on canvas, 28³/₄ x 18¹/₂; 27¹/₂ x 22¹/₄ inches
Museum of Fine Arts, Boston, Gift of the
Misses Aimée and Rosamond Lamb

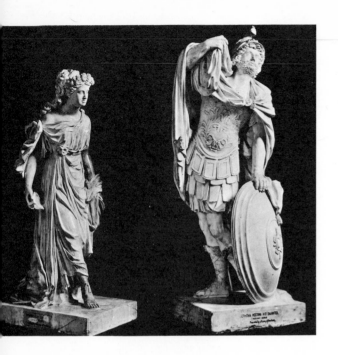

39 **Jephthah and His Daughter**
Hezekiah Augur (1791–1858)

Augur, a native of New Haven, Connecticut, was among the first carvers in America to consider himself an artist rather than an artisan. A failed dry-goods merchant, Augur became a wood-carver and invented, among other things, a wooden leg, which he patented. Then, about 1825, influenced by Samuel F. B. Morse, he began sculpting in marble and produced a series of neoclassical portrait busts and statues, possibly among these was the renowned group Jephthah and His Daughter. In October 1836 Augur wrote to Professor Silliman of Yale, offering to sell Jephthah and His Daughter to the university for the Trumbull Gallery, claiming them to be "the first marble group executed in this country, certainly the first by an American, and were commenced before Greenough's *Cherubs* . . . so that in priority of design, they are probably the first by a native artist." Augur's somewhat quaint Neo-Hellenistic figure treatment, charming in its freshness, is combined with a well-developed sense of sculptural form, making this an important early work in the development of American sculpture.

H. (with pedestal) 36¹/₂ inches
Yale University Art Gallery, Gift of the Citizens of New Haven

40 **The Return of Rip Van Winkle**
John Quidor (1801–1881)

Quidor was born in Tappan, New York, not far from the home grounds of Washington Irving, whose work was to be his main inspiration. In New York City he joined Henry Inman as a pupil of John Wesley Jarvis and subsequently made his living painting fire-engine panels, banners, and signs. Although he was listed in the New York City directories from 1827 to 1836 as a portraitist, Quidor concentrated on painting literary subjects drawn from Irving, Cervantes, and James Fenimore Cooper. The Return of Rip Van Winkle, painted in 1829, is characteristic of Quidor's sarcasm—ultimately derived from the work of the eighteenth-century English caricaturist Thomas Rowlandson—in its concentration on the exaggerated features and contorted bodies of the jeering village crowd surrounding the bewildered Rip. Such spirited mockery was not popular during Quidor's life, when sentiment, realism, and self-congratulation were expected ingredients of American genre scenes. Today his pictures are recognized as a major contribution to American genre painting.

Oil on canvas, 39³/₄ x 49³/₄ inches
Signed and dated (lower center): J. Quidor,/ N.Y./1829
National Gallery of Art, Washington, Andrew Mellon Collection, 1942

41 The Money Diggers
John Quidor

In "Wolfert Webber, or Golden Dreams," from Washington Irving's *Tales of a Traveller,* the for tune hunters Wolfert, Dr. Knipperhausen, and their helper, Sam, are surprised during a nocturnal excavation of a treasure chest by the ghost of its pirate owner angrily looming over a rock: "Wolfert gave a loud cry and let fall the lanthorn. . . . The negro leaped out of the hole, the doctor dropped his book and basket and began to pray in German. All was horror and confusion." Demonstrating the full range of his artistic and comic abilities in The Money Diggers, done in 1832, Quidor extracts all the nuances of the situation in this burlesque of fear and frustrated greed. Relinquishing realism, he uses color, line, and form for maximum expression. Wolfert's face is red, blue-green, yellow, and black, and the doctor has turned a smoky green. The figures are exaggerated to the point of caricature, and terror is graphically reflected in the twisted trees, craggy rocks, and hanging mosses.

Oil on canvas, 16³/₄ x 21¹/₂ inches
Signed and dated (lower right): J. Quidor Pinx/
N. York June, 1832
The Brooklyn Museum, Gift of Mr. and Mrs.
A. Bradley Martin

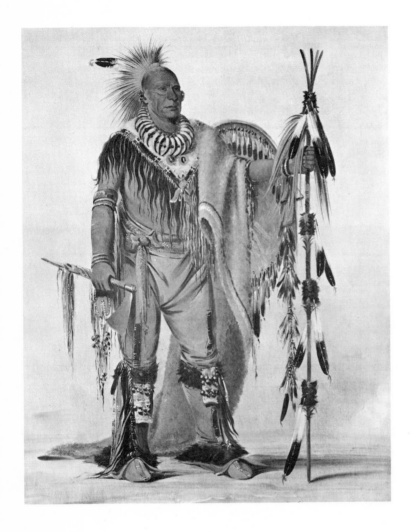

42 Kee-O-Kuk, Chief of the Sauk and Foxes
George Catlin (1796–1872)

Catlin, best known of the painters of American Indians, was born in Wilkes-Barre, Pennsylvania. Although he studied law, Catlin's first love was art. He became fascinated with the Indian artifacts and portraits he saw on his frequent visits to the Peale Museum in Philadelphia. After eight years of traveling around the United States recording Indian life on canvas, he left for Europe to exhibit his "Indian Gallery," having been discouraged by the United States government's failure to purchase his works for a future national museum. In 1879, seven years after his death, Thomas Donaldson, a lawyer who was active in Indian affairs and a western agent for the Smithsonian, purchased his paintings for the Institution. Kee-O-Kuk, Chief of the Sauk and Foxes, was painted in 1832. According to Catlin: "Kee-O-Kuk . . . is the present chief of the tribe, a dignified and proud man, with a good share of talent, and vanity enough to force into action all the wit and judgment he possesses, in order to command the attention and respect of the world. . . ." He added: "I was luckily born in time to see these people in their native dignity, and beauty, and independence. . . ."

Oil on canvas, 29 x 24 inches
National Collection of Fine Arts, Smithsonian Institution, Washington

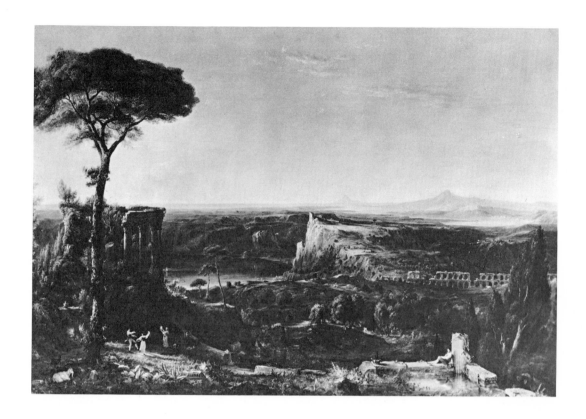

43 Italian Scenery—Landscape Composition
Thomas Cole (1801–1848)

Born in England, Cole arrived in Philadelphia with his family in 1818 and moved to Steubenville, Ohio, the following year. An otherwise forgotten artist named Stein taught him the rudiments of painting, but Cole's brief attempt as an itinerant portraitist proved unsuccessful. In 1823 he went to Philadelphia to study at the Pennsylvania Academy of the Fine Arts, where he discovered the landscapes of Thomas Doughty and Thomas Birch. Shortly after moving to New York in 1825, he made his first sketching trip to the unspoiled woodlands up the Hudson. The landscapes he did from these sketches established his reputation, and Cole is considered the founder of the Hudson River school of landscape painting. Following a trip to Niagara Falls in 1829, he went to Europe. Before leaving, he confided to the Baltimore collector Robert Gilmor, Jr., that "in going to study the great works of art, I feel like one who

is going to his first battle and knows neither his strength nor his weakness." After visiting England, France, and Italy, Cole returned to New York in 1832. Italian Scenery—Landscape Composition was painted the same year for Luman Reed (see no. 60), who also commissioned Cole to do the epic series The Course of Empire, now at the New-York Historical Society. Italian Scenery, in its expansive idyllic vista with ancient ruins and frolicking peasants, embodies some basic concepts of romantic expressionism. The picture is an early example in American art of the sweeping, bird's-eye view panorama, later employed so effectively by Frederic E. Church in the 1850s and 60s (see nos. 105-107).

Oil on canvas, 37¹/₂ x 54¹/₄ inches
Signed and dated (on rock in center): T. C. 1832
The New-York Historical Society

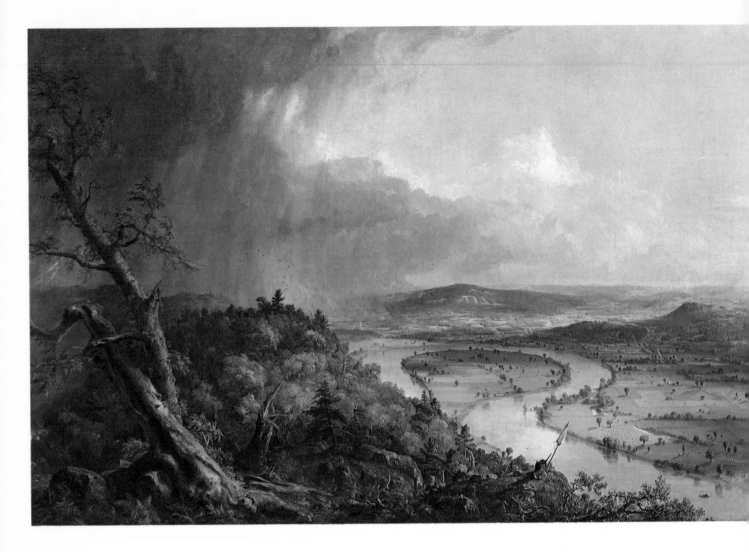

44 The Oxbow (The Connecticut River near Northampton)
Thomas Cole

On the recommendations of Asher B. Durand and Luman Reed to paint something expressly for exhibition and sale, Cole completed The Oxbow in the spring of 1836. His only doubt was, as he wrote Reed, "that I shall be able to sell it. I think I never sold but two pictures on exhibition in my life. . . ." The view, looking southwest from Mount Holyoke over the Oxbow downriver from Northampton, Massachusetts, did sell, and is among the grandest of Cole's pure landscapes. The storm-washed foreground, with its twisted trees—and incongruously dry artist—and the towering thunderheads are dramatically contrasted to the placid and carefully tended farmlands lying below in the distance. The result is a tautly composed, deliciously painted, and compelling vision of the wild yet domesticated American landscape, which for Cole expressed a deep-

er moral. The year before he painted The Oxbow, Cole composed this poem:

I sigh not for a stormless clime,
Where drowsy quiet ever dwells;
Where crystal brooks, with endless chime,
Flow winding through perennial dells.

For storms bring beauty in their train:
The hills below the howling blast,
The woods, all weeping in their rain,
How glorious, when the storm is past.

So storms of ill, when pass'd away,
Leave in the soul serene delight:
The gloom of the tempestuous day
But makes the following calm more bright.

Oil on canvas, 51¹/₂ x 76 inches
Signed and dated (lower left): T. Cole 1836
The Metropolitan Museum of Art, Gift of Mrs. Russell Sage, 08.228

The Voyage of Life
Thomas Cole

The Voyage of Life, conceived by Cole in October 1836, following his completion of The Course of Empire, was not begun until 1839, when he received a commission from the New York banker and collector Samuel Ward for a series for his "meditation room." Ward, who died before his commission was fulfilled, specified that the four paintings "be executed in the style of those by the same artist known as the Course of Empire." The series was finished in the fall of 1840 and briefly exhibited in New York. Cole painted another version, now in the Bethesda Home for the Aged, Cincinnati, during 1841 and 1842. The Voyage of Life was a success and numerous engravings of it were circulated. In 1848 the Ward Estate sold the paintings to the American Art-Union, where they were distributed by lot. The allegorical subjects, Childhood, Youth, Manhood, and Old Age demonstrate Cole's belief that painting should express moral, philosophical, and religious principles. This aim, evident in Cole's work as early as the late 1820s, is here realized on an epic scale.

The following texts, reprinted from the American Art-Union catalogue of 1848, were prepared by Cole to accompany the paintings when they were exhibited.

The series: Munson-Williams-Proctor Institute, Utica

45 Childhood

"A stream is seen issuing from a deep cavern, in the side of a craggy and precipitous mountain, whose summit is hidden in clouds. From out the cave glides a boat, whose golden prow and sides are sculptured into figures of the Hours: steered by an Angelic Form, and laden with buds and flowers, it bears a laughing Infant, the Voyager whose varied course the artist has attempted to delineate. On either hand the banks of the stream are clothed in luxuriant herbage and flowers. The rising sun bathes the mountains and flowery banks in rosy light.

"The dark cavern is emblematic of our earthly origin, and the mysterious Past. The Boat, composed of Figures of the Hours, images the thought, that we are borne on the hours down the Stream of Life. The Boat identifies the subject in each picture. The rosy light of the morning, the luxuriant flowers and plants, are emblems of the joyousness of early life. The close banks and the limited scope of the scene, indicate the narrow experience of Childhood, and the nature of its pleasures and desires. The Egyptian Lotus in the foreground of the picture is symbolical of Human Life. Joyousness and wonder are the characteristic emotions of childhood."

Oil on canvas, 52 x 78 inches
Signed and dated: (lower left) T COLE; (inner face of stretcher) T Cole/1839

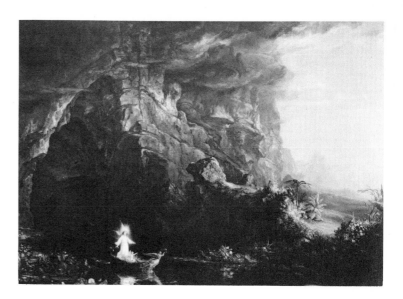

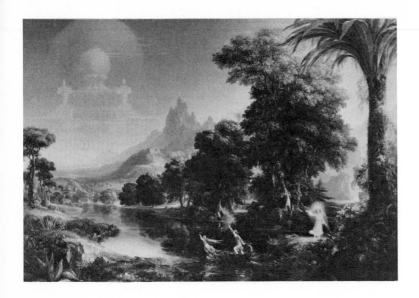

46 Youth

"The stream now pursues its course through a landscape of wider scope and more diversified beauty. . . . The Infant of the former scene is become a Youth on the verge of Manhood. He is now alone in the Boat, and takes the helm himself; . . . The Guardian Spirit stands upon the bank of the stream, and . . . seems to be bidding the impetuous voyager 'God speed.' The beautiful stream flows directly . . . for a distance; but at length makes a sudden turn, . . . until it at last descends with rapid current into a rocky ravine, where the voyager will be found in the next picture. . . .

"The scenery of this picture—its clear stream, its lofty trees, its towering mountains, its unbounded distance, and transparent atmosphere—figure forth the romantic beauty of youthful imaginings, when the mind magnifies the Mean and Common into the Magnificent, before experience teaches what is the real. The gorgeous cloud-built palace, whose most glorious domes seem yet but half revealed to the eye, growing more and more lofty as we gaze, is emblematic of the day-dreams of youth, its aspirations after glory and fame; and the dimly seen path would intimate that Youth, in his impetuous career, is forgetful that he is embarked on the Stream of Life, and that its current sweeps along with resistless force, and increases in swiftness as it descends toward the great Ocean of Eternity."

Oil on canvas, 52¹/₂ x 78¹/₂ inches
Signed and dated (lower center): T Cole/ 1840

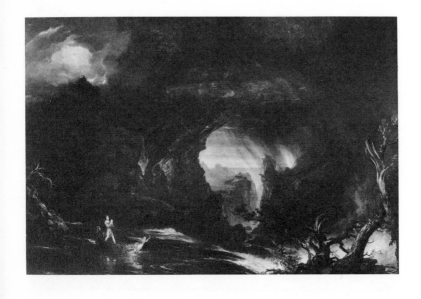

47 Manhood

"Storm and cloud enshroud a rugged and dreary landscape. Bare impending precipices rise in the lurid light. The swollen stream rushes furiously down a dark ravine, whirling and foaming in its wild career, and speeding toward the Ocean, which is dimly seen through the mist and falling rain. The boat is there, plunging amid the turbulent waters. The voyager is now a man of middle age: the helm of the boat is gone, and he looks imploringly toward heaven, as if heaven's aid alone could save him from the perils that surround him. The Guardian Spirit calmly sits in the clouds, watching with an air of solicitude the affrighted voyager. Demon forms are hovering in the air.

"Trouble is characteristic of the period of Manhood. In Childhood there is no cankering care;

in Youth no despairing thought. It is only when experience has taught us the realities of the world, that we lift from our eyes the golden veil of early life: that we feel deep and abiding sorrow; and in the picture, the gloomy, eclipse-like tone, the conflicting elements, the trees riven by tempest, are in the allegory; and the Ocean, dimly seen, figures the end of life, to which the voyager is now approaching. The demon forms are Suicide, Intemperance, and Murder, which are the temptations that beset men in their direst trouble. The upward and imploring look of the voyager, shows his dependence on a Superior Power, and *that* faith saves him from the destruction that seems inevitable."

Oil on canvas, 52 x 78 inches
Signed and dated (on rock at lower left): T Cole/1840

48 Old Age

"Portentous clouds are brooding over a vast and midnight Ocean. A few barren rocks are seen through the gloom—the last shores of the world. These form the mouth of the river, and the boat, shattered by storms, its figures of the hours broken and drooping, is seen gliding over the deep waters. Directed by the Guardian Spirit, who thus far has accompanied him *unseen*, the voyager, now an old man, looks upward to an opening in the clouds, from whence a glorious light bursts forth, and angels are seen descending the cloudy steps, as if to welcome him to the Haven of Immortal Life.

"The stream of life has now reached the Ocean, to which all life is tending. The world, to Old Age, is destitute of interest. There is no longer any green thing upon it. The broken and drooping figures of the boat show that Time is nearly ended. The chains of corporeal existence are falling away; and already the mind has glimpses of Immortal Life. The angelic Being, of whose presence until now the voyager has been unconscious, is revealed to him, and with a countenance beaming with joy, shows to his wondering gaze scenes such as mortal man has never yet seen."

Oil on canvas, 51³/₄ x 78¹/₄ inches
Signed and dated (lower center): T Cole/1840

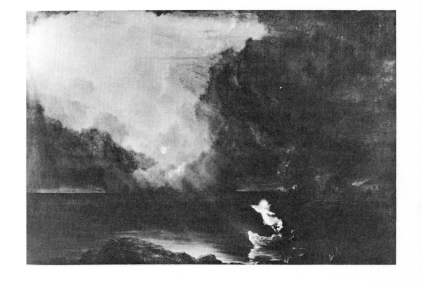

49 **The Architect's Dream**

Thomas Cole

The Architect's Dream, commissioned by Ithiel Town, one of the architects of the original Wadsworth Atheneum, Hartford, was executed by Cole in 1840. When the painting was completed, Town refused it, leaving Cole to express the following feelings in a letter to the painter Asher B. Durand: "Do you know I have received a letter from Town, telling me that neither he nor his friends like the picture I have painted for him, and desiring—expecting me to paint another in place of it, composed of *rich and various landscape, history, architecture of different styles and ages, etc.,* (these are his words) *or ancient or modern Athens?* . . . After having painted him a picture as near as I could accommodate my pictorial ideas to his prosaic voluminousness,—a picture of immense labour, . . .

he expects me again to spend weeks and weeks in pursuit of the uncertain shadow of his approbation. I will not do it; . . . beware how you paint for the same patron." The painting, reflecting the prevalent eclecticism of contemporary architecture in its assemblage of Egyptian, Greek, Roman, Gothic, and Moorish styles, is more than an amusing period piece; it is an exciting study in giganticism, forced perspective, and brilliant atmospheric effects, and ranks high among the artist's compositions.

Oil on canvas, 54 x 84 inches
Signed and dated (on capital): PAINTED BY T. COLE/ FOR I. TOWN ARCHT./1840.
The Toledo Museum of Art, Gift of Florence Scott Libbey, 1949

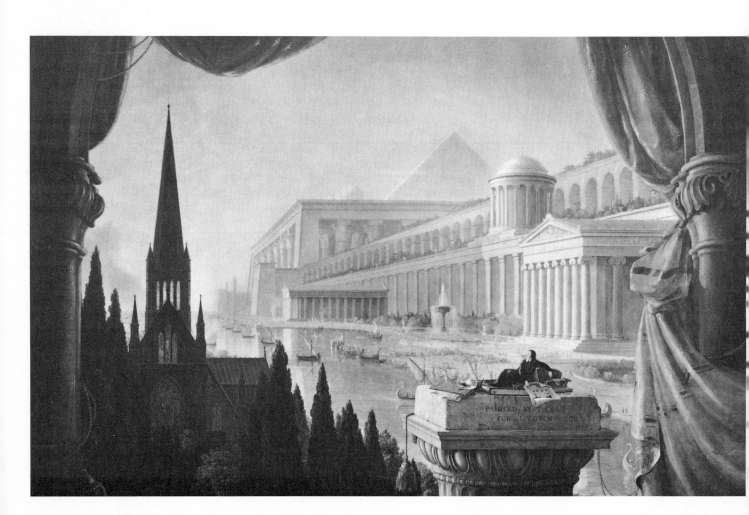

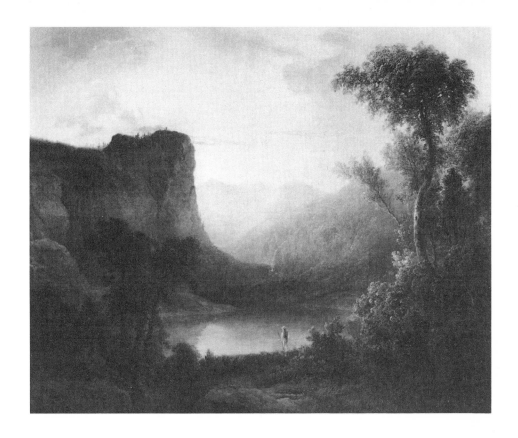

50 **In Nature's Wonderland**
Thomas Doughty (1793–1856)

In 1839 the English painter Thomas R. Hofland wrote in *The Knickerbocker:* "The American School of Landscape Painting is decidedly and peculiarly original, fresh, bold, brilliant and grand . . . we may mention Doughty of Boston as eminently combining these qualities. . . . He must undoubtedly be considered the master and founder of a new school." Doughty, born in Philadelphia, was one of the first artists of his generation to specialize in landscape. In 1820 he gave up his business as a leather currier to paint professionally, his only training a night-school drawing course and some lessons in oils from Thomas Sully. Within a few years he was highly successful, exhibiting at the Pennsylvania Academy of the Fine Arts, the National Academy of Design, and the Boston Athenaeum.

From 1832 to 1837 he lived in Boston, teaching drawing and painting and making extensive painting trips, seeking out "those beautiful scenes with which our country abounds." Little is known of In Nature's Wonderland, painted in 1835, except that it is said to represent a scene in the Adirondacks and that the title was Doughty's own. It is a beautiful example of the Claudian mode used to convey a highly personal sense of the ideal in nature.

Oil on canvas, 24¹/₄ x 30 inches
Signed, dated, and inscribed: (lower center) T DOUGHTY 1835; (on back) Painted by Tho's Doughty for John D. Fisher, M.D. 1835.
The Detroit Institute of Arts, Gibbs-Williams Fund

51 **Bargaining for a Horse**
William Sidney Mount (1807–1868)

Mount was born in Setauket, Long Island, and as a youth was an apprentice in his brother's New York sign-painting shop. He studied briefly with Henry Inman and at the newly founded National Academy of Design before producing his first known genre picture in 1830. After making a name for himself in the city as a portrait and genre painter, Mount moved permanently to Stony Brook, near Setauket. Here he depicted the rural pleasures and occupations he knew so well. Bargaining for a Horse, recorded by Mount's biographer, Edward P. Buffet, as having been posed at the side door of a barn on the Mount homestead, was painted for his patron, Luman Reed (see no. 60), in 1835. Exhibited at the National Academy of Design the following year, it was described by the *New York Herald* as "an image of pure Yankeeism and full of wholesome humor. Both of the yoemen seem to be 'reckoning,' both whittling, both delaying. The horse, which is the object of their crafty equivocations, stands tied as 'sleek as a whistle,' waiting for a change of owners." The painting, subsequently popularized through engravings, ranks among Mount's finest works in its effective use of a rustic theme, exquisite detailing, and atmospheric clarity. In 1854 Mount painted another version, called Coming to the Point, now at the New York Public Library.

Oil on canvas, 24 x 30 inches
Signed and dated (lower left): Wm S. Mount/ 1835
The New-York Historical Society

52 **Farmers Nooning**
William Sidney Mount

Farmers Nooning was painted by Mount in 1836 for Jonathan Sturges of New York, the former business partner of Luman Reed, who to some extent following Reed's death continued his leadership as patron of American painters. One of three paintings Mount did for Sturges, it was, according to Edward Buffet, posed in one of Mount's fields. Among his best works and widely known through engravings, the picture displays the relaxed, humorous mood characteristic of his style. Characteristic, too, is the rich application of paint, but the use of cool tones is unusual for Mount.

Oil on canvas, 20 x 24 inches
Signed and dated (lower left): Wm S. MOUNT/ 1836.
The Suffolk Museum and Carriage House, Stony Brook, Long Island, Melville Collection

53 Cider Making
William Sidney Mount

In December 1840 Mount wrote to the historian Benjamin F. Thompson: ". . . I have a picture on the esel [*sic*] I think you would be pleased to see. The subject is cider making in the old way." The picture was completed in 1841 for the New York merchant Charles Augustus Davis, who paid the artist $250 for it. The subject exemplifies Mount's conviction that he should "paint such pictures as speak at once to the spectator, scenes that are most popular, that will be understood on the instant." Cider Making is a masterful celebration in detail and color of familiar rural pleasures and countryside, and when it was exhibited in New York at the National Academy of Design, it must have had a strong nostalgic appeal for metropolitan viewers, so many of whom were country transplants.

Oil on canvas, 27 x 34¹/₈ inches
Signed, dated, and inscribed: (lower left)
Wm. S. Mount./1841; (on barrel) 1840.; (on back) CIDER-MAKING./Wm S. Mount./1841./
Painted for/C. Augt. Davis/N. York
The Metropolitan Museum of Art, Purchase, Charles Allen Munn Bequest, 66.126

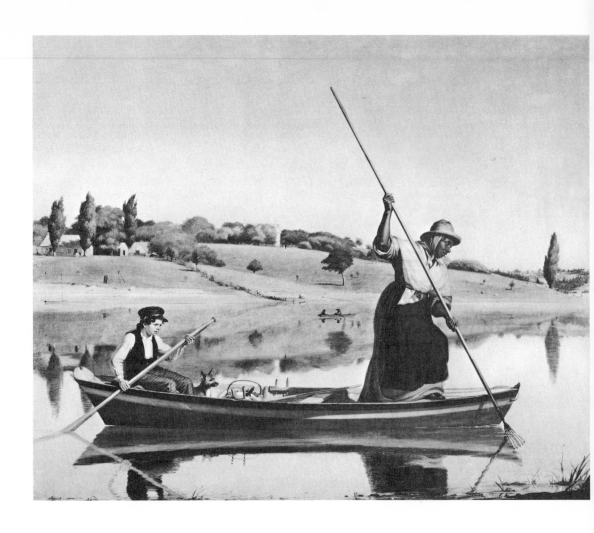

54. Eel Spearing at Setauket
William Sidney Mount

Eel Spearing at Setauket, Mount's unchallenged masterpiece, painted in 1845, was described by him as "Recollections of early days. Fishing along shore—with a view of the Hon Selah B. Strong's residence in the distance during a drought at Setauket, Long Island." As a youth, Mount had speared eels with an old Negro named Hector. This painting, based on the artist's experiences, captures both the absorption of the subjects in their pastime and, through the blond tonality of the color scheme, the dry heat of the summer day. Mount once noted that "it is not necessary to be gifted in languages to understand a painting—if the story is well told."

Oil on canvas, 29 x 36 inches
Signed and dated (lower right): Wm. S. Mount 1845
New York State Historical Association, Cooperstown

55. Long Island Farmhouses
William Sidney Mount

Mount once wrote that "If figures are the principal, everything else should be subordinate, depending on the taste of the artist. When landscape is primo, and figures are introduced, they are and must be secondo. See Coles and Durands landscapes in the Art Union or look at Claude's landscapes." In Long Island Farmhouses, painted between 1854 and 1859, the figures of the playing children assume a secondary position to the houses, producing a pure landscape composition rarely found among Mount's works. The picture is an accurate and expressive record of the changeable weather often encountered on Long Island Sound, and of the kind of farmhouses that dotted the area around Setauket where Mount grew up. It establishes him as an excellent landscapist as well as genre painter.

Oil on canvas, 21⁷/₈ x 29⁷/₈ inches
Signed (lower left): Wm. S. MOUNT
The Metropolitan Museum of Art, Gift of Louise F. Wickham, in memory of her father, William H. Wickham, 28.104

56. Andrew Jackson
Hiram Powers (1805–1873)

Powers, born in Woodstock, Vermont, apparently received his only instruction in modeling from the Prussian sculptor Frederick Eckstein, who worked in Cincinnati. In 1828, while repairing and animating wax figures for a Cincinnati chamber of horrors museum, Powers obtained his first portrait commissions. In 1834 his patron, Nicholas Longworth, sent him to Washington, where he produced busts of eminent Americans including Andrew Jackson. The bust of Jackson, acknowledged by Powers as one of his finest, was modeled the following year in three sittings at the White House. When he hesitated to represent Jackson's toothless mouth, Powers was admonished by the president: "Make me as I am, Mr. Powers, and be true to nature always. . . . I have no desire to look young as long as I feel old. . . ." In the Roman Republican portrait tradition, Powers depicted with unflagging realism the dignity and forcefulness of the sixty-eight-year old military and political fighter; it is a portrait that surpasses his later smooth busts and "fancy pieces." Powers carved this marble copy of the bust in Italy in 1837.

Marble, H. 34¹/₂ inches
Signed (on base): HIRAM POWERS/Sculp.
The Metropolitan Museum of Art, Gift of Mrs. Frances V. Nash, 94.14

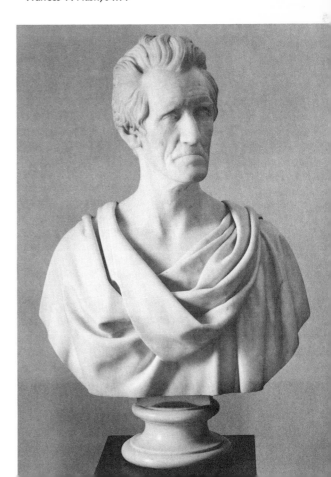

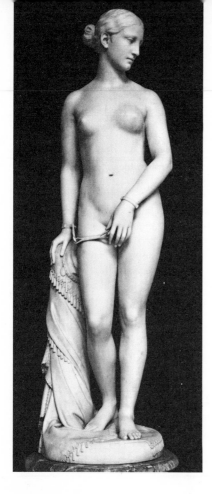 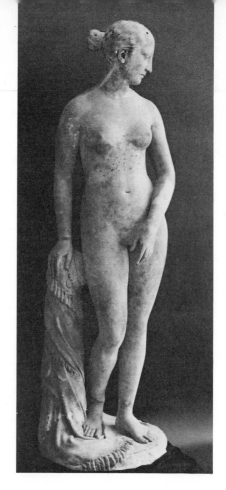

57 **The Greek Slave**
Hiram Powers

Powers worked in Italy from 1837 until his death in 1873, taking advantage of the cheap labor and availability of marble. Completed in Florence in 1843, The Greek Slave became his best-known work and made him the first American sculptor of international reputation. Inspired by the Greeks' struggle for liberty against the Turks, it portrays a young Greek girl for sale in a Turkish bazaar. According to Powers's written description of the piece: ". . . she stands exposed to the gaze of the people she abhors, and awaits her fate with intense anxiety, tempered indeed by the support of her reliance upon the goodness of God." The figure's controversial nudity caused it to be banned in Boston. But soon afterward, accompanied by a pamphlet with approving remarks by London critics and a minister, and with the sanction of a group of Cincinnati clergymen, it became a cause célèbre for those fighting to save art from the Philistines. Powers explained to his moralistic countrymen that it was "not her person but her spirit that stands exposed." John Quincy Adams wrote a poem to the sculptor, and Elizabeth Barrett Browning composed a sonnet in honor of the piece. Copies were made (this one in 1869), and miniatures in plaster, marble, and china decorated many an American mantel. The statue toured the United States and was an important attraction at the 1851 London Crystal Palace and the 1853 New York World's Fair.

Marble, H. 66 inches
Signed (on base): H Powers/Sculp
The Brooklyn Museum, Gift of Mr. Charles F.
Bound

58 **The Greek Slave**
Hiram Powers

In 1823 Powers learned from his teacher, Frederick Eckstein, the technique of casting a plaster replica from a clay original to serve as the model for subsequent marble reproductions. This plaster, one of the two surviving of the Greek Slave, retains the wire reference marks for the pointing machine used in carving the marble.

Plaster, H. 66 inches
National Collection of Fine Arts, Smithsonian
Institution, Washington

59 California
Hiram Powers

Because he was born on a farm, Powers's tremendous popular and financial success evokes the American dream of rags to riches. His chief appeal seems to have been his ability to give expression to the contemporary penchant for detailed naturalism and combine it with emotional narrative in an idealized classical style. For his sculpture California, originally entitled La Dorado, which he designed in 1850, Powers took as a model a plaster cast from the Venus de' Medici, which eventually served him as the basis for all his statues of nude women. According to Henry Tuckerman, the contemporary art historian, Powers's aim was "to contrast the fascination of form with the sinister expression of [the] face,—the thorn concealed in the left hand with the divining rod displayed in the right [Tuckerman confused the two hands],—and thus illustrate the deceitfulness of riches." About the figure, which had been sold to William Backhouse Astor in 1858, Tuckerman went on to say: "It is a singular coincidence that such an allegorical statue should adorn the dwelling of our wealthiest citizen." Astor donated the statue to the Metropolitan Museum in 1872; it was the first sculpture by an American artist to be part of the collection.

Marble, H. 71 inches
Inscribed (on base): EXECUTED FOR Wm.. B. ASTOR. BY/HIRAM POWERS/APRIL 3rd. 1858
The Metropolitan Museum of Art, Gift of William Backhouse Astor, 72.3

60 Luman Reed
Asher Brown Durand (1796–1886)

Born in Jefferson Village, New Jersey, Durand was apprenticed to the Newark engraver Peter Maverick in 1812, and five years later became his partner. Durand soon won the best commissions, and about 1820 set up shop on his own to reproduce John Trumbull's painting The Declaration of Independence, now at the Yale University Art Gallery, New Haven, a work that eventually earned him the reputation of America's foremost engraver. During the 1830s Durand, already active as a portraitist, became interested in landscape painting. He was encouraged in this by Luman Reed, who, according to Durand, was "determined to make something of me." Reed, here portrayed by Durand about 1835, achieved his great wealth as owner of a New York grocery business and was one of the first connoisseurs to encourage American artists. After briefly collecting old masters, he turned to the young artists exhibiting at the National Academy of Design and became the patron not only of Durand but of Thomas Cole, William S. Mount, and George Flagg. In the three years before his untimely death in 1836, Reed amassed a major collection of American paintings, and during his lifetime the gallery in his house was open to the public. Eventually his collection was given to the New-York Historical Society.

Oil on canvas, 30^1/$_8$ x 25^3/$_8$ inches
The Metropolitan Museum of Art, Bequest of Mary Fuller Wilson, 63.36

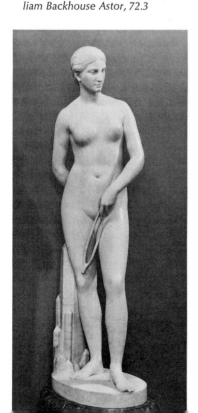

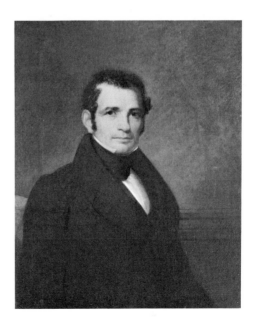

61 The Beeches

Asher Brown Durand

After a tour of European galleries in 1840, Durand settled in New York City to devote himself to painting the American landscape, working from sketches to turn out the large studio pieces that found a ready market among collectors. This example, painted in 1845, belongs to a series thought by Henry Tuckerman to have been inspired by a line of the poet Thomas Gray, "At the foot of yonder beech." The picture's lovely golden tone and filtered sunlight and the monumental scale of the trees are characteristic of Durand's landscapes of the 1840s, which were done in an earnest Claudian mode.

Oil on canvas, 60⁹/₈ x 48¹/₈ inches
Signed and dated (lower left): A. B. DURAND/ 1845
The Metropolitan Museum of Art, Bequest of Maria DeWitt Jesup, 15.30.59

Kindred Spirits

Asher Brown Durand

The year after Thomas Cole's death, Durand, his friend and with him one of the founders of the Hudson River school, depicted Cole and the poet William Cullen Bryant in Kindred Spirits. It was painted at the request of Cole's and Durand's patron, Jonathan Sturges, as a gift to Bryant in appreciation of his "Funeral Oration" for Cole. Sturges presented the painting with this note:

My Dear Sir: Soon after you delivered your oration of the life and death of our lamented friend Cole, I requested Mr. Durand to paint a picture in which he should associate our departed friend and yourself as kindred spirits. I think the design, as well as the execution, will meet your approbation, and I hope that you will accept the picture from me as a token of gratitude for the labor of love performed on that occasion.

Very truly yours,
Jon. Sturges

Bryant thanked the artist in a letter:

I have written to Mr. Sturges, to thank him for that beautiful painting of yours. . . . I was more delighted with it more than I can express, and am under very great obligations to you for having put so much of your acknowledged genius into a work intended for me. Every body admires it greatly and places it high as a work of art. I find that even those who are but slightly acquainted with me, recognize my figure in the landscape, without any previous suggestion that it is meant as the portrait of any person. The painting seems to me in your best manner, which is the highest praise.

Bryant had long been a friend of Cole, sharing with him (as did Durand) "many delightful rambles among the Catskills," and printing Cole's poems in his newspaper. Their friendship was first publicized in 1830, when Bryant wrote his sonnet "To Cole, the Painter, Departing for Europe." Durand's picture is a fitting memorial to the sympathy between the two, both early celebrators of the American wilderness, and portrays with a charming directness their wonder and delight before nature. The men stand—Bryant, hat in hand, Cole, gesturing with his walking stick—on a cliff above the Kaaterskill Clove, a scene rendered with an engraver's love of detail, which emphasizes the picturesqueness of the virgin forest. Through his careful control of space, scale, and light, Durand achieves a balance between the landscape and figures, creating a sense of harmony between man and unspoiled nature.

Oil on canvas, 46 x 36 inches
Signed, dated, and inscribed: (left center) A. B. Durand/1849; (on tree at left) BRYANT/COLE
The New York Public Library; Astor, Lenox and Tilden Foundations

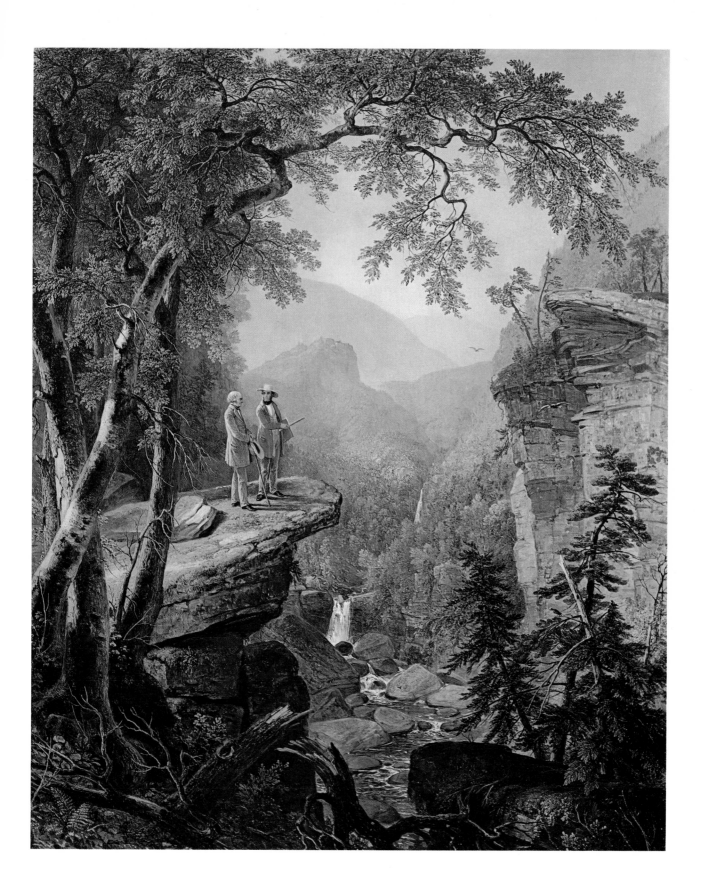

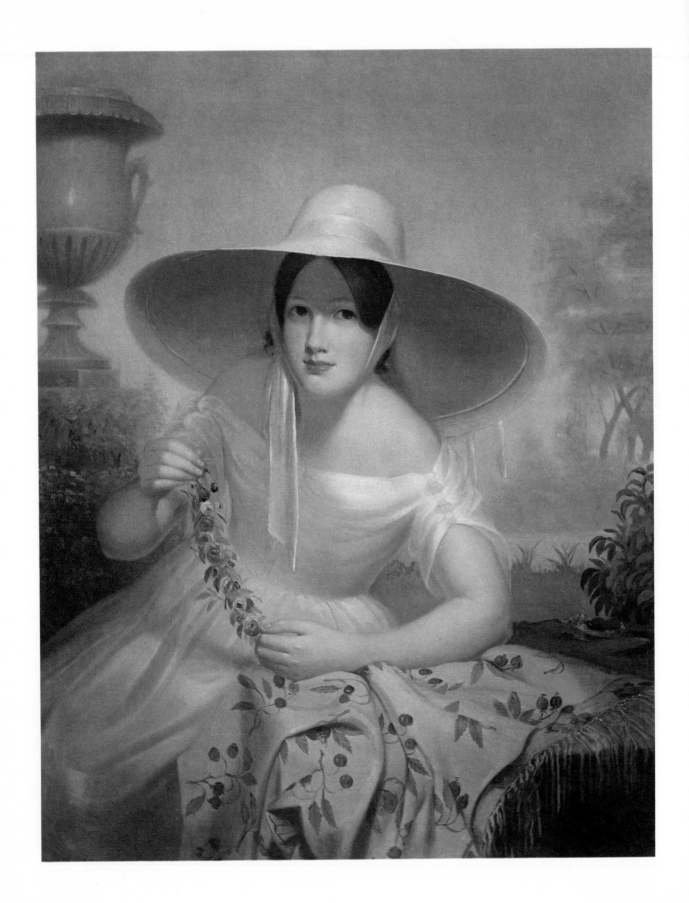

63 Spring

Cephas Giovanni Thompson (1809–1888)

Thompson, born in Middleboro, Massachusetts, was the son of portraitist Cephas Thompson. Young Cephas studied with his father and at the Boston Athenaeum. After working as an itinerant artist, he settled in New York in 1837. His friends included the influential writers William Cullen Bryant and Henry Tuckerman, and during the 1850s when he was in Rome painting portraits, landscapes, and copies of old masters, he met Nathaniel Hawthorne, who included him in his book on American artists in Rome, *The Marble Faun*. Tuckerman wrote about Thompson's early success in New York: "[he] was more or less the fashionable portrait-painter; two fancy-pieces, idealized likenesses of beautiful young women, called 'Spring' and 'Autumn,' gained him reputation. . . ." Spring was completed in 1838, and, as Thompson's masterpiece, combines romanticism, delicate modeling, and sunny coloring in one of the period's most captivating portraits.

Oil on canvas, 36 x 28³/₄ inches
Signed and dated (lower right): C. G. Thompson/Oct 1838
Mrs. Madeleine Thompson Edmonds, Northampton, Massachusetts

64 On the Susquehanna

Joshua Shaw (about 1777–1860)

Shaw was trained as a sign painter in England, and before he came to America, he was already an established landscapist. In 1817 Shaw arrived in Philadelphia and from there traveled throughout the country, making water colors and drawings in a sophisticated topographical style of "the best and most popular views" and sketches of Indian and frontier life. Some of his work appeared in magazines and gift books, and in 1819/20 John Hill engraved and aquatinted a series, *Picturesque Views of American Scenery . . . from Drawings by Joshua Shaw*, which comprised, according to the announcement, "all the varieties of the sublime, the beautiful, and the picturesque in nature." Shaw exhibited for many years at the Boston Athenaeum, the National Academy of Design, and the Pennsylvania Academy of the Fine Arts before turning to the invention of naval weaponry. His brightly painted On the Susquehanna, of 1839, which presents an idyllic view of the lives of Indian hunters, was probably developed from sketches he made during his early travels.

Oil on canvas, 39 x 55¹/₂ inches
Signed and dated (lower right): J. Shaw 1839
Museum of Fine Arts, Boston, M. and M. Karolik Collection

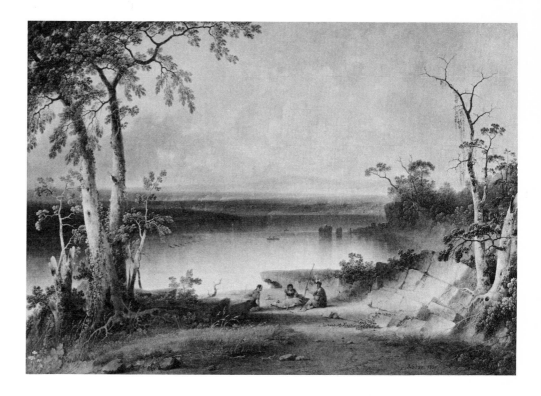

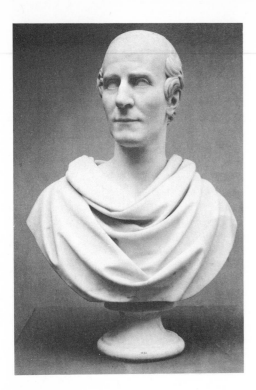

65 Thomas Cole
Henry Kirke Brown (1814–1886)

Brown, born in Massachusetts, was a pupil of the Boston portrait painter Chester Harding. He worked as a portraitist in Cincinnati until 1839, when, according to his friend and advisor Nicholas Longworth, "dropping the brush and wielding the chisel," he took up sculpture in hopes of greater success. Living in Albany from 1839 to 1841, Brown produced over forty busts of local worthies, including this one of the painter Thomas Cole (see nos. 43-49), who lived nearby at Catskill on the Hudson. It is characteristic of Brown's portraits, which were rarely more than detailed and unidealized studies of the physical appearance of the sitter, clad in the ubiquitous Roman toga. Despite this token adherence to neoclassicism, Brown, after a trip to Rome from 1842 to 1846, rejected the belief in the hegemony of Rome over contemporary sculpture held by many of his colleagues: "As far as Art is concerned . . . I am, daily, more and more convinced of the folly of studying the works of others; in no work of art is there anything beautiful but what nature fully justifies. . . ."

Marble, H. 28¹/₄ inches
The Metropolitan Museum of Art, Gift of the Children of Jonathan Sturges, 95.8.1

66 The Hollingsworth Family
George Hollingsworth (1813–1882)

Hollingsworth, a portraitist born in Milton, Massachusetts, exhibited his work at the Boston Athenaeum from 1839 to 1845 and earned recognition as a teacher at the Lowell Institute Drawing School, which operated in Boston from 1850 to 1879. In this painting of his family, of about 1840, the artist appears with his parents and brothers and sisters; he stands behind his mother and his father, the owner of a successful paper mill on the Neponset River in Milton. Anderson is at left, preoccupied with the family dog; Maria and her husband, Emmor Cornell, stand in the center; Cornelia is at the piano, flanked by the seated Lyman and John Mark. The artist, obviously trying for the most realistic effect, probably made separate preliminary studies of each person and object (including a mysterious jumble of antique weapons and armor at the right) before inserting them in the setting, a drawing room in the family's eighteenth-century house in Milton. The resulting picture is not successful as a coherent group portrait, but as a collection of individual studies and a record of a period interior it is of great interest.

Oil on canvas, 42 x 72 inches
Museum of Fine Arts, Boston, M. and M. Karolik Collection

67 Catherine Wheeler Hardy and Her Daughter
Jeremiah Pearson Hardy (1800–1888)

A native of New Hampshire, Hardy worked as an engraver before studying briefly in a Boston art academy and with Samuel F. B. Morse in New York. Hardy settled in Bangor, Maine, in 1838 and worked as a painter of portraits, genre scenes, miniatures, animals, and still lifes. According to his biographer, Fannie Hardy Eckstorm, his studio became "the meeting place of the witty, the brilliant, even the fashionable of the city. A portrait by Hardy was a mark of distinction." Catherine Wheeler Hardy and Her Daughter, of about 1842, portrays the artist's wife and daughter in their nicely appointed mid-Victorian parlor with a view of the Penobscot River framed in the window. The picture combines beautiful, luminous tone with the observation of detail and linear drawing that marks this somewhat melancholy scene as the work of a primarily self-taught artist. The fine quality of light and poetic mood give the picture special character and appeal.

Oil on canvas, 29¹/₄ x 36 inches
Museum of Fine Arts, Boston, M. and M. Karolik Collection

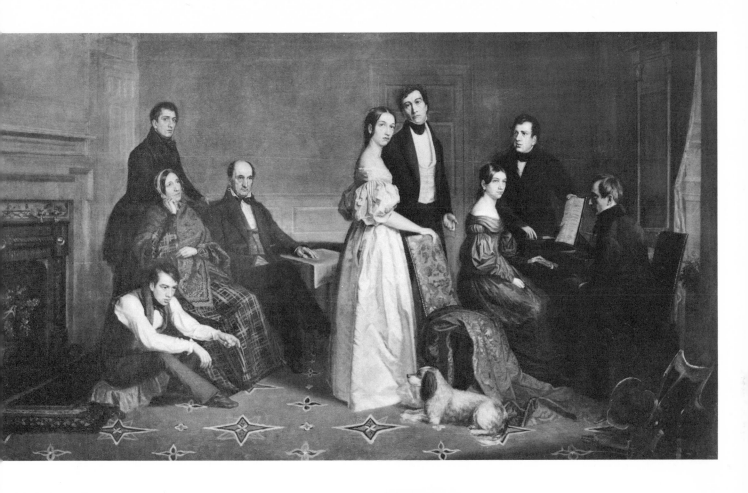

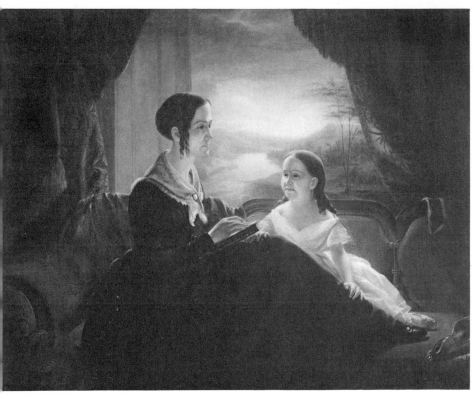

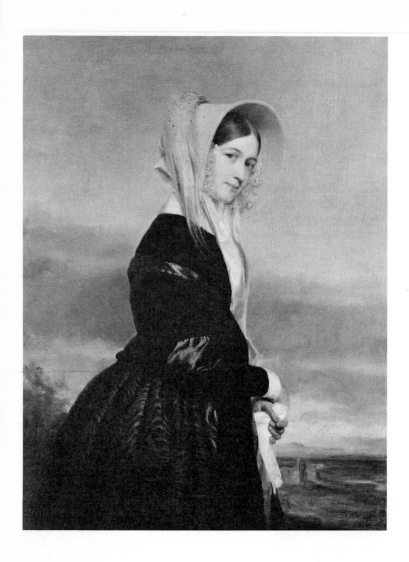

68 Euphemia White Van Rensselaer

George Peter Alexander Healy (1813–1894)

At the age of eighteen, and without any training, Healy, son of a poor Boston ship's captain, opened a portrait studio in that city. In 1834 he went to Paris to study with Baron Gros and was for a period in London. After eight years of hard work, he established himself as an internationally known portraitist, patronized by royalty and the upper class. When he returned to America, he spent most of his time filling commissions in Washington, D.C. From 1867 to 1892 Paris was his home, but work on both sides of the Atlantic caused him to shuttle regularly between Europe and the United States. Euphemia White Van Rensselaer (Mrs. John Church Cruger) was painted in Paris in 1842 and is one of Healy's finest pictures. The confident sitter, dressed in glistening silks, velvet, and a stylish bonnet, is shown before a sketchy landscape probably meant to be the Campagna near Rome, where she had visited the previous year. The firm drawing, lively color, and delicate modeling of the sitter's features suggest the impact of contemporary Parisian portraiture, especially that of Franz Xavier Winterhalter and Ingres.

Oil on canvas, 45³/₄ x 35¹/₄ inches
Signed and dated (lower right): G.P.A. Healy Paris 1842
The Metropolitan Museum of Art, Bequest of Cornelia Cruger, 23.102

69 **The Arch of Titus**

*George Peter Alexander Healy, Frederic Edwin
Church (1826–1900), and Jervis McEntee (1828–
1891)*

The Arch of Titus, dated 1871, was long attrib-
uted solely to Healy, but is now believed to be
the work of the three artists portrayed: Frederic
Church, who is seated, sketching; Church's pupil
Jervis McEntee, standing behind him; and Healy,
looking over Church's shoulder. The man and
woman passing under the arch are the poet
Henry Wadsworth Longfellow and his daughter
Edith. The figures are now attributed to Healy,
the background view of the Colosseum to Mc-
Entee, and the arch to Church. While collabora-
tion between landscape and portrait painters in
"club" pictures was not rare in American art, few
successful works on this scale with significant
contributions by three artists are known. It has
been pointed out that in such joint efforts usu-
ally either the landscape or portrait is dominant,
and that the remarkable aspect of this picture
is the harmony of its parts. The Arch of Titus is
a nostalgic tribute to Italian culture and the city
of Rome, where so many Americans, including
the five shown here, went to study the wonders
of the past.

Oil on canvas, 73¹/₂ x 49 inches

*Signed and dated (upper left): G. P. A. Healy
1871*

*The Newark Museum, Dr. J. Ackerman Coles
Bequest*

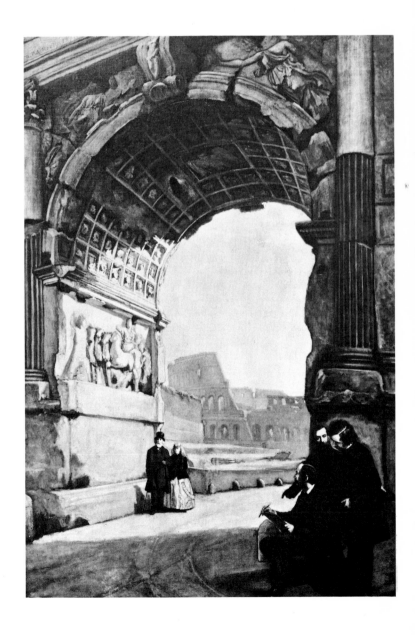

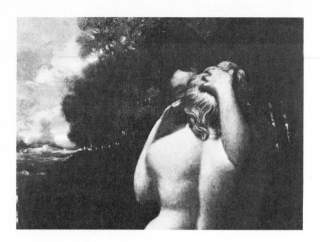

70 Cupid and Psyche
William Page (1811–1885)

Page left a New York law office to study with the portrait painter James Herring and in 1826 entered the newly founded National Academy of Design to work with Samuel F. B. Morse. After briefly interrupting his career to prepare for the ministry, Page resumed painting and was active in Albany, Boston, and New York in the 1840s. In March 1843 he wrote to his friend the poet and lawyer James Russell Lowell: "I am just finishing a small picture of Cupid and Psyche from the cast you may remember to have seen in my room —kissing in a wood. . . ." Although rejected because of its passionate subject by the exhibition committee of the National Academy of Design in 1843, despite Page's position as an Academician, the painting was shown that year at the Boston Athenaeum. One critic commented: "The people of Boston are either less refined or less squeamish, for it does not seem to have given any offense here." A theoretician and avid experimentalist, Page was characterized by Henry Tuckerman as one who "seems to unite the conservative instincts of an old-world artist with the bold experimental ambition of our young Republic." Cupid and Psyche presents an unusual composition, with the embracing couple against a background of dense forest that contrasts markedly with a small patch of light hazy landscape at the left. The subtle but rich effects of color gradations are explored in the warm luminous flesh tones and cool transparent glazes of the sky and distant landscape, clearly demonstrating Page's accomplishments as a colorist. Living in Rome during the 1850s, Page devoted himself to making copies of paintings by Titian, which aided him in his color experiments and gained him renown as the "American Titian."

Oil on canvas, 10⁷/₈ x 14³/₄ inches
Lent anonymously

71 Mrs. McCormick's General Store
Albertus D. O. Browere (1814–1887)

Born in Tarrytown, New York, Browere was the son of the sculptor and taker of life masks John H. I. Browere. Young Browere studied in New York City at the National Academy of Design before moving to Catskill, New York, where he worked in a drugstore and painted buggies, surreys, and signs. Except for two trips to California in search of gold during the 1850s, Browere spent most of his life in Catskill, painting a wide range of subjects including illustrations of Rip Van Winkle, Indian history, river landscapes, views of California mining towns, fires, and genre scenes like Mrs. McCormick's General Store. This picture, dated 1844, graphically confirms in comic terms that a shopkeeper's life is never easy and that the technique of shoplifting has not altered appreciably in over a hundred years. It is excellent as a record of mid-nineteenth-century village life in America, showing variations in dress—from slovenly to sedate— the casual arrangement of the shop front, and the simple Greek revival façades of the row houses in the background.

Oil on canvas, 20¹/₂ x 25 inches
Signed and dated (lower right): A. D. O. Browere /1844
New York State Historical Association, Cooperstown

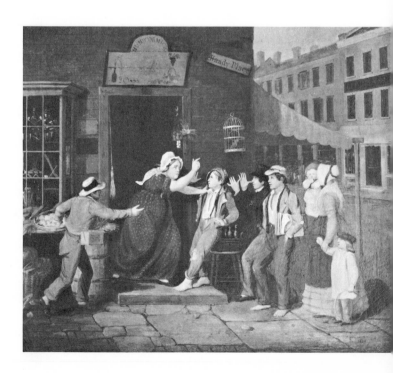

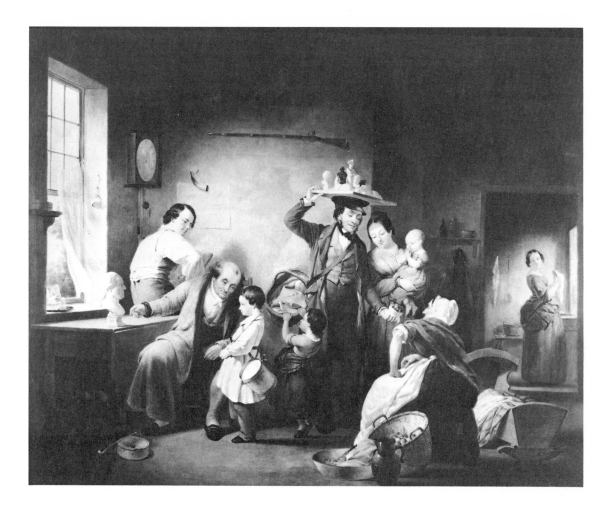

72 **The Image Pedlar**
Francis William Edmonds (1806–1863)

Following a brief apprenticeship with a Philadelphia engraver, Edmonds, a native of Hudson, New York, became a New York City banker. Years later he helped establish an engraving firm that was absorbed by the American Bank Note Company. Genre and portrait painting became his avocation, and after 1829 he exhibited for thirty years at the National Academy of Design and the American Art-Union, both of which he served as an officer. Edmonds was one of the enthusiastic minor artists devoted to portraying popular literary subjects and rustic life, often relying for models on etchings after Dutch genre pictures by artists like Ostade or Steen. The Image Pedlar, first exhibited at the National Academy in 1844, recreates the visit of a wandering hawker

of plaster busts and statuettes to a simple household. Glorifying the virtues of patriotism, domestic tranquility, and industriousness, Edmonds sympathetically portrays an elderly gentleman gesturing at a bust of Washington, while he instructs his grandson on the general's greatness. The other members of the family interrupt their work and play to surround the pedlar and inspect the proffered knickknacks. Despite its somewhat sentimental mood, the picture is carefully composed and beautifully painted, particularly in the scattered still-life ensembles of jugs, pans, baskets, fruit, and furniture.

Oil on canvas, 33 x 42 inches
The New-York Historical Society

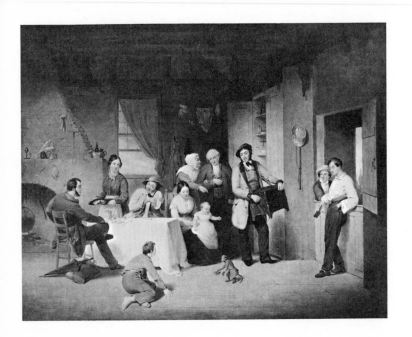

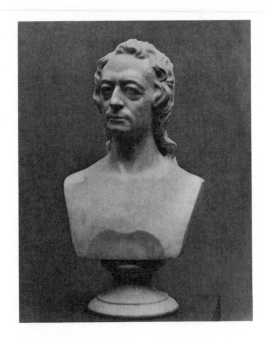

73 **The Organ Grinder**
Francis William Edmonds

The Organ Grinder, painted about 1850, depicts a pleasant interruption of the country routine by the appearance of the resigned-looking music merchant and his monkey. The picture follows the Dutch genre tradition in its use of a stagelike interior space and the attempt to mirror the reactions of each participant. More important, it provides a complete record of a modest rural room, including cupboard contents, cooking utensils, furnishings, clothing, and shows the relaxed complacency of the inhabitants. The carefully modulated light coloring and velvety definition of surfaces are characteristic of Edmonds's best work.

> *Oil on canvas, 31¹/₂ x 41¹/₂ inches*
> *Signed (lower right): FW Edmonds*
> *Mr. and Mrs. H. John Heinz III, Pittsburgh*

74 **Washington Allston**
Edward Augustus Brackett (1818–1908)

Brackett, born in Maine, was a sculptor and a poet. After studies in Cincinnati, he worked there, in Washington, and in New York making portrait busts, and in 1841 settled near Boston, where he lived the rest of his life. Based on a death mask taken by Brackett in 1843, this subtly modeled study of the painter Washington Allston (see nos. 5-7) emphasizes his handsome features and stately bearing. After completing the bust in 1844, Brackett composed the poem "Lines Suggested on Finishing a Bust of Washington Allston," of which the following is an excerpt:

> Upwards unto the living light,
> Intensely thou dost gaze,
> As if thy very soul would seek,
> In that far distant maze,
> Communion with those heavenly forms,
> .
> Thou who wast kind and good and great,
> Thy task on earth is done
> Of those that walked in beauty's light
> Thou wast the chosen one.

In life Allston reciprocated Brackett's admiration saying, "that in the rare power of expressing character and intellect, he has few equals."

> *Marble, H. 26 inches*
> *Signed (right shoulder): BRACKETT. Sc.*
> *The Metropolitan Museum of Art, Gift of the Children of Jonathan Sturges, 95.8.2*

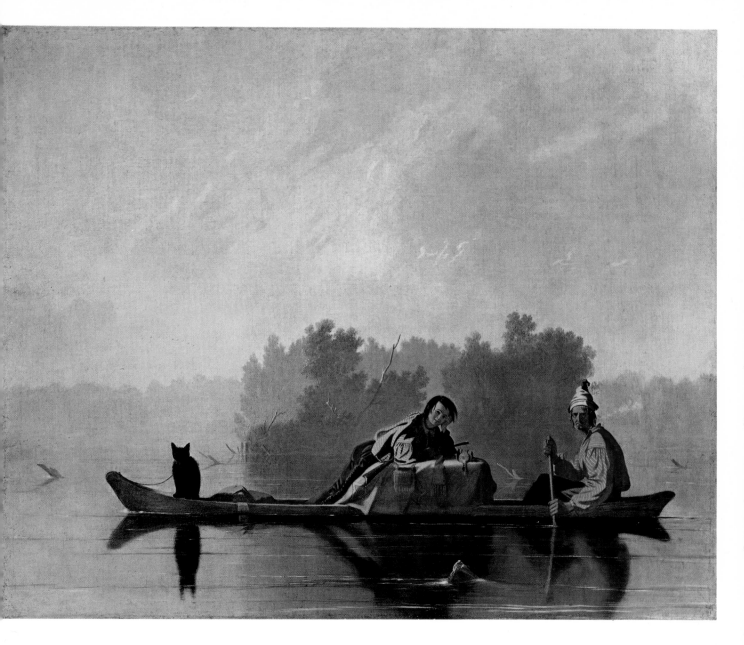

75 Fur Traders Descending the Missouri
George Caleb Bingham (1811–1879)

Bingham grew up in Missouri, where he studied theology and law and was apprenticed to a cabinetmaker before taking up portrait painting in the 1830s. By 1838, when he studied briefly at the Pennsylvania Academy of the Fine Arts, he was already experimenting in genre painting. In 1844, after working four years in Washington, D.C., as a portraitist, he returned to Missouri. He lived for some time along the banks of the Missouri River, where he may have done sketches for Fur Traders Descending the Missouri (originally titled French Trader and His Halfbreed Son), one

of the first of his western genre pictures submitted to the American Art-Union. Bingham's subjects were descendants of the "voyageurs" described by Washington Irving in his *Astoria, or Anecdotes of an Enterprise Beyond the Rocky Mountains* (1836): "The dress of these people is generally half civilized, half savage. They wear a capot or surtout, made of a blanket, a striped cotton shirt, cloth trousers, or leathern legging moccasins of deer skin, and a belt of variegated worsted, from which are suspended the knife, tobacco pouch, and other implements. . . . The lives of these voyageurs are passed in wild and extensive rovings. . . . They are dexterous boatmen, vigorous and adroit with the oar and paddle." Bingham depicted the Missouri on one of its calm, hazy days, and, through his painstaking clarity and classic organization achieved a mood of poetic stillness and intensity.

Oil on canvas, 29 x 36¹/₂ inches
The Metropolitan Museum of Art, Morris K. Jesup Fund, 33.61

76 Watching the Cargo
George Caleb Bingham

Bingham completed his major genre works between 1845 and 1856, after which, intent on achieving greater sophistication in his pictures, he went to Düsseldorf to study at the Royal Academy. During this period he evolved a classic monumental style, acquired in part by studying engravings after Renaissance and baroque painters and casts from antique sculpture. Watching the Cargo, Bingham's only known extant painting of 1849, portrays a group of Missouri River boatmen, temporarily stranded on a sandbar, guarding the cargo of a wrecked steamboat. In 1826 the missionary and traveler Timothy Flint had written of these men: "Theirs is . . . a way of life . . . in turn extremely indolent and extremely laborious; for days together requiring little or no effort, and attended with no danger, and then on a sudden, laborious and hazardous beyond Atlantic navigation." Bingham, characteristically, painted his subjects in postures of repose, intimate yet enigmatic, investing them with a sense of timelessness all the more striking for the specificity of time and place.

Oil on canvas, 26 x 36 inches
Signed and dated (lower left): G. C. Bingham/ 1849
The State Historical Society of Missouri, Columbia

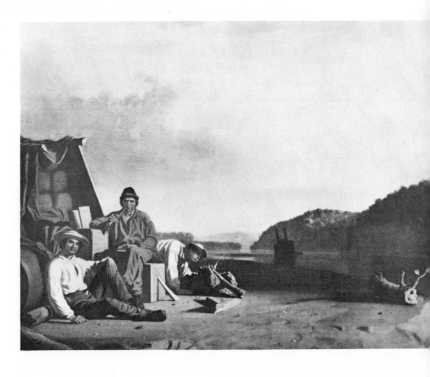

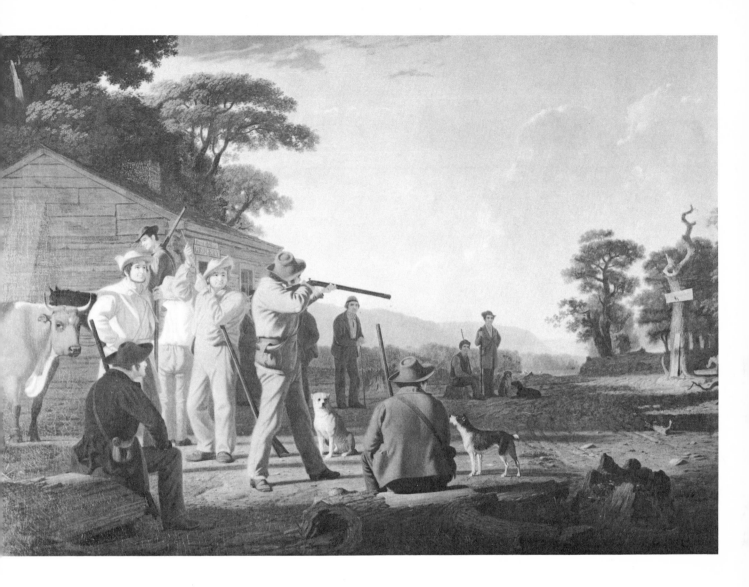

77 Shooting for the Beef
George Caleb Bingham

The subject of Shooting for the Beef, painted by Bingham in 1850, was a frequent amusement in the West. In his book, *The Far West: or, A Tour Beyond the Mountains* (1838), Edmund Flagg described the sport: "The regulations I found to be chiefly these: A bull's eye, with a centre nail, stands at a distance variously of from forty to seventy yards; and those five who, at the close of the contest, have most frequently *driven the nail*, are entitled to a fat ox divided into five portions." Of unusual size and complexity for Bingham's work of this period, Shooting for the Beef is for him a rare excursion into the genre of "sporting pictures," which gained great popularity from the 1840s onward. The elaborate massing of extraordinarily sculptural figures, skillful han-

dling of light and shade, and convincing unity of the glowing atmosphere, show the developing sophistication of his style after 1849. Typical of his compositional devices are the placement of the foreground figures before an architectural mass, flanking of the main action by the contained forms of two seated figures, and indications of depth in space by carefully placed horizontals and diagonals of shadows and rifle barrels. As a composition and a story told in paint the picture is one of Bingham's most successful.

Oil on canvas, 33¹/₂ x 49¹/₄ inches
Signed and dated (lower left): G.C. Bingham/ 1850.
The Brooklyn Museum, Dick S. Ramsay Fund

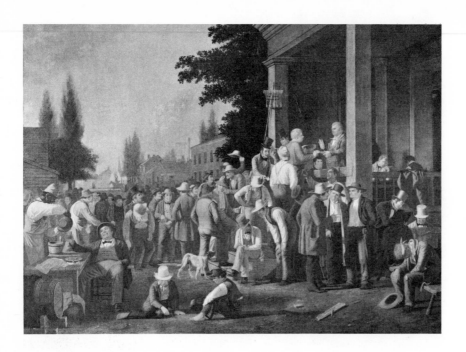

78 **The County Election**
George Caleb Bingham

In 1846 Bingham entered politics and was nar-
rowly defeated by Erasmus Darwin Sappington
for a seat in the Missouri legislature. Convinced
that the outcome was the result of political
maneuvering, Bingham appeared before the leg-
islature and "salted down the whole Sappington
family," and, according to a local paper, "cast
the hot shot in every direction." Two years later
he defeated Sappington by a wide margin. Bing-
ham brought his campaign experiences to bear
on his art in a series of election scenes, including
The County Election, painted in 1851/52 and en-
graved in 1854 by John Sartain. To obtain
subscriptions for the engraving, Bingham ex-
hibited a replica of the painting in several west-
ern states, where it drew large crowds and high
praise for its vitality, realism, and democratic sen-
timent. "All who have ever seen a county election
in Missouri," declared one observer, "are struck
with the powerful accumulation of incidents in
so small a space, each one of which seems to be
a perfect duplication from one of those momen-
tous occasions in real life." The most elaborate
figure composition Bingham had attempted up to
that time, the picture is a major achievement in
its powerful draughtsmanship, anecdotal variety,
and harmony of form and color.

Oil on canvas, 35 7/16 x 48³/₄ inches
City Art Museum of Saint Louis

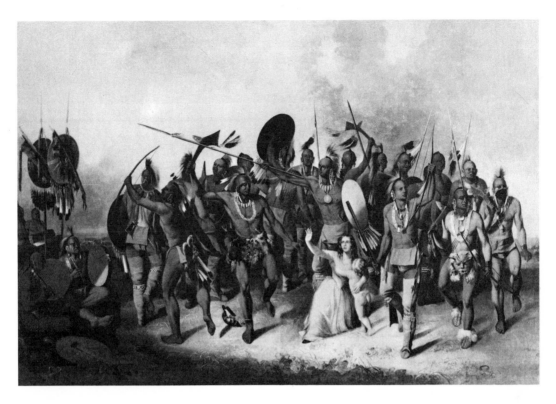

79 An Osage Scalp Dance
John Mix Stanley (1814—1872)

Stanley, born in Canandaigua, New York, began his career as a sign and house painter in Detroit in 1834 and by 1837 was listed in the city directories as a portraitist. Included among his early works were several Indian portraits executed at Fort Snelling, Minnesota. However, his real enthusiasm and skill as a chronicler of Indian life emerged during a series of painting tours of the western United States, the first in 1842. By 1851 Stanley had deposited over 100 paintings of Indians and the West at the Smithsonian Institution with the expectation that they would be bought for an Indian gallery; but in 1865 a fire swept the building destroying all but five. Among the surviving works was An Osage Scalp Dance, painted in 1845, which was described in the 1852 Smithsonian catalogue of Stanley's pictures: "All tribes of wild Indians scalp their cap-

tives, save the women and children who are treated as slaves until ransomed by the United States government. On returning from the scene of strife, they celebrate their victories by a scalp dance. . . . This picture represents the scalp dance of the Osages around a woman and her child; and a warrior in the act of striking her with his club, his chief springing forward and arresting the blow with his spear." The careful, slightly stiff arrangement of the figures indicates Stanley's reliance on individual field studies for his composition. The tearful melodrama of the scene was sure to appeal to mid-century gallerygoers, stirred by the gruesome accounts of white settlers taken captive by Indians.

Oil on canvas, 40 x 60 inches
National Collection of Fine Arts, Smithsonian Institution, Washington

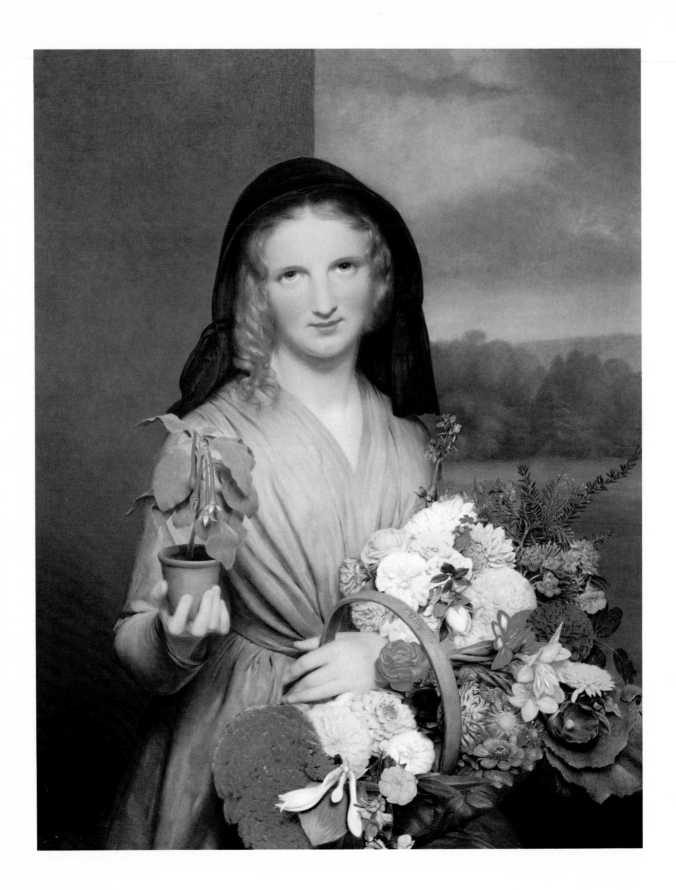

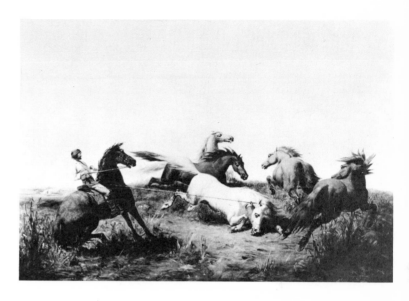

80 The Flower Girl

Charles Cromwell Ingham (1796–1863)

A portrait and miniature painter, Ingham came to America from Dublin in 1816. He spent the rest of his life in New York, where he enjoyed considerable success and was a leader in the art world. Ingham's forte was female portraiture. The Flower Girl, possibly Marie Perkins of New Orleans, painted in 1846, is a fine example of his style. The young lady, play acting as a soulful flower vendor, is given the bland, sweet, and refined features fashionable in mid-century novel-reading circles. However, it was Ingham's technique that earned him recognition among Knickerbocker society, and he was patronized principally because of the polished quality of his work. Ingham used successive glazings to produce an exquisite enamel-like finish. According to a contemporary, this method was "peculiar, and from the excessive patience and industry necessary to its success, was seldom imitated. He elaborated his flesh to the verge of hardness, touching and retouching his larger portraits, until the picture presented all the delicacy and finish of the finest miniature on ivory."

Oil on canvas, 36 x 28⁷/₈ inches
Signed and dated (on basket handle): C.C. Ingham. 1846.
The Metropolitan Museum of Art, Gift of William Church Osborn, 02.7.1

81 Hunting Wild Horses

William Tylee Ranney (1813–1857)

Ranney was an illustrator and portrait painter in New York before setting off in 1836 to join the Texas army. His experiences in the Southwest so impressed him that they proved to be the major inspiration for his work the rest of his life. After mustering out of the army, he worked in and around New York, where he painted western genre scenes and historical compositions based on the war. His West Hoboken studio, filled with stuffed animals, weapons, and frontier artifacts, took on the appearance of a pioneer's cabin. Ranney produced many pictures, characterized by the realistic treatment of somewhat melodramatic themes. Hunting Wild Horses, painted in 1846, is one of the earliest and best examples of his vigorous portrayals. A number of his pictures were engraved and widely circulated as prints.

Oil on canvas, 36 x 54¹/₂ inches
Signed and dated (lower left): Ranney/1846
Joslyn Art Museum, Omaha, Northern Natural Gas Company Collection

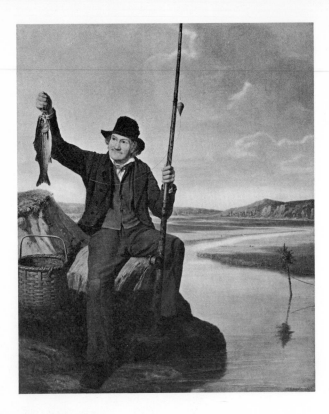

82 The Happy Moment
James Goodwyn Clonney (1812–1867)

Clonney emigrated as a youth from England to Philadelphia, where he worked during the 1830s as a lithographer and miniaturist. Moving to New York, he continued to produce miniatures, but he soon tired of such restricted, citified work and moved to the village of New Rochelle on Long Island Sound. Here he devoted himself to genre painting and, apparently, to fishing, since many of his scenes are of fishermen. The elderly subject of this one, The Happy Moment, has just caught a striped bass or rockfish. Clonney also painted farm and sporting scenes, usually blond in coloring and bright in spirit. His ability to combine commonplace subject matter and well-developed landscape in a carefully controlled composition relates his work to William S. Mount's (see nos. 51-55). Although Clonney's paintings lack the underlying seriousness of Mount's, they have undeniable beauty and charm.

> *Oil on canvas, 27 x 22 inches*
> *Signed and dated (lower right): CLONNEY 1847*
> *Museum of Fine Arts, Boston, M. and M. Karolik Collection*

83 Sioux Indians Breaking Up Camp
Seth Eastman (1808–1875)

Eastman, a native of Brunswick, Maine, entered West Point in 1824. He studied topographical drawing and upon graduation served with the First Infantry. In 1833 he returned to West Point as assistant drawing instructor. He resumed active duty in 1840. Stationed at Fort Snelling, Minnesota, in the 1840s, he served as peace-keeper among the white settlers and the Sioux and Chippewa Indians. Visiting Eastman in 1847, the author and amateur explorer Charles Lanman wrote that "All his [Eastman's] leisure time has been devoted to the study of Indian character, and the portraying upon canvass [sic] of their manners and customs, and the more important fragments of their history." Sioux Indians Breaking Up Camp, probably painted about the time of Lanman's visit, shows women dismantling the hide-covered lodges and loading the packs for travel. Eastman noted that the painting "explain[s] itself. I wish to show that the squaws do all the labor & drudgery the men looking on doing nothing." Eastman's pictures are usually more distinguished as reportage than as paintings, but this one is particularly appealing because of the dramatic treatment of the stormy sky.

> *Oil on canvas, 25¹/₂ x 35 inches*
> *Inscribed (on label on original stretcher): Sioux Indians Breaking up Camp Am. Art Union, painted by Seth Eastman USA Distributed December 22, 1848.*
> *Museum of Fine Arts, Boston, M. and M. Karolik Collection*

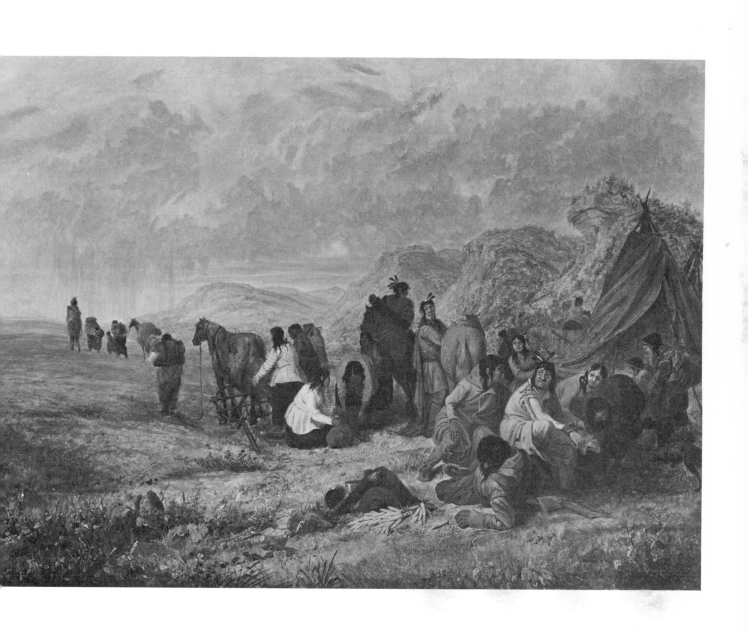

84 Politics in an Oyster House
Richard Caton Woodville (1825-1855)

Woodville's work occupies a major place in nineteenth-century American genre painting. After training in Baltimore during the late 1830s and early 40s with Alfred Jacob Miller among others, and briefly attending medical school, Woodville went to Düsseldorf to study under Karl Ferdinand Sohn, a leading genre and portrait painter at the Academy. Although Woodville remained abroad for the rest of his short life, his pictures continued to be of American subjects. Politics in an Oyster House, painted in 1848, marks a peak in his development. The small format, carefully conceived stagelike interior suggestive of Dutch compositions, meticulous detail, and graphic way in which facial expressions and attitudes convey the significance of the moment are all typical of his work, but are presented here with a new authority.

Oil on canvas, 16 x 13 inches
Signed and dated (lower left): R. C. W. 1848
The Walters Art Gallery, Baltimore

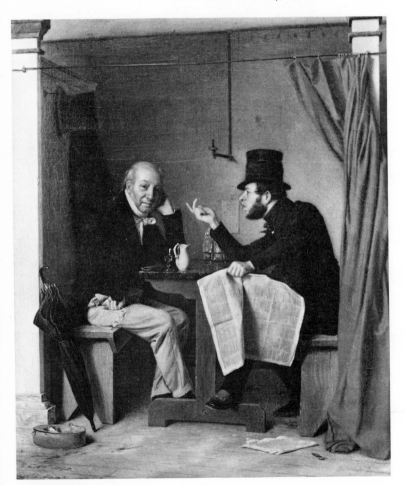

85 The Sailor's Wedding
Richard Caton Woodville

Woodville, according to a Baltimore newspaper after his death, was of "aristocratic lineage, courtly manners and very handsome . . . essentially the artist. Possessed of remarkable perceptive faculties, both mental and physical, he was a keen observor of character, and such was his acuteness of sight that the minutest details were visible to him at some distance. His sense of humor was refined and he expressed dramatic situations with rare power of composition." The artist used these different capabilities to excellent effect in The Sailor's Wedding. Echoes of Dutch and Flemish genre painting, evident in the treatment of lighting and interior and the open doorway with its crowd of spectators, are perhaps attributable to Woodville's youthful exposure to the Baltimore collection of Robert Gilmor, Jr., of Dutch and Flemish works, but more probably to his subsequent study in Europe. The tight organization of figures within an enclosed space, masterly characterizations of grumpy magistrate, obsequious best man, shy bride, proud groom, and distribution of accessory details sustaining the narrative combine to produce a work that exemplifies American genre painting at its best.

Oil on canvas, 18¹/₈ x 22 inches
Signed and dated (lower left): R. C. W./1852
The Walters Art Gallery, Baltimore

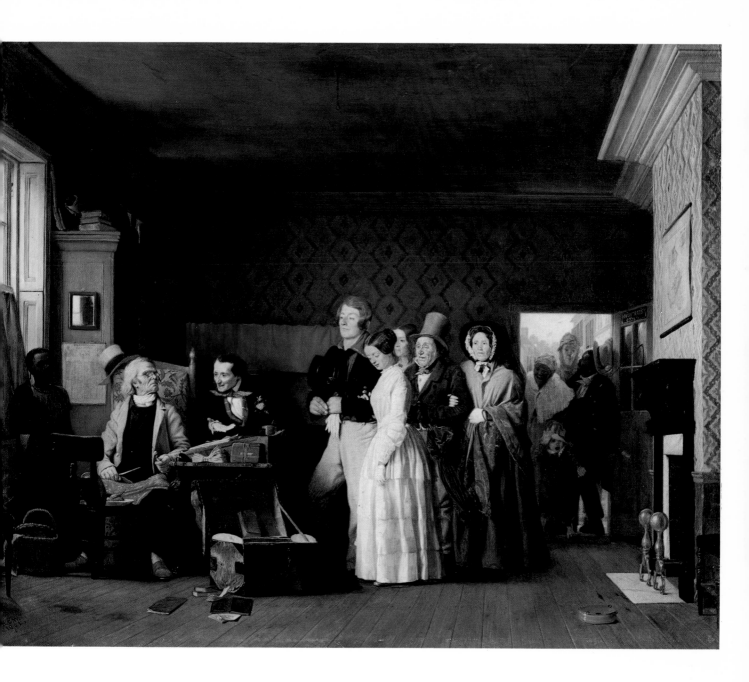

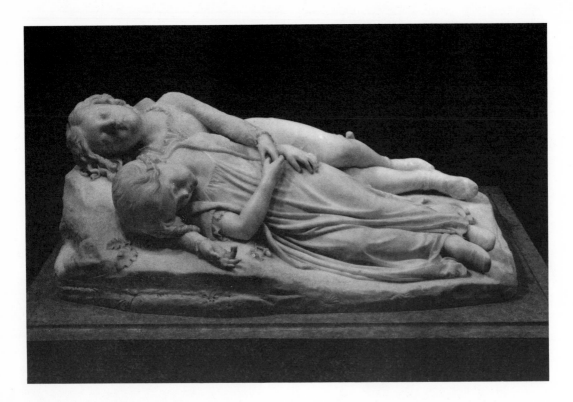

86 The Babes in the Wood
Thomas Crawford (1811 or 1813–1857)

Crawford was probably born in New York and, after an apprenticeship to a local wood-carver, he worked for the New York stonecutting, portrait and gravestone carving firm of Frazee and Launitz. Encouraged by Robert E. Launitz, Crawford went to Rome in 1835 to study with the renowned Danish neoclassical sculptor Albert Bertel Thorwaldsen. Except for brief visits to New York, he remained in Rome for the rest of his life. He is best remembered for his marble pediment of the United States Senate building and the bronze doors of the Capitol. The Babes in the Wood, done in 1851, is a naturalistic fancy piece, evidencing both Crawford's fascination with the funereal and his independence from the rigidly idealized classicism taught by Thorwaldsen. The subject, fashioned to the most sentimental taste, was taken from the nursery rhyme "The Babes in the Wood":

Thus wandered these two prettye babes,
Til deathe did end their grief
In one another's arms they dyed
As babes wanting relief;
No burial these prettye babes
Of any man receives
Til Robin-Red-Breast painfully
Did cover them with leaves.

The then well-known recumbent effigy of the Robinson children in Lichfield Cathedral, by the British sculptor Sir Francis Chantrey, may have prompted the arrangement and the lifelike appearance of the dead children.

Marble, L. 48¹/₂ inches
Signed, dated, and inscribed (on base): TC.
(monogram) Dec. 31./51./ THE GIFT OF
HAMILTON FISH
The Metropolitan Museum of Art, Bequest of
Hamilton Fish, 94.9.4

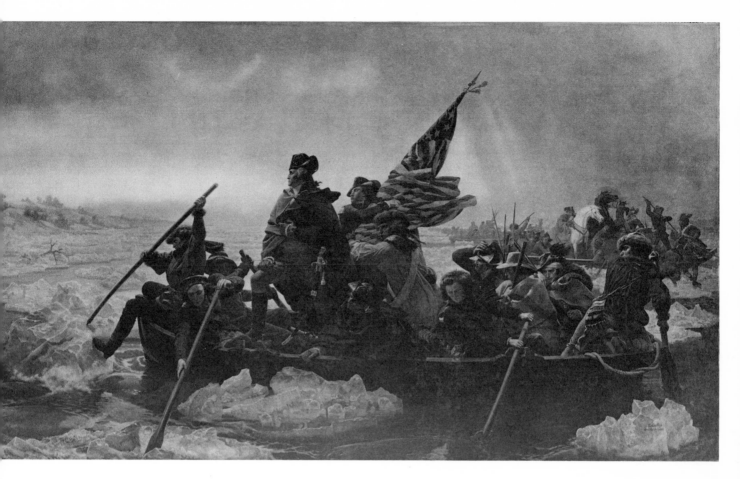

87 Washington Crossing the Delaware
Emanuel Gottlieb Leutze (1816–1868)

Leutze was born in Württemberg, Germany, came to America as a boy, and received his first artistic training in Philadelphia. In 1841 he went to Düsseldorf to study under Karl Friedrich Lessing at the Royal Academy and there learned the popular academic fashion of painting vast historical scenes in a tight, realistic manner. By 1848 he had begun his most celebrated work, Washington Crossing the Delaware. According to his friend the painter Worthington Whittredge, Leutze found the German models "either too small or too closely set in their limbs" to be taken for Americans, and he persuaded a number of American visitors to pose for him. Whittredge, who sat for the steersman and for Washington, wrote in his autobiography: "Clad in Washington's full uniform, heavy chapeau and all, spyglass in one hand and the other on my knee, I was nearly dead when the operation was over. They poured champagne down my throat and I lived through it." The original picture was se-

verely damaged in a studio fire in 1850. Leutze almost immediately repaired it and produced this replica in 1851. The replica was sent to America the same year and traveled the country, where it was greeted with great enthusiasm. Depicted is Christmas Night 1776, when Washington led his troops across the Delaware to Trenton to surprise the Hessians and turn the tide of the war. Although inaccurate in many of its details—for instance, the Durham iron boats used were much larger and the flag shown here was not adopted until six months later—the painting captures successfully the spirit of a great leader and the importance of a great event.

Oil on canvas, 12 feet 5 inches x 21 feet 3 inches
Signed and dated (lower right): E. Leutze. DUSSELDORF 1851
The Metropolitan Museum of Art, Gift of John Stewart Kennedy, 97.34

88 Hamilton Fish
Thomas Hicks (1823–1890)

Hicks received his first painting lessons from a relative, the Quaker artist Edward Hicks, who lived near him in Bucks County, Pennsylvania. Academic training at the Pennsylvania Academy of the Fine Arts and with Thomas Couture in Paris prepared him for a successful career in New York City, during which he portrayed many famous Americans, including Abraham Lincoln. Hicks's imposing study of Hamilton Fish, painted in 1852 when Fish was governor of New York, is like many *portraits d'apparat* of the period, showing the sitter in his daily environment, surrounded by objects symbolic of his activities. Fish stands in his office, resting his hand upon the document of the Homestead Exemption Act of 1850, which he approved and which gave the ordinary debtor recourse against dispossession. A variant of the present state seal hangs on the wall. The governor's black coat and silk hat lying on the chair lend a pleasantly informal air. Fish appears as dignified yet aggressive, a portrayal that perhaps bears out a contemporary evaluation of Hicks's likenesses: "[He] strives to reproduce the character of a sitter in its highest and truest condition, to become in sympathy with the best phase . . . and to transcribe it."

Oil on canvas, 108 x 78 inches
Signed and dated (lower left): T. Hicks/New York 1852
Art Commission of the City of New York

89 American Frontier Life
Arthur Fitzwilliam Tait (1819–1905)

Tait, painter of game pieces, wildlife, and hunting and sporting scenes, was born near Liverpool, England. Apprenticed to a picture dealer in Manchester, he taught himself to draw in his spare time, copying paintings and casts at the Royal Institution, and later taught drawing and lithography. He came to America in 1850, opened a studio in New York City and built a camp at Long Lake in the Adirondacks, which served him as a summer studio and shooting lodge. In 1858 the *Cosmopolitan Art Journal* reported: "Every summer, for several years, he has spent in the depths of the vast primeval forests of Northern New-York, trapping and gunning after the true back-woodsman fashion." On the strength of this experience—he had never been out West—Tait painted a series of "prairie trapper" scenes, which were lithographed by Currier and Ives and sold well. This painting, dated 1852, is called American Frontier Life, the title of the Currier and Ives series; the usual subtitle, describing the particular scene, was either never given to it or has been lost. It shows the competent draughtsmanship characteristic of Tait's work but is remarkable for the luxurious texture of paint and glowing color.

Oil on canvas, 24⁹/₈ x 26¹/₄ inches
Signed and dated (lower right): A. F. Tait/N.Y./'52
Yale University Art Gallery, New Haven, Whitney Collections of Sporting Art, given in memory of Harry Payne Whitney and Payne Whitney by Francis P. Garvan

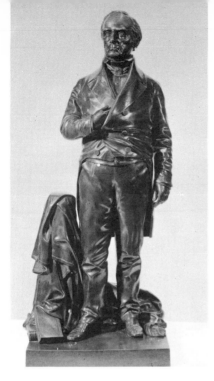

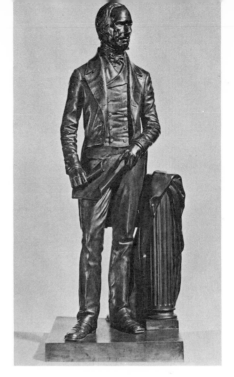

90 **Daniel Webster**
Thomas Ball (1819–1911)

Ball began his career in Boston as a portrait painter and miniaturist before turning to sculpture and specializing in statues of important Americans. Among his most successful works is this bronze statuette of Daniel Webster. Ball wrote in his autobiography that Webster "was one man whose 'godlike' head I had had in my mind ever since I was a boy and began to paint." He worked on a small bust during 1851/52, but dissatisfied with the result, he destroyed it. After attempting several other portraits of Webster, he made a small full-length figure in 1853 that he sold to an art dealer for casting in bronze. In Ball's statue the big head and solid stance suggest the vigor and imperturbability of Webster, the most famous orator of his day; it is a fine example of naturalistic portraiture. So many plaster and bronze replicas were cast that it can be considered one of the earliest mass-produced American sculptures. According to Ball's autobiography, one of the bronze replicas served as the model for the Webster monument in Central Park at Seventy-second Street.

Bronze, H. 29³/₄ inches
Signed, dated, and inscribed (on base): T. Ball Sculpt. / Boston Mass / 1853 / Patent Assigned To / GW Nichols
Founder's mark (on base): J. T. AMES / FOUNDER / CHICOPEE / MASS / 24
The Metropolitan Museum of Art, Gift of Thomas Kensett by Exchange, 69.219

91 **Henry Clay**
Thomas Ball

In 1858 Ball modeled a figure to match his Daniel Webster (no. 90). He wrote: "I made a statuette of Henry Clay, as a companion to my Webster. To me it was not as successful as the latter." It was, however, a fitting pendant. Both men were United States senators, both served as secretary of state, and they worked to preserve the Union in the years before the Civil War. Clay is portrayed as lean and wiry, Webster robust. Clay appears defiant, Webster determined. Each is rendered crisply without unusual pretension or embellishment except for the half column, an ancient device symbolic of the orator's role.

Bronze, H. 31 inches
Signed, dated, and inscribed (on base): T. BALL Sculpt. Boston 1858 / PATENT[as]signed to G. W. Nic[hols]
North Carolina Museum of Art, Raleigh, Gift of Mr. and Mrs. Robert Lee Humber, Greenville

92 Buffalo Newsboy
Thomas Le Clear (1818–1882)

Le Clear was born near Owego, New York. Henry Tuckerman records that his first oil painting was a portrait on a pine board made at the age of nine and that by twelve he had painted a head of St. Matthew "which made a sensation in that rural vicinage." In 1839 after seven years as an itinerant portraitist in Canada and around New York State, he arrived in New York City. There he studied with Henry Inman, opened his own studio, and exhibited at the National Academy of Design and the American Art-Union. Le Clear moved to Buffalo in 1847 and became a leader in the city's artistic life. Although his forte was portraiture, a large portion of his work done there was genre, then in its heyday. Le Clear frequently painted street scenes like Buffalo Newsboy, of 1853, which sympathetically depicts a relaxed but serious youth surrounded by dilapidated boxes, papers, and tattered posters. (Such pictures are the direct antecedents of the innumerable newsboys and shoeblacks painted by J. G. Brown later in the century.) Its simple and appealing subject, skilled brushwork, and fluent draughtsmanship set this picture apart from the dry, tightly constructed portraits that were the basis of Le Clear's success.

Oil on canvas, 24 x 20 inches
Signed and dated (lower left): T. Le Clear/ 1853
Albright-Knox Art Gallery, Buffalo, Charlotte A. Watson Fund

93 **Catskill Mountain House
(from North Mountain)**

Jasper Francis Cropsey (1823–1900)

Cropsey, born in Rossville, New York, practiced architecture before turning to the study of painting. He traveled in Europe from 1847 to 1849 and 1856 to 1863, settling for a time in London, where he exhibited at the Royal Academy. A member of the Hudson River school, Cropsey devoted himself to portraying naturalistic scenery and was known as a specialist in fall coloring. In the Catskill Mountain House (from North Mountain), of 1855, Cropsey demonstrates a high order of painterly knowledge: the draughtsmanship is clear and exact; the landscape is delineated as a series of receding planes, each with a different foliage texture; the white highlights—from fore-ground rocks to wispy clouds—add surface sparkle and greatly enliven the scene. Although the subject is typical of the Hudson River school, it is more broadly handled than most of the school works. The Catskill Mountain House, a Greek revival resort hotel constructed in the 1820s, was one of the most popular sites visited and painted by mid-century artists, who were attracted by its dramatic cliffside location.

Oil on canvas, 29 x 44 inches
Signed and dated (lower right): J. F. Cropsey/ 1855
The Minneapolis Institute of Arts, The William Hood Dunwoody Fund

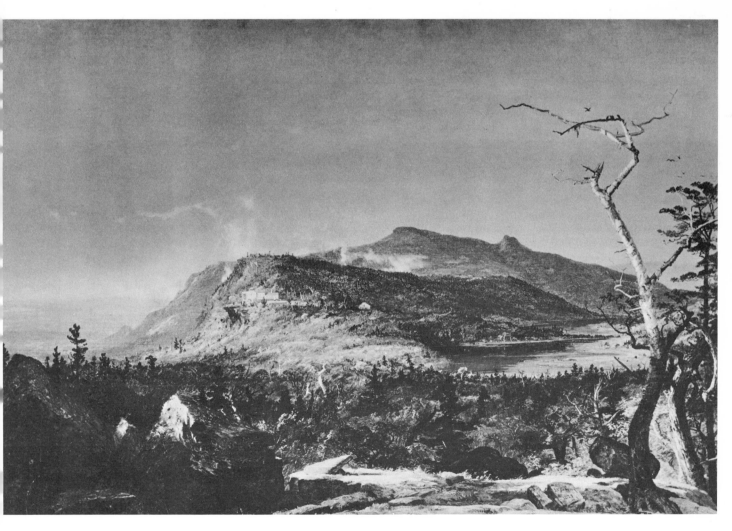

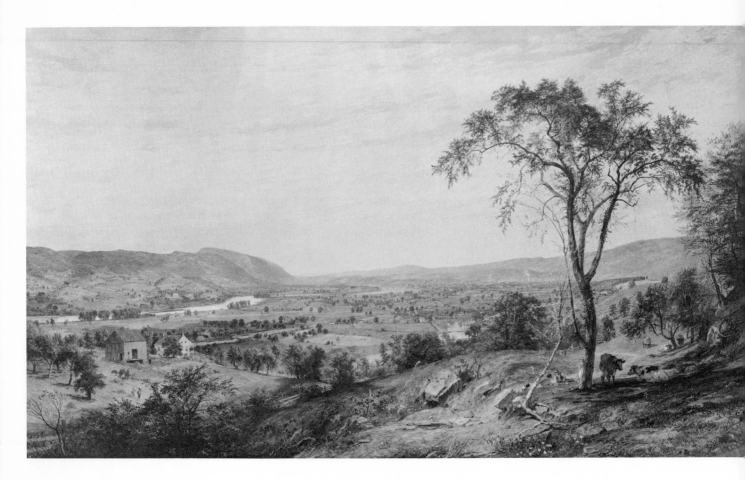

94. The Valley of Wyoming

Jasper Francis Cropsey

In 1865 Cropsey painted this large topographical view, The Valley of Wyoming, on commission for Milton Courtright, a wealthy Pennsylvanian who had been raised on a farm in the valley between Scranton and Wilkes-Barre. Based on a small oil sketch at the Metropolitan Museum, done the previous year, the all-embracing panorama records in painstaking detail the characteristic grasses, flowers, ragged trees and shrubbery, lazing children and cattle, farm buildings, checkered fields, as well as a distant town with red-brick structures and smokestacks. Theatrical shafts of sunlight pierce a broken sky, and the entire scene is unified by a wonderfully pervasive summer haze. The coloring is blander and the composition more diffuse than is usual in Cropsey's works.

Oil on canvas, 48 x 84 inches

Signed and dated (lower right): J. F. Cropsey/ 1865

The Metropolitan Museum of Art, Gift of Mrs. John C. Newington, 66.113

95 **The Lackawanna Valley**
George Inness (1825–1894)

Born in Newburgh, New York, Inness was a a largely self-taught painter who took drawing lessons in Newark before studying with the landscapist Régis Gignoux in New York. During the 1850s he made several trips to Italy and France, where he discovered the Barbizon school painters, noting that "As landscape-painters I consider Rousseau, Daubigny, and Corot among the very best." After his return to New York in 1855, Inness was commissioned by the president of the railroad to paint as an advertisement The Lackawanna Valley, or The First Roundhouse of the Delaware, Lackawanna and Western Railroad at Scranton. Alterations to his first attempt were proposed by the railroad committee, who insisted that all four trains of the road be shown with the company letters to appear clearly on one locomotive. Years later Inness said: "They paid me $75 for it. . . . I had to show the double tracks and the roundhouse, whether they were in perspective or not. But there is considerable power of painting in it, and the distance is excellent." The picture celebrates the beauties of green fields, hazy atmosphere, and golden light far more than the achievements of the railroad, which may explain why the company sold it.

Oil on canvas, 33⁷/₈ x 50¹/₄ inches
Signed (lower left): G. Inness
National Gallery of Art, Washington, Gift of Mrs. Huttleston Rogers, 1945

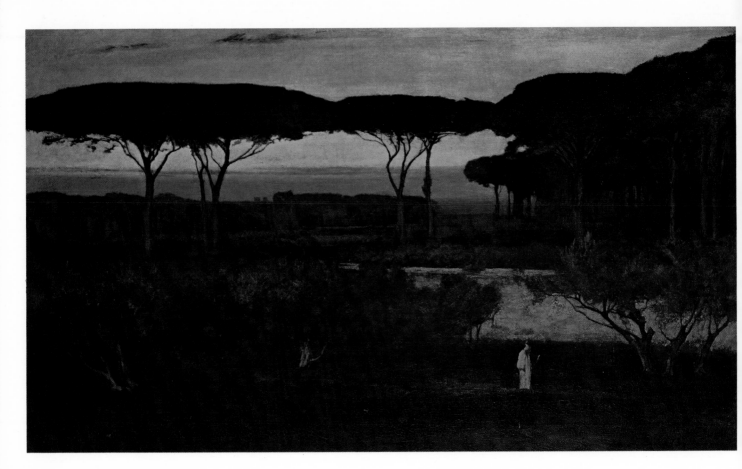

96 **The Monk**
George Inness

The Monk, painted in 1873 from inside the Bar-
berini Villa, Albano, Italy, represents a departure
from Inness's earlier naturalistic work. A strong
sense of structural coherence, achieved by means
of an intricately calculated pattern of silhouetted
dark and light shapes on contrasting grounds,
produces a decorative, highly elegant, and lyrical
composition. As Inness observed about his work:
"I have always felt that I have two opposing
styles, one impetuous and eager, the other clas-
sical and elegant. If a painter could combine the
two he would be the very god of art." In his
classical vein, the picture expresses Inness's reli-
gious mysticism and is one of his most haunting
compositions.

Oil on canvas, 39¹/₂ x 64 inches
Signed and dated (lower right): G. Inness 1873
*Addison Gallery of American Art, Phillips
Academy, Andover, Gift of Stephen C. Clark,
Esq., 1956*

97 The Coming Storm

George Inness

The Coming Storm, painted by Inness in 1878, characterizes a mature stage in the artist's development. Pungent color, free brushwork, and fluid composition distinguish it from his earlier more contrived works. A frequently recurring theme in his paintings is the approaching storm, represented by the interplay of dark clouds and intermittent sunlight in a strongly unified composition. The subject expresses Inness's convictions that "The true end of Art is not to imitate a fixed material condition, but to represent a living motion" and that "Landscape is a continued repetition of the same thing in a different form and in a different feeling."

Oil on canvas, 26 x 39 inches
Signed and dated (lower right): G. Inness 1878
Albright-Knox Art Gallery, Buffalo, Albert H. Tracy Fund

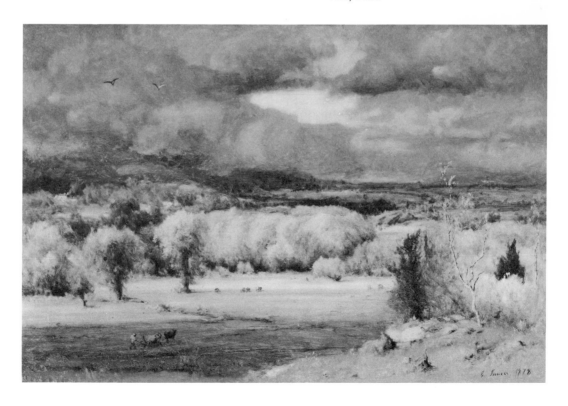

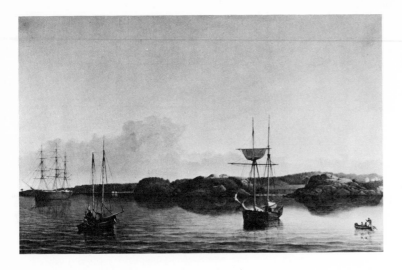

98 Stage Rocks and Western Shore of Gloucester Outer Harbor

Fitz Hugh Lane (1804–1865)

Born in Gloucester, Massachusetts, the son of a sailmaker, Lane worked there as a draughtsman and lithographer before becoming an apprentice in the Boston lithographic firm of William S. Pendleton in 1832. The landscape painter Benjamin Champney, an apprentice in the same shop, later wrote that Lane "did most of the views, hotels, etc. He was very accurate in his drawing, understood perspective and naval architecture perfectly, as well as the handling of vessels, and was a good all-round draughtsman." After working in Boston for three years, in partnership with John W. A. Scott, as a lithographer and marine painter, Lane returned to Gloucester in 1848. The rest of his career was spent portraying the harbors and the coast of northern New England, especially Maine. Stage Rocks and Western Shore of Gloucester Outer Harbor was painted about 1856, during Lane's most prolific period, and is a mature example of his style. Showing a meticulous use of line, subtle composition, and glowing atmosphere, it reflects not only his early training as a draughtsman but also his familiarity with seventeenth-century Dutch marine paintings and the luminous works of the Boston painter Robert Salmon (see no. 35). The low horizon, emphasized by the silhouetting of shoreline against sky, the configurations of land mirrored in correspondingly shaped clouds, and the arrangement of the vessels in opposing diagonals are evidence of Lane's skill as a designer, and contribute to the tranquility characteristic of his poetic realism.

Oil on canvas, 23 x 38 inches
Lent anonymously

99 Schooners before Approaching Storm

Fitz Hugh Lane

Painted in 1860, Schooners before Approaching Storm displays Lane's mastery of contrasting relationships in a deceptively simple yet completely controlled composition. The drama of the impending storm is heightened by the tranquility of the water reflecting the shapes of the foreground vessels; billowing clouds form a dark ground for the brilliant white sails; the precise rendering of the vessels lowering sail and rich tonal effects of the rippling, light-streaked water and glimmering sky are balanced against the sketchier, less vivid elements of the background. The skillful draughtsmanship and intense observation are typical of Lane's finest work.

Oil on canvas, 23¹/₂ x 38 inches
Signed and dated (lower right): F H Lane 1860
Lent anonymously

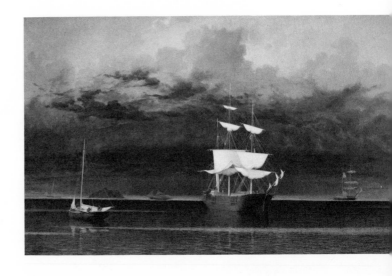

100 Lake Nemi
Sanford Robinson Gifford (1823–1880)

Gifford, born in Greenfield, New York, studied
in New York City under the drawing master John
Rubens Smith. In 1846 he made a sketching tour
of the Catskills and Berkshires, which fired his
enthusiasm for landscape painting, and during
the mid-1850s he traveled widely and worked in
Europe collecting, according to Henry Tucker-
man, "many interesting and genuine studies . . .
some of which he carefully and laboriously elab-
orated." Lake Nemi, a favorite subject for land-
scape painters of all nations, is located south of
Rome. Gifford painted it in 1856. The picture
shows his interest in contrast, reliance on back-
lighting, and technique of using small, exact
brushstrokes. Clean, precise outlines give it co-
herence; the forms themselves are still solid,
not yet dissolved in the misty atmosphere char-
acteristic of Gifford's later work.

Oil on canvas, 40 x 60 inches
*Signed, dated, and inscribed (on back, cov-
ered by lining): S. R. Gifford (?) Rome,
1856-7*
*The Toledo Museum of Art, Gift of Florence
Scott Libbey, 1957*

101 Kauterskill Falls
Sanford Robinson Gifford

Kauterskill Falls, one of the favorite Catskill mountain resorts and a frequent subject for Hudson River school artists, was painted by Gifford in 1862. One of his largest works, the picture is a sensitive and meticulous rendering of scenic detail and the effects of distance, light, and atmosphere upon it. A leader among the luminist painters, including John F. Kensett and Martin J. Heade, Gifford achieved his delicate, muted tones and indistinct outlines with the techniques described by George Sheldon in *American Painters* (1879): "Mr. Gifford varnishes the finished picture so many times with boiled oil, or some other semi-transparent or translucent substance, that a veil is made between the canvas and the spectator's eye—a veil which corresponds to the natural veil of the atmosphere." His debt to Claude Lorrain and Turner in composition and color, if not in mood, is clear.

Oil on canvas, 48 x 39⁷/₈ inches
Signed and dated (lower left): S. R. Gifford/ 1862
The Metropolitan Museum of Art, Bequest of Maria DeWitt Jesup, 15.30.62

102 Puck
Harriet Goodhue Hosmer (1830–1908)

Born and raised in Massachusetts, Harriet Hosmer spent her adult life as an expatriate in Rome. One of her earliest sculptures after taking up residence there was this figure of Puck seated on a toadstool, done about 1856 when she was studying with John Gibson the English neoclassical sculptor. Numerous copies were sold, and one critic accounted for its popularity: "In all the lines of the face, in all the action of the body, gleams forth the mischievous self-will of being scarcely aware of the pain he causes. ... What a moment of fun and drollery was that in which he was conceived. It is a laugh in marble." The Prince of Wales bought a copy, and the Crown Princess of Germany, on viewing Puck in the studio, reportedly exclaimed: "Oh, Miss Hosmer, you have such a talent for toes!"

Marble, H. 32 inches
Signed and inscribed (on base):
HARRIET HOSMER FECIT—ROMAE
James Ricau, Piermont, New York

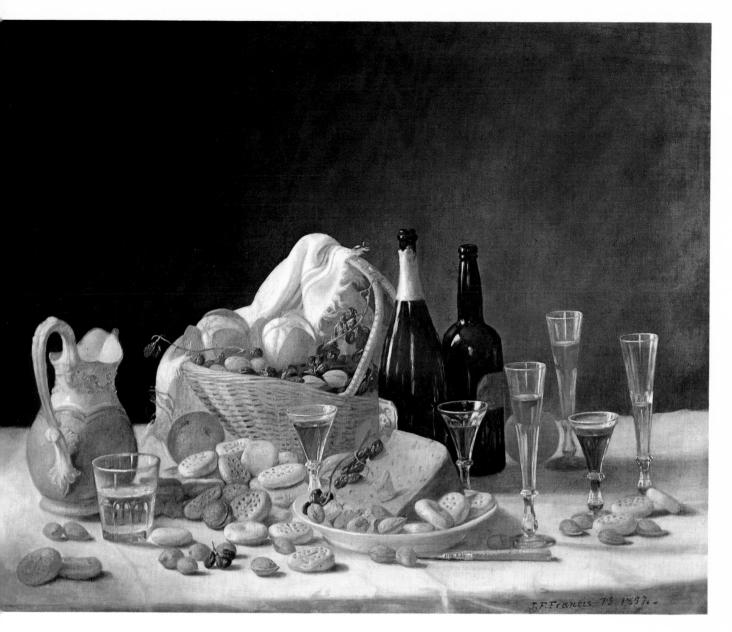

103 **Still Life with Wine Bottles and Basket of Fruit**
John F. Francis (1808–1886)

Francis worked in his native Philadelphia, parts of central Pennsylvania, Washington, D.C., and Nashville. A third of his paintings are portraits, the remainder with few exceptions are still lifes. Dated 1857, Still Life with Wine Bottles and Basket of Fruit demonstrates Francis's indebtedness to the seventeenth-century Dutch "luncheon type" still-life tradition, which also influenced the work of his less sophisticated contemporary Severin Roesen (see no. 104). Francis's work occupies a position between that of Raphaelle Peale and William Harnett in the history of American still-life painting, lacking the former's inventive content and textural differentiation and the latter's trompe-l'oeil technique (see nos. 22, 23, 170, 171). Working with a limited range of objects, often organized in a standardized composition, Francis reveals his aptitude as a colorist and his preoccupation with manipulating various shapes for rhythmic effects.

Oil on canvas, 25 x 30 inches
Signed and dated (lower right): J. F. Francis.
Pt. 1857.—
Museum of Fine Arts, Boston, M. and M.
Karolik Collection

104 **Still Life: Flowers**
Severin Roesen (died about 1871)

Roesen was a porcelain and enamel painter
from the Rhineland who emigrated to America
about 1848. There is little record of his career
other than his numerous fruit and flower still
lifes, but it is known that he painted for short
periods in New York and Philadelphia before
settling in Williamsport, Pennsylvania, about
1858. Still Life: Flowers is typical of his work in
its profusion of flowers, fruit, glistening dew-
drops, and bird's nest all heaped upon a
counter top. The meticulously drawn and bril-
liantly colored painting is executed with the
skillful facility, technical virtuosity, and extrava-
gant content characteristic of Roesen's best
work.

Oil on canvas, 40 x 50³/₈ inches
Signed (lower right): Roesen
The Metropolitan Museum of Art, Charles
Allen Munn Bequest; Fosburgh Fund, Inc., Gift;
Mr. and Mrs. J. William Middendorf II Gift;
and Henry G. Keasbey Bequest, 67.111

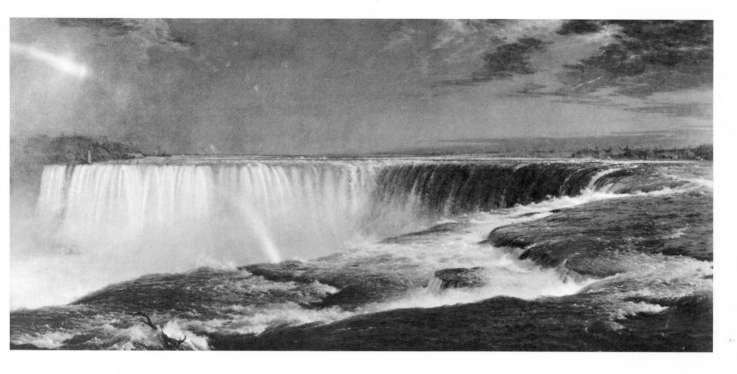

105 Niagara
Frederic Edwin Church (1826–1900)

Born in Hartford, Connecticut, Church studied art locally before becoming a pupil of Thomas Cole, whom he emulated in his early work. After 1850, inspired by the writings of the German naturalist-explorer Alexander von Humboldt, he became an artist-explorer, seeking out geological wonders and recording them in exquisite detail with an almost religious adoration. Possibly in response to Ruskin's treatise on Turner's painting of water, Church made three trips to Niagara Falls in 1856 to do studies for this picture. The view, from the Canadian side embracing the whole of the Horseshoe Fall to the tip of Goat Island, combines the sweep of a panorama with the controlled composition of an easel painting. Church places his spectator at the brink of the falls by eliminating the foreground (a device used also in Cotopaxi, no. 107), so that rushing and falling water seems to overwhelm him, according to a London critic, in an "abstraction of motion and sound." Shown throughout the country and popularized in a chromolithograph, Niagara aroused great enthusiasm; twice exhibited abroad, it was said to have given European critics "an entirely new and higher view both of American nature and art."

Oil on canvas, 42¹/₄ x 90¹/₂ inches
Signed and dated (lower right): F. E. CHURCH/ 1857
The Corcoran Gallery of Art, Washington

106 Heart of the Andes

Frederic Edwin Church

"He who . . . has himself travelled over the torrid zone, and seen the luxuriance and diversity of vegetation, on the declivities of the snow-crowned Andes . . . can alone feel what an inexhaustible treasure remains still unopened by the landscape painter." Thus, in the influential book *Kosmos* (1845-1862), Humboldt sounded the challenge that brought Church to South America in 1853 and again in 1857. During his second trip he conceived this heroic landscape of the Ecuadorian Andes, which he completed in 1859. First exhibited in a darkened gallery in Church's rooms in the Tenth Street Studio Building, mounted in a window-like frame, flanked by tropical foliage, and illuminated by concealed gas jets, the painting caused a sensation. Church's friends the novelist Theodore Winthrop and the Reverend Louis Legrand Noble,

Cole's biographer, glowingly described it in pamphlets that were in effect proclamations of Church's art. Winthrop wrote that Church had "condensed the condensation of nature" by portraying a region where a complete range of climatic conditions is found and combining their outstanding features in "a typical picture." Because of its importance to Church's contemporaries as a spectacular symbol of the awesome variety of nature and man's expanding frontiers, as well as its subtle treatment of light and lively use of pigment, this painting is a monument in nineteenth-century American art.

Oil on canvas, 66¹/₈ x 119¹/₄ inches
Signed and dated (on tree trunk, lower left): 1859/ F. E. Church
The Metropolitan Museum of Art, Bequest of Mrs. David Dows, 09.95

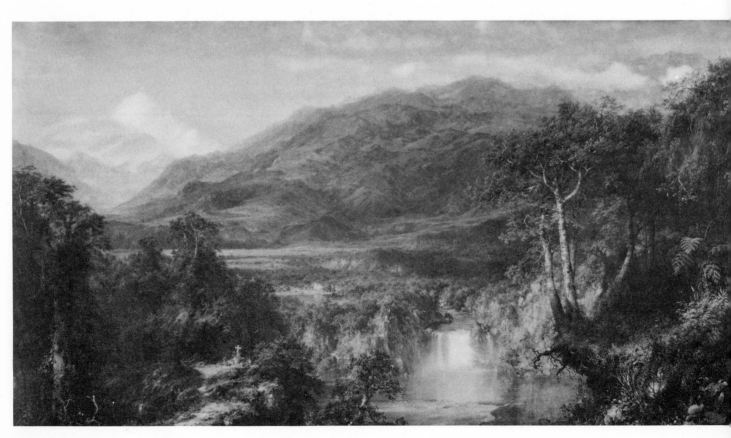

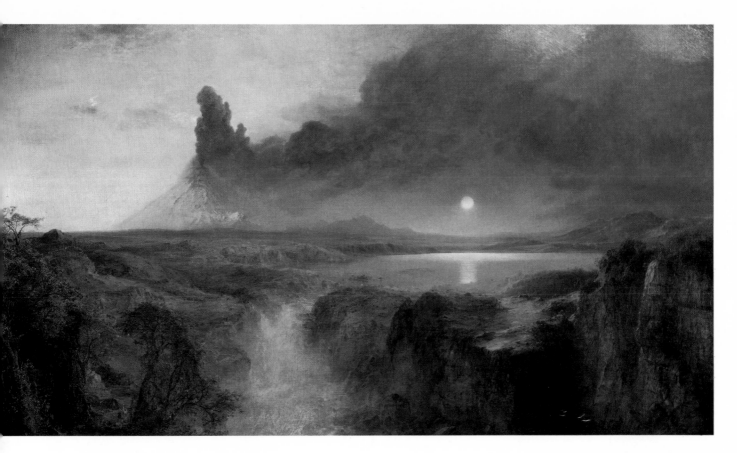

107 Cotopaxi
Frederic Edwin Church

Conceived as a pendant to Heart of the Andes (no. 106), Church's third and finest rendering of Cotopaxi, called by Humboldt "the most beautiful and the most terrible of the American volcanoes," was painted in 1862. Church described his picture thus when it was first exhibited in 1863: "Cotopaxi is represented in continuous but not violent eruption. The discharges of thick smoke occur in successive but gradual jets . . . so that the newly risen sun flares with a lurid fire through its thick volumes. . . . The cliffs and plateaus which diversify the surface of the country, the foliage in the foreground, and the aspect of the horizon and vegetation, are all minutely studied from nature." The subject enabled Church to display his knowledge of geological processes and to present a cosmic drama admirably suited to the scientific and religious concerns of his contemporaries. In splendid color and dramatic oppositions of light and dark, warm and cool, motion and rest, the scene evokes a vision of the dawn of earth.

Oil on canvas, 48 x 85 inches
John Astor, New York

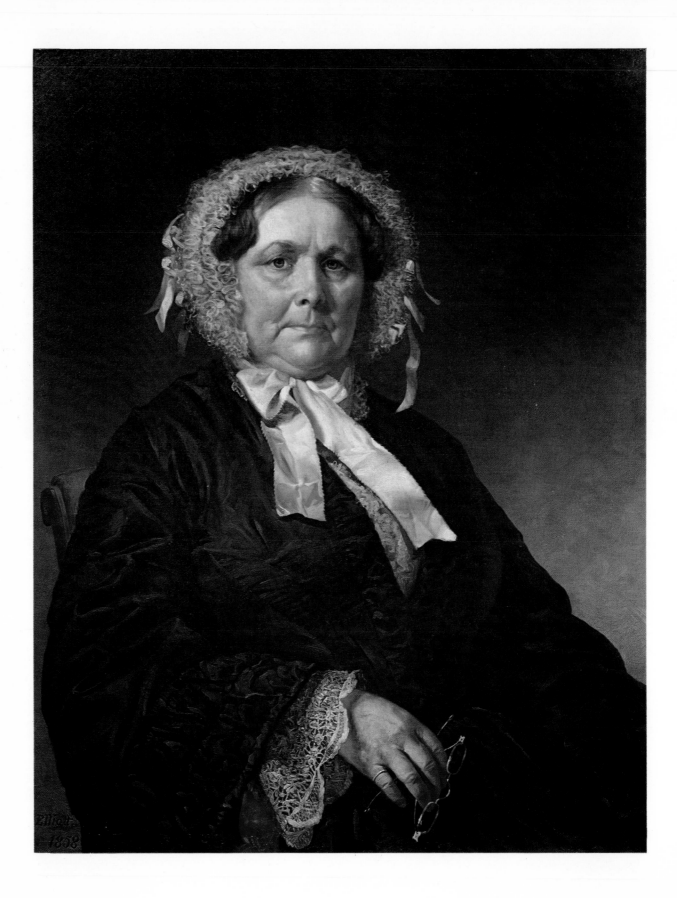

108 Mrs. Thomas Goulding
Charles Loring Elliott (1812–1868)

Elliott was considered New York City's leading portraitist in the 1850s. A pupil of John Trumbull and John Quidor, he spent several years as an itinerant artist in New York State before settling in the city about 1840. His portraits met with no great success until 1845, when they became popular with Knickerbocker society, and he received commissions from governors, novelists, merchants, and fellow artists. Elliott once said: "There is nothing in all nature like a fine human face." That his portraits could be penetrating studies of character is demonstrated by this forceful likeness of Mrs. Thomas Goulding, painted in 1858. The remarkable focus on each texture, crease, and fold in the face and costume, intensified by the harsh lighting, reflects the impact of photography on the portraitists of Elliott's generation. However, the vigorous expression in this work lifts it far above the often purely photographic and sentimental conceptions of his day.

Oil on canvas, 34¼ x 27 inches
Signed and dated (lower left): Elliott 1858
National Academy of Design, New York

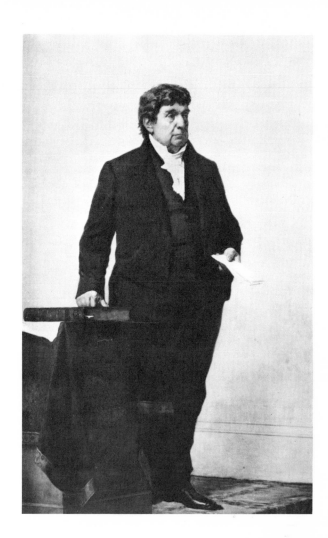

109 Lemuel Shaw
William Morris Hunt (1824–1879)

Born in Vermont, Hunt was raised in New Haven and received his first drawing lessons at home. Later he left Harvard to travel to Europe with his family. Intending to be a sculptor, he worked in the studio of H. K. Brown in Rome and subsequently attended the Düsseldorf Academy, where the regimented methods of study proved discouraging. After lessons with Thomas Couture in Paris, Hunt went to Barbizon and discovered Millet's work, which affected him profoundly. He returned to America in 1855 and eventually became prominent in Boston's art and social circles, where he popularized the pictures of the Barbizon school. In 1859 the members of the Essex County Bar resolved to commission a portrait of Lemuel Shaw for the Court House in Salem, in appreciation of Shaw's twenty-nine years of service as chief justice of the Supreme

Judicial Court of Massachusetts. Hunt accepted the commission. He refused Mrs. Shaw permission to view the work in progress, noting that "I was painting the Judge for the Essex Bar, and not for the family. . . . my impression of the man as I had seen him would have been changed,—perhaps weakened. . . . I wanted him to look as he did in court while giving his charge to the jury; not as he would appear at home, in his family." The completed portrait was well received. Shaw's great dignity is forcefully established through the silhouetting of his somberly dressed, erect figure against a simple light background, the absence of the accessories usual in a *portrait d' apparat,* and his unpretentious pose.

Oil on canvas, 78 x 50 inches
Essex Bar Association, Commonwealth of Massachusetts, Salem

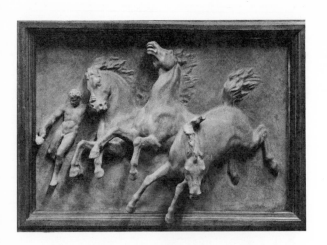

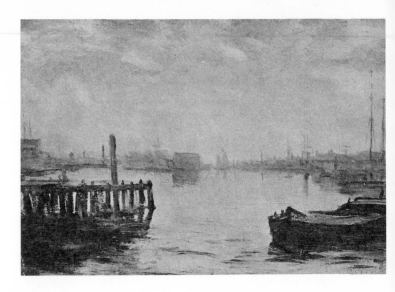

110 **The Horses of Anahita, or The Flight of Night**
William Morris Hunt

In 1846 Hunt's brother Leavitt sent him a translation of a Persian poem about Anahita, goddess of night. Inspired by the poem, Hunt made numerous studies and sketches for a composition on the subject, which occupied him intermittently until his death; among them was this spirited relief of plunging horses attended by a figure carrying an inverted torch, in classical art a symbol of night, sleep, or death. The great fire of 1872 destroyed Hunt's Boston studio and all of the Anahita studies with the exception of a photograph, a sketch on a tea tray, and the clay model for the relief, which was being cast in a plasterer's shop. Undaunted by the fire, Hunt made new studies, which were the basis for one of the murals he completed in 1878 for the Assembly Chamber of the new Capitol at Albany. Another of the artist's brothers, Richard Morris Hunt, architect of the main entrance block of the Metropolitan Museum, gave this relief to the Museum in 1880.

Painted plaster, 18¹/₂ x 28¹/₂ inches
The Metropolitan Museum of Art, Gift of Richard Morris Hunt, 80.12

111 **Gloucester Harbor**
William Morris Hunt

In 1876 Hunt discovered the North Shore village of Kettle Cove (now Magnolia) and moved there the following year. Gloucester Harbor, completed in a single afternoon in 1877, prompted him to comment: "I believe that I have painted a picture with *light* in it!" Carefully, almost symmetrically, composed but freely painted, the picture is a bright impressionistic study of fleeting effects, and was highly innovative for its time in American art.

Oil on canvas, 21 x 31¹/₄ inches
Museum of Fine Arts, Boston, Gift of H. Nelson Slater, Mrs. Esther Slater Kerrigan, and Mrs. Ray Slater Murphy, in memory of their mother

112 Portrait of the Artist
John La Farge (1835–1910)

La Farge, a landscape, still-life, and mural painter, stained-glass designer, traveler, writer, and lecturer, was born in New York of French parents. After graduating from college, he briefly held a job in a law office before going abroad in 1856. During this trip he studied French stained glass, the methods of the Flemish primitives with English artist Henry Le Strange, and worked in Thomas Couture's studio in Paris. He also traveled through Germany, Denmark, and England, where he acquainted himself with the works of the Pre-Raphaelites. "I kept in touch with that greatest of all characters of art, style," La Farge later wrote, ". . . the style of all the schools." In the winter of 1857/58 he returned to America and subsequently joined William and Henry James in the Newport studio of William Morris Hunt. He painted this self-portrait in the fall of 1859 on Long Island. The consciously elegant figure leaning on a painting umbrella reflects La Farge's appreciation of the sinuous, elongated figures in the neomedieval works of the Pre-Raphaelites; the dark silhouette against a luminous landscape foreshadows his preoccupation with light in his plein-air landscapes of the 1860s. (A stained-glass window by La Farge is illustrated in the furniture and other decorative arts volume, no. 194.)

Oil on wood, 16 1/16 x 11¹/₂ inches
Dated (lower right): October 26, 27/1859
The Metropolitan Museum of Art, Samuel D. Lee Fund, 34.134

113 The White Captive
Erastus Dow Palmer (1817–1904)

An upstate New Yorker, Palmer first worked as a master carpenter and builder. His career as a sculptor, for which he was completely self-taught, began about 1845 when he took up cameo cutting as a pastime. This proved too great a strain on his eyes, and he turned to larger works. In 1856, when he was living in Albany, Palmer was asked to exhibit in New York City. His "Palmer Marbles" quickly gained nationwide attention, disproving the theory that study in Italy was an absolute necessity for success. Although he sought an ideal characterization, it was based on naturalism rather than neoclassicism. He worked directly from live models. These were often his daughters, and one of them probably posed for this figure, completed in 1859. Possibly inspired by tales of frontier women captured by the Indians and clearly influenced by Hiram Powers's successful Greek Slave (no. 57), this was Palmer's first attempt at

a full-length nude. Henry Tuckerman, in an attempt to justify the figure's robust nudity to a fastidious public, described the Captive confronting her "relentless enemies . . . [realizing] through every vein and nerve the horrors of her situation; but virgin purity and Christian faith assert themselves . . . an inward comfort, an elevated faith, combines with and sublimates the fear and pain." Explanations aside, the sculpture is one of the loveliest and most graceful nudes produced in America during the nineteenth century.

Marble, H. 66 inches
Signed, dated, and inscribed (on base):
E. D. PALMER SC. 1859./THE GIFT OF HAMILTON FISH.
The Metropolitan Museum of Art, Bequest of Hamilton Fish, 94.9.3

114. Nydia
Randolph Rogers (1825–1892)

Rogers was born in upstate New York and grew up in Michigan. When he was about twenty he moved to New York City and took a job as a clerk in a dry-goods store. His success at making and selling drawings and cartoons so impressed his employers that they financed a trip to Italy in 1848. He studied first in the studio of the Florentine sculptor Lorenzo Bartolini and by 1851 had moved to Rome to become one of the better-known expatriate sculptors. His *Nydia, Blind Girl of Pompeii,* carved in 1853, is representative of the nineteenth-century motif of a literary sculpture with moralistic overtones. The subject is a character from Edward Bulwer-Lytton's *The Last Days of Pompeii* (1835), a flower girl who made her way to safety during the volcanic eruption that destroyed the town, and whom the author considered to be "a very emblem of the Soul itself—lone but comforted, amid the dangers and snares of life!" The pose and drapery are modeled after the Hellenistic sculpture The Old Market Woman, in the Vatican Gallery. Attesting to the popularity of Greco-Roman themes, almost 100 replicas of this figure were made. This, one of the earliest, was exhibited at the Philadelphia Centennial in 1876.

Marble, H. 55 inches
Signed and dated (on basket): Randolph Rogers,/ Rome 1859.
The Metropolitan Museum of Art, Gift of James H. Douglas, 99.7.2

115 **The Haymakers, Mount Mansfield, Vermont**
Jerome B. Thompson (1814–1886)

Thompson, son of the portrait painter Cephas Thompson and brother of Cephas G. Thompson (see no. 63), was born in Middleboro, Massachusetts. His father discouraged his artistic ambitions and set him to work on the family farm, but he left home and established himself as a sign, ornament, and portrait painter at Barnstable, Cape Cod. By 1835 he had moved to New York City, where he began to specialize in rural genre scenes. Thompson was elected an associate of the National Academy of Design in 1851 and in the following year went to England, where he studied the works of Hogarth, Turner, and Claude Lorrain. Like many artists of his time, he was deeply concerned with morality and religion, keeping a "Book of Advice" for his own

edification. His "Pencil Ballads," illustrating popular songs and verses, were widely distributed as lithographs and engravings. Thompson's best works, described by Henry Tuckerman as "half landscape and half rural labors or sport," were based on his summer sketching trips to the Massachusetts Berkshires and Vermont. The Haymakers, Mount Mansfield, Vermont, also called Harvest in Vermont and Reminiscences of Mount Mansfield, combines a convivial genre scene with a delicate, hazy landscape, amazing for its luminosity.

Oil on canvas, 30 x 50 inches
Signed and dated (lower left): Jerome Thompson/1859
Lent anonymously

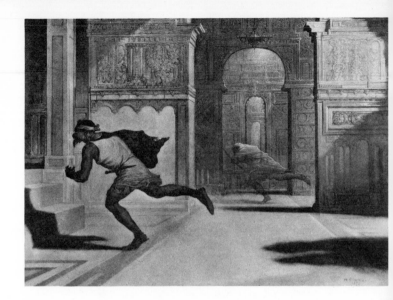

116 The Falling Gladiator
William Rimmer (1816–1879)

Rimmer was at various times a sculptor, painter, doctor, teacher, and writer on art. He has been called "The strangest historical painter of the American mid-century, and possibly the one possessed of the greatest inborn genius." Both he and his father believed themselves reincarnations of kings of France. Born in Liverpool, England, he was taken to Nova Scotia as an infant and then to Boston in 1826. During his early years he painted signs and portraits, working itinerantly before he settled in Randolph, a Boston suburb. While practicing medicine to support his family, Rimmer executed The Falling Gladiator between February and June, 1861. Because of his lack of technical knowledge, the work on the clay figure was delayed by frequent breakage and collapsings. The powerful realism of the anatomy, in contrast to the conventional nudes by some contemporary sculptors, prompted accusations during its exhibition at the Paris Salon of 1862 that it had been cast from life. After the fleeting attention won by the exhibition of this statue, Rimmer became professor of anatomy at the Lowell Institute in Boston. Although a skilled draughtsman and sculptor, he was largely neglected as an artist in his own time. The Falling Gladiator was not cast until twenty-seven years after his death.

Bronze, H. 62³/₄ inches
Signed (on base): W. Rimmer/Sc
Caster's mark (on base): P.P.Caproni & Bro.
Plaster Casts, Boston
Founder's mark (on base): JNO WILLIAMS INC./ BRONZE FOUNDRY. N.Y.
The Metropolitan Museum of Art, Rogers Fund, 07.224

117 Flight and Pursuit
William Rimmer

Unlike most of his contemporaries, Rimmer did not portray daily reality, but rather the fantasies and nightmares of his imagination. One of the most harrowing of his paintings is Flight and Pursuit, of 1872, in which a lightly clad man, dagger at his belt, races along the hall of an Arabian palace, preceded and pursued by ominous black shadows cast across the foreground. In the background a shrouded apparition mirrors the figure of the fleeing man. This blend of hallucination and exoticism is representative of the personal vision that was Rimmer's greatest contribution to nineteenth-century American art.

Oil on canvas, 18 x 26¹/₄ inches
Signed and dated (lower right): W. Rimmer/ 1872
Museum of Fine Arts, Boston, Bequest of Edith Nichols

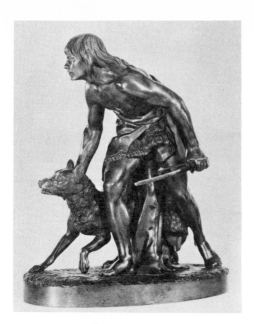

118 Indian Hunter
John Quincy Adams Ward (1830–1910)

Ward was born on a farm near Columbus, Ohio. His ambition to become a sculptor was realized when he entered the Brooklyn studio of Henry Kirke Brown in 1849. He remained there seven years, as student and then as assistant, working on Brown's equestrian statue of George Washington for Union Square. With no desire to become an expatriate artist in Europe (". . . we shall never have good art at home until our best artists reside here," he said), he spent two years in Washington, D.C., executing naturalistic portrait busts in the direct style that was the basis of most of his subsequent work. He returned to New York in 1860 and opened his own studio in 1861. Following a trip West to study the Indians, Ward enlarged a small model of an Indian hunter that he had done in Brown's studio. This large version became the model for a life-size group· completed in 1864. Funds were raised to have the group cast and placed in Central Park. Indian Hunter, well received by critics and public, particularly influenced the sculptor Augustus Saint-Gaudens, who called it "a revelation." Inspired by the supposed romance of Indian life, Ward created a dramatic idealization of a stalking brave that foreshadows the vivid anthropological bronzes of Frederic Remington and Charles Russell at the end of the century.

Bronze, H. 16 inches
Signed and dated (on base, under dog): J. Q. A. Ward/1860
The New-York Historical Society

119 Henry Ward Beecher
John Quincy Adams Ward

Ward devoted most of his career to sculpting portrait statues and monuments. This statuette of the author, clergyman, and orator Henry Ward Beecher is a study for the life-size bronze central figure of the Beecher monument unveiled in front of Borough Hall, Brooklyn, in 1891. The face was modeled after a death mask taken by Ward in 1887. The sculptor and critic Lorado Taft considered this robust and detailed portrait to be one of Ward's finest achievements: "In it Mr. Ward has inadvertently told us much of himself. None but a big man could have grasped that character; none but a strong nature could convey to others that impression of exuberant vitality and of conscious power."

Bronze, H. 14¹/₂ inches
Signed (on base): J.Q.A. Ward Sc.
Founder's mark (on base): GORHAM Co. Founders
The Metropolitan Museum of Art, Rogers Fund, 17.90.4

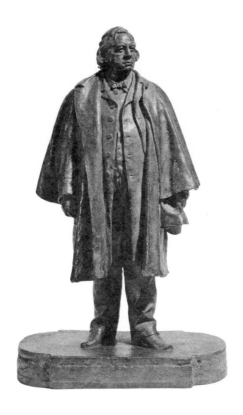

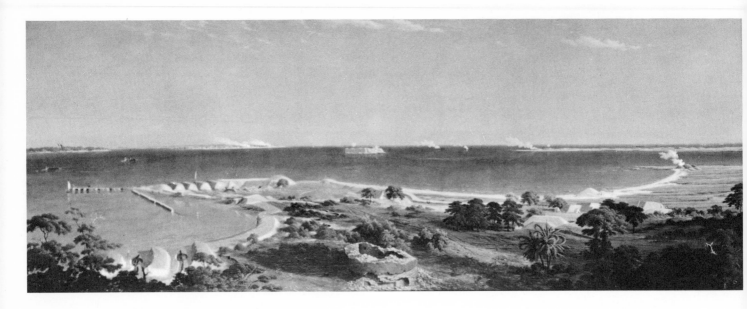

120 **The Bombardment of Fort Sumter**
Albert Bierstadt (1830–1902)

Bierstadt was born in Solingen, Germany; soon
afterward his parents emigrated to New Bedford,
Massachusetts. He was trained as a landscapist
at Düsseldorf in the mid-1850s and returned
to the United States in 1857 to specialize in paint-
ing the western region, "the least known scenery
of the New World." The Civil War led Bier-
stadt to produce one of his rare historical can-
vases, The Bombardment of Fort Sumter. Prob-
ably painted the following year from contem-
porary records of the event, the scene is of
Charleston harbor during the opening battle of
the war on April 12, 1861. On the eleventh, after
demands for evacuation had been refused, South
Carolina fired upon the Federal garrison occupy-
ing the fort, built on a shoal at the harbor's
mouth. Thirty-four hours later, when, according
to Sumter's commander, Major Anderson, "quar-
ters were entirely burned, the main gates de-
stroyed," the Federal troops marched out, "with
colors flying and drums beating." The elevated
viewpoint over a detailed, maplike scene gives
this picture a clarity and topographical character
surprising in Bierstadt's work, attesting to his
interest, in this case, in subject rather than style.

Oil on canvas, 26 x 68 inches
Signed (lower right): AB (monogram) ierstadt
The Union League of Philadelphia

121 **The Rocky Mountains**
Albert Bierstadt

In 1859 Bierstadt joined Colonel Frederick William Lander's expedition to survey an overland wagon route to the Far West. In a letter dated "ROCKY MOUNTAINS, *July* 10, 1859," he wrote: "The mountains are very fine; as seen from the plains, they resemble very much the Bernese Alps, . . . They are of a granite formation, . . . their jagged summits, covered with snow and mingling with the clouds, . . . the cotton-wood, lining the river banks, the aspen, and several species of the fir and the pine, . . . the Indians are still as they were hundreds of years ago, and now is the time to paint them, . . ." Bierstadt spent the summer of 1859 in the Wind River Range, Nebraska Territory. The Rocky Mountains, painted in 1863, is based on studies and sketches made at that time. It is a view of the western slope of the range, with Mount Lander (now Frémont Peak) in the central distance. In the foreground a band of Shoshone Indians camps near the headwaters of the Green River. This is one of the earliest and most popular of the large, panoramic studio pictures, combining extreme accuracy of detail with a melodramatic sense of nature, that established Bierstadt's reputation during his lifetime.

Oil on canvas, 73¼ x 120¾ inches
Signed and dated (lower right): A. Bierstadt 1863
The Metropolitan Museum of Art, Rogers Fund, 07.123

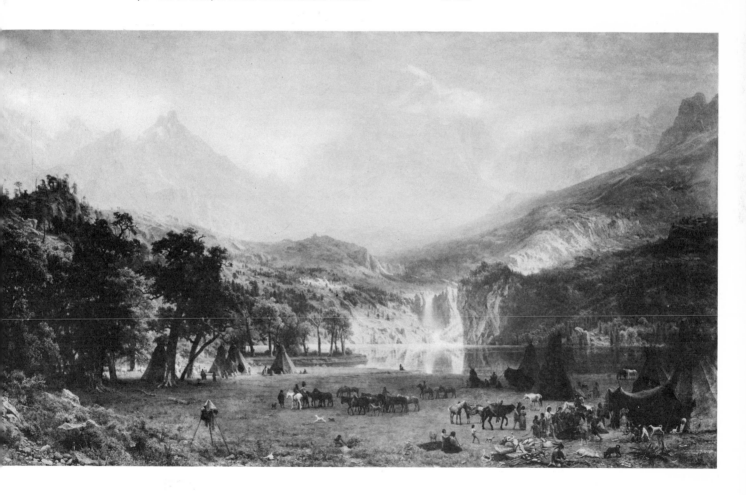

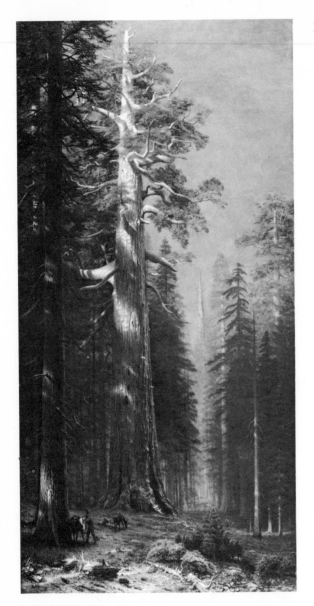

122 The California Redwoods
Albert Bierstadt

Bierstadt was in California in 1863 and again from 1871 to 1873. The California Redwoods probably dates from the second of these trips, when he occupied a studio in San Francisco, not far from the redwood forests that grow in the northern half of the state along the coast. The overwhelming presence of the giant trees is splendidly conveyed in this huge canvas, the extended vertical scale enabling the artist to portray an entire tree in Olympian perspective. Although the whole forest environment is rendered with great realism, the sweeping composition and superb handling of light produce a unity and directness of effect usually found only in Bierstadt's smaller studies, and remarkable in a picture of this size. Bierstadt's skillful naturalism and his eye for the dramatic and picturesque well qualified him to record the natural wonders of the West for the benefit of Easterners, whose interest in such scenes is attested to by the many reports of the redwoods appearing in magazines of the time.

Oil on canvas, 117 x 50 inches
Signed (lower left): A. Bierstadt
Lent anonymously

123 View near Cozzens Hotel from West Point
John Frederick Kensett (1816–1872)

Kensett, trained as an engraver in his father's New Haven shop, began painting under the guidance of John Casilear and completed his training traveling in England, France, Germany, and Italy during the 1840s. Returning to New York in 1847, he rapidly attained great popularity among painters and collectors by specializing in views of the mountains, rivers, lakes, and rocky coasts of the northeastern United States. The Hudson highlands, within pleasant cruising distance of New York City, offered landscape painters ready subject matter. Kensett's View near Cozzens Hotel from West Point encompasses massive hills, placid waters, fall coloring, and the reassuring indications of man's presence that are common to his balanced view of nature.

Oil on canvas, 20 x 34 inches
Signed and dated (lower center): JF. (monogram) K. '63
The New-York Historical Society

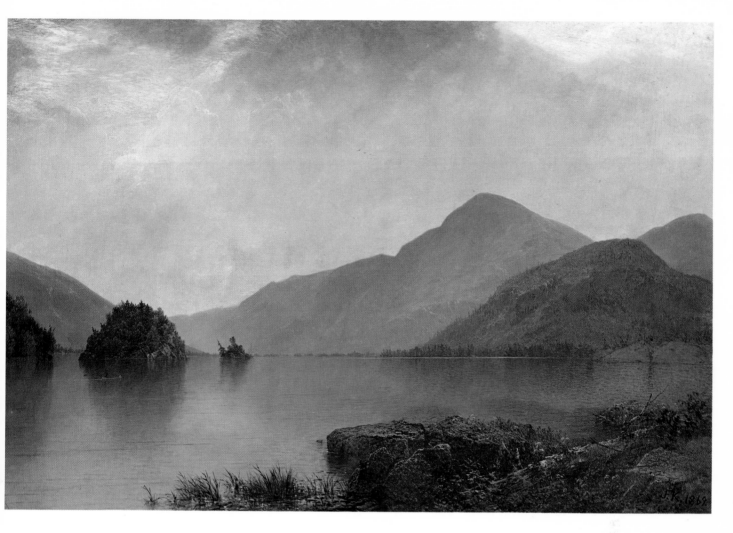

124 **Lake George**

John Frederick Kensett

The required itinerary for the mid-century land-
scapist included Lake George in the Adirondack
foothills, still relatively wild when Kensett visited
it during the 1840s, 50s, and 60s. For this large
picture, simply titled Lake George, he received
the then fabulous sum of $3000. One of his best
works, it offers a masterful treatment of shim-
mering light and atmosphere, evoking Kensett's
principal theme, the grand quiet of nature.

Oil on canvas, 44¹/₈ x 66³/₈ inches
Signed and dated (lower right): JF. (monogram)
K. 1869
The Metropolitan Museum of Art, Bequest of
Maria DeWitt Jesup, 15.30.61

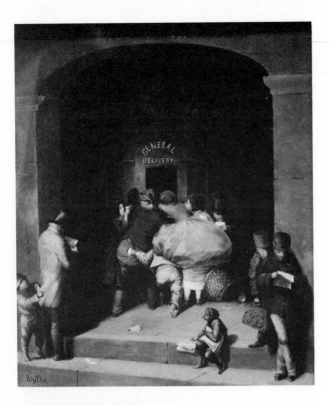

125 The Post Office, Pittsburgh
David Gilmour Blythe (1815–1865)

Blythe, born in East Liverpool, Ohio, was apprenticed at sixteen to a wood-carver in Pittsburgh. After serving in the navy as a ship's carpenter, he became an itinerant portrait painter, wood-carver, writer of doggerel, and caricaturist. From 1856 until his death Blythe worked mainly in Pittsburgh and painted the genre pictures lampooning the foibles of life on the city's streets that won him a local reputation as "the American Hogarth." Displayed in a local dealer's windows, his pictures, according to a friend, were "the talk of the town, and attracted such crowds that one could hardly get along the street." The Post Office, Pittsburgh, probably painted about 1863, exemplifies the originality, grotesque humor, and high artistic quality of Blythe's genre work. Dwelling on the ridiculous aspects of the motley crowd of shoving applicants for mail, nosy loungers, and pickpockets outside the new post office at Fifth Avenue and Smithfield Street, Blythe used a compact arrangement of figures and subdued varnish glazes to create a successful satire and solidly painted composition.

Oil on canvas, 24 x 20 inches
Signed (lower left): Blythe
Museum of Art, Carnegie Institute, Pittsburgh

126 The Questioner of the Sphinx
Elihu Vedder (1836–1923)

Vedder, born in New York City, began to study art at the age of twelve. He traveled to France and Italy in 1856 and in 1865 settled permanently in Rome but made frequent visits to America. He was primarily a painter of mystical figures and scenes, and is best known today for his illustrations of an edition of the *Rubaiyat of Omar Khayyam* published in 1885. The Questioner of the Sphinx was painted in 1863. The great head lies half-buried in the sand; an Arab bends forward and places his ear to its lips, awaiting an answer. A contemporary suggested that this scene "may stand for human longing and bewilderment in general, and also . . . for the artist's own position, at the outset of his career, when he might fairly be supposed to be demanding of destiny the enigma of his future." Vedder's aim in his allegorical pictures was to give an air of plausibility to the unreal, which he did by making his images substantial, almost sculpturesque. This work belongs to the academic Oriental art movement that spread from France and England to America after about 1850 and attracted such diverse artists as Frederic Church, Sanford Gifford, William Merritt Chase, and Louis Comfort Tiffany.

Oil on canvas, 36 x 41³/₄ inches
Signed and dated (lower right): Elihu Vedder/
1863
Museum of Fine Arts, Boston, Bequest of Mrs. Martin Brimmer

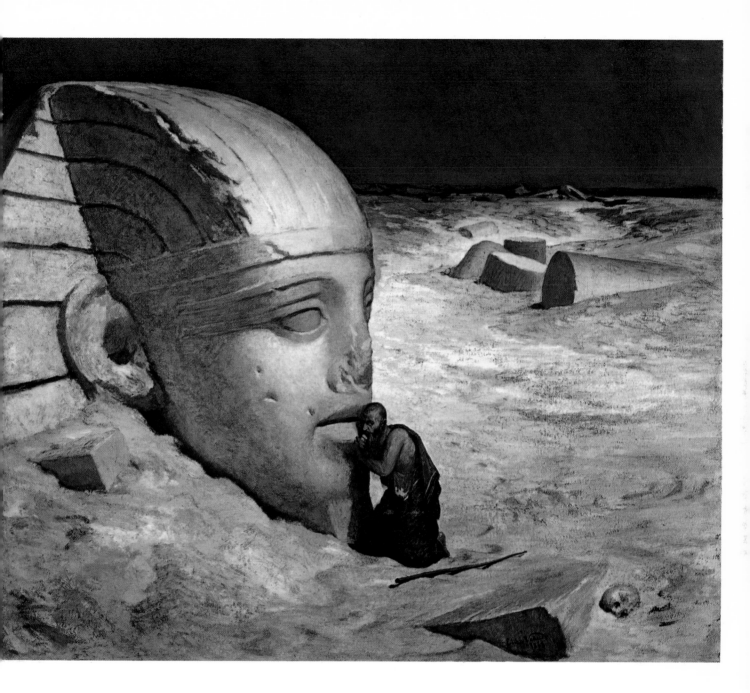

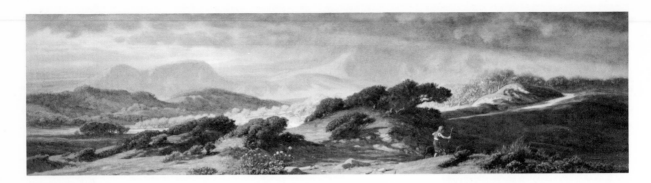

127 Storm in Umbria
Elihu Vedder

During his years in Italy, Vedder liked to roam the remote countryside. Some of his best works are sketches or oil paintings of the Italian landscape. In Storm in Umbria, painted in 1875, Vedder devoted himself mainly to depicting hills and olive trees caught in the extreme contrasts of light and shadow before an approaching storm. A small figure of a shepherd, his robe rippling in the stiff wind, urges his flock toward home through the storm-darkened fields. Here Vedder proves that he was just as adept at suggesting the power of nature as he was the power of the imagination.

> Oil on canvas, 13 x 45 inches
> Signed and dated (lower right): Elihu Vedder
> —Rome, 1875
> The Art Institute of Chicago, The Nickerson Collection

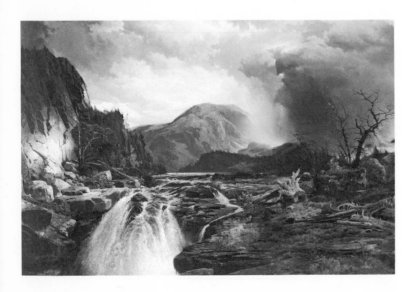

128 Western Landscape
Thomas Moran (1837–1926)

Moran, a native of Lancashire, England, came as a boy with his family to Philadelphia. There he later worked in an engraver's shop and studied painting with his brother Edward. However, the greatest influences on his style were the dramatic pictures of the American marine painter James Hamilton and the heroic works of Joseph M. W. Turner. In the summer of 1860 Moran made his first lengthy trip into the American wilderness in search of natural wonders, and the tour included Lake Superior, where he took sketches that provided material for his later lithographs and oils. Moran painted Western Landscape, formerly called The Wilds of Lake Superior, in 1864. This view of a stream cascading into a waterfall is an early example of his precise draughtsmanship, which gave his landscapes great depth as well as dramatic sweep. Although Moran is best known for his enormous panoramic canvases of the Far West, he excelled at scenes like this, in which his talent for spirited brushwork and forceful composition is brought into a smaller focus, where it can be better appreciated.

> Oil on canvas, 29 x 44 inches
> Signed and dated (lower left): THOS.
> MORAN. 1864/OP. 11
> The New Britain Museum of American Art, Charles F. Smith Fund

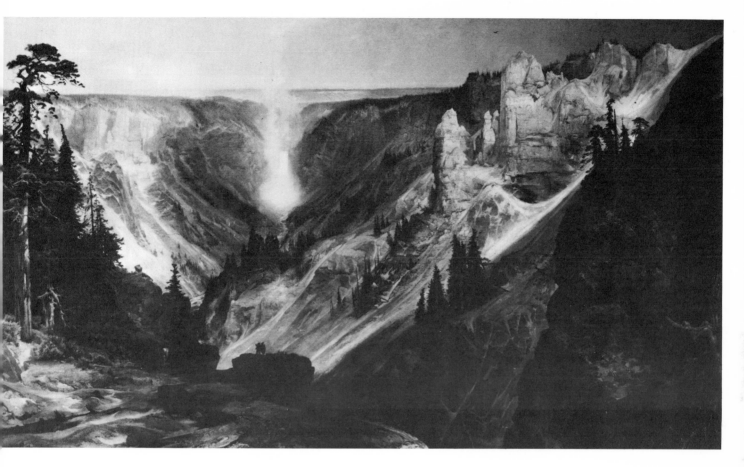

129 The Grand Canyon of the Yellowstone
Thomas Moran

The Grand Canyon of the Yellowstone is the most spectacular of Moran's many western views. Painted in autumn 1871, it was based on a series of sketches he did that summer as a member of Ferdinand V. Hayden's government survey of the Yellowstone and Grand Teton regions. Incorporating extreme accuracy, brilliant coloring, and panoramic scale, the painting was exhibited in New York and Washington in the spring of 1872 to an amazed public. The overwhelming character of the picture and its enthusiastic reception were essential in persuading Congress to establish Yellowstone as a national park the same year and to buy the painting. Moran wrote Hayden: "I have always held that

the grandest, most beautiful, or wonderful in nature, would . . . make the grandest, most beautiful or wonderful pictures. . . . All the above characteristics attach to the Yellowstone region, and if I fail to prove this, I fail to prove myself worthy of the name of painter. I cast all my claims to being an artist into this one picture of the Great Canyon and am willing to abide by the judgment on it."

Oil on canvas, 86 x 141 inches
Signed and dated (lower left): T. Moran/1872
U.S. Department of the Interior, on loan to the National Collection of Fine Arts, Smithsonian Institution, Washington

130 **"Wounded to the Rear"—
One More Shot**
John Rogers (1829–1904)

As a child in Salem, Massachusetts, Rogers wanted to become an artist, but he later chose a more profitable career as a draughtsman. Unemployed during the Panic of 1857, he decided to turn his hobby of clay modeling into a vocation and spent a year studying in Europe. There he found that his enthusiasm for realism was opposed to the accepted neoclassical ideal. "The success of a statue," he wrote his brother Henry from Rome, "depends more on the subject than anything else though it is strange that the artists here don't seem to appreciate it." Frustrated, he returned to America and worked as a draughtsman in Chicago. The success of a clay figure entered in a local bazaar led Rogers to seek commissions in New York, where he set up shop to produce inexpensive statuary. The Civil War brought a flood of illustrations of the battles in the popular weeklies, and, possibly influenced by these, Rogers, in 1864, issued "Wounded to the Rear"—One More Shot as his tribute to the common soldier. In this group he achieved a simplicity and monumentality lacking in most of his works. The statuette had almost instant appeal and was particularly favored as a gift for veterans.

Bronze, H. 23¹/₂ inches
Signed and inscribed: (on knapsack) 14 W 12 ST/JOHN ROGERS/NEW-YORK; (on base) "WOUNDED TO THE REAR"/ONE MORE SHOT/PATENTED/JAN. 17. 1865.
The Metropolitan Museum of Art, Rogers Fund, 17.174

131 **Rip Van Winkle Returned**
John Rogers

In 1876 a contemporary critic wrote of Rogers: "He is pre-eminently the sculptor of the people. He has taken the simple themes of life, that the unpretending people are interested in, and endowed them with a grace that is natural, a feeling that is profound, and intelligence that is not too far in the clouds to be appreciated by the humblest, and a depth that is of the heart and soul, so to speak, rather than of the head."

From 1860 to 1893 Americans bought about 80,000 of Rogers's putty-colored statuettes at an average price of $14. In addition to genre and historical groups, he issued many pieces illustrating scenes from fiction, poetry, and popular

plays. In August 1869 at New York's Booth Theatre, Rogers saw the actor Joseph Jefferson in the dramatization of Washington Irving's *Rip Van Winkle* and asked Jefferson to pose for a statuette of Rip. Rip Van Winkle Returned, modeled in the spring of 1871 and patented in July, was the last of three Rogers made. His catalogue of 1877 gave this melancholy caption for the piece: " 'My very dog,' sighed poor Rip, 'has forgotten me.' "

Painted plaster, H. 21¹/₂ inches

Signed and inscribed (on base): JOHN ROG-ERS/NEW YORK/RIP VAN WINKLE/RETURN-ED/PATENTED/JULY 25. 1871.

The Metropolitan Museum of Art, Edgar J. Kaufmann Charitable Foundation Fund, 68.110

132 Medea

William Wetmore Story (1819–1895)

Story was born in Salem, Massachusetts, son of Joseph Story, an associate justice of the United States Supreme Court. His family's wealth provided him with numerous cultural advantages, and he developed, according to Nathaniel Hawthorne, a "perplexing variety of talents and accomplishments— . . . being a poet, a prose writer, a lawyer, a painter, a musician, and a sculptor." He interrupted his law career in 1847, visiting Rome to execute a memorial to his father, and after his return to America decided that his "heart had gone over from the Law to Art." A typical nineteenth-century romantic, Story sought inspiration in ancient legends, ignoring his own time. His Medea, contemplating the vengeful murder of her children, was created in Rome in 1864, when the tragedy *Medea* was being performed with the actress Adelaide Ristori, a close friend of Story's, in the title role. He also wrote a poem, "Medea Meditating the Death of Her Children." A visitor to his studio remarked of the statue: "This is Medea with her stormy heart chained and still in marble; no actress's ravings ever told the story so well." Story made three replicas of Medea; this one was carved in 1868.

Marble, H. 76¹/₂ inches

Signed, dated, and inscribed (on base): WWS (monogram)/ROMA 1868/MEDEA

The Metropolitan Museum of Art, Gift of Henry Chauncey, 94.8

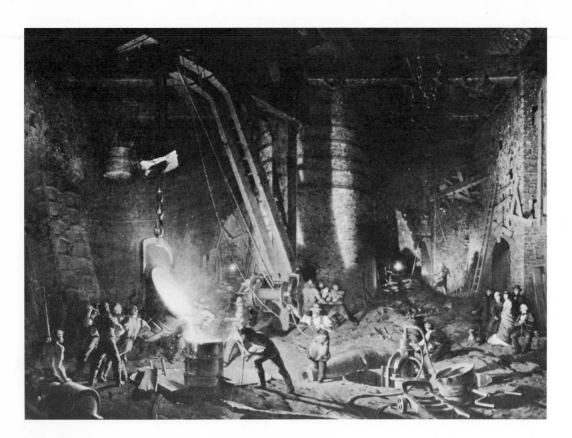

133 **The Gun Foundry**

John Ferguson Weir (1841–1926)

Weir, a painter, sculptor, author, and first director of the Yale School of the Fine Arts, was born at West Point, New York. He received his early training from his father, Robert W. Weir, who was drawing instructor at the United States Military Academy. Weir started work on this remarkable picture at the end of 1864, using studies he made in the West Point Foundry at Cold Spring. "I began to arrange the composition of 'The Gun Foundry,' " he later wrote, "in a large charcoal cartoon; assembling the masses, the big round furnace-stack and the cranes and rafters of the dusky place, with the foundrymen all in busy action absorbed in the work; the interior lit up by the glow of a great cauldron of molten-iron swung by a heavy crane to be tipped while the ropy metal was poured into the moulding-flask—which stood on end in a deep pit where a gun was to be cast. . . . I thus

secured an initial arrangement which required nearly two years to realize in the finished painting, with the workmen of the place for models in further visits to the foundry." The picture was completed in April 1866, and its exhibition at the National Academy of Design led to Weir's election as an Academician. Although The Gun Foundry is not unlike the dramatically conceived pictures of industrial and scientific subjects produced in considerable numbers in England and this country earlier in the century (see nos. 11, 21), it is painted with a sense of wonder rare among American artists.

Oil on canvas, 46¹/₂ x 62 inches
Signed and dated (lower right): John F. Weir/
1866
The Putnam County Historical Society, Cold
Spring, New York

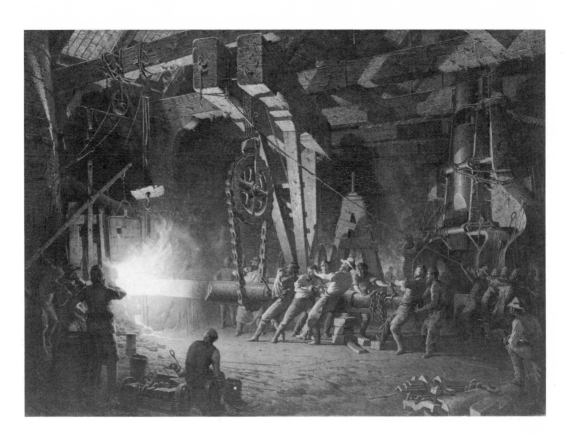

134 **Forging the Shaft**
John Ferguson Weir

Among the studies done by Weir at the old West Point Foundry at Cold Spring (see also no. 133) were those of the forging of heavy shafts for sidewheelers. As he noted: ". . . the primitive and massive appliance employed in this heavy work in the dingy shops, with the men sometimes stripped to the waist toiling vigorously, appealed to my imagination with a significance beyond that of the merely picturesque; . . ." He executed a painting of the forging operation in his New York studio in 1867, but it was destroyed by a fire while he was abroad. He completed this replica in 1877 and exhibited it at the Paris Exposition the following year. The vast foundry illuminated by the furnace and white-hot shaft demonstrates Weir's skill in depicting the dramatic effects of light; his almost boyish fascination with technology is evident in the many keenly observed details in this highly charged industrial scene.

Oil on canvas, 52 x 73¹/₄ inches
Signed (lower right): John F. Weir
The Metropolitan Museum of Art, Gift of Lyman G. Bloomingdale, 01.7.1

135 **Storm King on the Hudson**
Samuel Colman (1832–1920)

Colman, born in Maine, was introduced to art by his father, a print dealer and bookseller and publisher. He studied briefly with Asher B. Durand, and frequented the Hudson River, Lake George, and the White Mountains before departing in 1860 for Europe, where he traveled in France and Spain. One critic wrote that "the study of the architectural remains of old Spain had given him remarkable accuracy in drawing, and the rich tones of colour in the landscape and skies were a source from which much of the inspiration belonging to his pencil as a great colourist was drawn." Painted in 1866, after his return to America, Storm King on the Hudson effectively demonstrates these abilities with the precise rendering of the boats and the lyrical representation of mountains, water, clouds, and smoke. The mountain, according to an 1881 source, owes its name to "the fact that for years it . . . served as a weather-signal to the inhabitants of the immediate district," the heights attracting storms like the one depicted by Colman.

Oil on canvas, 31³/₄ x 59¹/₄ inches
Signed and dated (lower right): S. COLMAN. 66.
National Collection of Fine Arts, Smithsonian Institution, Washington

136 **The Mohawk Valley**
Alexander Helwig Wyant (1836–1892)

Wyant, born in Tuscarawas County, Ohio, was an apprentice harness maker before he took up landscape painting. His enthusiasm for the work of George Inness led him to make a trip to New York in 1858 to meet the artist. Encouraged by Inness and with the support of Nicholas Longworth of Cincinnati, he attended the National Academy of Design for a year and in 1865 went to Karlsruhe, Germany, to study with the successful Norwegian landscapist Hans-Fredrik Gude at the Academy. From Gude Wyant learned an extremely close, almost photographic technique and acquired a taste for dark cool coloring. The Mohawk Valley, painted in 1866 in Wyant's New York studio, is the largest, most meticulous work of his early maturity. The picture has been criticized for its cold and dry approach, but the clear focus on every visual fact and the zooming perspective give it a coherence lacking in his later extremely diffuse compositions. Wyant apparently disliked his early works, and his wife destroyed many of them after his death. This example is a rare survivor.

Oil on canvas, 34³/₄ x 53³/₄ inches
Signed and dated (lower left): A. H. Wyant/ 1866
The Metropolitan Museum of Art, Gift of Mrs. George E. Schanck, in memory of Arthur Hoppock Hearn, 13.53

137 William Cullen Bryant
Launt Thompson (1833–1894)

Born in Ireland, Thompson came to America in 1847. After studying anatomy with a doctor in Albany and working nine years for Erastus Dow Palmer, he opened his own studio in New York City in 1857. Among his pupils was William Waldorf Astor, who became his patron and did much to aid Thompson's entrance into the world of society. Thompson modeled a bust of the poet and editor William Cullen Bryant in 1865; this bronze replica was cast in 1867 as part of a monument for Bryant Park. The colossal work is done in a studied naturalistic style, emphasizing Bryant's impressive brow, wavy hair, side whiskers, beard, and heavy mustache. The calm dignity expressed here is typical of Thompson's portraits, but the gigantic scale and swelling surfaces are unique in his oeuvre.

Bronze, H. 46¹/₂ inches
Signed and dated (on base): L Thompson./ Oct, 1 67
Founder's mark (on back): BRONZE BY/L.A. Amouroux./N.Y.
Deposited in The Metropolitan Museum of Art by the New York City Department of Public Parks, 1896, O.L. 88. IV

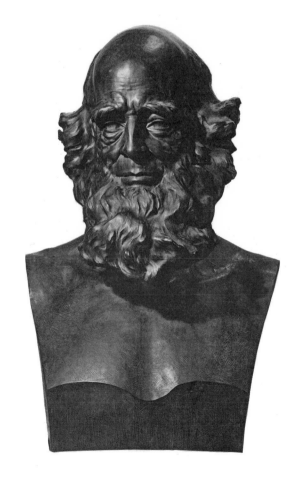

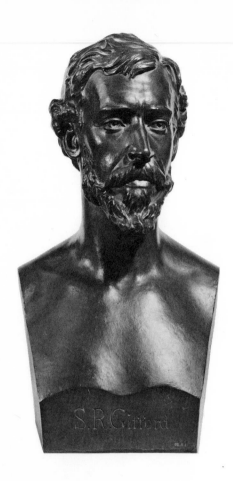

138 **Sanford R. Gifford**
Launt Thompson

Thompson's bust of the landscape painter, Sanford R. Gifford (see nos. 100, 101), was one of a number of sympathetic portraits he produced in the early 1870s at the high point of his career, before he became an alcoholic. The work is unburdened by stylistic pretensions, and is remarkable for its direct perception of Gifford's thoughtful and gentle character as well as for its vigorous form.

> Bronze, H. 22¹/₄ inches
> Signed, dated, and inscribed (on base): Launt. Thompson/Sc. 1871./S.R. Gifford
> Founder's mark (on base): E. Henry & Bonnard/Founders
> The Metropolitan Museum of Art, Gift of Mrs. Richard Butler, 02.11.1

139 **Thunderstorm, Narragansett Bay**
Martin Johnson Heade (1819–1904)

Heade was born in Bucks County, Pennsylvania, where he received his first art training from Edward and Thomas Hicks. After study in Italy, France, and England in the late 1830s, he worked as a portrait and landscape painter in the East and Midwest. From 1859 Heade maintained a base in New York but traveled extensively. He painted a lengthy series of peaceful New England coastal views, carefully studying the varieties of rock, wave, and sky, but in Thunderstorm, Narragansett Bay, dated 1868, he has gone far beyond the quiet mood and the mere recording of natural phenomena. Lightning flashes out of a stirring, treacherous sky above glassy water; vivid white sails ripple in the wind at the edge of the storm or hang limp and submissive in its midst. The subtle naturalistic gradations of tone, for which the artist was renowned, have been replaced by extreme contrasts of black and white, giving the scene a surrealistic appearance. Color has been employed sparingly to heighten the mood of fury and foreboding. An eerie seascape, conveying a sense of supernatural forces at work, it is surely the artist's most powerful picture.

> Oil on canvas, 32¹/₈ x 54³/₄ inches
> Signed and dated (lower left): M. J. Heade/1868.
> Mr. and Mrs. Ernest Rosenfeld, New York

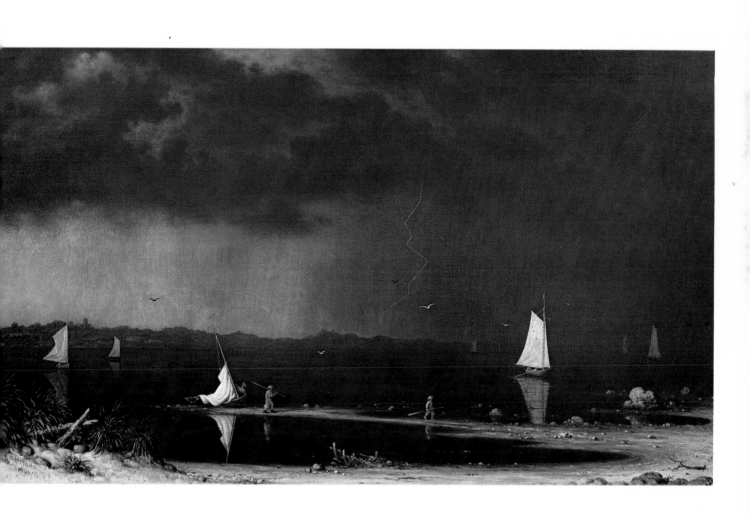

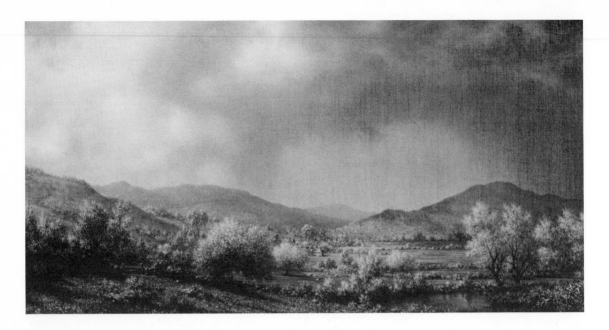

140 **Spring Shower, Connecticut Valley**
Martin Johnson Heade

Spring Shower, Connecticut Valley, of 1868, shows Heade's preoccupation with atmospheric effects and mood and his mastery at depicting them. Here he has painted a stormy sky above a densely humid but serene countryside, dotted with lavender-pink apple blossoms, for which he prepared separate studies.

Oil on canvas, 20 x 40 inches
Signed and dated (lower left): M. J. Heade—68
Museum of Fine Arts, Boston, M. and M. Karolik Collection

141 **Hummingbirds and Orchids**
Martin Johnson Heade

During the 1860s and 70s, Heade made trips to South America and the Caribbean and in 1883 settled permanently in St. Augustine, Florida. A poet and a naturalist, Heade is also known today for his paintings of tropical birds and flowers. His interest in hummingbirds dated from his childhood, when, as he later wrote, he "was attacked by the all-absorbing hummingbird craze." He studied their activities for more than fifty years, and his articles about them appeared in scientific journals. Heade went to Brazil in 1863 to prepare illustrations for a book on South American hummingbirds, which was never published. His combination of hummingbirds with orchids dates from the 1870s, and he continued to use the theme until his death. In contrast to Audubon, Heade never portrayed birds in flight but at rest on branches. His brightly colored birds and opulent plants are outlined against a remote tropical mountain landscape and heavy sky, striking the romantic note that makes this—like the rest of the series—more than just an exquisite ornithological and botanical rendering.

Oil on canvas, 14¹/₄ x 22¹/₄ inches
Signed (lower right): M. J. Heade
The Detroit Institute of Arts, Gift of Dexter M. Ferry, Jr.

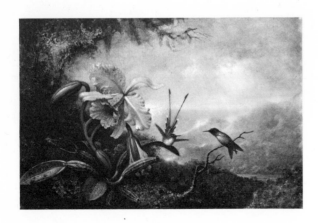

142 Crossing the Ford, Platte River, Colorado
Thomas Worthington Whittredge (1820–1910)

Born on a farm near Springfield, Ohio, Whittredge started out as a house and sign painter in Cincinnati, then worked briefly as a photographer and portraitist in Indiana and West Virginia before turning to landscape painting in 1843. Backed by wealthy Cincinnatians, he went to Europe in 1849, where he studied at the Royal Academy in Düsseldorf. From 1854 to 1859 he worked in Rome and afterward settled in New York City to produce views of New York and New England. In 1865/66, with Sanford Gifford and John F. Kensett, he accompanied Major General John Pope from Fort Leavenworth, Kansas, up the south branch of the Platte River through Denver, then south along the eastern Rockies into New Mexico. Whittredge wrote in his autobiography: "Whoever crossed the plains at that period . . . could hardly fail to be impressed with [the] vastness and silence and the appearance everywhere of an innocent, primitive existence," and he "cared more for [the plains] than for the mountains." Crossing the Ford, Platte River, Colorado, was painted in 1868 from field sketches and reworked in 1870 after another trip West to correct the appearance of the trees. The snow-capped mountain is probably Long's Peak, north of Denver. Like Albert Bierstadt, who combined ethnographic and topographic interests in his large compositions (see no. 121), Whittredge has included Indians and their trappings in his serene and freely painted composition, which emphasizes the flat expanse of the plain and the bright crystalline quality of the western air.

Oil on canvas, 40 x 68 inches
Signed and dated (lower right): W. Whittredge 1868/W. Whittredge/1870
The Century Association, New York

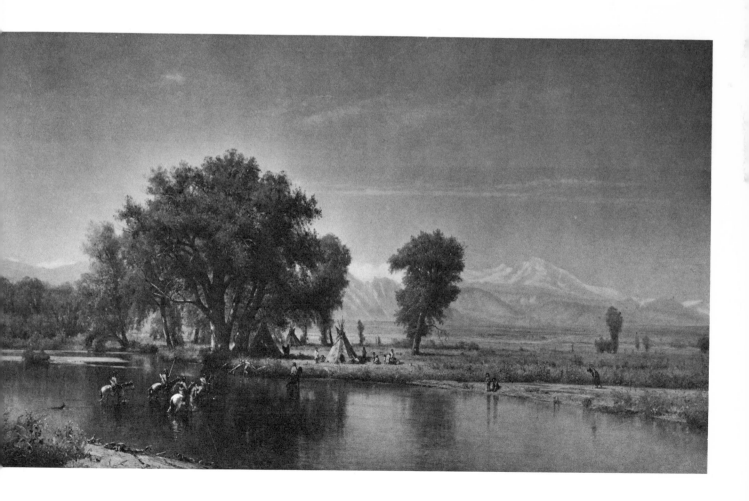

143 The Brown Family
Eastman Johnson (1824–1906)

Born at Lovell, Maine, Johnson was trained in a Boston lithographer's shop, and began his career as a portraitist, working in pencil and crayon. In 1849 he went to Europe to study painting at Düsseldorf, The Hague, and Paris, returning to America in 1855. He rapidly became known for his genre pictures. About 1860 he settled in New York, where he continued to paint genre scenes while making an excellent living as a portraitist.

Johnson was one of the ablest practitioners of the "portrait interior," which derived from the eighteenth-century conversation piece and enjoyed a great vogue in the prosperous decade following the Civil War. In this example James Brown, eminent banker, railway and shipping magnate, is shown with his wife, Eliza Coe Brown, and their grandson, William Adams Brown, in the parlor of their house on University Place. This room was completely redecorated after 1846 in the Renaissance revival style by the French cabinetmaker and interior furnisher Leon Marcotte (see furniture and other decorative arts volume no. 153), whose fashionable establishment was patronized by New York society in the third quarter of the nineteenth century. Considered one of his masterpieces, the room was dismantled in 1869, when Brown moved uptown to Park Avenue, and some of the decorations were installed in the new drawing room. Brown apparently commissioned this painting as a memento of his old home. It is possibly based in part on a photograph of the Browns in their parlor taken by Matthew Brady in the late 1850s, in which Mrs. Brown is shown in very much the same pose. The painting offers a superlative rendering of the rich brilliant colors of the room, its elegant proportions and opulent decor, and fine lifelike portraits of the Browns.

Oil on canvas, 38¹/₂ x 32¹/₂ inches
Signed and dated (lower right): E. Johnson./ 1869.

Mrs. John Crosby Brown II, Old Lyme, Connecticut

144 The Hatch Family
Eastman Johnson

In 1871 Alfrederick Smith Hatch, a prominent Wall Street broker, commissioned this portrait of his family in the library of his house at Park Avenue and Thirty-seventh Street. Hatch is seated at his desk at the right; his wife, Theodosia Ruggles Hatch, stands by the mantelpiece in a classic attitude. Her mother, Mrs. John Gould Ruggles, is seated with her knitting to the left of the table. Hatch's father, Dr. Horace Hatch, sits behind her, reading his newspaper. The Hatch children are (left to right): William Dennison, John Ruggles, Louisa Fisk, Frederic Horace, Emily Theodosia, Emily Nichols, Edward Payson II, Jessamine, Mary Yates (seated), Horace, and Jane Storrs. Family tradition records that when Emily Nichols was born in August 1871, Alfrederick Hatch wired Johnson telling him that he would receive another $1000 for including her. When Frederic H. Hatch presented the picture to the Metropolitan Museum in

1926, he recalled that Johnson required about a year and a half to complete it, and later thought it "the best of his works."

This painting, and that of the Brown family (no. 143), shows the draughtsman-like and highly finished realism Johnson favored when he wished to give an accurate representation of a room and its inhabitants; it contrasts markedly with the more atmospheric, painterly style of his experimental genre and outdoor scenes of the 1860s and 70s (see no. 145). The curious combination of classical figure-group composition and genre-like naturalness of pose is perhaps a response to the influence of group photographs of the period. The painting provides an excellent document of a domestic interior of the well-to-do class of the 1870s, at the height of eclecticism in decorative design. The bookcase and cornice are in the richest interpretation of the Renaissance revival style, which was characterized by geometric architectural lines like those of the woodwork and library table. The extensive use of contrasting veneers, incised lines, and rich black and gilt decoration on the bookcase and cornice are typical of the work of Leon Marcotte, who was responsible for refurbishing the Brown family parlor.

Oil on canvas, 48 x 73³/₈ inches
Signed and dated (lower left): E. Johnson 1871
The Metropolitan Museum of Art, Gift of Frederic H. Hatch, 26.97

145 In the Fields

Eastman Johnson

About 1870 Johnson took a studio on Nantucket, where he worked during the summer and fall for nearly twenty years. Here he found the picturesque subjects for his numerous and important genre pictures done during the 1870s. In these scenes he developed a remarkable brilliance of color and freedom of handling, particularly in the outdoor sketches, which exemplified the enthusiasm for plein-air painting then emerging in the art of America and Europe. In this study of cranberry pickers, painted in the mid-1870s, Johnson employs an almost impressionistic approach to light, color, and atmosphere, which parallels Homer's development at the same time (see no. 159). In marked contrast to the tight linear style of Johnson's portrait interiors of a few years earlier (see nos. 143, 144), the picture is a rapid plein-air sketch that captures the slanting sunlight of late afternoon, warm colors of the fields, and crispness of the autumn air. The figures are broadly and deftly painted, their forms defined in space by a few bold accents of sunlight.

Oil on academy board, 17³/₄ x 27¹/₂ inches
Signed (lower right): E.J.
The Detroit Institute of Arts, Gift of Dexter M. Ferry, Jr.

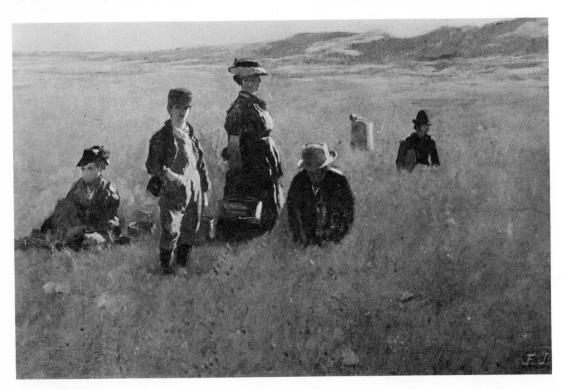

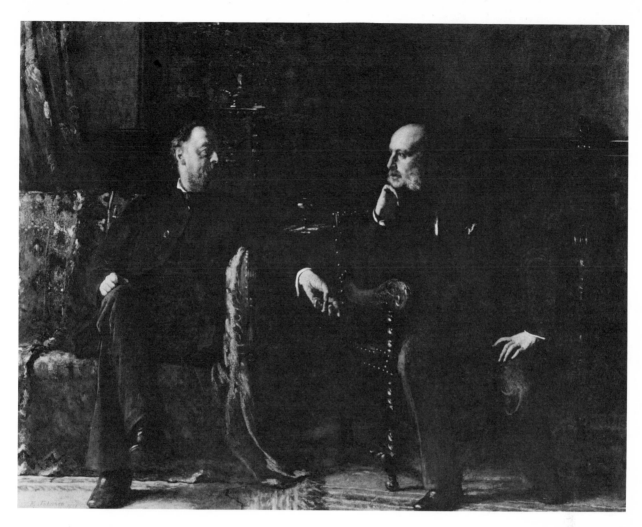

146 **The Funding Bill**
Eastman Johnson

From about 1880 until his death, Johnson devoted himself mainly to portrait commissions, abandoning the genre subjects for which he is most highly regarded today. The Funding Bill, which combines informal portraiture with genre interest, raises a prosaic subject to a high level of power and quality and reflects Johnson's absorption of the Rembrandtesque tradition of dramatic contrasts of dark and light, intense realism, and remarkable perception of personality. Facing each other in the picture are (left) Mrs. Johnson's brother-in-law, Robert W. Rutherfurd, a leading New York businessman, and (right) Samuel W. Rowse, a well-known portraitist and friend of Johnson's. The artist's wife

later recalled that "two friends of his were discussing 'The Funding Bill,' a political or financial question of 1881 [An Act to Facilitate the Refunding of the National Debt]. It happened he had no Academy exhibition picture for that year. . . . In three weeks it was finished and in the place of honor. . . ." The picture received considerable praise from the New York critics for the realistic treatment of subjects and setting, and became well known here and abroad before its acquisition by the Metropolitan Museum.

Oil on canvas, 60¹/₂ x 78¹/₄ inches
Signed and dated (lower left): E Johnson 1881
The Metropolitan Museum of Art, Gift of Robert Gordon, 98.14

147 The Music Lesson
John George Brown (1831–1913)

Born in England, Brown studied painting there and in Scotland before coming to America to work in a Brooklyn glass factory. His employer (subsequently his father-in-law) urged him to continue his studies under Thomas Seir Cummings, and in 1860 Brown took a studio in the Tenth Street Studio Building in New York. He became an Academician in 1863 and served as vice-president of the National Academy of Design, president of the American Water Color Society and of the Artists' Fund Society. Brown once noted that "Art should express contemporaneous truth, which will be of interest to posterity," and he was considered a visual historian of his times. He achieved great popularity and financial success as a painter of bootblacks and newsboys and the New York street scene. The Music Lesson, of 1870, represents a departure from his street urchins, but meets his own demands for contemporary reportage. It offers a careful description of an eclectic Victorian interior, including a Renaissance revival sofa and a Greek revival patent harp by Erard of London, as a setting for the music-making couple, a traditional theme of disguised courtship. The painting was engraved and circulated with the alternate title "A Game Two Can Play At."

Oil on canvas, 24 x 20 inches
Signed and dated (lower left): J. G. Brown/ N.Y. 1870
The Metropolitan Museum of Art, Gift of Colonel Charles A. Fowler, 21.115.3.

148 Lake Sanford in the Adirondacks, Spring
Homer Dodge Martin (1836–1897)

Martin was born in Albany, New York, and began painting landscapes in the 1850s after a fortnight's instruction from the Albany artist James Hart. From 1864 to 1869 he spent his summers exploring the Adirondacks, where his "favorite sketching ground," according to his biographer, Frank Jewett Mather, Jr., was the region of "forest-bound lakes at the headwaters of the Hudson." Lake Sanford in the Adirondacks, Spring, painted in 1870, was sketched from nature and the details and color added afterward. Although he later evolved a sophisticated style influenced by Corot, Whistler, and the impressionists, Martin never surpassed the delicacy and strength of this picture, with its subtle values, soft brilliance of color, and fine evocation of mood. The tension and isolation of the trees, the remoteness of the lake and stretch of woods—seen from a height that gives spaciousness and breadth—convey a sense of desolation that might have prompted the painter's friend John R. Dennett to remark: "Martin's landscapes look as if no one but God and himself had ever seen the places."

Oil on canvas, 24¹/₂ x 39¹/₂ inches
Signed and dated (lower left): H. D. Martin 1870
The Century Association, New York

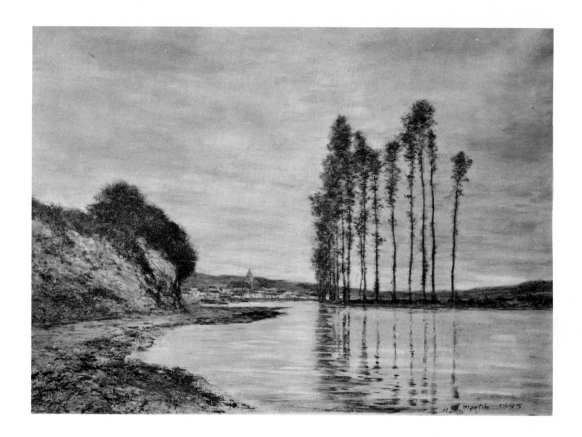

149 Harp of the Winds: A View on the Seine
Homer Dodge Martin

Martin lived in France for several years between 1882 and 1886, mostly at Villerville and Honfleur in Normandy. He did little painting, but the sketches made at this time resulted in some of his finest late canvases. In 1893 he went to St. Paul, Minnesota, where he spent the last years of his life. Harp of the Winds: A View on the Seine was completed in the late spring and summer of 1895, when he was nearly blind. Harp of the Winds was Martin's own title for the picture; in her *Homer Martin: A Reminiscence*, published in 1904, his wife relates that "he supposed it would seem too sentimental to call it by [that] name . . . , but that was what it meant to him, for he had been thinking of music all the while he was painting it. . . . In its primitive condition—and, indeed, from the moment when it was first charcoaled on the canvas, the trees so grouped that they suggested by their very contour the Harp to which he was inwardly listening—it was supremely elegant." The picture is a masterpiece of composition in its unity of spatial definition and curvilinear design. In the manner of Martin's impressionistic late style, the paint is laid on in layers with brush and palette knife and flattened to a uniform surface, creating rough yet luminous areas of broken tone.

Oil on canvas, 28³/₄ x 40³/₄ inches
Signed and dated (lower right): H D Martin 1895
The Metropolitan Museum of Art, Gift of Several Gentlemen, 97.32

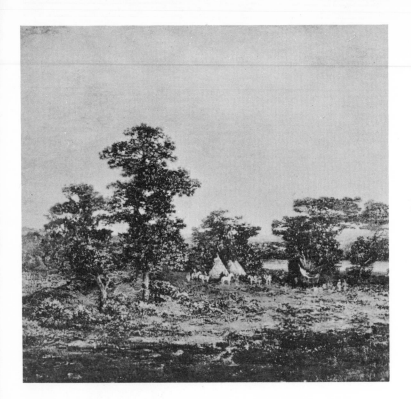

150 Indian Encampment
Ralph Albert Blakelock (1847–1919)

The son of an English physician, Blakelock was born in New York. He attended the Free Academy (now City College) for over a year before taking up painting, without any formal instruction, during the late 1860s. He traveled in the West from 1869 to 1872, producing hundreds of drawings, including some of the Indian tribes he had visited. Blakelock's moody pictures were generally unappreciated, and it was only after a series of mental breakdowns had hospitalized him that his work gained recognition. He then had the frustration of seeing his pictures forged, copied, and sold for high prices while he himself was unable to paint for the market. Indian Encampment, possibly of the 1870s, treats one of Blakelock's favorite themes, Indians in a woodland setting. Unlike the ethnological studies of George Catlin and Seth Eastman, or even Albert Bierstadt and Worthington Whittredge, Blakelock's concerns are wholly pictorial and expressive. The dramatic use of silhouetting, rough dark vegetation against the golden sky, and flickering light creating a dreamlike world between night and day are characteristic of Blakelock's most effective work. In mood and technique his pictures are closely related to Albert P. Ryder's, although his subjects never

reached the imaginative heights of his colleague's (see nos. 151, 152).

Oil on canvas, 37 7/16 x 40¹/₄ inches
Signed (in arrowhead, lower left): Ralph Albert Blakelock
The Metropolitan Museum of Art, Gift of George A. Hearn, 06.1269

151 Moonlight Marine
Albert Pinkham Ryder (1847–1917)

Born in the whaling port of New Bedford, Massachusetts, Ryder moved to New York City about 1870, where he studied painting at the National Academy of Design and was also a pupil of the portraitist and engraver William E. Marshall. Although Ryder traveled to England and the Continent, modern European art had little effect upon him. The greatest influence on his work was his lifelong fascination for the sea. The originality of his art is nowhere more apparent than in his small nocturnal sea studies. As Ryder once said: "The artist should fear to become the slave of detail. He should strive to express his thought and not the surface of it." Moonlight Marine is a design of stark simplicity, darkly colored to suggest mystery. The clouds are so dark, and their silhouettes against the sky so dominant that the even darker sails become almost a continuation of them.

These cloud shapes, with their emphatic halos, are vital design factors in most of Ryder's paintings and were one of his most powerful and individual creations. The elaborate texture and enamel-like surface sheen of his paintings are the result of the many layers of paint and glazes. Ryder often worked for years on a single picture, never dating any of them and sometimes even reworking ones he had already sold.

Oil on wood, 11³/₈ x 12 inches
Signed (lower left): Ryder
The Metropolitan Museum of Art, Samuel D. Lee Fund, 34.55

152 The Dead Bird
Albert Pinkham Ryder

This touchingly simple embodiment of fleeting frailty, painted about 1890 to 1900, is a variation from Ryder's haunting nocturnes and landscapes. Here he has used a golden palette and broad brushstroke to create the effect of a worked metallic surface. One of Ryder's many compositions on the theme of death, the picture is an original recasting of a prosaic still-life motif.

Oil on wood, 4¹/₄ x 9⁷/₈ inches
The Phillips Collection, Washington

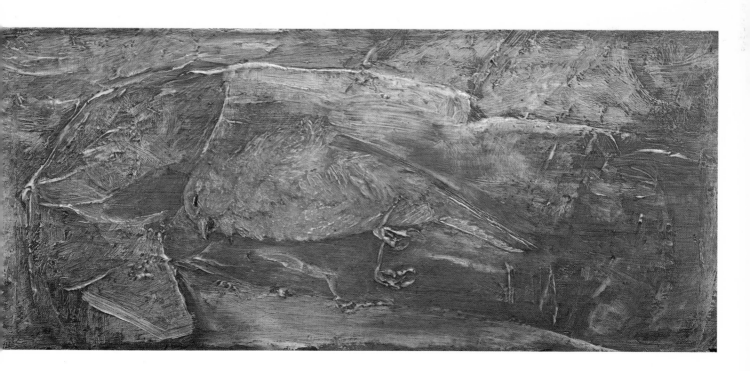

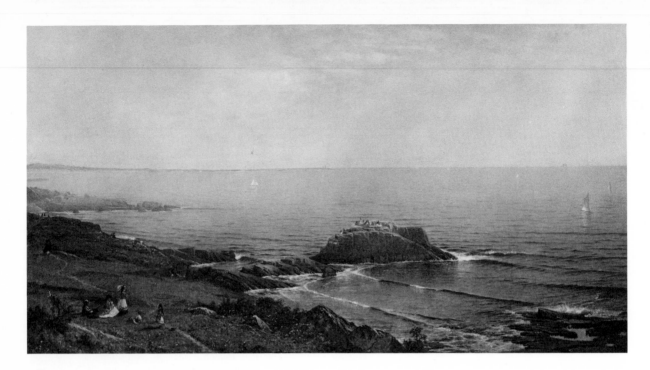

153 **Indian Rock, Narragansett Bay**
Alfred Thompson Bricher (1837–1908)

Bricher, a native of Portsmouth, New Hampshire, grew up in the coastal town of Newburyport, Massachusetts, and studied art at the Lowell Institute in Boston. In 1858 he opened a studio in Newburyport, where he worked for the next ten years, acquiring a reputation as a painter of autumn scenery. After moving to New York in 1868, he specialized in seascapes. "Mr. Bricher has studied waves and can paint them," declared a writer in *The New York Times*. When asked how he painted waves, Bricher said: "I watch a wave as it comes in onto the shore, and then I turn my head away the second before it breaks." He made annual trips along the New England coast and to the islands off Massachusetts, Maine, and New Brunswick, where he studied the ocean under varying conditions. Indian Rock, Narragansett Bay, painted in 1871 near Newport, Rhode Island, captures the radiant sky and high-keyed colors of summer, intricate patterns and textures of the shoreline, and sense of enjoyment of people in the refreshing ocean air. In subject and mood it is characteristic of the work for which Bricher was best known, although it is more colorful and less static than the usual blue and green shore scenes that came from his easel.

Oil on canvas, 27 x 50 inches
Signed and dated (lower left): A. T. Bricher 1871.
Lent anonymously

154 **Max Schmitt in a Single Scull**
Thomas Cowperthwait Eakins (1844–1916)

Born in Philadelphia, Eakins studied at the Pennsylvania Academy of the Fine Arts and attended anatomy classes at Jefferson Medical College before going to Paris in 1866. He entered the Ecole des Beaux-Arts to study under the leading academician and genre painter Jean-Léon Gérôme and was also a pupil of the fashionable portraitist Léon-Joseph-Florentin Bonnat and the sculptor Augustin-Alexandre Dumont. Before returning to America in 1870, Eakins visited Madrid and Seville to see the paintings of Velázquez and Ribera. From these European experiences Eakins developed an intense concern for close observation and logical technique. "The big artist," he wrote "does not sit down monkey-like and copy . . . he keeps a sharp eye on Nature and steals her tools."

In Max Schmitt in a Single Scull, painted in 1871, Eakins shows his boyhood friend, a champion oarsman, coasting in a scull on a bright Indian summer day on the Schuylkill River; he has portrayed himself rowing in the middle distance. Eakins's love of clarity and careful arrangement finds full expression in the measured order of this controlled composition, for which he prepared a variety of figure and perspective studies. Razor-sharp draughtsmanship, the repeated emphasis on lines parallel to the scull and horizon, and the harsh, seemingly artificial, light isolating each object, arrest all motion and present the scene for the closest scrutiny. The painting, uniting a popular sporting theme, topographical truth, and technical brilliance, is one of the finest genre scenes of nineteenth-century American art.

Oil on canvas, 32¹/₄ x 46¹/₄ inches
Signed, dated, and inscribed: (on scull in background) EAKINS/1871; (on scull in foreground) JOSIE
The Metropolitan Museum of Art, Alfred N. Punnett Fund and Gift of George D. Pratt, 34.92

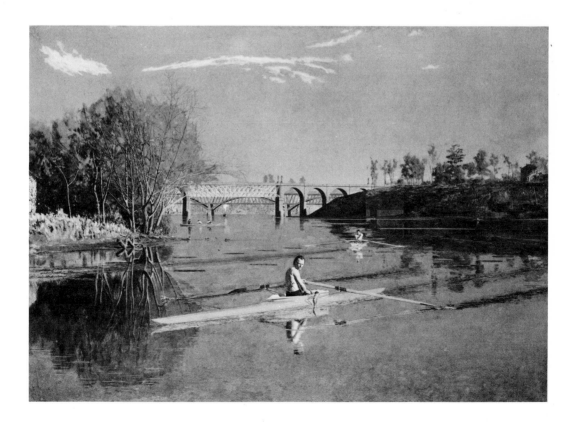

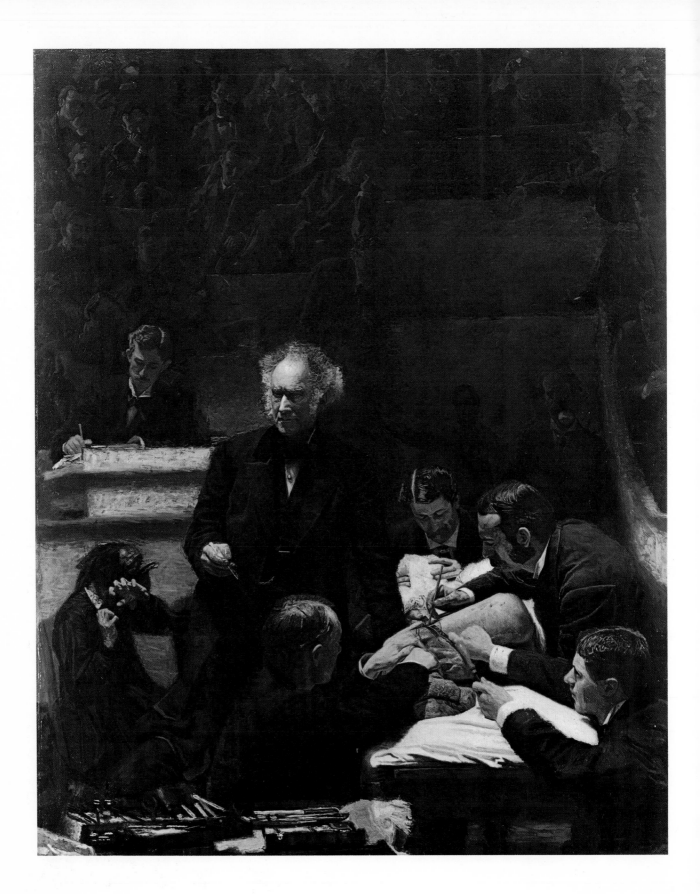

155 The Gross Clinic
Thomas Cowperthwait Eakins

Perhaps the most powerful and important painting by a nineteenth-century American artist, and certainly the most extraordinary history painting by any American artist, The Gross Clinic embodies both Eakins's profound concern with the human condition and his dispassionate investigation of its every detail. Combining elements of genre and portraiture, the painting grew out of his studies at Jefferson Medical College, where he attended lectures and witnessed dissections and operations. The greatest of the surgeons he saw there was Samuel David Gross, who is still remembered for his effective teaching and his writing of the best surgical textbook of the period, *A System of Surgery, Pathological, Diagnostic, Therapeutic and Operative.*

Eakins composed this *portrait d'apparat* for exhibition at the 1876 Philadelphia Centennial. It grasps the significance of Gross's life work, showing him in a highly charged but characteristic moment as he turns away from the patient to make his comment. His figure dominates the scene; surrounding him are his huddled assistants, a cringing lady observer, and the darkly lit class. Eakins is crouched in the front row at the far right, sketching. The paint, heavily applied, is essentially dark—with superb highlighting and color accents to rivet our attention. The debt to seventeenth-century Dutch group anatomy-lesson portraits, especially Rembrandt's The Anatomy Lesson of Dr. Tulp, is clear, as is Eakins's affinity for the dramatic black and silver coloring of Spanish portraiture. The picture was attacked for its shocking details, and denied proper installation at the Centennial. In 1878 it was purchased by the Jefferson Medical College. What Dr. Gross thought of the picture is not known, as he does not mention it in his autobiography; certainly for Eakins, its poor reception must have been a bitter disappointment.

Oil on canvas, 96¹/₄ x 78⁵/₈ inches
Signed and dated (on operating table, lower right): EAKINS 1875
The Jefferson Medical College of Philadelphia

156 The Pathetic Song
Thomas Cowperthwait Eakins

Musicians, singers, and the performance itself frequently served Eakins for subjects. The Pathetic Song, painted in 1881, is an example of the informal musical events often given in the Eakins home. The singer, Margaret Alexina Harrison, sister of the Philadelphia painters Thomas Alexander and Birge Harrison, is accompanied by a cellist named Stoltz, a member of the Philadelphia Philharmonic Orchestra, and a pianist, Susan Hannah Macdowell, Eakins's pupil and future wife. A strong source of light focuses on the singer, accentuating the center of a pyramidal composition. The light is also used as a modeling device, dramatically delineating the folds and ruffles of the singer's dress and revealing Eakins's Copley-like interest in textures. Unlike John G. Brown's sentimental treatment of a similar theme (no. 147), this painting is an austere and objective study, exemplifying the direct naturalistic style developed by Eakins. It utilizes contrasts of focus—the sharply defined against the indistinct—to maximum effect. More vital, however, to the life of the picture is the solemn mood evoked, establishing without any falseness the oneness of the participants in their music making.

Oil on canvas, 45 x 32¹/₂ inches
Signed and dated (lower left): Eakins/1881
The Corcoran Gallery of Art, Washington

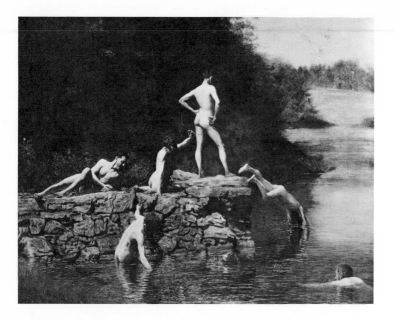

158 Miss Amelia C. Van Buren
Thomas Cowperthwait Eakins

The subject of this portrait painted about 1891 was Eakins's pupil at the Pennsylvania Academy of the Fine Arts. The somber young woman, dressed in pink, is seated in a heavy armchair upholstered in dark velvet with an elaborately carved cresting rail and turned supports. A strong light from the left rakes the figure, vigorously illuminating each contour of face, hands, and clothing. Eakins shows the sitter's introspective mood, demonstrating his insight into personality and ability to go beyond representational superficiality. He painted numerous portraits of a wide variety of people, but few, if any, approach this one for its penetration.

Oil on canvas, 45 x 32 inches
The Phillips Collection, Washington

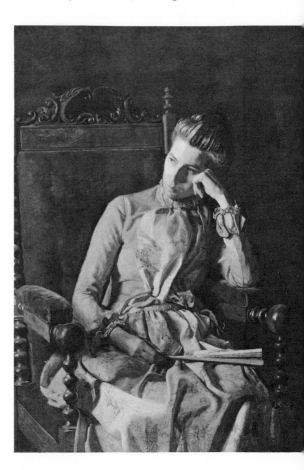

157 The Swimming Hole
Thomas Cowperthwait Eakins

In 1876 Eakins began his teaching career at the Pennsylvania Academy of the Fine Arts. The study of the human figure was the basis of his method. "To draw the human figure it is necessary to know as much as possible about it, about its structure and its movements, its bones and muscles, how they are made, and how they act," he once said. He encouraged his pupils to take anatomy courses and witness dissections, as he himself had done. Eakins's mastery of anatomy is fully demonstrated in this study of nude figures in a plein-air setting. Painted in 1883, The Swimming Hole has for its models Eakins's friends, Eakins himself (at lower right), and his dog, Harry. The picture celebrates his love of the outdoors and sports, as well as his enthusiasm for studied realism and precise composition. The deliberate pyramidal arrangement is strikingly classical, while the sequential distribution of the swimmers foreshadows Eakins's photographic figure-motion studies of the mid-eighties. Although somewhat rigidly composed, the picture succeeds as a sympathetic study of a beloved American pastime.

Oil on canvas, 27 x 36 inches
Signed and dated (on rock at end of pier): EAKINS 1883
Inscribed (on back, by Mrs. Eakins): Swimming Hole, Thomas Eakins, 1883
Fort Worth Art Center Museum

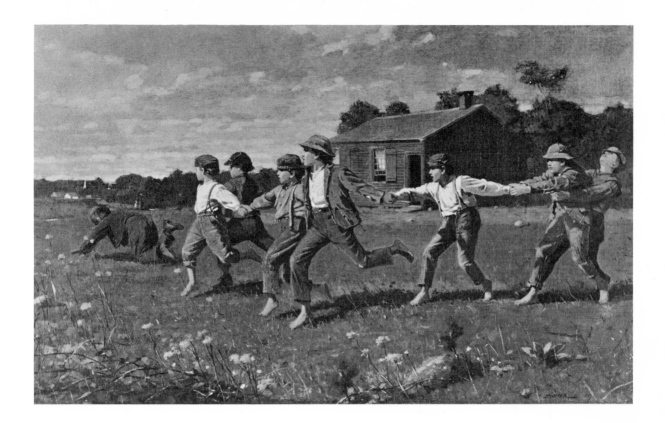

159 Snap the Whip
Winslow Homer (1836–1910)

Homer left the lithography firm of J. H. Bufford in Boston, his birthplace, to become a freelance illustrator. In 1859 he moved to New York, where he attended classes in Brooklyn and at the National Academy of Design, and took a few private lessons in oil painting from a French artist, Frédéric Rondel. During the 1860s Homer covered Lincoln's inauguration and sketched camp and campaign life of the Union troops for *Harper's Weekly*. In 1867 he was in Paris, where his painting Prisoners from the Front, now owned by the Metropolitan Museum, was on display. On his return to America, he settled in New York, spending his summers hunting, fishing, and painting in the Adirondacks and the White Mountains. In 1872 he painted two versions of Snap the Whip. The larger one, now at the Butler

Institute of American Art, Youngstown, Ohio, differs from this painting in having a mountainous background and additional figures. The children at play during school recess in a sunlit New England meadow are captured with an affectionately objective eye in a realistic illustrational mode. It is such a work that led Henry James to comment: "Mr. Homer goes in, as the phrase is, for perfect realism. . . . He is a genuine painter; . . . he naturally sees everything at one with its envelope of light and air. He sees not in lines, but in masses, in gross, broad masses. Things come already modelled to his eye. . . ."

Oil on canvas, 12 x 20 inches
Signed and dated (lower right): HOMER 1872
The Metropolitan Museum of Art, Gift of Christian A. Zabriskie, 50.41

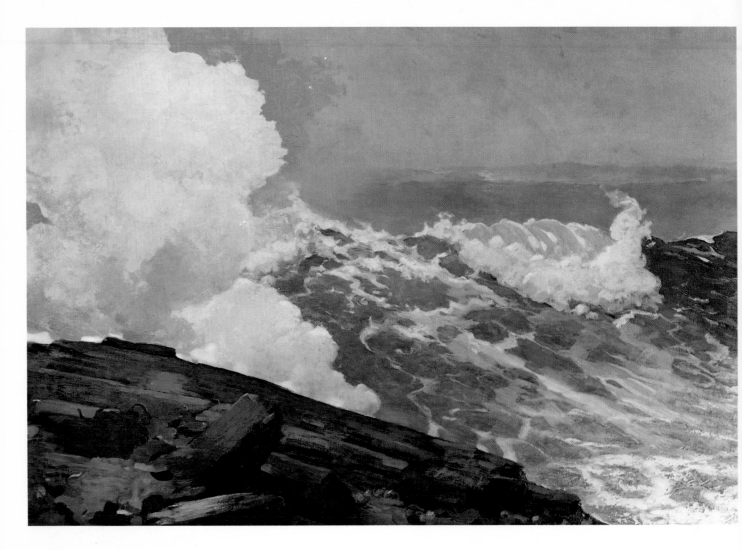

160 Northeaster
Winslow Homer

In 1881 Homer made his second trip abroad, staying in England near Tynemouth, Northumberland, on the North Sea. His earlier light-hearted beach scenes, like those of Long Branch, New Jersey, and Gloucester, Massachusetts, gave way to stirring representations of the North Sea fishermen and their families in their daily struggles against the sea. When he returned to America, he eventually settled in Prout's Neck, a rugged peninsula on the coast of Maine, where he produced some of his most dramatic marine studies. Painted in 1895, Northeaster is one of his best. The lack of figures and the close-up view with a high horizon give great immediacy and force to the rolling and breaking surf. The variegated tones of blue and green, the seething white foam and shooting spray, the turbulent green water against the leaden sky and gray and brown rocks show Homer's masterful use of a limited palette to powerful effect.

Oil on canvas, 34³/₈ x 50¹/₄ inches
Signed and dated (lower left, on rock):
HOMER/1895
The Metropolitan Museum of Art, Gift of George A. Hearn, 10.64.5

161 The Gulf Stream
Winslow Homer

Painted in 1899, The Gulf Stream is based on water-color studies that Homer made in the West Indies in 1885, and the brilliant color effects of his water colors have been successfully carried over in this oil. The dramatic scene of a Negro lying aboard a dismasted sloop, apparently oblivious to the nearby waterspout and circling sharks, is intensified by the vivid shades of green and blue of the stormy waters and the stark lighting. The critic Royal Cortissoz considered the picture "Homer's 'Raft of the Medusa' . . . his equivalent for the drama of a Gericault or a Delacroix." When Homer was asked to explain the subject for a perplexed group of ladies, he replied: "I regret very much that I painted a picture that requires any description. The subject . . . is comprised in *its title*. . . . I have crossed the Gulf Stream *ten* times & I should know something about it. The boat and sharks are outside matters of very little consequence. *They have been blown out to sea by a hurricane.* You can tell these ladies that the unfortunate negro who now is so dazed & parboiled, will be rescued & returned to his friends and home & ever after live happily."

Oil on canvas, 28¹/₈ x 49¹/₈ inches
Signed and dated (lower left): HOMER/1899.
The Metropolitan Museum of Art, Catharine Lorillard Wolfe Fund, 06.1234

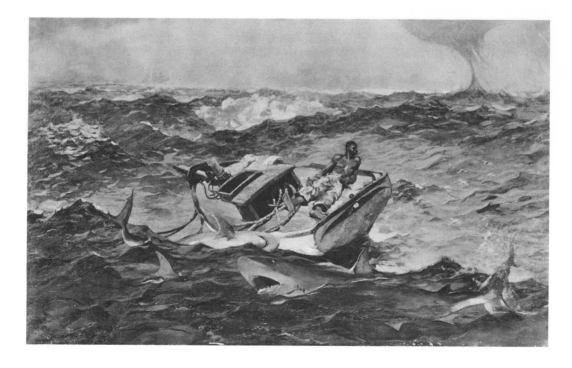

162 Arrangement in Grey and Black, No. 2: Portrait of Thomas Carlyle
James Abbott McNeill Whistler (1834–1903)

Whistler, considered the most avant-garde artist of his time because of his remarkable compositions and flamboyant life style, was born in Lowell, Massachusetts. He spent part of his childhood in Russia, where his father supervised the construction of the St. Petersburg-Moscow Railroad. He completed his education at West Point and in 1854/55 worked briefly for the Coastal and Geodetic Survey in Washington, learning the technique of etching. He went to Paris, made a name as an etcher, and found there the works that shaped his painting style: the cool, reserved portraits of Velázquez, brusquely painted scenes by Courbet, and Japanese prints, then being discovered in France.

In 1859 he moved to London and lived the rest of his life, first in the Wapping area of the docks and later in Lindsay Row, Chelsea, where he began his famous series of nocturnes. In 1872 Whistler exhibited his Arrangement in Grey and Black, No. 1: Portrait of the Artist's Mother, which he had been working on for several years. The picture was so admired by his Chelsea neighbor the Scottish philosopher and essayist Thomas Carlyle that he agreed to have his portrait painted in the same style and setting. Completed in 1872/73, the sensitive portrait pleased Carlyle, who was reported to have said that he saw in it "a certain *massive originality.*"

Whistler's picture of Carlyle, like many of his others, basically an arrangement of color and tone, softly drawn and dimly lit, ran counter to the carefully and traditionally constructed realistic literary and historical subjects turned out by the academic painters. When it was shown in London, the *Times* criticized it for the violation of "certain accepted canons about what constitutes good drawing, good colour, and good painting." Today the portrait is considered one of Whistler's finest works. In its assymetrical balance of forms taken from the Japanese, simple composition, and restrained silvery palette reminiscent of Velázquez, the portrait fulfills his intention to "put form and colour into such perfect harmony, that exquisiteness is the result."

Oil on canvas, 67³/₈ x 56¹/₂ inches
Signed (at right) with a butterfly in a circle
Glasgow Art Gallery and Museum, Purchased from the Artist by the Corporation of Glasgow, 1891

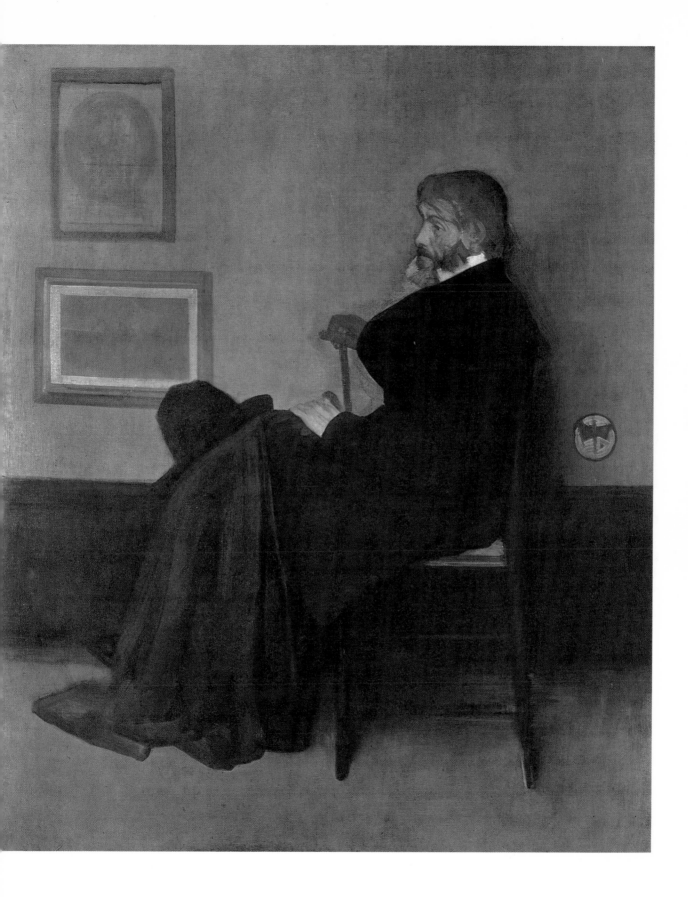

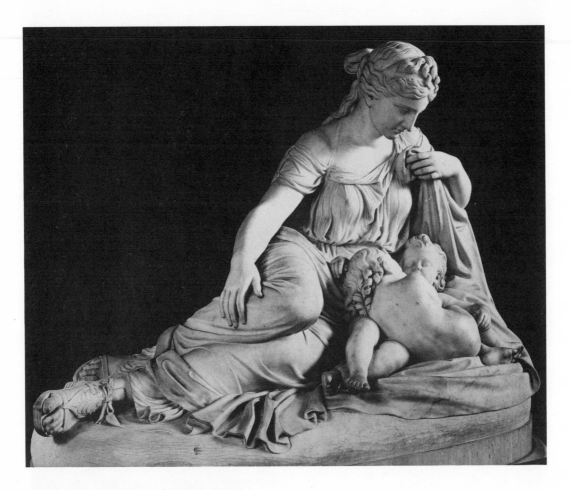

163 **Latona and Her Children, Apollo and Diana**
William Henry Rinehart (1825–1874)

Rinehart was born in Union Bridge, Maryland, the son of a prosperous farmer. As a youth he was apprenticed at a local quarry, and after moving to Baltimore in 1844, he worked in a stoneyard by day and attended art classes at the Maryland Institute by night. His sculpture attracted the attention of the merchant and collector William T. Walters, who financed his study in Italy. After two years in Florence and a brief visit to Baltimore, Rinehart opened a studio in Rome. Walters's patronage enabled him to devote most of his time to ideal works, one of his most famous being Latona, goddess of night, and her children by Jupiter. Commissioned in 1871, it was not completed until after his death in 1874. (The original plaster belongs to the Peabody Institute in Baltimore.) Lorado Taft, an

early historian of American sculpture and a sculptor himself, wrote that the group "is more than pretty sculpture; it has a measure of breadth and bigness. It shows . . . above all, dignity of conception and of treatment. . . . It may be added that few of our later sculptures possess the serene poetic charm of Rinehart's 'Latona.' " Rinehart left his estate in trust to provide for the education of young sculptors. The trust, considerably increased through the years, is still operative.

Marble, H. 46 inches
Signed and dated (on base): WM. H. RINE-HART / SCULPt. 1874 / ROME.
The Metropolitan Museum of Art, Rogers Fund, 05.12

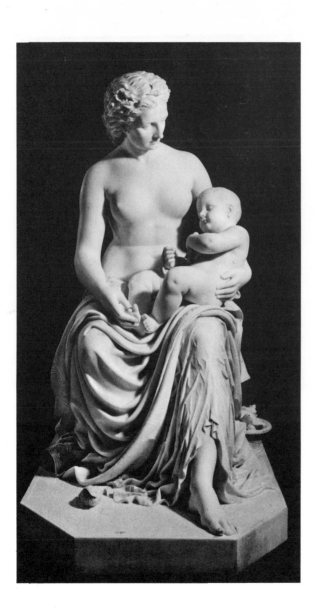

164 Thetis and Achilles

Pierce Francis Connelly (1841–after 1902)

Connelly, born in Louisiana, was educated in England and Italy. After attending the Ecole des Beaux-Arts in Paris and studying in Rome, he became a pupil of Hiram Powers, from whom he learned the craft of portrait sculpture and the composition of ideal subjects. One of the last exponents of the neoclassical style, Connelly carved Thetis and Achilles in 1874. Thetis, a sea goddess who married a mortal, is shown holding her son in her lap. Nude to the hips, her figure is smoothly modeled in the neoclassical manner, but the rather fussily handled hair and drapery show the influence of Beaux-Arts realism. Connelly successfully exhibited this group (with the title Thetis Thinking How She May Regain the Birthright of Her Son Achilles) and ten others at the 1876 Centennial Exposition in Philadelphia. There they must have formed a marked contrast to the new realistic American sculpture on display, particularly the works of Augustus Saint-Gaudens (see nos. 193, 194).

Marble, H. 56 inches
Signed and dated (back of rock): P. F.
Connelly/Fecit Flor 1874
The Metropolitan Museum of Art, Gift of Mrs.
A. E. Schermerhorn, 77.2

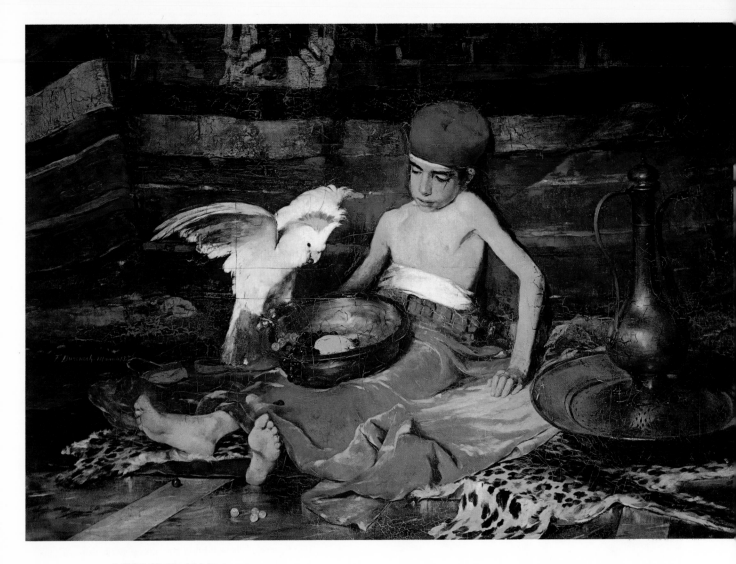

165 **The Turkish Page**
Frank Duveneck (1848–1918)

Born in Covington, Kentucky, Duveneck worked as a church decorator there and in Cincinnati before attending the Munich Academy in 1870 as a student of Wilhelm von Diez. The Turkish Page was painted in 1876 in the Munich studio of Duveneck's friend William Merritt Chase (see no. 172), whose taste for Oriental exoticism was well known and who probably supplied the props for this picture and possibly even influenced its subject. When it was exhibited at the National Academy of Design a year later, *The Art Journal* acknowledged that "the drawing and painting of the boy's limbs, the admirable texture of the bronze vessels, . . . the numerous perfect little pictures within the picture, are all very striking." But the *Journal* objected to "the excessive realistic attenuation of the boy's figure" and concluded: "It is a painting that would have placed

the painter on a very high plane had he but consented to believe that harshness is not a necessary element of strength, and that realism may be pushed to a repulsive extreme." The realism was chiefly the result of the influence of Wilhelm Leibl in Munich and the prevailing preoccupation there with the works of Hals, Velázquez, and Goya. The broad handling of paint and dramatic chiaroscuro appeared in American painting as a reaction to the tight and repetitious works of the entrenched older men, who fought to dismiss the new effects as willful and shabby.

Oil on canvas, 42 x 58¹/₄ inches
Signed and dated (lower left): F. Duveneck.
Munich. 1876
The Pennsylvania Academy of the Fine Arts,
Philadelphia

166 **Ralph Waldo Emerson**
Daniel Chester French (1850–1931)

A native of Exeter, New Hampshire, French attended the anatomy classes of William Rimmer in Boston. In 1876 he went to Italy for two years of study with Thomas Ball, followed in 1886 by further study with Marius-Jean-Antonin Mercié in Paris. Settling in New York, French became one of the leading figures in the American art world, producing numerous large public monuments. In 1903 he was elected a Trustee of the Metropolitan Museum, serving until his death as chairman of the Trustees' Committee on Sculpture.

"The more it resembles me, the worse it looks"—so philosopher Ralph Waldo Emerson is reported to have said as French modeled this bust from life in 1879. Previously Emerson had been instrumental in shaping French's career: it was largely through Emerson's efforts that Concord, Massachusetts, awarded French the commission for its Minute Man monument, which, completed in 1875, brought him almost immediate fame. It is therefore not surprising that his bust of Emerson is a strong and warmly conceived portrait. Emerson himself testified to the accuracy of the likeness: "Yes," he said, when shown the completed work, "that is the face I shave."

Bronze, H. 23 inches
Signed, dated, and inscribed (on base): D.C. FRENCH/1879/EMERSON
Founder's mark (on base): THE HENRY-BONNARD BRONZE CO./MT-VERNON. N.Y.
The Metropolitan Museum of Art, Gift of Daniel Chester French, 07.101

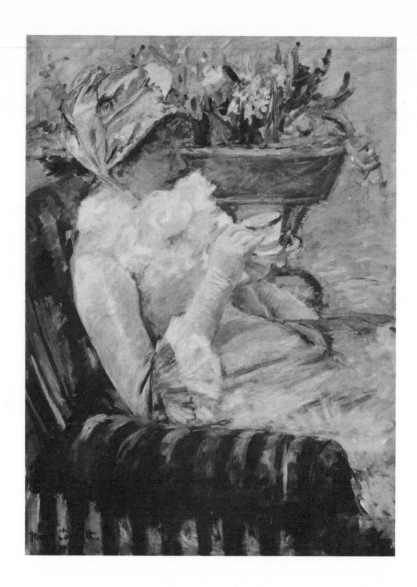

167 **The Cup of Tea**
Mary Cassatt (1844–1926)

Born in Allegheny City, Pennsylvania, the daughter of a successful broker, Mary Cassatt spent several years in Europe with her family as a young girl. Determined to become an artist, she attended the Pennsylvania Academy of the Fine Arts from 1861 to 1865, but the tediousness of the program caused her to leave and go to France in 1866. The Franco-Prussian War interrupted her stay. She returned to Europe in 1872 to study the works of Correggio, graphics and painting with Carlo Raimondi in Parma, and the paintings of Velázquez and Rubens in Spain, Belgium, and Holland before finally settling in Paris, where she met Degas. He invited her to join the impressionist group. Essentially self-

taught, she was the only American among the original members, exhibiting with them in the late 1870s. The Cup of Tea, completed in 1879, shows her sister, Lydia, dressed in a pink gown, gloves, and bonnet, sitting in a striped armchair. In this freely painted canvas, Mary Cassatt captures the subject in an intimate close-up, establishing a mood of casual bourgeois elegance and pleasure that appealed strongly to contemporary French and American taste.

Oil on canvas, 36³/₈ x 25³/₄ inches
Signed (lower left): Mary Cassatt
The Metropolitan Museum of Art, Anonymous Gift, 22.16.17

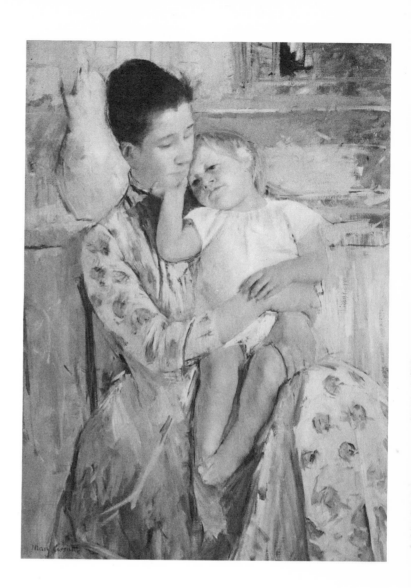

168 Mother and Child
Mary Cassatt

After becoming a member of the impressionist group, Mary Cassatt told Achille Segard, her biographer: "At last, I could work with absolute independence without considering the opinion of a jury. I had already recognized who were my true masters. I admired Manet, Courbet and Degas." In 1878 she was invited by J. Alden Weir to exhibit with the newly formed Society of American Artists, an organization founded by young European-trained artists like William Merritt Chase and Frank Duveneck in opposition to the conservative National Academy of Design. Attracted by their independence, she contributed two paintings the following year and became a member. Hers are among the earliest impressionist paintings shown in America, and she was instrumental in advising several collectors, particularly Louisine Havemeyer, to purchase impressionist pictures. Mother and Child, of about 1890, represents a recurring theme in Mary Cassatt's work, in which maternity is perceptively expressed with warmth, intimacy, and naturalness without sentimental overtones. It is painted in luminous yellows, flecked with red, in a high-key palette characteristic of impressionism.

Oil on canvas, 35¹/₂ x 25¹/₂ inches
Signed (lower left): Mary Cassatt
Wichita Art Museum, The Roland P. Murdock Collection

169 La Toilette
Mary Cassatt

In the spring of 1890 an exhibition of Japanese prints opened at the Ecole des Beaux-Arts in Paris, and although Japanese prints had appeared earlier in France, this collection had considerable impact on Parisian artists. Mary Cassatt visited the show several times with Degas and Berthe Morisot and subsequently acquired prints by Utamaro, Hokusai, and others. From 1890 to 1891 she worked on a series of ten color prints, inspired by the Japanese, and exhibited them at her first one-man show at the Durand-Ruel Gallery. The discipline she imposed upon herself by working in graphics, the concentration on color, line, structure, and pattern, permeated her painting. The effects are best seen in *La Toilette* ("The Bath"), done about 1891. The emphasis on the flat picture plane through the use of strong linear effects, patterning, simple color areas, marked silhouetting, and a shallow space are witness to her new interest. The superb pictorial arrangement and sympathetic portrayal of a woman at once embracing and washing a child make this work particularly appealing.

Oil on canvas, 39¹/₂ x 26 inches
Signed (lower left): Mary Cassatt
The Art Institute of Chicago, Robert A. Waller Fund

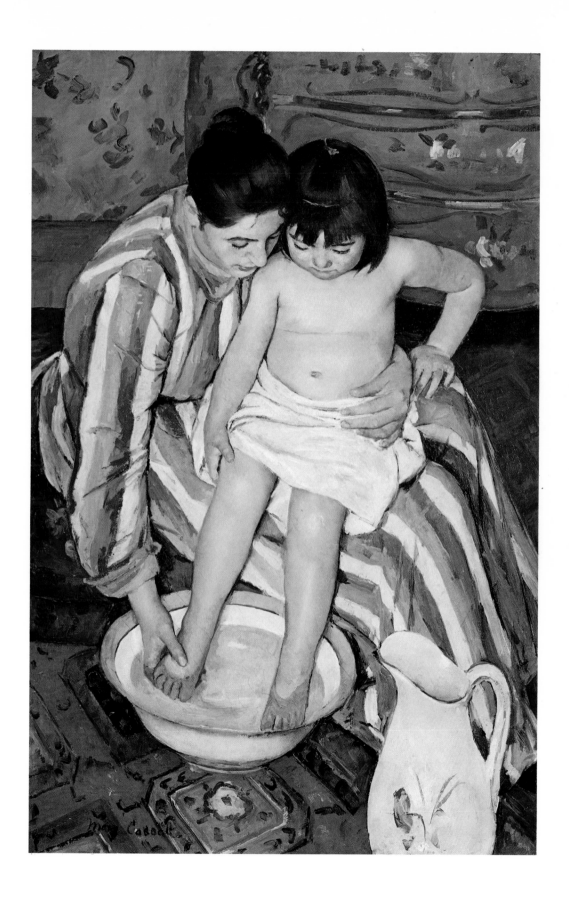

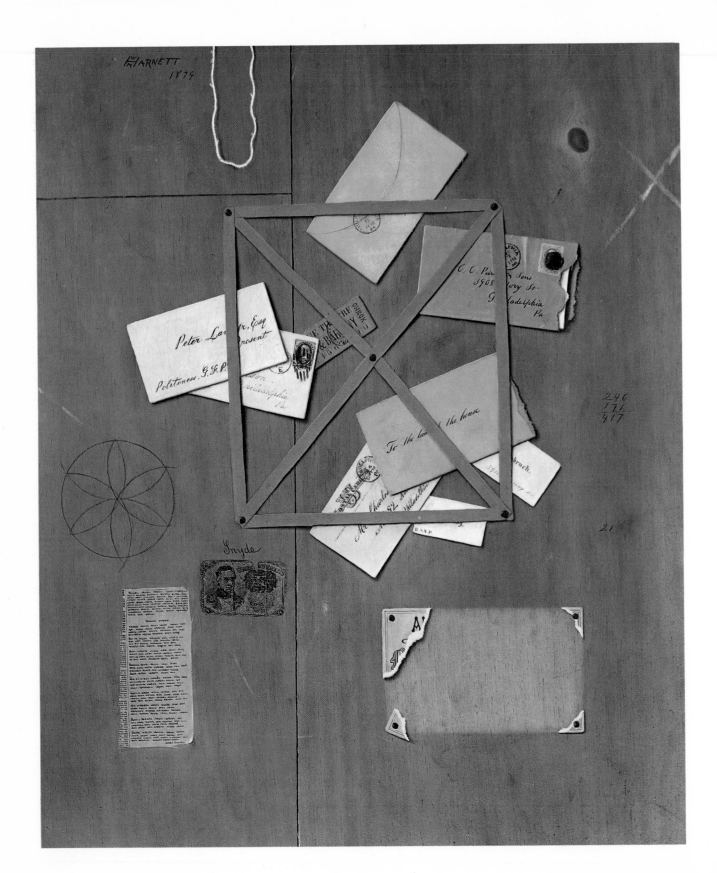

170 The Artist's Card Rack
William Michael Harnett (1848–1892)

Born in Ireland, Harnett was brought to America as an infant. During the late 1860s and early 70s, while attending the Pennsylvania Academy of the Fine Arts, Cooper Union, and the National Academy of Design, he supported himself as a silver engraver. In 1875 he gave it up to make painting his profession. In spite of his academic training, his mature style, with its sensitive textural effects and vivid trompe-l'oeil technique, was developed independently but owes a great debt to Raphaelle Peale (see no. 23), whose works he had seen in Philadelphia. The Artist's Card Rack, painted in 1879, ranks among Harnett's most successful pictures, exhibiting his fine color sense, flair for composition, and taste for curious subject matter. The card-rack motif has European precedents and was used on at least one occasion by Raphaelle Peale and numerous times by John F. Peto. Envelopes, calling cards, a post card, and theater ticket are tucked under tapes tacked to a subtly grained panel, which bears chalk and pencil marks, the remnants of a label, a clipping, a compass rosette, a piece of string, and currency issued during the Civil War. The inscriptions for the most part are so fragmentary or so obscured as to remain tantalizingly illusive, but it has been suggested that "Snyde" refers to the painting's first owner, a Philadelphia wool merchant named Israel Reifsnyder. The only other known rack picture by Harnett, identical in size, was painted in 1888.

Oil on canvas, 30 x 25 inches
Signed and dated (upper left): WMH (monogram) ARNETT/1879.
The Metropolitan Museum of Art, Morris K. Jesup Fund, 66.13

171 After the Hunt
William Michael Harnett

In 1880 Harnett went to Europe, remaining four years in Munich, a mecca for American artists of this period. Unsatisfied with the bravura technique taught at the Academy, he returned to his more meticulous method of working. Painted in Munich in 1883, this first version of After the Hunt marks the high point of his art, utilizing the full extent of his illusionistic skill in a masterful arrangement of well-used hunting equipment, old sword with an ivory handle, game birds, Tyrolean hat, and sheaf of grain against a door bearing decorative hardware. Harnett once remarked that his "chief difficulty" was not the grouping of his models "but their choice. . . . As a rule, new things do not paint well. . . . I want my models to have the mellowing effect of age." A Munich critic, while acknowledging the "astonishing powers of observation and imitation" in this still life, noted: "For us this is . . . far too painstaking in its orderliness, so that its painterly effect is impaired." After producing two more versions, Harnett, determined to test his work in a "higher court," went to Paris and spent three months painting a final one, now in the California Palace of the Legion of Honor. Accepted by the Paris Salon of 1885, the picture was highly praised in the press, and has since become his most celebrated work.

Oil on canvas, 52½ x 36 inches
Signed and dated (lower left): WMH (monogram) ARNETT./Munchen/1883
The Columbus Gallery of Fine Arts, Columbus, Ohio, Gift of Francis C. Sessions

172 In the Studio

William Merritt Chase (1849–1916)

Chase, born and raised in Indiana, studied in the Midwest before attending the National Academy of Design in New York. In 1872 he went to Munich to the Academy, where he absorbed the current taste for Spanish and Dutch painting, as well as the flamboyant handling of paint exemplified in the stylish figure and still-life compositions of Wilhelm Leibl. Chase returned to New York in 1878, a recognized artist, to teach at the Art Students League, established in opposition to the conservative National Academy, and over a long career he probably guided more students than any other American painter. A frequent traveler and tireless collector, he filled his Tenth Street studio with bizarre objects and aesthetic paraphernalia. In 1879 a reporter for *The Art Journal* mentioned Chase's

pictures, hangings, books, furniture, armor, weapons, musical instruments, "quaint jars, Egyptian pots, paint-brushes, strange little wood-carvings of saints, Virgins, crucifixes, and many other articles too varied to specify." In the Studio, painted about 1880, documents Chase's taste for the exotic as well as his mastery of color, texture, and dashing brushwork. He dazzles the eye with glittering surface highlights and bright color accents, which act as counterpoint to the somber background of floor and chest. As pure painting and frank self-advertisement, it is a remarkable accomplishment.

Oil on canvas, 28¹/₂ x 40¹/₄ inches
Signed (lower right): Wm. M. Chase
The Brooklyn Museum, Gift of Mrs. C. H. De Silver, in memory of her husband

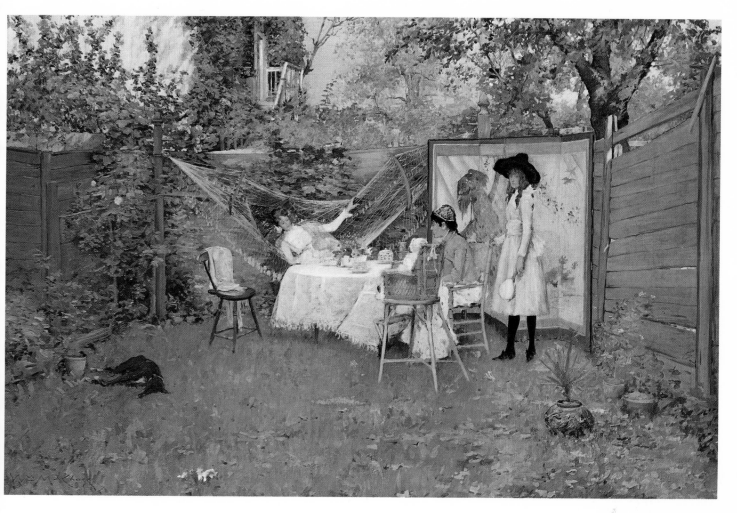

173 **The Open Air Breakfast**
William Merritt Chase

In the late 1880s, stimulated by his move to Brooklyn's Prospect Park area, Chase began painting park and garden scenes, usually with figures. Travels to England, where he met Whistler, and to the Continent had resulted in his adoption of a light impressionistic palette, better suited to his brightly lit outdoor subjects. The Open Air Breakfast, painted about 1888, combines Chase's new enthusiasm for the out-of-doors with his continued fascination for the exotic. It shows the painter's youthful wife and new baby seated at table, with one of his sisters-in-law reclining in a string hammock and another standing before a Japanese screen, battledore in hand, wearing a seventeenth-century Dutch-style hat. One of Chase's lanky Russian

hounds is stretched out on the grass. The canvas presents a delicious mixture of brushstrokes in springlike colors and the seemingly casual composition characteristic of his finest work. Although his talent was eclectic—his work was at various times close to that of Frank Duveneck, Manet, Mariano Fortuny, Whistler, or, especially in brushwork, to Sargent—he was a master of technique and a keen observer, whose zest for the pleasures of life is always reflected in his pictures.

Oil on canvas, 37¹/₂ x 56³/₄ inches
Signed (lower left): Wm. M. Chase
The Toledo Museum of Art, Gift of Florence Scott Libbey, 1953

174 **The Road to Concarneau**
William Lamb Picknell (1853–1897)

Born in Hinesburg, Vermont, Picknell received most of his painting instruction abroad, studying with George Inness in Rome and with Jean-Léon Gérôme in Paris. In 1876 he joined the small international artists' colony in the fishing village of Pont-Aven in Brittany. Here he worked with the Anglo-American painter Robert Wylie, whose impressionistic use of the palette knife contributed greatly to Picknell's own technique. Concarneau is a fishing port about eighteen miles from Pont-Aven and is a commercial center for the department of Finistère. The Road to Concarneau was painted in 1880 and that year won an honorable mention at the Paris Salon. It shows a colorful Brittany peasant motif of the type often painted by Wylie, but the depth of perspective, strong composition, and vibrant light and atmosphere are characteristic of Picknell's vigorous style. As described by Picknell's biographer, William Howe Downes, "His style is naturalistic and large; the construction is notably firm, and there is an invigorating atmosphere in his canvases of fresh air and strong sunlight."

Oil on canvas, 42³/₈ x 79³/₄ inches
*Signed and dated (lower right): W. L. Picknell/
1880*
The Corcoran Gallery of Art, Washington

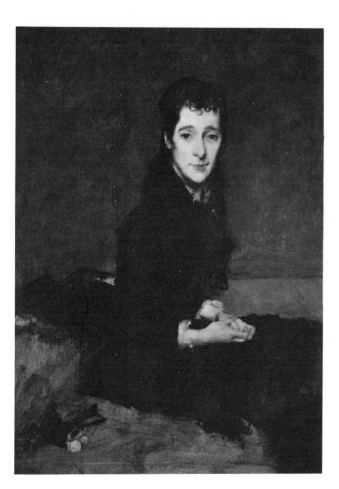

175 **Mrs. Charles Gifford Dyer**
John Singer Sargent (1856–1925)

Sargent was the son of cultivated parents, who, living and traveling in Europe, exposed him not only to cosmopolitan society and the holdings of important museums, but to the pleasures of keeping a sketchbook as well. Born and raised in Florence, he received art training in that city before entering, in 1874, the Paris atelier of the prestigious portraitist Emile Auguste Carolus-Duran. There Sargent learned the brilliant handling of paint and elegant posing of subjects that became key elements in his portraiture. Success came rapidly to him in the late seventies for his bright genre scenes and portraits of Parisian society figures. His pictures have often been criticized for their psychological superficiality, but in sensitive portrayals like this one of Mrs. Charles Gifford Dyer, he shows himself capable of considerable insight. Mrs. Dyer, the wife of an American painter working in Europe, is depicted as a wispy beauty, seated uneasily and glancing waveringly upward. Sargent has prophetically caught in the face and pose the emotional frailty of Mrs. Dyer, who shortly afterward went insane.

Oil on canvas, 24³/₈ x 17¹/₄ inches
Inscribed (across top): To my friend Mrs. Dyer John S. Sargent Venice 1880
The Art Institute of Chicago, Friends of American Art Collection

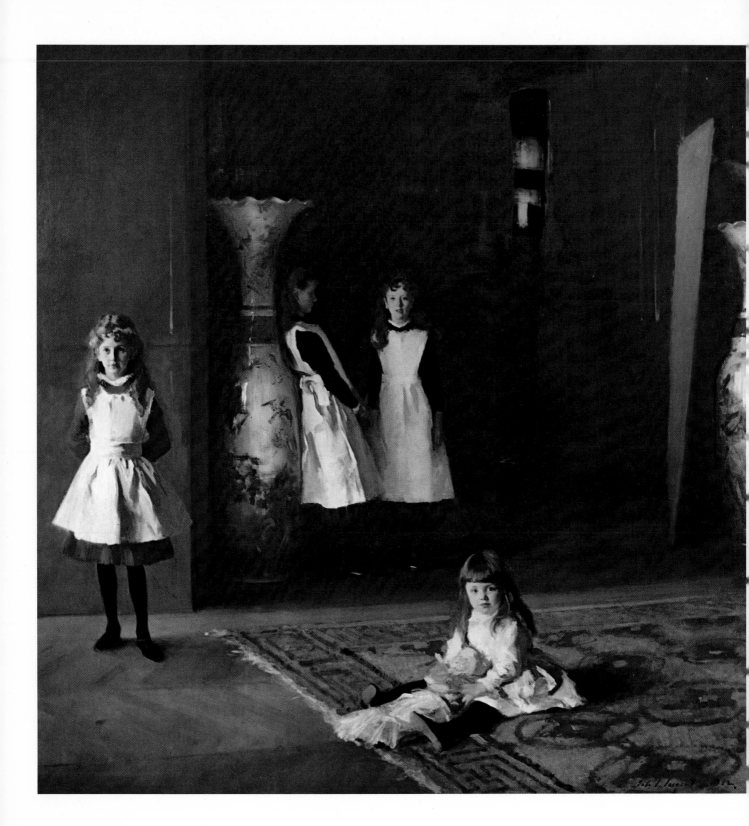

176 Daughters of Edward Darley Boit
John Singer Sargent

In late 1879 Sargent traveled from Paris to Spain and Morocco, stopping in Madrid where he saw the paintings of Velázquez. He was especially impressed by the group compositions *Las Hilanderas* and *Las Meninas,* which he copied. Their example of a large format, several strongly set figures in a deep and mysterious interior, forceful lighting, and cool, rich coloring markedly affected his own portraiture, deflecting it in the direction of genre. In 1882 Sargent painted this portrait of the four daughters of his landscape painter friend, Edward Darley Boit, in the latter's Paris apartment, which included among the furnishings these large Japanese vases and matching rug. When the painting was shown at the 1883 Salon, critics objected to the bare composition and the isolation of the figures in the large space. It was these features, however, that enabled Sargent to focus individually and sympathetically on each child.

Henry James considered this one of Sargent's finest works and wrote of it in *Harper's New Monthly Magazine* in 1887: "The artist has done nothing more felicitous and interesting than this view of a rich, dim, rather generalized French interior . . . which encloses the life and seems to form the happy play-world of a family of charming children. The treatment is eminently unconventional, and there is none of the usual symmetrical balancing of the figures in the foreground. The place is regarded as a whole; it is a scene, a comprehensive impression; yet none the less do the little figures in their white pinafores . . . detach themselves, and live with a personal life." Sargent himself said of the painting: "There is no real composition at all, merely an amateurish sort of arrangement that could find its rebuke in any good Japanese print."

Oil on canvas, 87 x 87 inches
Signed and dated (lower right): John S Sargent 1882
Museum of Fine Arts, Boston, Gift of Mary Louisa Boit, Florence D. Boit, Jane Hubbard Boit, and Julia Overing Boit, in memory of their father

177 Venetian Interior
John Singer Sargent

Venetian Interior is one of many scenes of Venice, done after Sargent visited the city in 1880 and 1882. Sargent took rooms in the Palazzo Rezzonico, then an artists' residence, during his first trip, and in the Palazzo Barbaro during his second. This picture has been given the subtitle "The Rezzonico," but because of its traditional date, 1882, it might depict the Palazzo Barbaro or some other building. In 1887 in *Harper's New Monthly Magazine* Henry James aptly described this or a similar sketch: ". . . a small group of Venetian girls of the lower class, sitting in gossip together one summer's day in the big, dim hall of a shabby old palazzo. The shutters let in a clink of light; the scagliola pavement gleams faintly in it; the whole place is bathed in a kind of transparent shade; the tone of the picture is dark and cool. . . . The figures are extraordinarily natural and vivid; . . ." Sargent dedicated the picture to a fellow impressionist, Jean Charles Cazin.

Oil on canvas, 19 1/16 x 23 15 /16 inches
Signed and inscribed (lower right): to my friend J. C. Cazin/John S. Sargent
Sterling and Francine Clark Art Institute, Williamstown, Massachusetts

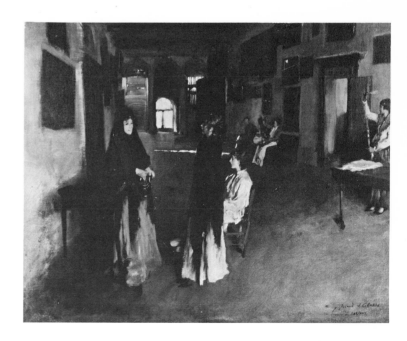

Madame Gautreau, born Judith Avegno in New Orleans, married a Parisian banker and became one of the city's notorious beauties during the 1880s. Sargent probably met her in 1881. Impressed by her charms and theatrical use of heavy lavender make-up, he determined to paint her. In 1882 he wrote: "I have a great desire to paint her portrait and have reason to think she would allow it and is waiting for someone to propose this homage to her beauty." Work began the following year, but was attended by delays and numerous reworkings of the canvas. At one point Sargent referred dejectedly to "the unpaintable beauty and hopeless laziness of Madame Gautreau." Appropriate to her reputation for attracting men, Mme. Gautreau wears a crescent-moon headdress, symbol of Diana, goddess of the hunt. The picture was shown at the 1884 Salon with the title *Portrait de Mme. . . .*, to avoid the indelicacy of mentioning the sitter's name, and was given a scathing reception by reviewers critical of the impropriety of her dress and the blue-gray color of her skin. Sargent finally withdrew it from exhibition. The portrait lacks the bravura brushwork of many of his major pictures, partly because of the many reworkings, but the elegant pose and outline of the figure, recalling Sargent's debt to Velázquez, make it one of his most striking canvases. When he sold it to the Metropolitan Museum in 1916, Sargent wrote: "I suppose it is the best thing I have done."

Oil on canvas, 82¹/₈ x 43¹/₄ inches

Signed and dated (lower right): John S. Sargent 1884

The Metropolitan Museum of Art, Arthur Hoppock Hearn Fund, 16.53

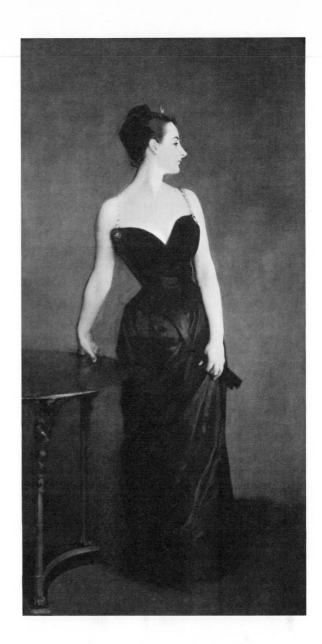

179 Steelworkers Noontime
Thomas Pollock Anshutz (1851–1912)

Anshutz moved with his family from his birth-place in Kentucky to Philadelphia in 1870. The following year he enrolled in the National Academy of Design in New York and in 1876 entered the Pennsylvania Academy of the Fine Arts to study under Thomas Eakins. Ten years later he succeeded Eakins as instructor and taught there the rest of his life. Among his pupils were Robert Henri, George Luks, William Glackens, and John Sloan. Anshutz thus links the teaching tradition of Eakins with the Ashcan school and its descendants. This powerfully painted and arranged picture, originally known as The Ironworkers' Noontime, was probably done about 1882, when Anshutz was Eakins's assistant at the Academy. Exhibited in New York in 1883, it was lavishly praised by the critics and engraved and published in a leading journal as "a representative American art work of the year." It shows Eakins's influence in the careful study of anatomy, conscious posing of the figures—derived from the study of photographs—cloudy sky, and subdued colors (compare no. 154). However, the industrial landscape, strong geometrical design with a diagonal perspective, and even application of paint look forward to Edward Hopper and the precisionists, such as Anshutz's pupils Charles Demuth and Charles Sheeler, in the twentieth century.

Oil on canvas, 17 x 24 inches
Signed (lower left): Thos. Anshutz
Dr. and Mrs. Irving F. Burton, Huntington Woods, Michigan

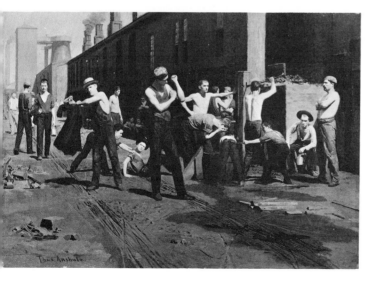

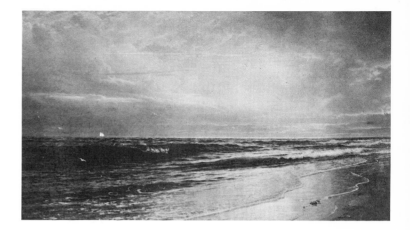

180 On the Coast of New Jersey
William Trost Richards (1833–1905)

Richards, a Philadelphia-born artist, went abroad in 1853 to study in Florence, Rome, and Paris. His decisive experience abroad was his exposure to the ideas of John Ruskin and the Pre-Raphaelites. For many years Richards was the most productive Ruskinian naturalist among American artists, consistently trying to give each object in his landscapes and still lifes its most precise form and greatest intensity of local color. About 1867 he witnessed a storm at sea off New Jersey, and it led to his intensive study of waves along the coast and ultimately to his painting of seascapes. On the Coast of New Jersey, dated 1883, is a fine example of Richards's talent for depicting water and stretches of breaking waves. While retaining a literal fidelity to nature, he was still able to create a certain grandeur of effect that makes his marine paintings his most satisfying works. Richards's fascination for his subject led him to reduce his compositions to the simplest elements—bands of sky, water, and sand—and to emphasize variations of light and texture.

Oil on canvas, 40¼ x 72¼ inches
Signed and dated (lower right): Wm T. Richards. 1883.
The Corcoran Gallery of Art, Washington

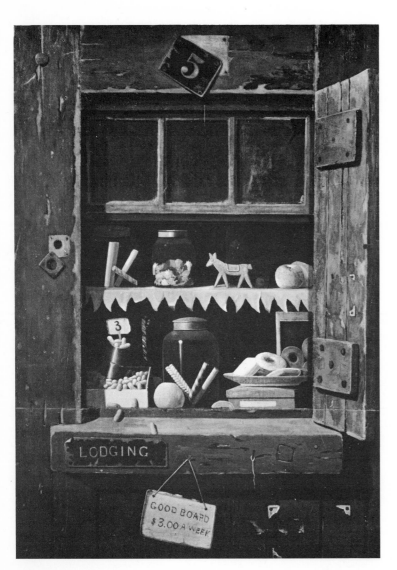

181 The Poor Man's Store
John Frederick Peto (1854–1907)

Born in Philadelphia, Peto was first listed as a painter in the Philadelphia directory of 1876. Two years later he was enrolled as a student at the Pennsylvania Academy of the Fine Arts. The primary influence upon his painting was the work of William M. Harnett (see nos. 170, 171), whom Peto met in Philadelphia between 1876 and 1880. The extent of this influence is demonstrated by the number of Peto's paintings—with forged Harnett signatures—that were successfully sold as Harnett's until Alfred Frankenstein, in an article in the March 1949 *Art Bulletin,* distinguished Peto's work from Harnett's and gave it deserved recognition. While following Harnett's choice of subject and iconography, Peto worked in a broader style. The Poor Man's Store, completed in 1885, is a theme that Peto had used before, and which is related in its scarred, time-worn woodwork, label remnants, pieces of string, and lettered signs to his office-board and rack paintings, done in the late 1870s and the 80s. This picture reveals his interest in the careful arrangement of simple objects and in the effects of a direct light source upon them. The concern for light and the soft contours, with the subordination of intrinsic textural qualities to pictorial effect, distinguishes Peto's paintings from the more generally lit, carefully detailed, and harder paintings of Harnett, and mark him as an artist of considerable accomplishment.

Oil on canvas and wood, 36 x 25¹/₂ inches
Signed and dated (upper left): J.F. Peto/85
Museum of Fine Arts, Boston, M. and M. Karolik Collection

182 **Arques-La-Bataille**

John Henry Twachtman (1853–1902)

Born in Cincinnati, Twachtman received his early training there, attending evening drawing classes at the Ohio Mechanics Institute until 1871 and then entering the McMicken School of Design. He subsequently met Frank Duveneck and under his influence enrolled in the Munich Academy in 1875 to study with Ludwig Loefftz. He accompanied Duveneck and William Merritt Chase to Venice on a painters' outing in 1877, and returned the following year to America. Two years later he joined the teaching staff of Duveneck's school in Florence and subsequently toured Holland, painting with J. Alden and John F. Weir. Between 1883 and 1885 Twachtman studied at the Académie Julian in Paris, spending the summers painting outdoors with Childe Hassam, Theodore Robinson, and others on the Normandy coast. The high point of his work of this

period is the stately landscape Arques-La-Bataille, done in 1885. The dark palette, strong contrasts, heavy impasto, and facile brushstroke of his Munich works are replaced by a restricted palette of subtle grays, greens, and blues with gradual tonal transitions, and large forms of equal density serving as a ground for strongly calligraphic motifs. The painting, reflecting the influence of Whistler's suave style, reduces pictorial elements to the barest essentials. The visual idiom is poetic in its simplicity and highly evocative in mood.

Oil on canvas, 60 x 78⁷/₈ inches
Signed and dated (lower left): J. H. TWACHT-MAN./1885/PARIS
The Metropolitan Museum of Art, Morris K. Jesup Fund, 68.52

183 Le Jour du Grand Prix
Childe Hassam (1859–1935)

A leading exponent of American impressionism and one of the founders of the Ten American Painters group, Hassam was born in Dorchester, Massachusetts. After leaving high school, he worked briefly in an accounting office and then for a commercial wood engraver. He also illustrated books and contributed to periodicals. His art studies included life classes at the Boston Art Club and lessons at the Lowell Institute and with the German artist Ignaz Gaugengigl. On his second trip to Europe in 1886, Hassam settled in Paris, where he found that his chief interest was not in the conservative teachings of the Académie Julian, where he was enrolled, but in impressionism, then at its height in the city. Le Jour du Grand Prix, painted in Paris in 1887, shows the crowds on their way to the great horse race held at Longchamps on the last Sunday in June, an event that also marks the beginning of the summer season. Here Hassam shows himself thoroughly committed to the impressionist aesthetic in his selection of an eccentric viewpoint with sharp cutting off of the picture plane, use of a diagonal perspective, and creation of a large expanse of open foreground broken only by the cast shadow at the right. The effect of a fragmentary, fast-changing spectacle is enhanced by the rapid brushstroke. Hassam painted a larger version, now at the New Britain Museum of American Art.

Oil on canvas, 24 x 34 inches
Signed and dated (lower left): CHILDE HASSAM (preceded by a crescent) PARIS 1887
Museum of Fine Arts, Boston, Ernest Wadsworth Longfellow Fund

184 Fiacre, Rue Bonaparte, Paris
Childe Hassam

Hassam painted Fiacre, Rue Bonaparte, Paris, in 1888, the year before he returned to America. Here the city, a frequent impressionist theme, is seen under the special conditions of a rainy day. The subtle properties of the gleaming wet pavement and rain-washed umbrellas are explored with great freedom in rapidly applied brushstrokes. In this picture Hassam demonstrates his abilities as a draughtsman and a painter through his intense awareness of surface textures—both of things and of the paint itself.

Oil on canvas, 41 x 30¹/₂ inches
Signed (lower left): Childe Hassam
Mr. and Mrs. Irving Mitchell Felt, New York

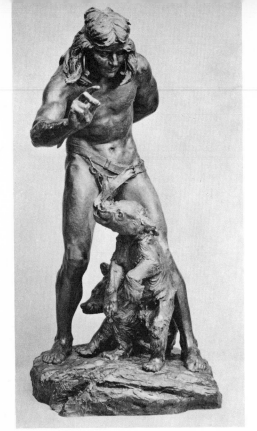

185 Bohemian Bear Tamer
Paul Wayland Bartlett (1865–1925)

Born in New Haven, Connecticut, the son of a sculptor, Bartlett spent the greater part of his life in Paris. He studied at the Ecole des Beaux-Arts and later became a pupil of the animal sculptor Emmanuel Frémiet. Bartlett's most important commission was the equestrian statue of Lafayette completed in 1907 and eventually set up in the court of the Louvre. Greatly admired, it was considered to be a reciprocal gift to France for the Statue of Liberty. He sculpted the Bohemian Bear Tamer in 1887, when he was twenty-two. His choice of an American Indian boy and a pair of cubs was in keeping with the ethnographical and *animalier* interests of the late nineteenth-century French sculptors and the desire of American artists to represent American themes. Here he has combined fully modeled forms, varied surfaces, and a popular subject to produce an appealing work.

Bronze, H. 68¹/₂ inches

Signed and dated (on base): Paul. W. Bartlett./87

Founder's mark (on base): GRUET FONDEUR/ PARIS

The Metropolitan Museum of Art, Gift of an Association of Gentlemen, 91.14

186 Bird's Eye View—Giverny
Theodore Robinson (1852–1896)

Born in Vermont, Robinson studied in Chicago and in New York at the National Academy of Design before going abroad in 1876 to continue his training with Emile Auguste Carolus-Duran and Jean-Léon Gérôme. Returning to America in 1879, he taught and did decorative work for John La Farge and later assisted Prentice Treadwell in decorating the Metropolitan Opera. He went back to Europe in 1884 and remained, except for brief trips home, for eight years. In 1887 Robinson painted at Giverny, a Norman village on the Seine near Vernon, where his close friend Claude Monet worked. Bird's Eye View—Giverny was done on a return visit there in 1889. Although Robinson was quick to state he was not a pupil of Monet, his pictures of this period were clearly painted under Monet's influence. The light pastel palette, built-up impasto, and hazy atmosphere found in this work are part of the impressionist aesthetic, but the almost topographical linearity, solidity of form, and descriptive realism belong to the American landscape tradition.

Oil on canvas, 26 x 32¹/₄ inches

Signed and dated (lower left): TH. ROBINSON —1889

The Metropolitan Museum of Art, Gift of George A. Hearn, 10.64.9

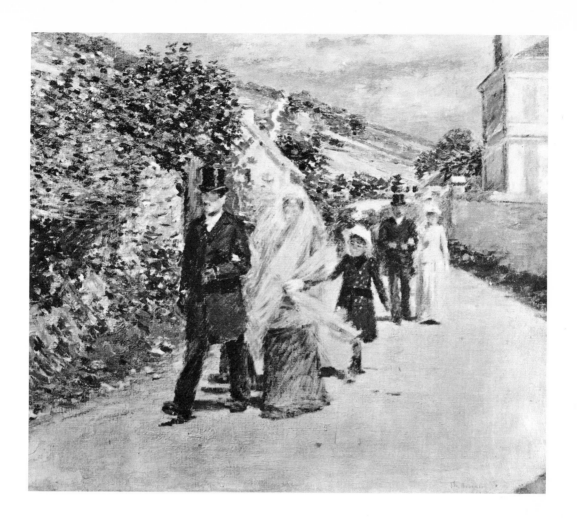

187 **The Wedding March**
Theodore Robinson

In his diary for May 1892, Robinson's last year in France, he expressed the fear of "an insufficient rendering of things—I must strive for more completeness, grasp. Less foolish scumbling with tones somewhere near, a greater integrity of endeavor, of touch, at all stages of the work." This resolution sets the ambience for The Wedding March and suggests his dissatisfaction with the loss of concreteness inherent in the techniques of impressionism. The wedding in Giverny the following August of a friend named Butler provided Robinson with the jaunty subject matter for one of his most successful pictures. The bright summer foliage, glistening sunlight, and sprightly participants are treated impressionistically, but the clarity of drawing and rather abrupt diagonal composition suggest that Robinson had achieved the "completeness" of form he sought.

Oil on canvas, 22 x 26 inches
Signed (lower right): Th. Robinson
Mrs. John Barry Ryan, New York

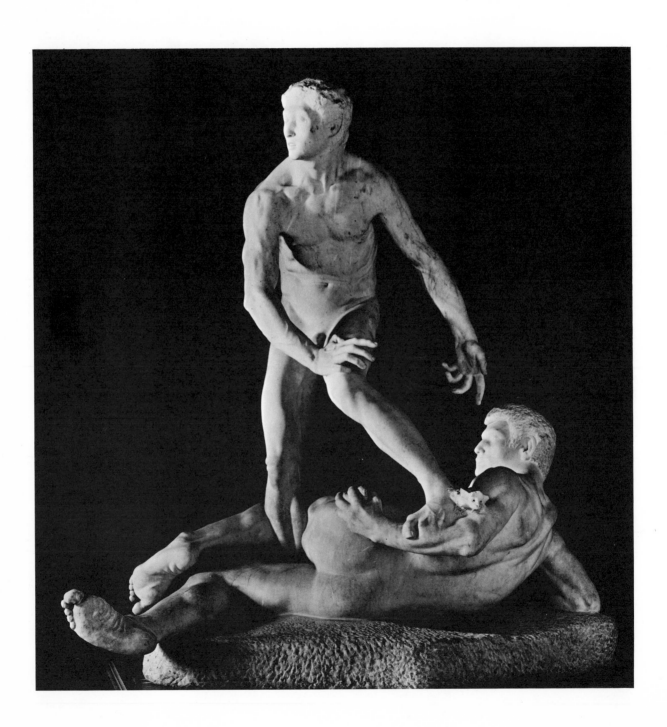

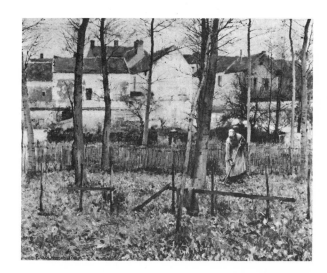

188 **Struggle of the Two Natures in Man**
George Grey Barnard (1863–1938)

Barnard was a Pennsylvanian who went to Paris at the age of twenty to study sculpture. After two years at the Ecole des Beaux-Arts, he opened a studio in Paris and worked there for the next ten years, enjoying the patronage of Alfred Corning Clark, the American businessman and collector. Not attracted to French academic sculpture, Barnard was influenced by Michelangelo and Rodin. Today he is remembered primarily for his collection of Romanesque and Gothic sculpture, which eventually became the nucleus of the Metropolitan Museum's collection of medieval art, now at The Cloisters. Struggle of the Two Natures in Man, his best-known work, was begun in 1888. The model was finished in 1891. Shortly after it was cast in plaster, Clark commissioned Barnard to execute it in marble. Completed in 1894, the group was sent to the Paris Salon, where it was exhibited as *Je sens deux hommes en moi* ("I feel two beings within me"), the title of a poem by Victor Hugo. Rodin was among those who praised the sculpture, which was admired for its great expressiveness and moral power. Barnard himself explained the work: "The young man just facing life has no conception of his higher self, his oneness with the Divine. But . . . as soon as his sense of immortality is born, then he begins to cast off the earthly and reach up toward the stars."

Marble, H. 101¹/₂ inches
The Metropolitan Museum of Art, Gift of Alfred Corning Clark, 96.11

189 **November**
Robert William Vonnoh (1858–1933)

Born in Hartford, Connecticut, Vonnoh moved to Boston as a boy and entered the Massachusetts School of Art. In 1881 he went to Paris to study at the Académie Julian and later was in Paris from 1886 to 1890. Subsequently at the Pennsylvania Academy of the Fine Arts, he was the teacher of many notable artists including Robert Henri, John Sloan, and William Glackens. Vonnoh was one of a group of distinguished American impressionists, and his art derived ultimately from Monet's in its use of broken color and depiction of illusory light. November was painted at the end of Vonnoh's second stay in Paris, when he devoted himself to the study of the figure out-of-doors. With its subtle harmonization of varying hues and continuous, diffused source of light, the picture reveals him as a painter of the serene aspects of nature.

Oil on canvas, 32 x 40¹/₂ inches
Signed and dated (lower left): R. W. Vonnoh 1890
The Pennsylvania Academy of the Fine Arts, Philadelphia

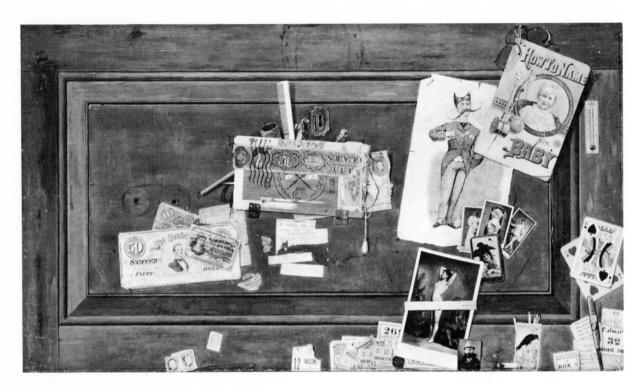

190 **A Bachelor's Drawer**
John Haberle (1856–1933)

Haberle is acknowledged today, along with William M. Harnett and John F. Peto, as one of the most accomplished trompe-l'oeil painters who worked at the end of the nineteenth century. He was born in New Haven, Connecticut, where he lived most of his life. For a time he studied at the National Academy of Design in New York. Subsequently he prepared exhibits for O. C. Marsh, the Yale paleontologist, from whom he learned the objectivity and precise techniques of reproducing different surfaces in paint that later distinguished his art. A Bachelor's Drawer, done between 1890 and 1894, is Haberle's best-known work. It shows his delight in assembling an amusing and incongruous assortment of objects: old banknotes, stamps, a tintype self-portrait, a cigar-box lid, playing cards, a "girly" photo, and a *How to Name the Baby* book cover. There are also three newspaper clippings describing accusations actually made against Haberle, that he pasted real objects onto his canvases. A fourth clipping and a cluster of paper currency refer to charges of counterfeiting leveled against his painted money by a Chicago critic. Depicting mostly two-dimensional objects in an extremely shallow space and meticulously drawing each detail, Haberle created a remarkable illusion of reality.

Oil on canvas, 20 x 36 inches
Signed and dated (upper left): • HABERLE • 1890-94
Mr. and Mrs. J. William Middendorf II, New York

191 **Nathan Hale**
Frederick William MacMonnies (1863–1937)

MacMonnies was born in Brooklyn. As a boy he amused himself by modeling small wax figures; at eighteen, after working briefly as a clerk and attending art classes at Cooper Union, he became a studio handy man for Augustus Saint-Gaudens. Later promoted to assistant, he began studying evenings at the Art Students League and the National Academy of Design. In 1884 MacMonnies went to Munich and to Paris, where he was a pupil of the academic sculptors Jean-Alexandre-Joseph Falguière and Marius-Jean-Antonin Mercié. He was successful and remained in Paris, except for two years in New York, until the First World War, busily completing works commissioned by Americans. One of these, done in 1890, was the statue of Nathan Hale for City Hall Park, New York; this is a small version cast at the same time. The patriot-spy, carefully depicted in period dress, after the manner of costume-genre pictures by the popular painters Jean Georges Vibert and Alfred Stevens, is shown, bound, just before his execution by the British. In the defiance and helplessness expressed by Hale's posture and features, MacMonnies has exemplified his concept of a successful likeness, one that "should be so conceived as an ideal that the figure should symbolize the life-work of the subject."

Bronze, H. 28¹/₂ inches

Signed and dated (on base): F. MacMonnieS 1890

Founder's mark (on base): E. GRUET/JEUNE/ FONDEUR/44bis AVENUE DE CHATILLON • PARIS •

The Metropolitan Museum of Art, Bequest of Mary Stillman Harkness, 50.145.38

192 Bacchante and Infant Faun
Frederick William MacMonnies

MacMonnies' Bacchante and Infant Faun, completed in 1893, is indicative of the new naturalism, vigor, and increasingly decorative quality found in American sculpture during the last quarter of the nineteenth century. Although it is a classical subject, it is not in the neoclassical mode. Slender in proportions, fluid and graceful, with lively surface textures, the statue is typical of the French Beaux-Arts style, which gradually replaced neoclassicism during the latter part of the century. Commissioned by the architect Charles F. McKim for his Boston Public Library, the Bacchante caused a commotion when placed in the courtyard in 1897. Bostonians, rallied by the Women's Christian Temperance Union, protested not so much against the figure's nudity as against its wanton drunkenness, which was considered the supreme insult to American motherhood. McKim was forced to remove the statue to New York, where it was accepted by the Metropolitan Museum.

Bronze, H. 83 inches
Signed and dated (on base): F MacMonnieS/ 1893
Founder's mark (on base): THIEBAUT. FRERES. Fondeurs. PARIS
The Metropolitan Museum of Art, Gift of Charles Follen McKim, 97.19

193 The Puritan
Augustus Saint-Gaudens (1848–1907)

Saint-Gaudens, son of a French shoemaker, was born in Dublin. He was brought to New York as a child and at thirteen was apprenticed to a cameo cutter. The three and a half years spent in the shop he remembered as "miserable slavery," but attributed to this experience much of his patience and perseverance. While next employed by a more sympathetic cutter, he was able to attend night classes at Cooper Union and the National Academy of Design. At nineteen his father sent him to Paris, where he studied with François Jouffroy at the Ecole des Beaux-Arts. After visiting Rome, he returned to America in 1872. He went back to Europe two years later and remained there until 1875. Saint-Gaudens led the movement of American sculptors away from neoclassicism to a more vigorous and realistic, more specifically American manner of representation. The new realism is exemplified in this bronze, a small version of his 1887 monument to Deacon Samuel Chapin at Springfield, Massachusetts. Through carefully selected and arranged naturalistic details both the image and the subject gain vitality. Rather than create an exact likeness of Chapin, virtually every line and form work to express the dynamic and self-assured character of the American Puritan.

Bronze, H. 31 inches
Signed, dated, and inscribed (on base): AVGVSTVS SAINT GAVDENS/M•D•CCCXCIX/ THE PVRITAN/COPYRIGHT BY/AVGVSTVS SAINT GAVDENS
The Metropolitan Museum of Art, Bequest of Jacob Ruppert, 39.65.53

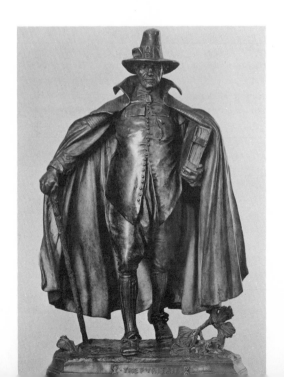

194 Diana

Augustus Saint-Gaudens

His commission of a weather vane of Diana for the Madison Square Garden tower provided Saint-Gaudens with the opportunity to do one of the few nudes of his career and to emphasize a simple design and strong silhouette rather than the lively realism called for by the public monuments and portraits for which he was well known. After the original statue was in place, both Saint-Gaudens and the architect of the tower, Stanford White, realized that it was too large for the structure beneath, and they replaced it with a somewhat smaller version. This, an even smaller one, cast in 1928 after Saint-Gaudens's death, is identical to the earlier two except for the omission of the drapery sash looping behind the figure.

Gilded bronze, H. 112 inches
Founder's mark: P.B. v. Co. MUNICH MADE IN GERMANY ©
The Metropolitan Museum of Art, Rogers Fund, 28.101

195 **The Red Bridge**
Julian Alden Weir (1852–1919)

Weir was born in West Point, New York, the youngest son of the artist Robert W. Weir. After study at the National Academy of Design, young Weir went to Paris in 1873, where he became the pupil of Jean-Léon Gérôme and enjoyed the friendship and guidance of Jules Bastien-Lepage and Whistler. After several trips to Europe, Weir settled in New York in 1883 and became a leader in artists' society. The decade of the 1890s was an experimental period for Weir. The Red Bridge, painted in 1895, shows him developing a lyrical impressionist style, with unusual yellow gray-green coloring on a muted scale. Here, he has chosen a prosaic subject, an iron bridge close to his family summer home in

Windham, Connecticut. According to his daughter and biographer, Weir "was dismayed to find that one of the picturesque old covered bridges that spanned the Shetucket River had been taken down and a stark iron bridge erected in its place. . . . one day he suddenly saw in the ugly modern bridge a picture. . . . The severe iron bridge with its preparatory undercoating of red lead, gay against the green landscape, the river, the sky, and the luxuriant river banks all form a harmonious whole, redolent of summer."
Oil on canvas, 24¹/₄ x 33³/₄ inches
Signed (lower left): J. Alden Weir
The Metropolitan Museum of Art, Gift of Mrs. John A. Rutherfurd, 14.141

196 **The Factory Village**
Julian Alden Weir

The Factory Village was painted in 1897 at Willimantic, Connecticut, near Weir's summer home at Windham. The picture is a mature example of his gradually evolved style, seen in its initial stages in The Red Bridge (no. 195). Although Weir's study of plein-air painting dated from his student days, it was not until the 1890s that the restricted dark palette and precise draughtsmanship of his academic period gave way to a fresh palette and free brushwork. The works he exhibited at his one-man show at the Blakeslee Gallery in 1891 caused a critic to comment: "Mr. Weir has gone over to the apostles of plein air impressionism." In the same year Weir wrote to his brother John: ". . . I feel that I can enjoy studying any phase of nature, which before I had restricted to preconceived notions of what it ought to be." Nature dominates this landscape, and the industrial scene—so vividly portrayed by John (see nos. 133, 134)—is reduced to a smoking chimney and factory building. This picture was among those Weir contributed to the first exhibition in 1898 of the new association of impressionists called Ten American Painters, or The Ten, which included in its membership Childe Hassam, John H. Twachtman, and Edmund Tarbell.

Oil on canvas, 29 x 38 inches
Signed and dated (lower left): J. Alden Weir 1897
Mrs. Charles Burlingham, New York

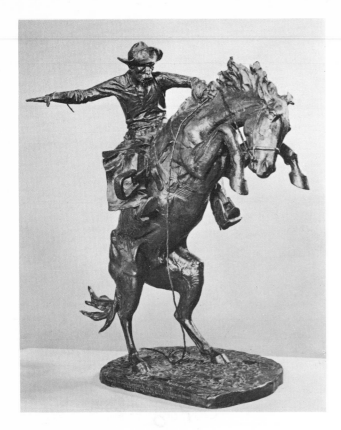

197 The Bronco Buster
Frederic Sackrider Remington (1861–1909)

Born in Canton, New York, Remington grew up an active swimmer, fisherman, hunter, and rider. After a short stay at Yale, where he attended classes but concentrated on football, Remington went West on the first of several extended trips. During these he tried ranching and being a part owner of a saloon; more important, he worked as a cowboy, rode with the army, and participated in Indian fighting, all the while making sketches of the rapidly vanishing frontier life. By 1886 he was established as a painter and an illustrator of western articles for *Harper's Weekly*. In 1895, with the encouragement of the sculptor Frederic W. Ruckstull, Remington made his first attempt at modeling. Said Ruckstull: "All you need . . . is a popular subject, a fine composition, correct movement and expressive form. . . . Take that drawing of yours of a Bronco Buster—you can start with that." The piece was cast and copyrighted in October 1895, and was an immediate hit. Remington later wrote: "I have always had a feeling for mud, and I did that [The Bronco Buster]—a long work attended with great difficulty. . . . [Sculpture] is a great art and satisfying to me, for my whole feeling is for form." Rem-

ington's close friend Theodore Roosevelt, who received a cast of The Bronco Buster as a gift from the Rough Riders after the Spanish-American War, wrote: "The soldier, the cowboy, the rancher, the Indian, the horses and cattle of the plains will live in his pictures and bronzes . . . for all time."

Bronze, H. 23 inches
Inscribed (on base): Copyright by/Frederic Remington./Tiffany & Co
Founder's mark: (on base) ROMAN BRONZE WORKS, N.Y.; (inside base) No. 61
The Metropolitan Museum of Art, Rogers Fund, 07.78

198 The Wounded Bunkie
Frederic Sackrider Remington

Remington rarely depicted men or horses at rest; his cowboys and Indians and their mounts are usually engaged in vigorous, if not violent, activities. Here in Remington's second sculpture, done in 1896, a trooper leans forward in his saddle to support his wounded bunk mate, while their horses run at full tilt beneath them. With a keen sense of drama, Remington has turned the uninjured soldier's gaze toward the still-present danger somewhere to his left. Neither sentimental nor melodramatic, the work is an illustration and not an interpretation of an aspect of life in the West.

Bronze, H. 21³/₄ inches
Signed and inscribed (on base): Frederic Remington/Copyrighted by/Frederic Remington 1896
Founder's mark (on base): CAST BY THE HENRY-BONNARD BRONZE Co. N.Y. 1896.
The Metropolitan Museum of Art, Bequest of Jacob Ruppert, 39.65.46

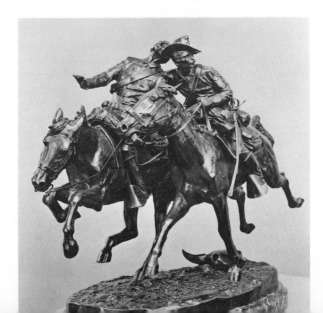

199 **The Young Mother**
Bessie Potter Vonnoh (1872–1955)

Mrs. Vonnoh, wife of the painter Robert Vonnoh
(see no. 189), was born in St. Louis, Missouri.
About 1890 she went to study with Lorado Taft
at the Art Institute in Chicago. As one of his
group of female assistants, known as "the White
Rabbits," she worked on Taft's projects for
the World's Columbian Exposition of 1893. Here
she saw Paul Troubetzkoy's elegant bronze
statuettes of fashionable women and was in-
spired to do some small genre pieces herself.
The Young Mother, the first of many such
statuettes, was completed in 1896 after a trip
to Paris, and shows her awareness of the tender
and simple domestic subject matter treated by
painters like Renoir and Mary Cassatt (see nos.
167-169). The group illustrates a contemporary
critic's description of her works: "Their very
triviality—their intellectual fragility—permits
them to be intimate and personal. It gives them
a special individuality as the record of a pass-
ing thought, the grace of a happy moment, the
flowering of an emotion."

Bronze, H. 14¹/₂ inches
Signed, dated, and inscribed (on base):
Bessie O. Potter/1896./Copyright/no. VI.
Founder's mark (on base): Roman Bronze
Works N.Y.
The Metropolitan Museum of Art, Rogers
Fund, 06.306

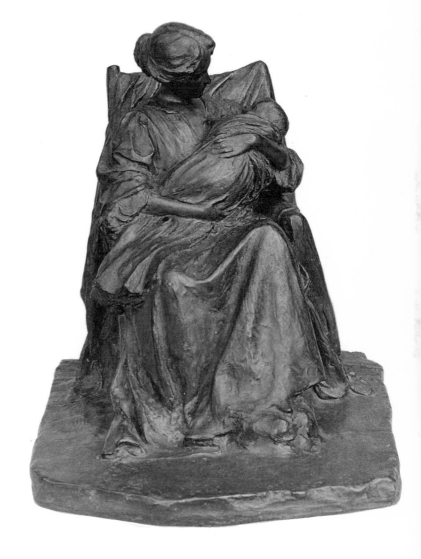

200 Isabella; or, The Pot of Basil
John White Alexander (1856–1915)

Born in Allegheny, Pennsylvania, Alexander worked as an illustrator during the 1870s before going abroad to study in Munich. He joined the American artists' colony in Polling, Bavaria, and there was one of the followers of Frank Duveneck. He traveled to Florence and Venice, where he met Whistler, who greatly influenced his work. Alexander came back to America during the 1880s, became eminent as a portraitist, and did illustrations for *Harper's* and *Century* magazines. He returned to Paris at the end of the century and familiarized himself with the art nouveau style. During this period Alexander created some of his best work, mainly elegant portraits and figure compositions, including this one painted in 1897. The theme, popular with the Pre-Raphaelites, is from Boccaccio's *Decameron* and was also treated by Keats in his poem "Isabella; or, The Pot of Basil." According to the poem, Isabella's humbly born lover was murdered and buried in a wood near Florence by her ambitious brothers, bent on marrying her to a nobleman. She later unearthed the body, and mad with grief, severed the head and hid it in a garden pot planted with sweet basil, an Italian symbol for love.

And so she ever fed it with thin tears,
Whence thick, and green, and beautiful it grew,
So that it smelt more balmy than its peers
Of basil-tufts in Florence; for it drew
Nurture besides, and life, from human fears,
From the fast mouldering head there shut from view:
So that the jewel, safely casketed,
Came forth, and in perfumed leaflets spread.

Alexander's heroine exemplifies the languid, voluptuous art nouveau female; his treatment of the theme brings out the chilling exoticism of the subject. The flowing line and stylized figure and drapery create a trancelike, romantic mood, which is strengthened by the eerie lighting, an indication of his interest in stage design.

Oil on canvas, 75^1/$_2$ x 35^3/$_4$ inches
Signed and dated (lower left): John Alexander '97
Museum of Fine Arts, Boston, Gift of Ernest Wadsworth Longfellow

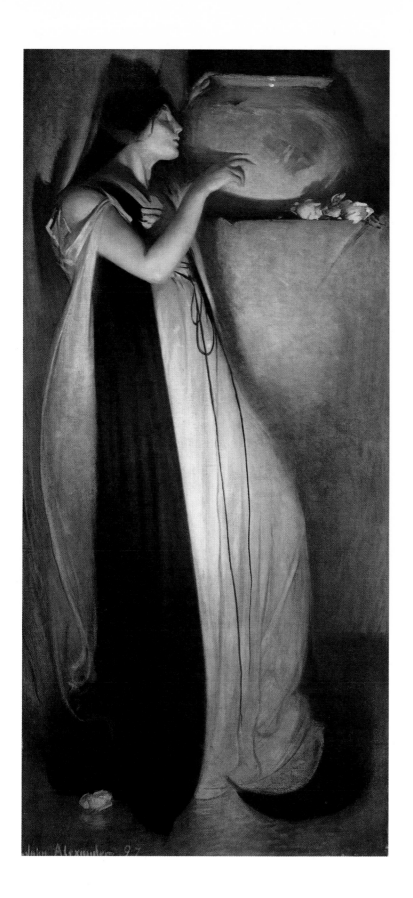

201 **Girl in Pink and Green**
Edmund Charles Tarbell (1862–1938)

Tarbell, a native of West Groton, Massachusetts, was an apprentice at the Forbes Lithographic Company of Boston at fifteen; the three years he spent there he considered "the best start [he] could possibly have had." In 1879 he attended the school of the Museum of Fine Arts in Boston. During the 1880s, when impressionism was at its height in Paris, he studied at the Académie Julian with Louis Boulanger and Jules Joseph Lefebvre. The year after his return from Paris in 1889, Tarbell became an instructor in drawing and painting at the Museum of Fine Arts. Girl in Pink and Green, painted in 1897, shows three members of his family: his daughter, Josephine Tarbell Ferrell, holding a parasol; his mother, Mrs. Hartford, in a white cap; and his wife, Emeline. The informality and asymmetry of the composition and disposition of the figures, the arbitrary cutting off of pictorial elements at the edges of the canvas, the interest in pattern, and the emphasis on medium and free brushstroke are all features adopted from impressionism. In 1898 Tarbell joined the Ten American Painters. This picture was in their first New York exhibition the same year.

Oil on canvas, 48 x 36¹/₈ inches
Signed and dated (lower left): Edmund C Tarbell/97
Mr. and Mrs. Raymond J. Horowitz, New York

INDEX AND BIBLIOGRAPHY

INDEX

SELECTED BIBLIOGRAPHY

GENERAL WORKS

Contemporary Sources

Benjamin, S. G. W. *Our American Artists,* Boston, 1879
Art in America, A Critical and Historical Sketch, New York, 1880
Clement, Clara Erskine, and Hutton, Laurence. *Artists of the Nineteenth Century and Their Works . . . ,* rev. ed., Boston and New York, 1884
Cummings, Thomas S. *Historic Annals of the National Academy of Design,* Philadelphia, 1865
Dickson, Harold Edward, ed. *Observations on American Art: Selections from the Writings of John Neal (1793-1876),* Pennsylvania State College Studies No. 12, State College, Pennsylvania, 1943
Dunlap, William. *History of the Rise and Progress of the Arts of Design in the United States,* 2 vols., New York, 1834; new edition, ed. by Frank W. Bayley and Charles E. Goodspeed, 3 vols., Boston, 1918; rev. enl. edition, ed. by Alexander Wyckoff, preface by William P. Campbell, 3 vols., New York, 1965
Diary of William Dunlap: The Memoirs of a Dramatist, Theatrical Manager, Painter, Critic, Novelist and Historian, ed. by Dorothy C. Barck, 3 vols., New York, 1930
Greenough, Horatio. *The Travels, Observations, and Experiences of a Yankee Stonecutter,* New York, 1852
Jarves, James Jackson. *The Art-Idea,* New York, 1864; new edition, ed. by Benjamin Rowland, Jr., Cambridge, Massachusetts, 1960
Lanman, Charles. *Letters from a Landscape Painter,* Boston, 1845
Haphazard Personalities, Chiefly of Noted Americans, Boston and New York, 1886
Lester, Charles Edwards. *The Artist, The Merchant and The Statesman,* 2 vols., New York, 1845
The Artists of America: A Series of Biographical Sketches of American Artists, with Portraits and Designs on Steel, New York, 1846

McCoubrey, John W., ed. *American Art 1700-1960, Sources and Documents,* Sources and Documents in the History of Art Series, Englewood Cliffs, New Jersey, 1965
Sheldon, G. W. *American Painters: With Eighty-Three Examples of Their Work Engraved on Wood,* New York, 1879
Hours with Art and Artists, New York, 1882
Thorpe, Thomas Bangs. "New-York Artists Fifty Years Ago," *Appleton's Journal,* vol. 7 (1872), pp. 572-575
Tuckerman, Henry T. *Artist-Life: or Sketches of Eminent American Painters,* New York, 1847
Book of the Artists, American Artist Life, New York, 1867; new edition, ed. by James F. Carr, New York, 1966

Dictionaries and
Exhibition Records

Cowdrey, Mary Bartlett, comp. *National Academy of Design Exhibition Record, 1826-1860,* 2 vols., New York, 1943
American Academy of Fine Arts and American Art-Union, 1816-1852, 2 vols., New York, 1953
Dictionary of American Biography, ed. by Allen Johnson and Dumas Malone, New York, 1928-1964
Fielding, Mantle. *Dictionary of American Painters, Sculptors, and Engravers,* Philadelphia, 1926
Groce, George C., and Wallace, David H. *The New-York Historical Society's Dictionary of Artists in America, 1564-1860,* New Haven and London, 1957
Rutledge, Anna Wells, comp. and ed. *Cumulative Record of Exhibition Catalogues, The Pennsylvania Academy of the Fine Arts, 1807-1870, The Society of Artists, 1800-1814, The Artists' Fund Society, 1835-1845,* Memoirs of the American Philosophical Society, vol. 38, Philadelphia, 1955

Swan, Mabel M. *The Athenaeum Gallery, 1827-1873,* Boston, 1940

Museum Collections

The Metropolitan Museum of Art. *American Paintings, A Catalogue of the Collection of The Metropolitan Museum of Art. I, Painters born by 1815,* by Albert TenEyck Gardner and Stuart P. Feld, New York, 1965
American Sculpture, A Catalogue of the Collection of The Metropolitan Museum of Art, by Albert TenEyck Gardner, New York, 1965
Museum of Fine Arts, Boston. *M. and M. Karolik Collection of American Paintings 1815 to 1865,* introd. by John I. H. Baur, Cambridge, Massachusetts, 1949
M. & M. Karolik Collection of American Water Colors & Drawings, 1800-1875, 2 vols., Boston, 1962

General Surveys and
Recent Studies

The Art Institute of Chicago (Feb. 15-Mar. 25, 1945), Whitney Museum of American Art, New York (Apr. 17-May 18, 1945). *The Hudson River School and the Early American Landscape Tradition,* by Frederick A. Sweet, Chicago, 1945
Barker, Virgil. *American Painting, History and Interpretation,* New York, 1950
Born, Wolfgang. *Still-Life Painting in America,* New York, 1947
American Landscape Painting, An Interpretation, New Haven, 1948
The Brooklyn Museum. *Leaders of American Impressionism, Mary Cassatt, Childe Hassam, John H. Twachtman, J. Alden Weir,* introd. by John I. H. Baur, (Oct. 1937), Brooklyn, 1937
Burroughs, Alan. *Limners and Likenesses, Three Centuries of American Painting,* Cambridge, Massachusetts, 1936

Caffin, Charles H. *American Masters of Painting*, New York, 1902
American Masters of Sculpture, New York, 1903
The Story of American Painting, New York, 1907

Cahill, Holger, and Barr, Alfred H., Jr. *Art in America: A Complete Survey*, New York, 1934

Callow, James T. *Kindred Spirits, Knickerbocker Writers and American Artists, 1807-1855*, Chapel Hill, North Carolina, 1967

Clark, Eliot. *History of the National Academy of Design*, New York, 1954

Cortissoz, Royal. *American Artists*, New York and London, 1923

Craven, Wayne. *Sculpture in America*, New York, 1968

The Detroit Institute of Arts and The Toledo Museum of Art. *Travelers in Arcadia, American Artists in Italy, 1830-1875*, by E. P. Richardson and Otto Wittmann, Jr., Detroit, 1951

Fairman, Charles E. *Art and Artists of the Capitol of the United States of America*, Washington, 1917

Flexner, James Thomas. *America's Old Masters, First Artists of the New World*, New York, 1939
American Painting: The Light of Distant Skies, 1760-1835, New York, 1954
That Wilder Image, The Painting of America's Native School from Thomas Cole to Winslow Homer, Boston and Toronto, 1962

Frankenstein, Alfred. *After the Hunt: William Harnett and Other American Still Life Painters, 1870-1900*, Berkeley and Los Angeles, 1953; rev. ed., California Studies in the History of Art, vol. 12, Berkeley and Los Angeles, 1969

Garrett, Wendell D., Norton, Paul F., Gowans, Alan, Butler, Joseph T. *The Arts in America, The Nineteenth Century*, New York, 1969

Hagen, Oskar. *The Birth of the American Tradition in Art*, New York, 1940

Harris, Neil. *The Artist in American Society, The Formative Years, 1790-1860*, New York, 1966

Hartmann, Sadakichi. *A History of American Art*, Boston, 1902

Hirschl and Adler Galleries, New York. *The American Impressionists*, foreword by Stuart P. Feld, introd. by Van Deren Coke, (Nov. 12-30, 1968), New York, 1968

Isham, Samuel. *A History of American Painting*, New York, 1905; reprinted, with additions by Royal Cortissoz, New York, 1927

La Follette, Suzanne. *Art in America*, New York and London, 1929

Larkin, Oliver W. *Art and Life in America*, New York, 1949; rev. ed., New York, 1960

McCoubrey, John W. *American Tradition in Painting*, New York, 1963

McCracken, Harold. *Portrait of the Old West*, New York, 1952

McLanathan, Richard. *The American Tradition in the Arts*, New York, 1968

McSpadden, Joseph. *Famous Sculptors of America*, New York, 1924

Miller, Lillian B. *Patrons and Patriotism, The Encouragement of the Fine Arts in the United States, 1790-1860*, Chicago and London, 1966

Neuhaus, Eugen. *The History and Ideals of American Art*, Stanford, California, 1931

New York State University College at Geneseo, Fine Arts Center. *Hudson River School*, exhib. cat. by Agnes Halsey Jones, Geneseo, New York, 1968

Novak, Barbara. *American Painting of the Nineteenth Century, Realism, Idealism, and the American Experience*, New York, 1969

Pinckney, Pauline. *American Figureheads and Their Carvers*, New York, 1940

Prown, Jules David. *American Painting From Its Beginnings to the Armory Show*, introd. by John Walker, Geneva, 1969

Richardson, Edgar Preston. *American Romantic Painting*, New York, 1944
Painting in America: The Story of 450 Years, New York, 1956; reprinted, New York, 1965

Saint-Gaudens, Homer. *The American Artist and His Time*, 2 vols., New York, 1941

Sears, Clara Endicott. *Highlights Among the Hudson River Artists*, Boston, 1947

Sherman, Frederic Fairchild. *Early American Painting*, New York, 1932

Taft, Lorado. *The History of American Sculpture*, New York, 1903; new rev. ed., New York, 1924

Taft, Robert. *Artists and Illustrators of the Old West: 1850-1900*, New York, 1953; new ed., New York, 1969

Wilmerding, John. *A History of American Marine Painting*, Boston and Toronto, 1968

ABBREVIATIONS

of Frequently Cited Sources
from the General Bibliography

Clement and Hutton. *Artists of the Nine-teenth Century*

Clement, Clara Erskine, and Hutton, Laurence. *Artists of the Nineteenth Century and Their Works . . .* , rev. ed., Boston and New York, 1884

Craven. *Sculpture in America*

Craven, Wayne. *Sculpture in America,* New York, 1968

DAB

Dictionary of American Biography, ed. by Allen Johnson and Dumas Malone, New York, 1928-1964

Dunlap. *History*

Dunlap, William. *History of the Rise and Progress of the Arts of Design in the United States,* 2 vols., New York, 1834

Dunlap. *Diary*

Dunlap, William. *Diary of William Dunlap: The Memoirs of a Dramatist, Theatrical Manager, Painter, Critic, Novelist and Historian,* ed. by Dorothy C. Barck, 3 vols., New York, 1930

Frankenstein. *After the Hunt*

Frankenstein, Alfred. *After the Hunt: William Harnett and Other American Still Life Painters, 1870-1900,* Berkeley and Los Angeles, 1953

Groce and Wallace. *Dictionary*

Groce, George C., and Wallace, David H. *The New-York Historical Society's Dictionary of Artists in America, 1564-1860,* New Haven and London, 1957

McSpadden. *Famous Sculptors of America*

McSpadden, Joseph. *Famous Sculptors of America,* New York, 1924

Gardner and Feld. *MMA American Paintings I*

The Metropolitan Museum of Art. *American Paintings, A Catalogue of the Collection of The Metropolitan Museum of Art. I, Painters born by 1815,* by Albert TenEyck Gardner and Stuart P. Feld, New York, 1965

Gardner. *MMA American Sculpture*

The Metropolitan Museum of Art. *American Sculpture, A Catalogue of the Collection of The Metropolitan Museum of Art,* by Albert TenEyck Gardner, New York, 1965

Karolik

Museum of Fine Arts, Boston. *M. and M. Karolik Collection of American Paintings 1815 to 1865,* introd. by John I. H. Baur, Cambridge, Massachusetts, 1949

Swan. *Athenaeum*

Swan, Mabel M. *The Athenaeum Gallery, 1827-1873,* Boston, 1940

Taft. *History of American Sculpture*

Taft, Lorado. *The History of American Sculpture,* New York, 1903

Tuckerman. *Book of the Artists*

Tuckerman, Henry T. *Book of the Artists, American Artist Life,* New York, 1867

Wilmerding. *History of American Marine Painting*

Wilmerding, John. *A History of American Marine Painting,* Boston and Toronto, 1968

SOURCES FOR INDIVIDUAL ARTISTS

References arranged alphabetically by artist and chronologically within each entry

ALEXANDER, JOHN WHITE

Keats, John. "Isabella; or, The Pot of Basil," in *The Complete Poetical Works of John Keats*, notes and appendices by H. Buxton Forman, New York, 1895, p. 260

Museum of Fine Arts, Boston. *Handbook*, Boston, 1908

Caffin, Charles H. "John W. Alexander," *Arts and Decoration*, vol. 1, no. 4 (Feb. 1911), pp. 147-149, 178

Carnegie Institute, Pittsburgh. *Catalogue of Paintings, John White Alexander Memorial Exhibition, March, 1916*, Pittsburgh, 1916

Fine Arts Federation of New York. *Address of Mr. John G. Agar (President National Arts Club) and Resolutions Adopted at the Testimonial to John W. Alexander, Sunday Evening May 28, 1916*, New York, 1916

DAB

ALLSTON, WASHINGTON

Ware, William. *Lectures on the Works and Genius of Washington Allston*, Boston, 1852

Flagg, Jared B. *The Life and Letters of Washington Allston*, London, 1893

The Detroit Institute of Arts (May-June, 1947), Museum of Fine Arts, Boston (July-Aug., 1947). *Washington Allston 1779-1843, A Loan Exhibition of Paintings, Drawings and Memorabilia*, by Edgar Preston Richardson, Detroit, 1947

Richardson, Edgar Preston. *Washington Allston; A Study of the Romantic Artist in America*, Chicago, 1948

ANSHUTZ, THOMAS POLLOCK

American Art Galleries, New York. *The Private Collection of Paintings by Exclusively American Artists, Owned by Thomas B. Clarke* (Dec. 28, 1883-Jan. 12, 1884), New York, 1883

Clarke, Thomas B. *Catalogue of the Private Art Collection of Thomas B. Clarke*, New York, sales cat., Chickering Hall and American Art Galleries, New York, (Feb. 14-18, 1899)

The Graham Gallery, New York. *Thomas Anshutz 1851-1912*, (Feb. 19-Mar. 16, 1963), New York, 1963

DAB

AUDUBON, JOHN JAMES

Audubon, John James. *Ornithological Biography*, 5 vols., Edinburgh, 1831-1839

Corning, Howard, ed. *Journal of John James Audubon Made During His Trip to New Orleans in 1820-1821*, Cambridge, Massachusetts, 1929

Peattie, Donald Culross, ed. *Audubon's America*, Boston, 1940

Dwight, Edward H. "Audubon's Oils," *Art in America*, vol. 51, no. 2 (Apr. 1963), pp. 77-79

Ford, Alice. *John James Audubon*, Norman, Oklahoma, 1964

McDermott, John Francis. *Audubon in the West*, Norman, Oklahoma, 1965

Munson-Williams-Proctor Institute, Utica, New York (Apr. 11-May 30, 1965), The Pierpont Morgan Library, New York (June 15-July 30, 1965). *Audubon Watercolors and Drawings*, introd. by Edward H. Dwight, Utica, 1965

Bland, D. S. "Three Paintings by Audubon," *Apollo*, n.s., vol. 83 (Mar. 1966), pp. 208-209

Davidson, Marshall B. *The Original Watercolor Paintings by John James Audubon for The Birds of America (from the Collection of The New-York Historical Society)*, New York, 1966

Ford, Alice, ed. *The 1826 Journal of John James Audubon*, Norman, Oklahoma, 1967

AUGUR, HEZEKIAH

Gratz Collection, The Historical Society of Pennsylvania. Ms. letter, Hezekiah Augur to Professor Benjamin Silliman, Jr. of Yale, (Oct. 18, 1836). Archives of American Art, microfilm roll P22, frame 0029

Groce and Wallace. *Dictionary*

DAB

Craven. *Sculpture in America*

BALL, THOMAS

Ball, Thomas. *My Threescore Years and Ten, An Autobiography*, 2nd ed., Boston, 1892

Partridge, William. "Thomas Ball," *New England Magazine*, n.s., vol. 12 (1895), pp. 291-304

Craven, Wayne. "The Early Sculptures of Thomas Ball," *North Carolina Museum of Art Bulletin*, vol. 5, nos. 1 and 2 (Fall 1964, Winter 1965), pp. 3-12

Sculpture in America

BARNARD, GEORGE GREY

M., G. P. "I Feel Two Natures within Me," *The Congregationalist* [Boston], (Nov. 3, 1900)

McSpadden. *Famous Sculptors of America*

Dickson, Harold E. "Log of a Masterpiece, Barnard's 'Struggle of the Two Natures of Man'," *The Art Journal*, vol. 20, no. 3 (Spring 1961), pp. 139-143

The Pennsylvania State University Library, University Park, and The Pennsylvania Historical and Museum Commission, Harrisburg. *George Grey Barnard, 1863. Centenary Exhibition. 1963*, University Park, 1964

Gardner. *MMA American Sculpture*

Craven. *Sculpture in America*

BARTLETT, PAUL WAYLAND

Bartlett, Ellen. "Paul Bartlett: An American Sculptor," *New England Magazine*, vol. 33 (1905), pp. 369-382

Wheeler, Charles V. "Bartlett (1865-1925)," *The American Magazine of Art*, vol. 16, no. 11 (Nov. 1925), pp. 573-585

Gardner. *MMA American Sculpture*

Craven. *Sculpture in America*

BIERSTADT, ALBERT

B[ierstadt], [Albert]. "Country Correspondence: Rocky Mountains, July 10, 1859," *The Crayon*, vol. 6 (Sept. 1859), p. 287

Greeley, Horace. *The American Conflict: A History of the Great Rebellion in The United States of America, 1860-'64: . . .*, 2 vols., Hartford and Chicago, 1865, Major Robert Anderson quoted in vol. 1, p. 449

Tuckerman. *Book of the Artists*

Karolik

Santa Barbara Museum of Art, Santa Barbara, California. *A Retrospective Exhibition, Albert Bierstadt 1830-1902*, introd. by Thomas W. Leavitt, (Aug. 5-Sept. 13, 1964), Santa Barbara, 1964

Hendricks, Gordon. "The First Three Western Journeys of Albert Bierstadt," *The Art Bulletin*, vol. 46, no. 3 (Sept. 1964), pp. 333-365

BINGHAM, GEORGE CALEB

Flint, Timothy. *Recollections of the Last Ten Years, Passed in Occasional Residence and Journeying in the Valley of the Mississippi*, Boston, 1826, as quoted in Demos, p. 225

Irving, Washington. *Astoria, or Anecdotes of an Enterprise Beyond the Rocky Mountains*, 1st ed., 2 vols., Philadelphia, 1836; quotation taken from 1851 London ed., pp. 22-23

Flagg, Edmund. *The Far West: or, A Tour Beyond the Mountains. Embracing Outlines of Western Life and Scenery; Sketches of the Prairies, Rivers, Ancient Mounds, Early Settlements of the French, . . .*, 2 vols., New York, 1838, vol. II, pp. 58-59, as quoted in Bloch, vol. 1, p. 118

Boonville Weekly Observer [Boonville, Missouri], (Mar. 11, 1847), p. 1, col. 6, as quoted in Bloch, vol. 1, p. 129

McDermott, John Francis. *George Caleb Bingham, River Portraitist*, Norman, Oklahoma, 1959

Demos, John. "George Caleb Bingham: The Artist as Social Historian," *American Quarterly* (1965), pp. 218-228

Gardner and Feld. *MMA American Paintings I*

National Collection of Fine Arts, Smithsonian Institution (Oct. 19, 1967-Jan. 1, 1968), The Cleveland Museum of Art (Jan. 24-Mar. 10, 1968), The Art Galleries, University of California at Los Angeles (Apr. 7-May 19, 1968). *George Caleb Bingham 1811-1879*, introd. by E. Maurice Bloch, Washington, 1967

Bloch, E. Maurice. *George Caleb Bingham: The Evolution of an Artist; George Caleb Bingham: A Catalogue Raisonné*, 2 vols., California Studies in the History of Art, vol. 7, Berkeley and Los Angeles, 1967

BIRCH, THOMAS

Bowen, Abel. *The Naval Monument*, Boston, 1816, Commodore Stephen Decatur quoted p. 25

Thomas, Abel C. "Obituary of Artist: Sketch of Thomas Birch," *Philadelphia Art Union Reporter*, vol. 1, no. 1 (Jan. 1851), pp. 22-23

Stauffer, David M. *American Engravers upon Copper and Steel*, 2 vols., New York, 1907

The Historical Society of Pennsylvania, Philadelphia. *Catalogue Descriptive and Critical of the Paintings and Miniatures in The Historical Society of Pennsylvania*, by William Sawitsky, Philadelphia, 1942

Karolik

Philadelphia Maritime Museum. *Thomas Birch, 1779-1851, Paintings and Drawings*, introd. by William H. Gerdts, (Mar. 16-May 1, 1966), Philadelphia, 1966

Gerdts, William H. "Thomas Birch: America's First Marine Artist," *Antiques*, vol. 89, no. 4 (Apr. 1966), pp. 528-534

Wilmerding. *History of American Marine Painting*

BLAKELOCK, RALPH ALBERT

Daingerfield, Elliott. *Ralph Albert Blakelock*, New York, 1914

Whitney Museum of American Art, New York. *Ralph Albert Blakelock Centenary Exhibition in Celebration of the Centennial of the City College of New York*, introd. by Lloyd Goodrich, (Apr. 22-May 29, 1947), New York, 1947

The Art Galleries, University of California, Santa Barbara (Jan. 7-Feb. 2, 1969), California Palace of the Legion of Honor, San Francisco (Feb. 15-Mar. 16, 1969), Phoenix Art Museum (Mar. 24-Apr. 27, 1969), The Heckscher Museum, Huntington, New York (May 17-June 23, 1969). *The Enigma of Ralph A. Blakelock 1847-1919*, by David Gebhard and Phyllis Stuurman, Santa Barbara, 1969

BLYTHE, DAVID GILMOUR

Hadden, James. *A History of Uniontown*, Uniontown, Pennsylvania, 1913, chapter on "David G. Blythe," pp. 589-604

"Paintings by David G. Blythe," *Carnegie Magazine*, vol. 6, no. 8 (Jan. 1933), pp. 229-232

Abraham, Evelyn. "David G. Blythe, American Painter and Woodcarver (1815-1865)," *Antiques*, vol. 27, no. 5 (May 1935), pp. 180-183

Whitney Museum of American Art, New York. *Paintings by David G. Blythe, 1815-1865—Drawings by Joseph Boggs Beale, 1841-1926*, introd. to Blythe by Lloyd Goodrich, (Apr. 7-May 7, 1936), New York, 1936

O'Connor, John, Jr. "A Pittsburgh Scene, 'Post Office' by David G. Blythe Purchased by the Carnegie Institute," *Carnegie Magazine*, vol. 16, no. 8 (Jan. 1943), pp. 227-229

Karolik

Miller, Dorothy. *The Life and Work of David G. Blythe*, Pittsburgh, 1950

Columbus Gallery of Fine Arts. *Works by David Blythe, 1815-1865*, (Mar. 8-31, 1968), Columbus, Ohio, 1968

BRACKETT, EDWARD AUGUSTUS

Brackett, Edward Augustus. *Twilight Hours; or Leisure Moments of an Artist*, Boston, 1845

Lee, Hannah. *Familiar Sketches of Sculpture and Sculptors*, 2 vols., Boston, 1854

Gardner, Albert T. "Memorials of an American Romantic," *The Metropolitan Museum of Art Bulletin*, n.s., vol. 3, no. 2 (Oct. 1944), pp. 54-59

Gardner. *MMA American Sculpture*

Craven. *Sculpture in America*

BRICHER, ALFRED THOMPSON

A. T. Bricher papers, Archives of American Art. A collection including a sketch, a letter to his daughter, newspaper clippings and sales catalogues with prices marked. Microfilm roll D32, frames 455-689

Groce and Wallace. *Dictionary*

Preston, John Duncan. "Alfred Thompson Bricher, 1837-1908," *The Art Quarterly*, vol. 25, no. 2 (Summer 1962), pp. 149-157

Wilmerding. *History of American Marine Painting*

BROWERE, ALBERTUS D. O.

Hart, Charles Henry. *Browere's Life Masks of Great Americans*, New York, 1899

American Art Association, Anderson Galleries, New York. *Sale of American Historical Paintings*, sales cat., (Jan. 27, 1938)

Albertus D. O. Browere papers, American Artists Files (Mary Bartlett Cowdrey). Archives of American Art. *Catskill Daily Mail* (Apr. 24, 1939, Apr. 25, 1939), microfilm roll NY 59-19, frames 449-483

M. Knoedler and Co., New York. Paintings by A. D. O. Browere (Feb. 21-24, 1940), typescript in Frick Art Reference Library, New York

Millard, Everett L. "Sign Painter Succeeds in Genre Field. Albertis D. O. Browere Left Valuable Records of Last Century," *The New York Sun* (Feb. 10, 1949). Also in Albert Duveen files, Archives of American Art, microfilm roll NDU 1

Conkling, R. P. "Reminiscences on the Life of Albertis del Orient Browere," *Los Angeles County Museum Quarterly*, vol. 8, no. 1 (1950), pp. 2-6

Groce and Wallace. *Dictionary*

Smith, Mabel P., with MacFarlane, Janet R. "Unpublished Paintings by Alburtis Del Orient Browere," *Art in America*, vol. 46, no. 3 (Fall 1958), pp. 68-71

BROWN, HENRY KIRKE

DAB

Gardner. *MMA American Sculpture*

Craven. *Sculpture in America*, includes quotations from Brown ms.

Craven, Wayne. "Henry Kirke Brown in Italy, 1842-1846," *The American Art Journal*, vol. 1, no. 1 (Spring 1969), pp. 65-77

BROWN, JOHN GEORGE

John George Brown papers. The New York Public Library, Art Division, Artists Clipping file. Unidentified magazine engraving shows The Music Lesson as "A Game Two Can Play At. Painted by J. G.

BROWN, JOHN GEORGE, *Continued*

Brown. Engraved and Printed by Ulman (?) Brothers." *Archives of American Art*, microfilm roll NY59, frame 697

Tuckerman. *Book of the Artists*

Sheldon, G. W. *American Painters: With Eighty-Three Examples of Their Work Engraved on Wood*, New York, 1879

Benjamin, S. G. W. *Art in America, A Critical and Historical Sketch*, New York, 1880

"A Painter of the Streets," *The Magazine of Art*, vol. 5 (1882), pp. 265-267

Sheldon, G. W. *Hours with Art and Artists*, New York, 1882

Brown, Mrs. Emma A., and Dunn, George W., Esq. *Catalogue of the Finished Pictures and Studies left by the Well-Known American Artist The Late J. G. Brown, N. A. to be Sold at unrestricted Public Sale by Order of Mrs. Emma A. Brown and George W. Dunn, Esq., Executors . . .*, sales cat., American Art Galleries, New York, (Feb. 9-10, 1914)

Groce and Wallace. *Dictionary*

Haverstock, Mary Sayre. "The Tenth Street Studio," *Art in America*, vol. 54, no. 5 (Sept.-Oct. 1966), pp. 48-57

CASSATT, MARY

Huysmans, J. K. *L'Art Moderne*, Paris, 1883

Segard, Achille. *Un peintre des enfants et des mères, Mary Cassatt*, Paris, 1913

Watson, Forbes. *Mary Cassatt*, American Artists Series, New York, 1932

Baltimore Museum of Art. *Mary Cassatt. The Catalogue of a Comprehensive Exhibition of Her Work*, (Nov. 28, 1941-Jan. 11, 1942), Baltimore, [n.d.]

Breeskin, Adelyn D. *The Graphic Work of Mary Cassatt, a catalogue raisonné*, New York, 1948

The Art Institute of Chicago (Jan. 14-Feb. 25, 1954), The Metropolitan Museum of Art (Mar. 25-May 23, 1954). *Sargent, Whistler and Mary Cassatt*, by Frederick A. Sweet, Chicago, 1954

International Galleries, Chicago. *Mary Cassatt 1844-1926 Retrospective Exhibition*, introd. notes by Frederick A. Sweet, (Nov.-Dec. 1965), Chicago, [n.d.]

Carson, Julia M. H. *Mary Cassatt*, New York, 1966

The Knoedler Galleries, New York. *The Paintings of Mary Cassatt*, introd. by Adelyn D. Breeskin, (Feb. 1-26, 1966), New York, 1966

Sweet, Frederick A. *Miss Mary Cassatt Impressionist From Pennsylvania*, Norman, Oklahoma, 1966

The Museum of Graphic Art, New York, and participating museums (1967-1968). *The Graphic Art of Mary Cassatt*, introd. by Adelyn D. Breeskin, foreword by Donald H. Karshan, New York and Washington, 1967

Joslyn Art Museum, Omaha, Nebraska. *Mary Cassatt Among the Impressionists*, (Apr. 10-June 1, 1969), Omaha, 1969

CATLIN, GEORGE

Catlin, George. *The Manners, Customs, and Conditions of the North American Indians*, 2 vols., London, 1841

Haberly, Loyd. *Pursuit of the Horizon, A Life of George Catlin, Painter & Recorder of the American Indian*, New York, 1948

McCracken, Harold. *George Catlin and the Old Frontier*, New York, 1959

Ross, Marvin C., ed. *George Catlin, Episodes from Life Among the Indians and Last Rambles, with 152 Scenes and Portraits by the Artist*, Norman, Oklahoma, 1959

Plate, Robert. *Palette and Tomahawk. The Story of George Catlin*, New York, 1962

National Collection of Fine Arts, Smithsonian Institution. *Catlin's Indian Gallery, The George Catlin Paintings in the United States National Museum*, by Marjorie Halpin, (July 19-late Sept. 1965), Washington City, 1965

Roehm, Marjorie Catlin. *The Letters of George Catlin and His Family, A Chronicle of the American West*, Berkeley and Los Angeles, 1966

CHASE, WILLIAM MERRITT

Moran, John. "Studio Life in New York," *The Art Journal* [New York], vol. 5 (Nov. 1879), pp. 343-345

Van Rensselaer, M. G. "William M. Chase," *American Art Review*, vol. 2 (1881), pp. 91-98, 137-142; reprinted in *American Art and American Art Collections*, Walter Montgomery, ed., Boston 1889, pp. 209-230

The Metropolitan Museum of Art. *Loan Exhibition of Paintings by William M. Chase*, (Feb. 19-Mar. 18, 1917), New York, 1917

Roof, Katharine Metcalf. *The Life and Art of William Merritt Chase*, New York, 1917

Newhouse Galleries, Saint Louis. *Paintings by William M. Chase, N.A., LL.D.*, foreword by Royal Cortissoz, Saint Louis, 1927

College Art Association. "William Merritt Chase—Painter, 1849-1916," *The Index of Twentieth Century Artists*, vol. 2, no. 2 (Nov. 1934), pp. 17-27

John Herron Art Museum, Indianapolis. *Chase Centennial Exhibition, Commemorating the Birth of William Merritt Chase, November 1, 1849*, introd. by Wilbur D. Peat, (Nov. 1-Dec. 11, 1949), Indianapolis, 1949

Toledo Museum of Art. *Museum News*, no. 149 (Nov.-Dec. 1953); n.s., vol. 7, no. 3 (Autumn 1964), pp. 57-62

The Parrish Art Museum, Southampton, New York. *William Merritt Chase, 1849-1916, A Retrospective Exhibition*, introd. by M. L. D'Otrange-Mastai, (June 30-July 27, 1957), Southampton, 1957

The Art Gallery, University of California, Santa Barbara (Oct. 6-Nov. 8, 1964), La Jolla Museum of Art, La Jolla, California (Dec. 1-27, 1964), California Palace of the Legion of Honor, San Francisco (Jan. 10-Feb. 7, 1965), Seattle Art Museum (Mar. 3-Apr. 4, 1965), The Gallery of Modern Art, New York (Apr. 27-May 30, 1965). *The First West Coast Retrospective Exhibition of Paintings by William Merritt Chase (1849-1916)*, Santa Barbara, 1964

CHURCH, FREDERIC EDWIN

Humboldt, [Friedrich Heinrich] Alexander, Baron von. *Cosmos: A Sketch of a Physical Description of the Universe*, trans. by E. C. Otté, New York, 1850-1859 (German ed., Stuttgart and Tubingen, 1845-1862)

[Review of Niagara], *The Times* [London], quoted in *Cosmopolitan Art Journal*, vol. 2 (1857-1858), pp. 38-39, and in "Church's Picture of Niagara," *The Crayon*, vol. 4 (Sept. 1857), p. 282

Noble, Louis Legrand. *Church's Painting, The Heart of the Andes*, New York, 1859

Winthrop, Theodore. *A Companion to The Heart of the Andes*, New York, 1859

[Review of Cotopaxi], *The New York Post* (Mar. 14, 1863)

"Fine Arts. Mr. Church's 'Cotopaxi'," *The New York Herald* (Mar. 16, 1863)

"Cotopaxi," *Harper's Weekly* (Apr. 4, 1863), p. 210

"Frederic Edwin Church," *Harper's Weekly* (June 8, 1867), p. 364

Gardner, Albert TenEyck. "Scientific Sources of the Full-Length Landscape: 1850," *The Metropolitan Museum of Art Bulletin*, n.s., vol. 4, no. 2 (Oct. 1945), pp. 59-65

Huntington, David C. "Landscape and Diaries: the South American Trips of F. E. Church," *The Brooklyn Museum Annual*, vol. 5 (1963-1964), pp. 65-98

The Landscapes of Frederic Edwin Church, Vision of an American Era, New York, 1966

National Collection of Fine Arts, Smithsonian Institution (Feb. 12-Mar. 13, 1966), Albany Institute of History and Art, Albany, New York (Mar. 30-Apr. 30, 1966), M. Knoedler and Co., New York (June 1-30, 1966). *Frederic Edwin Church*, introd. by David C. Huntington, Washington, 1966

CLONNEY, JAMES GOODWYN
[The National Academy of Design, Twenty-second Annual Exhibition], The Knickerbocker, vol. 29 (June 1847), p. 572
Bolton, Theodore. Early American Portrait Painters in Miniature, New York, 1921
Karolik
Groce and Wallace. Dictionary

COLE, THOMAS
American Art-Union, New York. Exhibition of the Paintings of the Late Thomas Cole at the Gallery of the American Art-Union, New York, 1848
Noble, Louis Legrand. The Life and Works of Thomas Cole, New York, 1853; ed. by Elliot S. Vesell, Cambridge, Massachusetts, 1964
Durand, John. The Life and Times of A. B. Durand, New York, 1894
Wadsworth Atheneum, Hartford (Nov. 12, 1948-Jan. 2, 1949), Whitney Museum of American Art, New York (Jan. 8-30, 1949). Thomas Cole 1801-1848 One Hundred Years Later, a Loan Exhibition, by Esther Isabel Seaver, Hartford, 1948
Gardner and Feld. MMA American Paintings I
Dwight, Edward H., and Boyle, Richard J. "Rediscovery: Thomas Cole's 'Voyage of Life'," Art in America, vol. 55 (May-June 1967), pp. 60-63
The Baltimore Museum of Art. Annual II. Studies on Thomas Cole, An American Romanticist, Baltimore, 1967 [1968]
Memorial Art Gallery of the University of Rochester, Rochester, New York (Feb. 14-Mar. 23, 1969), Munson-Williams-Proctor Institute, Utica, New York (Apr. 7-May 4, 1969), Albany Institute of History and Art, Albany, New York (May 9-June 20, 1969), Whitney Museum of American Art, New York (June 30-Sept. 1, 1969). Thomas Cole, by Howard S. Merritt, Rochester, 1969

COLMAN, SAMUEL
Samuel Colman papers. The New York Public Library, Art Division, Artists Clipping File. Includes article "American Painters.—Samuel Colman, N.A.," The Art Journal, 76, 264-266. Archives of American Art, microfilm roll N99, frames 285-372
Tuckerman. Book of the Artists
Benjamin, S. G. W. Our American Artists, Boston, 1879
Sheldon, G. W. American Painters: With Eighty-Three Examples of Their Work Engraved on Wood, New York, 1879
Ruttenber, E. M., and Clark, L. H., comps. History of Orange County, New York, Philadelphia, 1881
Sheldon, G. W. Hours with Art and Artists, New York, 1882

American Art News, vol. 14 (Nov. 20, 1915), p. 7
Groce and Wallace. Dictionary
Art News, vol. 67 (Sept. 1968), p. 32

CONNELLY, PIERCE FRANCIS
United States Centennial Commission. International Exhibition, 1876, Official Catalogue. Part II. Art Gallery, Annexes, and Out-Door Works of Art. Department IV.—Art. 9th and rev. ed., Philadelphia, 1876
Gardner. MMA American Sculpture
Craven. Sculpture in America

CRAWFORD, THOMAS
Gale, Robert. Thomas Crawford, American Sculptor, Pittsburgh, 1964
Gardner. MMA American Sculpture
Craven. Sculpture in America

CROPSEY, JASPER FRANCIS
"Domestic Art Gossip," The Crayon, vol. 2 (Dec. 1855), p. 361
Stone, William Leete. The Poetry and History of Wyoming; containing Campbell's Gertrude; with a Biographical Sketch of Thomas Campbell by Washington Irving, 3rd ed., Philadelphia, 1864
Forman, William Henry. "Jasper Francis Cropsey, N.A.," The Manhattan, vol. 3 (Apr. 1884), pp. 372-382
Cropsey, Maria. Catalogue of the Collection of Oil Paintings and Water Colors by the Gifted American Artist, the Late Jasper F. Cropsey, N.A., Belonging to the Estate of . . ., sales cat., Silo Art Galleries, New York, (Dec. 6-8, 1906)
Feld, Stuart P. " 'Loan Collection,' 1965," The Metropolitan Museum of Art Bulletin, n.s., vol. 23, no. 8 (Apr. 1965), pp. 275-294
Van Zandt, Roland. The Catskill Mountain House, New Brunswick, New Jersey, 1966
University of Maryland Art Gallery, J. Millard Tawes Fine Arts Center, College Park, Maryland. Jasper F. Cropsey 1823-1900, A Retrospective View of America's Painter of Autumn. An exhibition of oil paintings and watercolors by the artist along with selected works by Thomas Cole, David Johnson and George Inness, by Peter Bermingham, preface by George Levitine, foreword by William H. Gerdts, (Feb. 2-Mar. 3, 1968), College Park, 1968

DOUGHTY, THOMAS
Hofland, Thomas R. "The Fine Arts in the United States, with a sketch of their present and past history in Europe," The Knickerbocker, vol. 14 (July 1839), pp. 39-52
Burroughs, Clyde H. "Early American Landscape Paintings," Bulletin of the

Detroit Institute of Arts of the City of Detroit, vol. 15, no. 6 (Mar. 1936), pp. 86-89
Doughty, Howard N. Unpublished biographical sketch of Thomas Doughty. Ms. dept., The New-York Historical Society
"Thomas Doughty, Painter of Scenery," Appalachia, n.s., vol. 13, no. 103 (June 1947), pp. 307-309
Sears, Clara Endicott. Highlights Among the Hudson River Artists, Boston, 1947
Karolik
Groce and Wallace. Dictionary

DURAND, ASHER BROWN
Asher B. Durand papers. The New-York Historical Society and The New York Public Library, Manuscript Division
Bryant, William Cullen. "To Cole, the Painter, Departing for Europe," first published in The Talisman (1830), in The Poetical Works of William Cullen Bryant, Roslyn ed., New York, 1903
Asher B. Durand papers. The New York Public Library, Manuscript Division. Letter, Durand to John Casilear, (Boston, June 14, 1835)
Bryant, William Cullen. A Funeral Oration Occasioned by the Death of Thomas Cole, Delivered Before the National Academy of Design, New-York, May 4, 1848, New York, 1848
Asher B. Durand papers. The New York Public Library, Manuscript Division. Letter, Bryant to Durand, Feb. 26, 1849
Durand, Asher B. "Letters on Landscape Painting," The Crayon, vol. 1 (Jan.-June 1855), pp. 1-2, 34-35, 66-67, 97-98, 145-146, 209-211, 273-275, 354-355, vol. 2 (July-Dec., 1855), pp. 16-17
Tuckerman. Book of the Artists
Godwin, Parke. A Biography of William Cullen Bryant, with Extracts from His Private Correspondence, 2 vols., New York, 1883
Durand, John. The Life and Times of A. B. Durand, New York, 1894
Gardner and Feld. MMA American Paintings I
Miller, Lillian B. Patrons and Patriotism, The Encouragement of the Fine Arts in the United States, 1790-1860, Chicago and London, 1966
Callow, James T. Kindred Spirits, Knickerbocker Writers and American Artists, 1807-1855, Chapel Hill, North Carolina, 1967

DUVENECK, FRANK
[The National Academy of Design, Fifty-second Annual Exhibition], The Art Journal [New York], n.s., vol. 3 (1877), p. 157
[The National Academy of Design, Fifty-second Annual Exhibition], The New York Times (Apr. 3, 1877), p. 5, col. 5

DUVENECK, FRANK, *Continued*

Heermann, Norbert. *Frank Duveneck,* Boston and New York, 1918
Cincinnati Museum Association. *Frank Duveneck 1848-1919,* Cincinnati, 1919
Cincinnati Art Museum. *Exhibition of the Work of Frank Duveneck,* (May 23-June 21, 1936), Cincinnati, 1936
The Parrish Art Museum, Southampton, New York. *William Merritt Chase, 1849-1916, A Retrospective Exhibition,* introd. by M. L. D'Otrange-Mastai, (June 30-July 27, 1957), Southampton, 1957

EAKINS, THOMAS COWPERTHWAIT

Goodrich, Lloyd. *Thomas Eakins, His Life and Work,* New York, 1933
College Art Association. "Thomas Cowperthwait Eakins—Painter, 1844-1916," *The Index of Twentieth Century Artists,* vol. 1, no. 4 (Jan. 1934), pp. 49-59
McKinney, Roland. *Thomas Eakins,* American Artists Series, New York, 1942
McHenry, Margaret. *Thomas Eakins Who Painted,* [Oreland, Pennsylvania], 1946
Porter, Fairfield. *Thomas Eakins,* The Great American Artists Series, New York, 1959
National Gallery of Art, Smithsonian Institution (Oct. 8-Nov. 12, 1961), The Art Institute of Chicago (Dec. 1, 1961-Jan. 7, 1962), Philadelphia Museum of Art (Feb. 1-Mar. 18, 1962). *Thomas Eakins, A Retrospective Exhibition,* introd. by Lloyd Goodrich, 1961
"Samuel David Gross," in *DAB*
Schendler, Sylvan. *Eakins,* Boston and Toronto, 1967
Hendricks, Gordon. "The Champion Single Sculls," *The Metropolitan Museum of Art Bulletin,* n.s., vol. 26, no. 7 (Mar. 1968), pp. 306-307
"Thomas Eakins's *Gross Clinic,*" *The Art Bulletin,* vol. 51, no. 1 (Mar. 1969), pp. 57-64
The Corcoran Gallery of Art, Washington, D.C. *The Sculpture of Thomas Eakins,* by Moussa M. Domit, (May 3-June 10, 1969), Washington, 1969

EASTMAN, SETH

Lanman, Charles. *A Summer in the Wilderness,* New York, 1847, p. 59
Eastman, Mary. *Dahcotah; or, Life and Legends of the Sioux Around Fort Snelling, Illustrated from Drawings by Captain Eastman,* New York, 1849
The American Aboriginal Portfolio, Illustrated by S. Eastman, U. S. Army, Philadelphia, 1853
Karolik
Groce and Wallace. *Dictionary*
McDermott, John Francis. *Seth Eastman, Pictorial Historian of the Indian,* Norman, Oklahoma, 1961

EDMONDS, FRANCIS WILLIAM

Lanman, Charles. *Letters from a Landscape Painter,* Boston, 1845, pp. 239-241
Cummings, Thomas S. *Historic Annals of the National Academy of Design,* Philadelphia, 1865
Tuckerman. *Book of the Artists*
Groce and Wallace. *Dictionary*
DAB
The Kennedy Galleries, Inc., New York. *An American Survey, Paintings from Two Centuries* (Mar. 14-Apr. 28, 1967), New York, 1967, no. 48

ELLIOTT, CHARLES LORING

Tuckerman. *Book of the Artists*
L[ester], C. E. "Charles Loring Elliott," *Harper's New Monthly Magazine,* vol. 38 (1868), pp. 42-50
Bolton, Theodore. "Charles Loring Elliott; An Account of His Life and Work; A Catalogue of the Portraits Painted by Charles Loring Elliott (1812-1868)," *The Art Quarterly,* vol. 5, no. 1 (Winter 1942), pp. 59-96

FRANCIS, JOHN F.

Fielding, Mantle. *Dictionary of American Painters, Sculptors, and Engravers,* Philadelphia, 1926
Born, Wolfgang. *Still-Life Painting in America,* New York, 1947
Karolik
Frankenstein, Alfred. "J. F. Francis," *Antiques,* vol. 59, no. 5 (May 1951), pp. 374-377, 390
After the Hunt
Groce and Wallace. *Dictionary*

FRENCH, DANIEL CHESTER

Harding, Chester. "A Sculptor's Reminiscences of Emerson," *Art World* (Oct. 1916), pp. 44-47
McSpadden. *Famous Sculptors of America*
French, Mary A. *Memories of a Sculptor's Wife,* Boston and New York, 1928
Adams, Adeline. *Daniel Chester French: Sculptor,* Boston and New York, 1932
Cresson, Margaret. *Journey Into Fame: The Life of Daniel Chester French,* Cambridge, Massachusetts, 1947
Gardner. *MMA American Sculpture*
Craven. *Sculpture in America*

GIFFORD, SANFORD ROBINSON

Tuckerman. *Book of the Artists*
Sheldon, G. W. *American Painters: With Eighty-Three Examples of Their Work Engraved on Wood,* New York, 1879
The Metropolitan Museum of Art. *A Memorial Catalogue of the Paintings of Sanford Robinson Gifford, N.A., with a Biographical and Critical Essay by Prof. John F. Weir,* New York, 1881

[Whittredge, Worthington]. "The Autobiography of Worthington Whittredge, 1820-1910," ed. by John I. H. Baur, *Brooklyn Museum Journal,* (1942), pp. 7-68
Groce and Wallace. *Dictionary*

GUY, FRANCIS

Shakspeare Gallery. *Catalogue of Landscape Paintings by the Late Guy, Exhibiting at Shakspeare Gallery, 11 Park,* [New York, 1820]
Description of the Brooklyn Snow-Piece in the Gallery of Paintings, 11 Park, [New York, 1820]
Stiles, Henry R. *A History of the City of Brooklyn,* 2 vols., Brooklyn, 1869
Pleasants, J. Hall. *Four Late Eighteenth Century Anglo-American Landscape Painters,* Worcester, Massachusetts, 1943. Reprinted from *The Proceedings of the American Antiquarian Society* (Oct. 1942)
The Brooklyn Museum. *Handbook,* Brooklyn, 1967

HABERLE, JOHN

Frankenstein. *After the Hunt*
La Jolla Museum of Art, La Jolla, California (July 11-Sept. 19, 1965), Santa Barbara Museum of Art, Santa Barbara, California (Sept. 28-Oct. 31, 1965). *The Reminiscent Object, Paintings by William Michael Harnett, John Frederick Peto and John Haberle,* introd. by Alfred Frankenstein, 1965
The Baltimore Museum of Art (July 9-Sept. 24, 1967), The Metropolitan Museum of Art (Oct. 4-Nov. 26, 1967). *American Paintings & Historical Prints from The Middendorf Collection,* prefs. by Stuart P. Feld and J. William Middendorf, II, New York, 1967

HARDING, CHESTER

Harding, Chester. *My Egotistography,* Cambridge, Massachusetts, 1866. Reprinted as *A Sketch of Chester Harding, Artist, Drawn by His Own Hand,* ed. and with preface by Margaret E. White, Boston and New York, 1890. Reprinted, edited and annotated by W. P. G. Harding, Boston and New York, 1929
DAB
Gardner and Feld. *MMA American Paintings I*

HARDY, JEREMIAH PEARSON

Eckstorm, Fannie Hardy. "Jeremiah Pearson Hardy—A Maine Portrait Painter," *Old-Time New England,* vol. 30 (Oct. 1939), pp. 41-66
Karolik
Groce and Wallace. *Dictionary*

HARNETT, WILLIAM MICHAEL

Handelsblatt, Munich, clipping dated 1884 in the Blemly Scrapbook [William Ignatius Blemly Scrapbook sold by his son William Aloysius Blemly to Mrs. Edith Gregor Halpert, director of the Downtown Gallery, New York], translated and cited in Frankenstein, *After the Hunt,* p. 69

Williams, Hermann W., Jr. "Notes on William M. Harnett," *Antiques,* vol. 43, no. 6 (June 1943), pp. 260-262

Frankenstein, Alfred. "Harnett, True and False," *The Art Bulletin,* vol. 31, no. 1 (Mar. 1949), pp. 38-56

Goodrich, Lloyd. "Notes: Harnett and Peto: A Note on Style," *The Art Bulletin,* vol. 31, no. 1 (Mar. 1949), pp. 57-58

Frankenstein. *After the Hunt*

La Jolla Museum of Art, La Jolla, California (July 11-Sept. 19, 1965), Santa Barbara Museum of Art, Santa Barbara, California (Sept. 28-Oct. 31, 1965). *The Reminiscent Object, Paintings by William Michael Harnett, John Frederick Peto and John Haberle,* introd. by Alfred Frankenstein, 1965

Frankenstein, Alfred. "Mr. Hulings' Rack Picture," *Auction* (Feb. 1969), pp. 6-9

[Various owners]. *18th-20th Century American Paintings—Drawings—Sculpture,* sales cat., Parke-Bernet Galleries, Inc., New York, (Mar. 19 and 20, 1969), no. 62, pp. 70-71

HASSAM, CHILDE

Robinson, Frank T. *Living New England Artists,* Boston, 1888

Pattison, James William. "The Art of Childe Hassam," *House Beautiful,* vol. 23 (Jan. 1908), pp. 19-20

White, Israel L. "Childe Hassam—A Puritan," *International Studio,* vol. 45, no. 178 (Dec. 1911), pp. xxix-xxxiii

Pousette-Dart, Nathaniel, comp. *Childe Hassam,* Distinguished American Artists Series, introd. by Ernest Haskell, New York, 1922

Hassam, Childe. "Twenty-five Years of American Painting," *Art News,* vol. 26 (Apr. 14, 1928), pp. 22-28

College Art Association. "Childe Hassam—Painter and Graver, 1859-1935," *The Index of Twentieth Century Artists,* vol. 3, no. 1 (Oct. 1935), pp. 169-183

Adams, Adeline. *Childe Hassam,* New York, 1938

Young, Dorothy Weir. *The Life & Letters of J. Alden Weir,* ed. with an introd. by Lawrence W. Chisolm, New Haven, 1960

Hirschl and Adler Galleries, New York. *Childe Hassam 1859-1935,* (Feb. 18-Mar. 7, 1964), New York, 1964

The Corcoran Gallery of Art, Washington, D.C. (Apr. 30-Aug. 1, 1965), Museum of Fine Arts, Boston (Aug. 17-Sept. 19, 1965), Currier Gallery of Art, Manchester, New Hampshire (Sept. 28-Oct. 31, 1965), Gallery of Modern Art, New York (Nov. 16-Dec. 19, 1965). *Childe Hassam, A Retrospective Exhibition,* foreword by Hermann Warner Williams, Jr., introd. by Charles E. Buckley, Jr., Washington, 1965

HEADE, MARTIN JOHNSON

Museum of Modern Art, New York. *Romantic Painting in America,* exhib. cat. by James Thrall Soby and Dorothy C. Miller, New York, 1943

McIntyre, Robert George. *Martin Johnson Heade, 1819-1904,* New York, 1948

Karolik

Flexner, James Thomas. *That Wilder Image, The Painting of America's Native School from Thomas Cole to Winslow Homer,* Boston and Toronto, 1962

Wilmerding. *History of American Marine Painting*

Museum of Fine Arts, Boston (July 9-Aug. 24, 1969), University of Maryland Art Gallery, College Park, Maryland (Sept. 14-Oct. 23, 1969), Whitney Museum of American Art, New York (Nov. 10-Dec. 21, 1969). *Martin Johnson Heade,* by Theodore E. Stebbins, Jr., College Park, 1969

HEALY, GEORGE PETER ALEXANDER

Healy, George P. A. *Reminiscences of a Portrait Painter,* Chicago, 1894

[Bigot, Mary]. *Life of George P. A. Healy By His Daughter Mary (Madame Charles Bigot), Followed by a Selection of His Letters,* [n.p.], [n.d.]

de Mare, Marie. *G. P. A. Healy, American Artist, An Intimate Chronicle of the Nineteenth Century,* New York, 1954

Gerdts, William H. "Four Significant Paintings: Acquisitions and Reattributions; Church, Healy, McEntee: The Arch of Titus," *The Museum* [published by The Newark Museum], vol. 10, no. 1 (Winter 1958), pp. 18-20

Gardner and Feld. *MMA American Paintings I*

HICKS, THOMAS

Sheldon, G. W. *American Painters: With Eighty-Three Examples of Their Work Engraved on Wood,* New York, 1879

Tuckerman. *Book of the Artists*

Hicks, George A. "Thomas Hicks, Artist, a Native of Newtown," *Bucks County Historical Society Papers,* vol. 4 (1917), pp. 89-92

GEORGE HOLLINGSWORTH

Parker, Barbara N. "George Hollingsworth and His Family," *Boston Museum Bulletin,* vol. 50 (June 1952), pp. 30-31

Groce and Wallace. *Dictionary*

HOMER, WINSLOW

James, Henry. "On Some Pictures Lately Exhibited," *The Galaxy,* vol. 20 (July 1875), pp. 88-97

Downes, William Howe. *The Life and Works of Winslow Homer,* Boston and New York, 1911

Cox, Kenyon. *Winslow Homer,* New York, 1914

Cortissoz, Royal. *American Artists,* New York and London, 1923

Goodrich, Lloyd. *Winslow Homer,* New York, 1944

Smith College Museum of Art, Northampton, Massachusetts (Feb. 1951), Williams College, Williamstown, Massachusetts (Mar. 1951). *Winslow Homer: Illustrator, Catalogue of The Exhibition with a Checklist of Wood Engravings and a List of Illustrated Books,* text by Mary Bartlett Cowdrey, Northampton, 1951

Gardner, Albert TenEyck. "Metropolitan Homers," *The Metropolitan Museum of Art Bulletin,* n.s., vol. 17, no. 5 (Jan. 1959), pp. 132-143

Goodrich, Lloyd. *Winslow Homer,* The Great American Artists Series, New York, 1959

Gardner, Albert TenEyck, *Winslow Homer, American Artist, His World and His Work,* New York, 1961

Beam, Philip C. *Winslow Homer at Prout's Neck,* foreword by Charles Lowell Homer, Boston and Toronto, 1966

Flexner, James Thomas, and the Editors of Time-Life Books. *The World of Winslow Homer, 1836-1910,* Time-Life Library of Art, New York, [1966]

The Museum of Graphic Art, New York, and participating Museums [1968-1970]. *The Graphic Art of Winslow Homer,* by Lloyd Goodrich, foreword by Donald H. Karshan, New York, 1968

HOSMER, HARRIET GOODHUE

Tuckerman. *Book of the Artists*

Bradford, R. A. "Life and Works of Harriet Hosmer," *New England Magazine,* n.s., vol. 45 (1911), pp. 265 ff.

Carr, Cornelia. *Harriet Hosmer, Letters and Memories,* New York, 1912

McSpadden. *Famous Sculptors of America*

Thorp, Margaret. "The White Marmorean Flock," *New England Quarterly* (June 1959), pp. 147-169

Gardner, Albert TenEyck. *Yankee Stonecutters: The First American School of Sculpture, 1800-1850,* New York, 1945

Gerdts, William H. "American Sculpture: the collection of James H. Ricau," *Antiques,* vol. 86, no. 3 (Sept. 1964), pp. 291-298

HUNT, WILLIAM MORRIS

"William Morris Hunt," *The Art Journal* [New York], n.s., vol. 5 (1879), pp. 346-349

HUNT, WILLIAM MORRIS, *Continued*

Museum of Fine Arts, Boston. *Exhibition of the Works of William Morris Hunt*, (Dec. 20, 1879-Jan. 31, 1880), [7th ed.], Boston, 1880

Angell, Henry C. *Records of William M. Hunt*, Boston, 1881

Knowlton, Helen M. *Art-Life of William Morris Hunt*, London, 1899

Shannon, Martha A. S. *Boston Days of William Morris Hunt*, Boston, 1923

Gardner, Albert TenEyck. "A Rebel in Patagonia," *The Metropolitan Museum of Art Bulletin*, n.s., vol. 3, no. 9 (May 1945), pp. 224-227

DAB

Gardner. *MMA American Sculpture*

INGHAM, CHARLES CROMWELL

Tuckerman. *Book of the Artists*

Gardner, Albert TenEyck. "Ingham in Manhattan," *The Metropolitan Museum of Art Bulletin*, n.s., vol. 10, no. 9 (May 1952), pp. 245-253

Groce and Wallace. *Dictionary*

Gardner and Feld. *MMA American Paintings I*

INNESS, GEORGE

"A Painter on Painting," *Harper's New Monthly Magazine*, vol. 56 (1878), pp. 458-461

"Mr. Inness on Art-Matters," *The Art Journal* [New York], n.s., vol. 5 (1879), pp. 374-377

Sheldon, G. W. *American Painters: With Eighty-Three Examples of Their Work Engraved on Wood*, New York, 1879

"His Art His Religion: An Interesting Talk with the Late Painter George Inness on His Theory of Painting; Greatest Landscapist of the Day," *The New York Herald* (Aug. 12, 1894), section 4, p. 9, cols. 5-6

Inness, George, Jr. *Life, Art and Letters of George Inness*, New York, 1917

Hartley, Mrs. Jonathan Scott. *Works by George Inness, The Collection of Mrs. Jonathan Scott Hartley sold by Her Order . . .*, sales cat., American Art Association, New York, (Mar. 24, 1927)

Flexner, James Thomas. *That Wilder Image, The Painting of America's Native School from Thomas Cole to Winslow Homer*, Boston and Toronto, 1962

The Montclair Art Museum, Montclair, New Jersey. *George Inness of Montclair. An exhibition of paintings chiefly from the artist's Montclair period: 1878-1894* (Jan. 12-Feb. 16, 1964), [Montclair, 1964]

Ireland, LeRoy. *The Works of George Inness, An Illustrated Catalogue Raisonné*, Austin, Texas, and London, 1965

University Art Museum of The University of Texas, Austin, Texas. *The Paintings of George Inness (1844-94)*, preface by LeRoy Ireland, introd. by Nicolai Cikovsky, Jr., notes by Donald B. Goodall, (Dec. 12, 1965-Jan. 30, 1966), Austin, [n.d.]

JARVIS, JOHN WESLEY

Harrington, John Walker. "John Wesley Jarvis, Portraitist," *American Magazine of Art*, vol. 18, no. 11 (Nov. 1927), pp. 577-584

Bolton, Theodore and Groce, George C., Jr. "John Wesley Jarvis, An Account of His Life and the First Catalogue of His Work," *The Art Quarterly*, vol. 1, no. 4 (Autumn 1938), pp. 299-321

Dickson, Harold Edward. *John Wesley Jarvis, American Painter, 1780-1840*, New York, 1949

JOHNSON, EASTMAN

Benson, Eugene, in *The Galaxy*, vol. 6, no. 1 (July 1868), pp. 111-112

Low, Will H., Beckwith, Carroll, Isham, Samuel, and Fowler, Frank. "The Field of Art: Eastman Johnson—His Life and Works," *Scribner's Magazine* (1906), pp. 253-256

Walton, William. "Eastman Johnson, Painter," *Scribner's Magazine* (1906), pp. 263-274

French, Edgar. "An American Portrait Painter of Three Historical Epochs," *World's Work*, vol. 13 (Dec. 1906), pp. 8307-8323

Selby, Mark. "An American Painter: Eastman Johnson," *Putnam's Monthly*, vol. 2 (1907), pp. 533-542

Hartmann, Sadakichi. "Eastman Johnson: American Genre Painter," *International Studio*, vol. 34, no. 134 (Apr. 1908), pp. 106-111

Letter, Mrs. Eastman Johnson to the Museum, (New York, Jan. 25, [1913]), in The Metropolitan Museum of Art Archives

Letters, Frederic Horace Hatch to the Museum, (New York, 1926), in The Metropolitan Museum of Art Archives

Lesley, Parker. "Eastman Johnson's 'In the Fields'," *Bulletin of the Detroit Institute of Arts of the City of Detroit*, vol. 18, no. 1 (Oct. 1938), pp. 2-4

Baur, John I. H. *An American Genre Painter, Eastman Johnson, 1824-1906*, [The Brooklyn Museum], Brooklyn, 1940

Crosby, Everett U. *Eastman Johnson at Nantucket*, Nantucket, Massachusetts, 1944

Kouwenhoven, John A. *Partners in Banking, an Historical Portrait of a Great Private Bank, Brown Brothers Harriman & Co., 1818-1968*, Garden City, New York, 1968

KENSETT, JOHN FREDERICK

The Century Association, New York. *Eulogies on John F. Kensett. Proceedings at a Meeting of The Century Association held in Memory of John F. Kensett, December, 1872*, New York, 1872

Kensett, John F. *The Collection of Over Five Hundred Paintings and Studies, by the Late John F. Kensett will be sold at Auction . . .*, sales cat., Association Hall, New York, (Mar. 24-29, 1873)

National Academy of Design, New York. *On exhibition only: Mr. Kensett's last summer's work, and his private collection of pictures of cotemporaneous artists*, New York, 1873

The Metropolitan Museum of Art. *Descriptive catalogue of the thirty-eight paintings, "The Last Summer's Work," of the late John F. Kensett, presented by Mr. Thomas Kensett of Baltimore, Maryland . . . to the Metropolitan Museum of Art*, New York, 1874

Cowdrey, Bartlett. "The Return of John F. Kensett, 1816-1872, Painter of Pure Landscape," *The Old Print Shop Portfolio*, vol. 4, no. 6 (Feb. 1945), pp. 121-136

Johnson, Ellen H. "Kensett Revisited," *The Art Quarterly*, vol. 20, no. 1 (Spring 1957), pp. 71-92

Hathorn Gallery, Skidmore College, Saratoga Springs, New York. *John Frederick Kensett, A Retrospective Exhibition*, introds. by James Kettlewell and Joan C. Siegfried, (Apr. 13-May 3, 1967), [n.p.], [n.d.]

The American Federation of Arts, New York. *John Frederick Kensett 1816-1872*, by John K. Howat, New York, 1968

Howat, John K. "John F. Kensett, 1816-1872," *Antiques*, vol. 96, no. 3 (Sept. 1969), pp. 397-401

KING, CHARLES BIRD

Ewers, John C. "Charles Bird King, Painter of Indian Visitors to the Nation's Capital," *Annual Report of the Board of Regents of the Smithsonian Institution* (1953), pp. 463-473

Groce and Wallace. *Dictionary*

LA FARGE, JOHN

La Farge, John. *Considerations on Painting, Lectures Given in the Year 1893 at the Metropolitan Museum of New York*, New York and London, 1895

Cortissoz, Royal. *John La Farge, A Memoir and A Study*, Boston and New York, 1911

Letter, Henry A. La Farge to the Museum, (Mount Carmel, Connecticut, July 8, 1935), in The Metropolitan Museum of Art Archives

The Metropolitan Museum of Art. *An Exhibition of the Work of John La Farge*, (Mar. 23-Apr. 26, 1936), New York, 1936

The Graham Gallery, New York. *John La Farge* (May 4-June 10, 1966), New York, 1966

LANE, FITZ HUGH
Champney, Benjamin. *Sixty Years' Memories of Art and Artists*, Woburn, Massachusetts, 1900
Karolik
M. Knoedler and Co., New York. *Commemorative Exhibition, Paintings by Martin J. Heade (1819-1904) Fitz Hugh Lane (1804-1865) from The Private Collection of Maxim Karolik and The M. and M. Karolik Collection of American Paintings from The Museum of Fine Arts, Boston,* introd. by John I. H. Baur, (May 3-28, 1954), New York, 1954
Museum of Fine Arts, Boston. *Fitz Hugh Lane,* Picture Book No. 8, by Richard B. K. McLanathan, Boston, 1956
Wilmerding, John. *Fitz Hugh Lane 1804-1865, American Marine Painter,* Salem, Massachusetts, 1964
History of American Marine Painting

LE CLEAR, THOMAS
Tuckerman. *Book of the Artists*
The Buffalo Fine Arts Academy, Albright Art Gallery, Buffalo, New York. *Catalogue of the Paintings and Sculpture in the Permanent Collection,* ed. by Andrew C. Ritchie, Buffalo, 1949
Viele, Chase. "Four Artists of Mid-Nineteenth Century Buffalo," *New York History,* vol. 43, no. 1 (Jan. 1962), pp. 49-78

LEUTZE, EMANUEL GOTTLIEB
[Whittredge, Worthington]. "The Autobiography of Worthington Whittredge, 1820-1910," ed. by John I. H. Baur, *Brooklyn Museum Journal* (1942), pp. 7-68
Hutton, Anne H. *Portrait of Patriotism, Washington Crossing the Delaware,* Philadelphia, 1959
Flexner, James Thomas. *That Wilder Image, The Painting of America's Native School from Thomas Cole to Winslow Homer,* Boston and Toronto, 1962
Stehle, Raymond L. "Washington Crossing the Delaware," *Pennsylvania History,* vol. 31 (July 1964), pp. 269-294
The Baltimore Museum of Art (July 9-Sept. 24, 1967), The Metropolitan Museum of Art (Oct. 4-Nov. 26, 1967). *American Paintings & Historical Prints from The Middendorf Collection,* prefs. by Stuart P. Feld and J. William Middendorf, II, New York, 1967
Howat, John K. "Washington Crossing the Delaware," *The Metropolitan Museum of Art Bulletin,* n.s., vol. 26, no. 7 (Mar. 1968), pp. 289-299

MacMONNIES, FREDERICK WILLIAM
McSpadden. *Famous Sculptors of America,* quotation from MacMonnies, p. 84
Moore, Charles. *The Life and Times of Charles Follen McKim,* Boston, 1929

Gardner. *MMA American Sculpture*
Craven. *Sculpture in America*

MARTIN, HOMER DODGE
Martin, Elizabeth Gilbert Davis. *Homer Martin, A Reminiscence,* New York, 1904
Isham, Samuel. *A History of American Painting,* New York, 1905
Sturges, Russell. *The Appreciation of Pictures,* New York, 1905
Meyer, Ann Nathan. "Homer Martin: American Landscape Painter," *International Studio,* vol. 35, no. 140 (Oct. 1908), pp. 255-262
Mather, Frank Jewett, Jr. *Homer Martin, Poet in Landscape,* New York, 1912
Van Dyke, John C. *American Painting and Its Tradition,* New York, 1919
Whitney Museum of American Art, New York. *A Century of American Landscape Painting, 1800-1900,* introd. by Lloyd Goodrich, (Jan. 19-Feb. 25, 1938), New York, 1938

MORAN, THOMAS
United States Geological Survey, Records (Record Group 57). Hayden Survey: letters received (correspondence of Moran with F. V. Hayden and James Stevenson; also, of Richard Watson Gilder with Hayden), in United States National Archives, Washington
Jackson, W. H. "Famous American Mountain Paintings—With Moran in the Yellowstone," *Appalachia,* vol. 21, no. 82 (Dec. 1936), pp. 149-158
Fryxell, Fritiof, ed. *Thomas Moran, Explorer in Search of Beauty,* East Hampton, New York, 1958
The Picture Gallery, University of California, Riverside, California. *Thomas Moran 1837-1926,* by William H. Gerdts, with additional essays by Louise Nelson and Samuel Sachs, II, (Apr. 17-June 7, 1963), [n.p.], [n.d.]
Wilkins, Thurman. *Thomas Moran, Artist of the Mountains,* Norman, Oklahoma, 1966

MORSE, SAMUEL FINLEY BREESE
Dunlap. *Diary,* Cooper quotation, p. 608
Morse, Samuel F. B. *Descriptive Catalogue of the Pictures, Thirty-seven in Number, From the Most Celebrated Masters, Copied Into The Gallery of the Louvre, Painted in Paris, in 1831-32, By Samuel F. B. Morse,* New York, 1834
Prime, Samuel Irenaeus. *The Life of Samuel F. B. Morse, LL.D., Inventor of the Electro-Magnetic Recording Telegraph,* New York, 1875
Morse, Edward Lind, ed. *Samuel F. B. Morse, His Letters and Journals, Edited and Supplemented by His Son, Edward Lind Morse, . . . ,* 2 vols., Boston and New York, 1914

The Metropolitan Museum of Art. *Samuel F. B. Morse, American Painter, A Study Occasioned by an Exhibition of His Paintings, February 16 through March 27, 1932,* by Harry B. Wehle, New York, 1932
Mabee, Carleton. *The American Leonardo, A Life of Samuel F. B. Morse,* New York, 1943
National Academy of Design, New York. *Morse Exhibition of Arts and Science, . . . ,* exhibited at The American Museum of Natural History, New York, (Jan. 18-Feb. 28, 1950), New York, 1950
Larkin, Oliver W. *Samuel F. B. Morse and American Democratic Art,* New York, 1954
Gardner and Feld. *MMA American Paintings I*

MOUNT, WILLIAM SIDNEY
Mount, William Sidney. Catalogue of portraits and pictures painted by William Sidney Mount, ms. in Suffolk Museum and Carriage House at Stony Brook, New York
Mount, William Sidney. Journal, ms. formerly in the Whitney Museum of American Art, New York, now in Suffolk Museum and Carriage House at Stony Brook, New York
Dunlap. *History*
Buffet, Edward Payson. "William Sidney Mount: A Biography," *Port Jefferson Times* (Dec. 1923-June 1924). Clippings in scrapbooks, The Metropolitan Museum of Art and The New York Public Library
Cowdrey, Bartlett, and Williams, Hermann W., Jr. *William Sidney Mount,* New York, 1944
Gardner and Feld. *MMA American Paintings I*
Feld, Stuart P. "In the Midst of 'High Vintage'," *The Metropolitan Museum of Art Bulletin,* n.s., vol. 25, no. 8 (Apr. 1967), pp. 292-307
National Gallery of Art, Washington, D.C. (Nov. 23, 1968-Jan. 5, 1969), City Art Museum of St. Louis (Jan. 18-Feb. 15, 1969), Whitney Museum of American Art, New York (Mar. 3-Apr. 15, 1969), M. H. de Young Memorial Museum, San Francisco (May 1-31, 1969). *Painter of Rural America: William Sidney Mount 1807-1868,* by Alfred Frankenstein, introd. by Jane des Grange, Washington, 1968

OTIS, BASS
Dunlap. *History*
Otis, Bass. Miscellaneous letters and notes, Frick Art Reference Library, New York
Jackson, Joseph. "Bass Otis, America's First Lithographer," *Pennsylvania Maga-*

OTIS, BASS, *Continued*

zine of History and Biography, vol. 37 (Oct. 1913), pp. 385-394
DAB

PAGE, WILLIAM
Letter, William Page to James Russell Lowell, (Mar. 21, 1843). Ms. Am 765, folder 618, The Houghton Library, Harvard University, Cambridge, Massachusetts
Brother Jonathan [New York], vol. 6, no. 4 (Sept. 23, 1843), p. 101, cited in Taylor, p. 63
Tuckerman. *Book of the Artists*
Taylor, Joshua C. *William Page, The American Titian*, Chicago, 1957

PALMER, ERASTUS DOW
Palmer, Erastus Dow. "Philosophy of the ideal," *The Crayon*, vol. 3 (Jan. 1856), pp. 18-20
Chester, Anson G. "Erastus Dow Palmer," *Cosmopolitan Art Journal*, vol. 2 (1858)
Anonymous. "Palmer's White Captive," *The Atlantic Monthly*, vol. 5 (Jan. 1860), pp. 108-109
Jarves, James Jackson. *The Art-Idea*, New York, 1864
Tuckerman. *Book of the Artists*
Taft. *History of American Sculpture*
Gardner, Albert TenEyck. *Yankee Stonecutters: The First American School of Sculpture, 1800-1850*, New York, 1945
Gardner. *MMA American Sculpture*
Craven. *Sculpture in America*

PEALE, CHARLES WILLSON
Sellers, Horace W., ed. "Letters of Thomas Jefferson to Charles Willson Peale, 1796-1825," *Pennsylvania Magazine of History and Biography*, vol. 28 (1904)
Pennsylvania Academy of the Fine Arts, Philadelphia. *Catalogue of an Exhibition of Portraits by Charles Willson Peale and James Peale and Rembrandt Peale* (Apr. 11-May 9, 1923), final edition, Philadelphia, 1923
Vail, R. W. G. *The American Sketchbooks of Charles Alexandre Lesueur 1816-1837*, Worcester, Massachusetts, 1938. Reprinted from *The Proceedings of the American Antiquarian Society* (Apr. 1938)
Sellers, Charles Coleman. *The Artist of the Revolution, The Early Life of Charles Willson Peale*, Hebron, Connecticut, 1939
Charles Willson Peale, Volume II, Later Life (1790-1827), Memoirs of the American Philosophical Society, vol. 23, pt. 2, Philadelphia, 1947
Portraits and Miniatures by Charles Willson Peale, Transactions of the American Philosophical Society, vol. 42, pt. 1, Philadelphia, 1952
The Peale Museum, Baltimore. *The Story*

of America's Oldest Museum Building, by Wilbur Harvey Hunter, Baltimore, 1964
The Peale Family and Peale's Baltimore Museum 1814-1830, by Wilbur Harvey Hunter, Baltimore, 1965
The Detroit Institute of Arts (Jan. 18-Mar. 5, 1967), Munson-Williams-Proctor Institute, Utica, New York (Mar. 28-May 7, 1967). *The Peale Family, Three Generations of American Artists*, ed. by Charles H. Elam, articles by Charles Coleman Sellers, E. Grosvenor Paine, and Edward H. Dwight, Detroit, 1967
Sellers, Charles Coleman. *Charles Willson Peale A Biography by . . .*, New York, 1969

PEALE, JAMES
Pennsylvania Academy of the Fine Arts, Philadelphia. *Catalogue of an Exhibition of Portraits by Charles Willson Peale and James Peale and Rembrandt Peale* (Apr. 11-May 9, 1923), final edition, Philadelphia, 1923
Sellers, Charles Coleman. *The Artist of the Revolution, The Early Life of Charles Willson Peale*, Hebron, Connecticut, 1939
Baur, John I. H. "The Peales and the Development of American Still Life," *The Art Quarterly*, vol. 3, no. 1 (Winter 1940), pp. 81-92
Sellers, Charles Coleman. *Charles Willson Peale, Volume II, Later Life (1790-1827)*, Memoirs of the American Philosophical Society, vol. 23, pt. 2, Philadelphia, 1947
Gardner and Feld. *MMA American Paintings I*
The Detroit Institute of Arts (Jan. 18-Mar. 5, 1967), Munson-Williams-Proctor Institute, Utica, New York (Mar. 28-May 7, 1967). *The Peale Family, Three Generations of American Artists*, ed. by Charles H. Elam, articles by Charles Coleman Sellers, E. Grosvenor Paine, and Edward H. Dwight, Detroit, 1967

PEALE, RAPHAELLE
Sellers, Charles Coleman. *The Artist of the Revolution, The Early Life of Charles Willson Peale*, Hebron, Connecticut, 1939
Charles Willson Peale, Volume II, Later Life (1790-1827), Memoirs of the American Philosophical Society, vol. 23, pt. 2, Philadelphia, 1947
The Detroit Institute of Arts (Jan. 18-Mar. 5, 1967), Munson-Williams-Proctor Institute, Utica, New York (Mar. 28-May 7, 1967). *The Peale Family, Three Generations of American Artists*, ed. by Charles H. Elam, articles by Charles Coleman Sellers, E. Grosvenor Paine, and Edward H. Dwight, Detroit, 1967

PEALE, REMBRANDT
Peale, Rembrandt. *Introduction to "Notes of the Painting Room"*, [n.p.], [n.d., ca. 1859]
Pennsylvania Academy of the Fine Arts, Philadelphia. *Catalogue of an Exhibition of Portraits by Charles Willson Peale and James Peale and Rembrandt Peale* (Apr. 11-May 9, 1923), final edition, Philadelphia, 1923
Sellers, Charles Coleman. *The Artist of the Revolution, The Early Life of Charles Willson Peale*, Hebron, Connecticut, 1939
Charles Willson Peale, Volume II, Later Life (1790-1827), Memoirs of the American Philosophical Society, vol. 23, pt. 2, Philadelphia, 1947
The Peale Museum, Baltimore. *The Story of America's Oldest Museum Building*, by Wilbur Harvey Hunter, Baltimore, 1964
The Peale Family and Peale's Baltimore Museum 1814-1830, by Wilbur Harvey Hunter, Baltimore, 1965
Feld, Stuart P. " 'Loan Collection,' 1965," *The Metropolitan Museum of Art Bulletin*, n.s., vol. 23, no. 8 (Apr. 1965), pp. 275-294
The Detroit Institute of Arts (Jan. 18-Mar. 5, 1967), Munson-Williams-Proctor Institute, Utica, New York (Mar. 28-May 7, 1967). *The Peale Family, Three Generations of American Artists*, ed. by Charles H. Elam, articles by Charles Coleman Sellers, E. Grosvenor Paine, and Edward H. Dwight, Detroit, 1967

PETO, JOHN FREDERICK
Frankenstein, Alfred. "Harnett, True and False," *The Art Bulletin*, vol. 31, no. 1 (Mar. 1949), pp. 38-56
Goodrich, Lloyd. "Notes: Harnett and Peto: A Note on Style," *The Art Bulletin*, vol. 31, no. 1 (Mar. 1949), pp. 57-58
Smith College Museum of Art, Northampton, Massachusetts (Mar. 1-24, 1950), The Brooklyn Museum (Apr. 11-May 21, 1950), California Palace of the Legion of Honor, San Francisco (June 10-July 9, 1950). *John F. Peto*, by Alfred Frankenstein, Brooklyn, 1950
Frankenstein. *After the Hunt*
La Jolla Museum of Art, La Jolla, California (July 11-Sept. 19, 1965), Santa Barbara Museum of Art, Santa Barbara, California (Sept. 28-Oct. 31, 1965). *The Reminiscent Object, Paintings by William Michael Harnett, John Frederick Peto and John Haberle*, introd. by Alfred Frankenstein, 1965

PICKNELL, WILLIAM LAMB
Chennevières, Marquis de. "Le Salon de 1880," *Gazette des Beaux-Arts*, vol. 22, pt. 2 (July 1880), p. 66

PICKNELL, WILLIAM LAMB, *Continued*

Clement and Hutton. *Artists of the Nineteenth Century*
Fielding, Mantle. *Dictionary of American Painters, Sculptors and Engravers*, Philadelphia, 1926
Groce and Wallace. *Dictionary*
Downes, William Howe. "William Lamb Picknell," in *DAB*
"Robert Wylie," in *DAB*

POWERS, HIRAM

Lester, Charles Edwards. *The Artist, The Merchant, and The Statesman*, 2 vols., New York, 1845, Jackson sittings described, vol. 1, pp. 62-66
Tuckerman. *Book of the Artists*
Bellows, Henry W. "Seven Sittings with Powers the Sculptor," *Appleton's Journal*, vol. 1 (1869), pp. 342-343, 359-361, 402-404, 470-471, 595-597; vol. 2 (1870), pp. 54-55, 106-108
Gardner, Albert TenEyck. "Hiram Powers and 'The Hero'," *The Metropolitan Museum of Art Bulletin*, n.s., vol. 2, no. 2 (Oct. 1943), pp. 102-108
"A Relic of the California Gold Rush," *The Metropolitan Museum of Art Bulletin*, n.s., vol. 8, no. 4 (Dec. 1949), pp. 117-121
MMA American Sculpture
The Brooklyn Museum. *Handbook*, Brooklyn, 1967
Craven. *Sculpture in America*

QUIDOR, JOHN

[Irving, Washington]. *The Sketch Book of Geoffrey Crayon, Gent.*, New York, 1820
Tales of a Traveller, by Geoffrey Crayon, Gent., Philadelphia, 1824
Dunlap. *History*
The Brooklyn Museum. *John Quidor* (Jan. 23-Mar. 8, 1942), by John I. H. Baur, Brooklyn, 1942
Munson-Williams-Proctor Institute, Utica, New York. *John Quidor*, by John I. H. Baur, (Nov. 1965-Apr. 1966), Utica, 1965

RANNEY, WILLIAM TYLEE

Cummings, Thomas S. *Historic Annals of the National Academy of Design*, Philadelphia, 1865
Karolik
Flexner, James Thomas. *That Wilder Image, The Painting of America's Native School from Thomas Cole to Winslow Homer*, Boston and Toronto, 1962
The Corcoran Gallery of Art, Washington, D.C. (Oct. 4-Nov. 11, 1962), The Detroit Institute of Arts (Nov. 27, 1962-Jan. 1, 1963), The Dallas Museum of Fine Arts (Jan. 28-Mar. 11, 1963). *William Ranney, Painter of the Early West*, by Francis S. Grubar, foreword by Hermann Warner Williams, Jr., Washington, 1962

REMINGTON, FREDERIC SACKRIDER

Remington, Preston. "The Bequest of Jacob Ruppert," *The Metropolitan Museum of Art Bulletin*, vol. 34, no. 7 (July 1939), pp. 166-172
McCracken, Harold. *Frederic Remington, Artist of the Old West*, introd. by James Chillman, Jr., Philadelphia and New York, 1947
Gardner. *MMA American Sculpture*
The Paine Art Center and Arboretum, Oshkosh, Wisconsin (Aug. 1-Sept. 24, 1967), The Minneapolis Institute of Arts (Oct. 11- Nov. 12, 1967), Sterling and Francine Clark Art Institute, Williamstown, Massachusetts (Dec. 2-31, 1967). *Frederic Remington, A Retrospective Exhibition of Painting and Sculpture*, Oshkosh, 1967
Craven. *Sculpture in America*

RICHARDS, WILLIAM TROST

Morris, Harrison Smith. *Masterpieces of the Sea: William T. Richards, a Brief Outline of His Life and Art*, Philadelphia and London, 1912
Groce and Wallace. *Dictionary*
DAB

RIMMER, WILLIAM

Rimmer, William. *Elements of Design*, Boston, 1864
Art Anatomy, Boston, 1877
Bartlett, Truman H. *The Art Life of William Rimmer, Sculptor*, Boston, 1882
Whitney Museum of American Art, New York (Nov. 5-27, 1946), Museum of Fine Arts, Boston (Jan. 7-Feb. 2, 1947). *William Rimmer 1816-1879*, foreword by Juliana Force, catalogue by Lincoln Kirstein, [New York, 1946]
Gardner. *MMA American Sculpture*
Craven. *Sculpture in America*

RINEHART, WILLIAM HENRY

Taft. *History of American Sculpture*
Rusk, William Sener. *William Henry Rinehart, Sculptor*, Baltimore, 1939
The Peabody Institute and The Walters Art Gallery, Baltimore. *A Catalogue of the Work of William Henry Rinehart, Maryland Sculptor, 1825-1874*, by Marvin Chauncey Ross and Anna Wells Rutledge, Baltimore, 1948
Gardner. *MMA American Sculpture*
Craven. *Sculpture in America*

ROBINSON, THEODORE

Baur, John I. H. *Theodore Robinson 1852-1896* [The Brooklyn Museum, Brooklyn Institute of Arts and Sciences], Brooklyn, 1946
Kennedy Galleries, Inc., New York. *Theodore Robinson, American Impressionist (1852-1896), Exhibition of Paintings, Pas-*

tels, Watercolors, and Drawings Held at . . . (Winter 1966), New York, [n.d.]

ROESEN, SEVERIN

"August Roesen, Artist; An Interesting Williamsport Genius Recalled by His Works," *Williamsport Sun and Banner* [Williamsport, Pennsylvania], (June 27, 1895)
Born, Wolfgang. *Still-Life Painting in America*, New York, 1947
Stone, Richard B. " 'Not Quite Forgotten' A Study of the Williamsport Painter, S. Roesen," *Lycoming Historical Society Proceedings and Papers* [Williamsport, Pennsylvania], No. 9 (Nov. 1951)
Frankenstein. *After the Hunt*
Mook, Maurice A. "S. Roesen, 'The Williamsport Painter'," *The Morning Call* [*S. Pennsylvaanisch Deitsch Eck*], Allentown, Pennsylvania, (Dec. 3, 1955)
Groce and Wallace. *Dictionary*
"Roesen's Art Seen at Dinner," *Sun Gazette* [Williamsport, Pennsylvania], (Oct. 19, 1965)

ROGERS, JOHN

Barck, Dorothy C. "Rogers Groups in the Museum of the New-York Historical Society," *The New-York Historical Society Quarterly Bulletin*, vol. 16, no. 3 (Oct. 1932), pp. 67-86
Smith, Mr. and Mrs. Chetwood. *Rogers Groups Thought & Wrought by John Rogers*, Boston, 1934
Gardner. *MMA American Sculpture*
Wallace, David H. *John Rogers: The People's Sculptor*, Middletown, Connecticut, 1967

ROGERS, RANDOLPH

Bulwer-Lytton, Edward George. *The Last Days of Pompeii*, 2 vols., New York, 1835, vol. 2, p. 189
Gardner. *MMA American Sculpture*
Craven. *Sculpture in America*

RUSH, WILLIAM

Taylor, Charles, comp. *The Artist's Repository; or, Encyclopedia of the Fine Arts*, London, 1808
Scharf, J. Thomas, and Westcott, Thompson. *History of Philadelphia, 1609-1884*, 3 vols., Philadelphia, 1884
Gilliams, E. Leslie. "A Philadelphia Sculptor," *Lippincott's Magazine* (Aug. 1893), pp. 249-253
Pennsylvania Museum of Art, Philadelphia. *William Rush, 1756-1833, The First Native American Sculptor*, by Henri Marceau, Philadelphia, 1937

RYDER, ALBERT PINKHAM

Ryder, Albert P. "Paragraphs from the Stu-

RYDER, ALBERT PINKHAM, *Continued*
dio of a Recluse," *Broadway Magazine*, vol. 14 (Sept. 1905), pp. 10-11
Fry, Roger. "The Art of Albert P. Ryder," *The Burlington Magazine*, vol. 13 (Apr. 1908), pp. 63-64
Sherman, Frederic Fairchild. "The Marines of Albert P. Ryder," *Art in America*, vol. 8, no. 1 (Dec. 1919), pp. 28-32
Albert Pinkham Ryder, New York, 1920
Robinson, John. "Personal Reminiscences of Albert Pinkham Ryder," *Art in America*, vol. 13 (June 1925), pp. 176-187
Craven, Thomas. "An American Master," *The American Mercury*, vol. 12 (Dec. 1927), pp. 490-497
Goodrich, Lloyd. *Albert Pinkham Ryder*, The Great American Artists Series, New York, 1959
Young, Dorothy Weir. *The Life & Letters of J. Alden Weir*, ed. with an introd. by Lawrence W. Chisolm, New Haven, 1960
The Corcoran Gallery of Art, Washington, D.C. *Albert P. Ryder*, by Lloyd Goodrich, (Apr. 8-May 12, 1961), Washington, 1961

SAINT-GAUDENS, AUGUSTUS
Cortissoz, Royal. *Augustus Saint-Gaudens*, Boston and New York, 1907
Hind, C. Lewis. *Augustus Saint-Gaudens*, New York, 1908
Saint-Gaudens, Homer, ed. *The Reminiscences of Augustus Saint-Gaudens*, 2 vols., New York, 1913
Gardner. *MMA American Sculpture*
Craven. *Sculpture in America*
Thorp, Louise Hall. *Saint-Gaudens and the Gilded Era*, Boston and Toronto, 1969

SALMON, ROBERT
Tuckerman. *Book of the Artists*
Wilmerding, John. "A New Look at Robert Salmon," *Antiques*, vol. 87, no. 1 (Jan. 1965), pp. 89-93
DeCordova Museum, Lincoln, Massachusetts. *Robert Salmon: The First Major Exhibition*, by John Wilmerding, (Apr.-May, 1967), Lincoln, 1967
Wilmerding, John. *Robert Salmon, Painter of Ship and Shore*, Boston, 1968
History of American Marine Painting

SARGENT, HENRY
Dunlap. *History*
Museum of Fine Arts, Boston. *Catalogue of Paintings*, Boston, 1921
Sargent, Emma Worcester and Charles Sprague. *Epes Sargent and His Descendants*, Boston, 1923
Addison, Julia DeWolf. "Henry Sargent: A Boston Painter," *Art in America*, vol. 17, no. 6 (Oct. 1929), pp. 279-284
Swan. *Athenaeum*
Dickson, Harold Edward, ed. *Observations on American Art: Selections from the*

Writings of John Neal (1793-1876), Pennsylvania State College Studies No. 12, State College, Pennsylvania, 1943, includes *Randolph* quotation
Ralston, Ruth. "Nineteenth-Century New York Interiors, Eclecticism Behind the Brick and Brownstone," *Antiques*, vol. 43, no. 6 (June 1943), pp. 266-270
The Metropolitan Museum of Art. *French Paintings, A Catalogue of the Collection of The Metropolitan Museum of Art. Vol. II, XIX Century*, by Charles Sterling and Margaretta M. Salinger, New York, 1966

SARGENT, JOHN SINGER
James, Henry. "John S. Sargent," *Harper's New Monthly Magazine* (Oct. 1887), pp. 688, 689
Downes, William Howe. *John S. Sargent: His Life and Work*, Boston, 1925
Charteris, Evan. *John Sargent*, New York, 1927
Birnbaum, Martin. *John Singer Sargent January 12, 1856: April 15, 1925, A Conversation Piece*, New York, 1941
The Art Institute of Chicago (Jan. 14-Feb. 25, 1954), The Metropolitan Museum of Art (Mar. 25-May 23, 1954). *Sargent, Whistler and Mary Cassatt*, by Frederick A. Sweet, Chicago, 1954
Mount, Charles Merrill. *John Singer Sargent, A Biography*, New York, 1955; London, 1957
McKibbin, David. *Sargent's Boston with an Essay & a Biographical Summary & a complete Check List of Sargent's portraits*, Boston, 1956
The Corcoran Gallery of Art, Washington, D.C. (Apr. 18-June 14, 1964), The Cleveland Museum of Art (July 7-Aug. 16, 1964), Worcester Art Museum, Worcester, Massachusetts (Sept. 17-Nov. 1, 1964), Munson-Williams-Proctor Institute, Utica, New York (Nov. 15, 1964-Jan. 3, 1965). *The Private World of John Singer Sargent*, by Donelson F. Hoopes, foreword by Hermann Warner Williams, Jr., New York, 1964

SHAW, JOSHUA
Dunlap. *History*
Stokes, I. N. Phelps, and Haskell, Daniel C. *American Historical Prints; Early Views of American Cities, Etc., from the Phelps Stokes and Other Collections*, New York, 1932, pp. 102-103
Karolik
Gardner and Feld. *MMA American Paintings I*
Wilmerding. *History of American Marine Painting*

SKILLIN, WORKSHOP OF SIMEON
Albrizzi, [I. (Teotochi)] Countess d'. *The*

Works of Antonio Canova in Sculpture and Modelling Engraved in Outline by Henry Moses; with Descriptions from the Italian of the Countess Albrizzi, and a Biographical Memoir by Count Cicognara, London, 1824
Coletti, Luigi. "La fortuna del Canova," *Bollettino del Reale Istituto di Archeologia e Storia dell'Arte*, vol. I, fasc. 4-6 (Rome, 1927), pp. 21-96
Swan, Mabel M. "A Revised Estimate of McIntire," *Antiques*, vol. 20, no. 6 (Dec. 1931), pp. 338-343
Thwing, Leroy L. "The Four Carving Skillins," *Antiques*, vol. 33, no. 6 (June 1938), pp. 326-328
Labaree, Benjamin W., ed. *Samuel McIntire A Bicentennial Symposium 1757-1957*, Salem, Massachusetts, 1957
Kosareva, N[ina] K[onstantinova]. *Kanova i, ego proizvedeniia v Ermitazhe*, Leningrad, 1961
Sommer, Frank H. "Sculpture at Winterthur," *Antiques*, vol. 85, no. 2 (Feb. 1964), pp. 182-184

STANLEY, JOHN MIX
Stanley, John Mix. *Portraits of North American Indians, with Sketches of Scenery, etc., Painted by J. M. Stanley*, Smithsonian Institution Publications, No. 53, [n.p.], 1852. Reprinted in *Smithsonian Miscellaneous Collections*, vol. 2 (1862)
Kinietz, W. Vernon. *John Mix Stanley and His Indian Paintings*, Ann Arbor, Michigan, 1942
McCracken, Harold. *Portrait of the Old West*, New York, 1952
Groce and Wallace. *Dictionary*

STORY, WILLIAM WETMORE
Hawthorne, Nathaniel. *The French and Italian Note-books*, Boston, 1858, vol. 1, p. 69, as quoted in Taft, p. 151
Phillips, Mary E. *Reminiscences of William Wetmore Story . . .*, Chicago and New York, 1897
James, Henry. *William Wetmore Story and His Friends, From Letters, Diaries, and Recollections*, 2 vols., Boston, 1903
Taft. *History of American Sculpture*
Gardner. *MMA American Sculpture*
Craven. *Sculpture in America*

STUART, GILBERT
Dunlap. *History*
Mason, George C. *The Life and Works of Gilbert Stuart*, New York, 1879
"Gilbert Stuart," *Masters in Art*, (1906), pp. 23-42
Park, Lawrence. *Gilbert Stuart, An Illustrated Descriptive List of His Work*, 4 vols., New York, 1926
Wehle, Harry B. "A Portrait of President Monroe," *The Metropolitan Museum of*

STUART, GILBERT, *Continued*

Art Bulletin, vol. 24, no. 8 (Aug. 1929), pp. 198-199

Morgan, John Hill. *Gilbert Stuart and His Pupils,* New York, 1939

Flexner, James Thomas. *Gilbert Stuart, A Great Life in Brief,* New York, 1955

"James Monroe," in *DAB*

Mount, Charles Merrill. *Gilbert Stuart, A Biography,* New York, 1964

Gardner and Feld. *MMA American Paintings I*

National Gallery of Art, Washington (June 28-Aug. 20, 1967), Museum of Art, Rhode Island School of Design, Providence, Rhode Island (Sept. 9-Oct. 15, 1967). *Gilbert Stuart, Portraitist of the Young Republic, 1755-1828,* Providence, 1967

SULLY, THOMAS

Dunlap. *History*

Tuckerman. *Book of the Artists*

Sully, Thomas. *Hints to Young Painters,* Philadelphia, 1873; reprinted in a new format, with introd. by Faber Birren, New York, 1965

Scharf, J. Thomas, and Westcott, Thompson. *History of Philadelphia, 1609-1884,* 3 vols., Philadelphia, 1884

Morton, Thomas George, and Woodbury, Frank. *The History of the Pennsylvania Hospital,* Philadelphia, 1895

Sully, Thomas. *A Register of Portraits Painted by Thomas Sully 1801-1871,* arranged and ed. with an introd. and notes by Charles Henry Hart, Philadelphia, 1908

Burroughs, Bryson. "Examples of Thomas Sully's Work," *The Metropolitan Museum of Art Bulletin,* vol. 9, no. 12 (Dec. 1914), pp. 248-250

Biddle, Edward, and Fielding, Mantle. *The Life and Works of Thomas Sully,* Philadelphia, 1921

Pennsylvania Academy of the Fine Arts, Philadelphia. *Catalogue of the Memorial Exhibition of Portraits by Thomas Sully,* 2nd ed., Philadelphia, 1922

Karolik

Prown, Jules David. "Two Ms. Notebooks of Thomas Sully," *Yale University Library Gazette,* vol. 39, no. 2 (Oct. 1964), pp. 73ff.

Gardner and Feld. *MMA American Paintings I*

TAIT, ARTHUR FITZWILLIAM

"Arthur F. Tait," *Cosmopolitan Art Journal* (Mar. and June 1858), pp. 103-104

Kennedy and Co., New York. *Exhibition of Paintings by A. F. Tait* (Nov. 1921), New York, 1921

Peters, Harry Twyford. *Currier & Ives,*

Print Makers to the American People, Garden City, New York, 1929-1931

Groce and Wallace. *Dictionary*

DAB

TARBELL, EDMUND CHARLES

Coburn, Frederick W. "Edmund C. Tarbell," *International Studio,* vol. 32, no. 127 (Sept. 1907), pp. lxxv-lxxxvii

Museum of Fine Arts, Boston. *Frank W. Benson, Edmund C. Tarbell, Exhibition of Paintings, Drawings, and Prints,* introd. by Lucien Price and Frederick W. Coburn, (Nov. 16-Dec. 15, 1938), Boston, 1938

DAB

THOMPSON, CEPHAS GIOVANNI

Dunlap. *History*

Tuckerman. *Book of the Artists*

Clement and Hutton. *Artists of the Nineteenth Century*

Karolik

Groce and Wallace. *Dictionary*

THOMPSON, JEROME B.

An Amateur [pseud.]. *A Critical Guide to the Exhibition at the National Academy of Design,* New York, 1859

Tuckerman. *Book of the Artists*

Clement and Hutton. *Artists of the Nineteenth Century*

Thompson, Charles Hutchinson. *A Genealogy of the Descendants of John Thomson of Plymouth, Mass.,* Lansing, Michigan, 1890

Karolik

Groce and Wallace. *Dictionary*

DAB

THOMPSON, LAUNT

Taft. *History of American Sculpture*

Groce and Wallace. *Dictionary*

Gardner. *MMA American Sculpture*

Craven. *Sculpture in America*

TRUMBULL, JOHN

Dunlap. *History*

Trumbull, John. *Autobiography, Reminiscences and Letters of John Trumbull, from 1756 to 1841,* New York, London and New Haven, 1841

Weir, John F. *John Trumbull, A Brief Sketch of His Life, to Which is Added A Catalogue of His Works,* New York, 1901

Wadsworth Atheneum, Hartford. *John Trumbull, Painter-Patriot, An Exhibition Organized to Honor the Bicentennial of the Artist's Birth,* preface by Evan H. Turner, introd. by Theodore Sizer, (Oct. 10-Nov. 25, 1956), Hartford, 1956

Sizer, Theodore. *The Works of Colonel John Trumbull, Artist of the American Revolution,* by . . . , with the assistance

of Caroline Rollins, rev. ed., New Haven and London, 1967

TWACHTMAN, JOHN HENRY

Clark, Eliot. *John Twachtman,* New York, 1924

Tucker, Allen. *John H. Twachtman,* American Artists Series, New York, 1931

The Cincinnati Art Museum. *A Retrospective Exhibition, John Henry Twachtman,* introd. by Richard J. Boyle, introd. to prints by Mary Welsh Baskett, (Oct. 7-Nov. 20, 1966), [n.p.], [n.d.]

Ira Spanierman, New York. *John Henry Twachtman 1853-1902, An Exhibition of Paintings & Pastels* (Feb. 3-24, 1968), [n.p.], [n.d.]

VANDERLYN, JOHN

Gosman, Robert. Unpublished biographical sketch of John Vanderlyn, Artist. Ms. two drafts at the Senate House Museum, Kingston, New York; typed copy at The New-York Historical Society

Barlow, Joel. *Columbiad,* Philadelphia, 1807

Letter, John Vanderlyn to Washington Allston, (May 7, 1809), Darrow Collection, Senate House Museum, Kingston, New York, as quoted in Mondello, p. 172

Letter, John Vanderlyn to Colonel C. Gibbs, (Dec. 24, 1811), John Paul Remensnyder Collection, Senate House Museum, Kingston, New York, as quoted in Schoonmaker, p. 26, Mondello, p. 172

Dunlap. *History*

[A Friend of the Artist]. *Review of The "Biographical Sketch" of John Vanderlyn, Published by William Dunlap, in His "History of The Arts of Design;" With Some Additional Notices, Respecting Mr. Vanderlyn, As An Artist. By A Friend of the Artist,* New York, 1838

Tuckerman. *Book of the Artists*

[Kip, William Ingraham]. "Recollections of John Vanderlyn," *The Atlantic Monthly,* vol. 19 (Feb. 1867). Reprinted in "John Vanderlyn, His Work and His Character," *The Kingston Daily Freeman* (June 13, 1931)

Pritchard, Kathleen H. "Shorter Notes: John Vanderlyn and the Massacre of Jane McCrea," *The Art Quarterly,* vol. 12, no. 4 (Autumn 1949), pp. 361-366

Schoonmaker, Marius. *John Vanderlyn, Artist 1775-1852, Biography by . . . ,* Kingston, New York, 1950

Miller, Lillian Beresnack. "John Vanderlyn and the Business of Art," *New York History,* vol. 32, no. 1 (Jan. 1951), pp. 33-44

Mondello, Salvatore. "John Vanderlyn," *The New-York Historical Society Quarterly,* vol. 52, no. 2 (Apr. 1968), pp. 161-183

VEDDER, ELIHU
Bishop, W. H. "Elihu Vedder," in *American Art and American Art Collections*, Walter Montgomery, ed. Boston, 1889, pp. 161-176
Vedder, Elihu. *The Digressions of V. Written for His own Fun and that of His Friends*, Boston and New York, 1910 *Doubt and Other Things*, Boston, 1922

VONNOH, BESSIE POTTER
Monroe, Lucy. "Bessie Potter," *Brush and Pencil*, vol. 2, no. 1 (Apr.-Sept. 1898), pp. 29-36
"A Sculptor of Statuettes," *Current Literature*, vol. 34 (June 1903), pp. 699-702
McSpadden. *Famous Sculptors of America*
Gardner. *MMA American Sculpture*
Craven. *Sculpture in America*

VONNOH, ROBERT WILLIAM
Vonnah [sic], Robert. "The Relation of Art to Existence, A Noted Painter Voices Some Common-sense Concerning Everyday Beauty," *Arts and Decoration*, vol. 17, no. 5 (Sept. 1922), pp. 328-329
"Vonnoh's Half Century," *International Studio*, vol. 77, no. 313 (June 1923), pp. 231-233
Clark, Eliot. "The Art of Robert Vonnoh," *Art in America*, vol. 16, no. 5. (Aug. 1928), pp. 223-232
DAB

WALDO, SAMUEL LOVETT
W[ehle], H. B. "Two Portraits by Waldo," *The Metropolitan Museum of Art Bulletin*, vol. 18, no. 3 (Mar. 1923), pp. 63-64
Karolik
Groce and Wallace. *Dictionary*
Gardner and Feld. *MMA American Paintings I*

WARD, JOHN QUINCY ADAMS
Sheldon, G. W. "An American Sculptor," *Harper's Magazine*, vol. 57 (June 1878), pp. 62-68
Taft. *History of American Sculpture*
Adams, Adeline. *John Quincy Adams Ward, an Appreciation*, New York, 1912
Gardner. *MMA American Sculpture*
Thorp, Margaret. *The Literary Sculptors*, Durham, North Carolina, 1965
Craven. *Sculpture in America*

WEIR, JOHN FERGUSON
Tuckerman. *Book of the Artists*

Sizer, Theodore, ed. *The Recollections of John Ferguson Weir, Director of the Yale School of the Fine Arts 1869-1913*, New York and New Haven, 1957. Reprinted, with additions, from *The New-York Historical Society Quarterly* (Apr., July, Oct., 1957)

WEIR, JULIAN ALDEN
The Century Association, New York. *Julian Alden Weir, An Appreciation of His Life and Works*, ed. by J. B. Millet, New York, 1921
The Metropolitan Museum of Art. *Memorial Exhibition of the Works of Julian Alden Weir*, introd. by William A. Coffin, (Mar. 17-Apr. 20, 1924), New York, 1924
The Brooklyn Museum. *Leaders of American Impressionism, Mary Cassatt, Childe Hassam, John H. Twachtman, J. Alden Weir*, introd. by John I. H. Baur, (Oct. 1937), Brooklyn, 1937, quote, p. 12
Young, Dorothy Weir. *The Life & Letters of J. Alden Weir*, ed. with an introd. by Lawrence W. Chisolm, New Haven, 1960

WHISTLER, JAMES ABBOTT McNEILL
"Art and Mr. Whistler," *The Art Journal* [London], vol. 56 (Dec. 1894), pp. 358-360
Pennell, E. R. and J. *The Life of James McNeill Whistler*, 2 vols., London and Philadelphia, 1908
Duret, Theodore. *Whistler*, trans. by Frank Rutter, London, 1917
Pennell, E. R. and J. *The Whistler Journal*, Philadelphia, 1921
Glasgow Art Gallery. *Whistler: Arrangements in Grey & Black, 1 & 2*, by T. J. Honeyman, (Apr.-June 1951), Glasgow, 1951
The Art Institute of Chicago (Jan. 14-Feb. 15, 1954), The Metropolitan Museum of Art (Mar. 25-May 23, 1954). *Sargent, Whistler and Mary Cassatt*, by Frederick A. Sweet, Chicago, 1954
The Arts Council Gallery, London (Sept. 1-24, 1960), The Knoedler Galleries, New York (Nov. 2-30, 1960). *James McNeill Whistler, An Exhibition of Paintings and Other Works Organized by The Arts Council of Great Britain and The English-Speaking Union of the United States*, introd. by Andrew McLaren Young, [n.p.], 1960
Sutton, Denys. *Nocturne: The Art of James McNeill Whistler*, Philadelphia and New York, 1964

The Art Institute of Chicago (Jan. 13-Feb. 25, 1968), Munson-Williams-Proctor Institute, Utica, New York (Mar. 17-Apr. 28, 1968). *James McNeill Whistler*, by Frederick A. Sweet, Chicago, 1968

WHITTREDGE, THOMAS WORTHINGTON
[Whittredge, Worthington]. "The Autobiography of Worthington Whittredge, 1820-1910," ed. by John I. H. Baur, *Brooklyn Museum Journal* (1942), pp. 7-68
Munson-Williams-Proctor Institute, Utica, New York (Oct. 12-Nov. 16, 1969), Albany Institute of History and Art, Albany, New York (Dec. 2, 1969-Jan. 18, 1970), Cincinnati Art Museum (Feb. 6-Mar. 8, 1970). *Worthington Whittredge (1820-1910), A Retrospective Exhibition of an American Artist*, introd. by Edward H. Dwight, Utica, 1969

WOODVILLE, RICHARD CATON
Tuckerman. *Book of the Artists*
The Sun [Baltimore, Maryland], Supplement (Nov. 15, 1881), p. 1
Woodville, Richard Caton, Jr. *Random Recollections*, London, 1914
Cowdrey, Bartlett. "Richard Caton Woodville," *American Collector*, vol. 13 (Apr. 1944) pp. 6-7, 14, 20
The Walters Art Gallery, Baltimore. *Catalogue of the American Works of Art, Including French Medals Made for America*, by Edward S. King and Marvin C. Ross, Baltimore, 1956
The Corcoran Gallery of Art, Washington, D.C. (Apr. 21-June 11, 1967), The Walters Art Gallery, Baltimore (Sept. 5-Oct. 5, 1967), Munson-Williams-Proctor Institute, Utica, New York (Nov. 6-Dec. 10, 1967), The High Museum of Art, Atlanta, Georgia (Jan. 5-Feb. 5, 1968), The Brooklyn Museum (Mar. 5-Apr. 5, 1968). *Richard Caton Woodville an early American Genre Painter*, Washington, 1967

WYANT, ALEXANDER HELWIG
Clark, Eliot. *Alexander Wyant*, New York, 1916
Sixty Paintings by Alexander H. Wyant, Described by . . ., New York, 1920
Utah Museum of Fine Arts, University of Utah, Salt Lake City. *Alexander Helwig Wyant 1836-1892* (Mar. 3-31, 1968), Salt Lake City, 1968